THE CINEMA OF APARTHEID

KEYAN TOMASELLI

THE CINEMA
OF
APARTHEID

Race and Class in South African Film

A SMYRNA/LAKE VIEW PRESS BOOK
New York/Chicago

This book is a joint publication of Smyrna Press (paperback edition), Box 021803-GPO, Brooklyn, NY 11202 and Lake View Press (hardback edition), Box 578279, Chicago, IL 60657.

ISBN 0-918266-19-X (paperback)

ISBN 0-941702-28-9 (hardback)

Cover photo from Impact Visuals. Detail from a photo showing South African police laying seige to a union office while looking for members of the ANC.

Cover design: Robert W. Brown

Library of Congress Catalogue Card No. 87-13121

Library of Congress Cataloging-in-Publication Data

Tomaselli, Keyan G., 1948-
 The cinema of apartheid.

 Filmography: p.
 Bibliography: p.
 Includes index.
 1. Motion-pictures—South Africa—History.
2. Apartheid—South Africa. I. Title.
PN1993.5.S6T58 1987 384'.8'0968 87-13121
ISBN 0-918266-19-X (pbk.)

Manufactured in the United States of America
by:
ATHENS PRINTING COMPANY
New York, N. Y.

Acknowledgements

The present volume takes *The S.A. Film Industry* (Johannesburg: University of Witwatersrand, 1979) as its point of departure. Some material from that book has been dropped or updated and many new chapters have been added. Nonetheless, I remain greatly indebted to the African Studies Institute for granting permission to use some of the original material and to John van Zyl for his support of the original project.

I thank the University of Witwatersrand for providing a Senate Research Grant for *The S.A. Film Industry* and to the Rhodes University Council for a grant to cover costs of research conducted in 1983 and 1984. I also wish to acknowledge the assistance of the Department of Commerce, Trade and Industry and the National Film Archives for information relating to the filmographies found in the present volume.

Further thanks are due to Kevin Carlean and Larry Strelitz for comments and assistance on individual chapters. Most of all, I wish to thank my wife, Ruth, with whom I spent many hours in discussion and proofreading.

 KEYAN TOMASELLI

Notes on Language and Style

American usage in spelling and grammar has been used for the most part in the editing of this book. In some instances, however, South African conventions have been followed. The most obvious example is the use of the South African racial term, *coloured*. This was essential to prevent the text from being overloaded with explanatory footnotes, and this use of *coloured* in no way constitutes the publisher's endorsement of such racial classifications. *Color* (the American spelling) is used when race is not involved with the exception of direct quotes from English and South African publications in which case the original spelling (and punctuation) has been retained. The South African practice of not capitalizing *van* in a name such as John van Zyl when *van* is preceded by a first name has been adopted. Citations reflect a blend of usage in the U.S. and South Africa with the emphasis on providing all data required to fully identify a source. The name of a film is first given in the language of release with parenthesis used to indicate a dubbed or subtitled version, a circumstance often found in South Africa. Transliterations from native languages have followed South African models and the inconsistencies in different sources have been standardized whenever possible.

Contents

INTRODUCTION

The publication of this book coincides with an unprece-
dented challenge to apartheid. Both divestment and desertion
by multi-national capital threatened the economy of the mid-
80s. By 1980 the violence more and more took on the charac-
ter of a civil war, intensified by the blacks who fled to join the
African National Congress (ANC) after the state mounted its
counter-attack to the Soweto uprising of 1976. The ANC sur-
prised many observers by increasing its pressure on the South
African state after the Nkomati Accord with Mozambique in
1983—so much so that the government made a brief conditional
offer to release Nelson Mandela after twenty years in prison. It
was, however, clear by December 1986 that the government was
going to concede nothing, and, instead, increased repression and
media censorship. Apartheid, "reformed" or otherwise, seemed
here to stay.

Despite the intransigence of the state, the strength of its
repressive agencies had yet to be fully tested. "Reform," the
buzz word of the eighties, represented little more than a delay-
ing tactic. Black resisters responded by attacking the Bantu
education system, black informers, collaborationist city council-
lors, policemen, mayors and politicians. The conflict reached a
threshold where nothing less than a total reorganization of the
South African political and economic system would be accepted.

While the English-language South African press demanded
the release of Mandela and the legalization of the ANC, much
of the film industry blithely continued as if nothing was hap-
pening. The Producers Institute vehemently objected to an issue
of *The SAFTTA Journal* which focused on the cultural boycott,
while Agfa-Gevaert, a German producer of film stock, with-
drew is advertising from the *Journal* in protest.

9

The mid-eighties, however, saw some small stirrings in the film industry, as it entered a period in which some business interests, under international pressure, joined the battle against apartheid. Kodak divested lock, stock and barrel, withdrawing from the country in April 1987. The two main distributor-exhibitor chains, agents for the bulk of American product, closed cinemas in towns which refused to allow integrated audiences. For the first time cinema chains showed a film critical of apartheid, *A Place of Weeping* (1987); *Night at the Palace* (1987), however, was briefly banned from screening in South Africa by Paramount, which held the international rights. *The Weekly Mail,* with the help of some technicians, organized a South African Film Festival and the first Independent Film-makers Conference, giving progressive non-commercial work a high national profile for the first time. This dynamic will no doubt continue as pressure against apartheid intensifies and more films are made by producers who have identified suffering under apartheid as a marketable commodity.

Yet it is outside the country that the debates about the political role of the South African cinema started, and, as the place of publication of this book suggests, continues. The origin of these debates can be traced particularly to the Amiens Film Festival against Racism and for Friendship between Peoples, held in Amiens, France, in November 1983. The festival gave rise to a variety of publications, some sponsored by the festival itself, others by the United Nations, SAFTTA and the French journal, *CinemAction.*

A second source of the debates was, ironically, the international financial success of Jamie Uys' *The Gods Must Be Crazy.* While the film itself drew attention to South African cinema, world interest was heightened by the campaign of anti-apartheid organizations to boycott the film. More column inches discussed the political character of this film than any other film ever made in South Africa: was it politics or entertainment? White South African audiences and critics, not surprisingly saw the film as entertainment, and few shared the overseas critique, from which they were, in any case, shielded.

Despite the interest occasioned by the debates, the study of South African cinema remains confined to a handful of scholars.

The strategic ideological importance of South African cinema—indeed, of the media in general—is rarely appreciated, when concern is directed to the more pressing issues of repression. However, repression has to be legitimized in some way, and cinema has historically played an important role in presenting apartheid as a natural way of life. The process of legitimation is an underlying theme of this book, which is concerned with the contemporary industry, how it functions and what effects it has on the social mosaic that makes up South Africa.

Conventional sources of investment, both domestic and international, continue to produce bland, and often racist, feature films, films which legitimate current political processes or show American, colonial and white myths about Africa and Africans. However, funds made available by Western churches, foundations and foreign embassies stimulated a progressive film and video movement at grassroots levels. Crews often drawn from repressed communities, have documented resistance to apartheid and the very struggle for existence itself with small format equipment such as Super-8 VUS, Beta and U-Matic video equipment. At the same time, this movement is introducing democratic structures and ways of producing films which give oppressed people control over the way they are represented. As embattled and intimidated as filmmakers are, their future lies here also, and not only with the commercial industry which does everything it can to smother progressive ideas and perpetuate passive black and white audiences.

The National Party is determined to contest the inexorable movement of history, but it can only delay the inevitable. This book is dedicated to those creators of film and video, critics, and theorists who are working towards a democratic future in South Africa. Film and video will always be crucial legitimating agents and will hopefully be able to take their place in helping to forge a new, free and peaceful society in the years to come.

CHAPTER ONE

CENSORSHIP

"The duty of the Publications Bodies is, they must ask the question, 'What does the average man in the street with a Standard Seven Education think?' The Publications Bodies, the adjudicators, must decide what the moral standards are of the general community, the bulk of which is not sophisticated."

JUDGE L. SNYMAN, *Chairman of the Publications Appeal Board, 1980*[1]

South African critics of censorship usually ignore racism and limit their comments to matters of sex and nudity. This preoccupation obscures the underlying economic determinants which created apartheid. While racism is not peculiar to South Africa, its legal form as shaped by the specific dominant ideology is. Laws affecting race relations in South Africa grew with industrialization and urbanization, reaching a crescendo following the coming to power of the National Party in 1948. Long before the triumph of the National Party, however, film had been used as a means of shaping class perceptions and work roles. From the early Cape Province ordinances of 1910 through the most recent national legislation, government policy has been geared not only to upholding "morality" but, more importantly, to upholding the prevailing class structure of South African society.

In 1910, *The Johnson-Jeffries Fight*, which had sparked race riots in the United States, was banned. Whites responded through the press that the film's inculcation of race hatred would be ob-

viated by prohibiting its exhibition to blacks. This remarkable conclusion accords with a prime tenet of apartheid ideology: that racism is found mainly in blacks. In 1913, an investigating commission advocated strict censorship of all pictures exhibited to mixed audiences. The Public Control Ordinance (Cape Province) of 1916 prohibited films deemed to bring any section of the public into ridicule or contempt. The Cinematograph Film Ordinance (Cape) of 1917 included clauses prohibiting scenes "representing antagonistic relations between Capital and Labor; pugilistic encounters between Europeans and non-Europeans [and] scenes tending to disparage public characters or to create public alarm."

In response to lobby group pressures and following discussions with the film industry, the Entertainment Act of 1931 provided for censorship clearance before public screening. The Act further called for the censorship of "scenes of intermingling of Europeans and non-Europeans." A 1934 amendment prevented film societies, particularly those with "native members," from screening "communist propaganda."

Up to 1963 film censorship mostly applied to imported material, since local producers rarely challenged the *status quo*. Some exceptions concerned internationally financed films to be shot in South Africa. One was a proposed MGM film of South African author Stuart Cloete's *Turning Wheels,* a story of a love affair between an Afrikaans man and a coloured woman. (South Africa's racial classification has four major divisions: white, coloured, Asian, and black.) The Minister of External Affairs threatened, "If MGM produces *Turning Wheels,* I say irrevocably that not another MGM film will ever be allowed to come into South Africa." The proposal was shelved.[2]

The Publications and Entertainments Act of 1963 for the first time made formal provision for the censorship of locally produced material. The institution of the Publications Control Board (PCB) had an indelible effect on the film industry, and it is argued by some producers that censorship of local films is more rigorous than for imported material.

POLITICS AND PROTECTING
THE NATION'S MORALS

"I think it is a myth that we [Afrikaners] must be protected. If we have such a shallow society, if our heritage lies so shallow, is it worth protecting it by legislation?"

JOHAN VAN JAARSVELD, *scriptwriter*, The Star, *May 8, 1984*

The antics of Jannie Kruger, chairman of the PCB during the decade of the 1960s, were ridiculous. He assailed any films which departed from strict Calvinism.[3] *Debbie* (1965) was initially banned because Kruger believed that Afrikaans girls do not get pregnant out of wedlock. Of Mario Schiess' *Onwettige Huwelik* (*Unlawful Wedding*, 1970), he complained that in South Africa there is no such thing as an unlawful wedding.

The Board's treatment of *Die Kandidaat* (1968) set the pattern for the next eight years. Nofal and Rautenbach had already weathered heavy cultural criticism of their first film, *Wild Season* (1967), which had escaped the attention of the PCB. *Die Kandidaat* deals with the ambivalent class position of colored South Africans, who derive from miscegenation between early Dutch settlers and the indigenous population. Under the aegis of the 1963 Act, the censors cut a scene from *Die Kandidaat* in which the question of whether coloureds were Afrikaners or not was discussed. The PCB's argument was that as coloureds might one day become Afrikaners, this sequence could give offense. For *Katrina* (1969) the producer shot two endings. The first was true to the resolution of the original play where the characters emigrate. The other is ambiguous, but ideologically "correct": the white man rejects his coloured girlfriend because of their cultural differences. The PCB demanded the latter ending.

The Board's action against Rautenbach's films should be seen in relation to coloured disenfranchisement during the early 1930s. Taking away the right to vote was supported and encouraged by the Afrikaner Broederbond, which saw "this coura-

geous step... as one of the most important milestones in our
struggle for white survival."[4] As whites gained total sovereignty
in parliament, the media had to be persuaded to portray as real
the new set of social relations governing this enforced class
structure. Under the 1963 Act, a differential censorship based
on race became commonplace and appeals had to be made di-
rectly to the Minister of the Interior.

A 1974 amendment cancelled the racial basis of censorship
but retained the right to restrict films "to persons in a specific
category ... or at a specific place." It also substituted an internal
Appeal Board within what was now called the Directorate of
Publications. Section 47 of the legislation deemed undesirable
any film which (1) brings any section of the inhabitants of the
Republic into ridicule or contempt; (2) is harmful to the rela-
tions between any sections of the inhabitants of the Republic;
and (3) is prejudicial to the safety of the state, the general wel-
fare or the peace and good order. This is a very wider ranging
set of conditions which were usually applied in a manner which
ensured positive representations of whites on screen, though a
degree of criticism against apartheid was allowed to filter through.

Kruger had retired by the time the new Act came into force
in 1975, having been replaced by Judge Lammie Snyman. The
new administration approved the release of *The South Africans*
in 1976 and overturned a Committee decision to ban Tommie
Meyer's *Springbok* (1976). This later film traces the life of
a coloured child who passes for white and eventually earns
Springbok rugby colours.

The *rapprochement* between whites and coloureds grew
towards the end of the 1970s and consolidated itself in the
early 1980s when the legitimate coloured political parties were
co-opted by the state into a racially segregated central parlia-
mentary system which replaced the Westminster system in 1984.
Cinema began to reflect such "integration." More and more films
involved coloured characters, such as the comedy, *Diamant en
die Dief* (1978), the politically satirical *Skelms* (1980), the im-
plied criticism of National Party voters in *Herfsland* (1979)
and the embittered acceptance of white domination by the
coloured subversive in *April '80*. The Nadine Gordimer film,
City Lovers (1983), which deals with the Group Areas and

Immorality Acts in terms of a sexual relationship between a coloured shop assistant and a white Austrian immigrant, is a later example of this shift. This film was made from a story written in the 1960s and explores the insidious, unstated violence of the South African political system against lovers who break the color bar. Her *Country Lovers* (1983) has a rural setting where a white farm boy has a love affair with the daughter of a black farm laborer.

Despite a third generation of censor administration which took office in 1980 and censored films in terms of the "probable viewer" and Supreme Court precedents rather than Snyman's norm of the unintelligent "average viewer," Gordimer's films ran into problems. This "probable viewer" was defined as "the mature, serious-minded filmgoer who will see the film in proper perspective."[5] Even against the background of white-coloured political cooperation and the stated intention by the Prime Minister of his wish to delete the Immorality Act from the statute books, these films proved to be unacceptable to the Publications Committee, which is the first stage of censorship. The committee complained that *Country Lovers* contained a "sympathetic portrayal" of "immorality." The implied criticism of the police and the "offensive and indecent" explicit medical examination of two characters were considered "wholly out of perspective." They charged that the film would give undue "publicity" to sexual behavior which was no longer prosecuted and would thus be counterproductive to the state at a time when it was negotiating a "new constitutional dispensation" with coloureds and Indians. These objections related to the "sympathy" shown to blacks, the "emotional" content of one of the scenes, and contraventions of the law of the land.

The Appeal Board overturned both Committee decisions on the basis that the films would not be "widely screened," would be linked to academic discussions and that "sufficient latitude must be allowed for political debate, criticism and pleas for change":

> The mere fact that treatment of this theme evokes sympathy for the protagonists is not enough for a finding of undesirability. The application of the acceptability

criterion is also incorrect. The question is whether the treatment of the theme can be "tolerated." As appellant's council indicated by way of statistics, the Publication Committee's statement that prosecutions no longer take place is incorrect. This is also substantiated by a statement by the Minister of Law and Order in Parliament during 1983. The aspect of publicity is also not relevant. The whole matter of section 16 of the Immorality Act has been referred by Parliament to a Select Committee, and this film can only contribute to the on-going debate on section 16 of the Immorality Act. The subject is a controversial one, but this does not justify its not being debated fully, even in films. With regard to the Publication Committee's finding that the police are portrayed sympathetically, the Board is of the view that the police have been portrayed as sympathetically as possible under the circumstances. It was common cause that the police were doing their duty and it is almost impossible to deal with the matter in a different manner. As the enforcers of a controversial law, the police are inevitably drawn into controversy . . . Although both films, by implication, criticize section 16, immorality is not propagated at all. The accent is placed on the very real problems which result from an application of the Act or, in any case, from South African mores.[6]

While this attitude on the part of the Appeal Board has been described in terms of their more "enlightened" outlook, and by Ster-Kinekor as a result of their policy "to bring our cases to the Publications Appeal Board,"[7] there can be no doubt that the Directorate was attempting to lay the ideological groundwork for the "new dispensation" which includes coloureds and Indians on an unequal basis.

COOPERATING WITH REPRESSIVE AGENCIES

> "Sometimes the police think you are making propaganda films on how badly we treat blacks, for overseas television. We now approach the station commander and tell him we are filming in this area and there are no problems."
>
> TONIE VAN DER MERWE, *director of films aimed at blacks, May 11, 1979*

Comparing the position of South African filmmakers to those in dictatorships such as Pinochet's Chile in the decade following 1964,[8] it is apparent that they get off comparatively lightly. While torture, exile, interrogation, confiscation and sometimes destruction of material is unlikely in South Africa, some erring film makers have been arrested, intimidated and had their films intercepted by state security agents. A number of documentary and news cameramen have run afoul of legislation such as the Prisons Act, while even film makers who work within Nationalist discourse have experienced trouble with the police, who have been known to misinterpret action involving black actors.

The most well-documented example of methods of state intimidation concerns Sven Persson's *Land Apart* (1974). Persson was subjected to police surveillance; his film rushes disappeared; permission to film in a number of black areas was refused; and the Prime Minister's office killed a viable local distribution by intimidating MGM's head office in California. After a two year battle with the PCB—and later with the Directorate of Publications which replaced it—a re-edited version of the film secured censorship exemption on a technicality.

In 1976, the black scriptwriter and director of *How Long*, Gibsen Kente, was arrested for a period while making the film in the Eastern Cape. The production period had coincided with the nationwide unrest of that year, which had made the police extra-cautious with regard to scenes critical of the police. In 1980 a film made by Witwatersrand University students of the painting of an image of a bulldozer on a Pageview house in a vacated Indian Group Area, Johannesburg, led to the painters'

and the filmmakers' arrests. The non-white residents of Pageview had been forcibly removed by the state to make way for "urban renewal" and white habitation. The painting was applied to a house due for demolition. It is with some irony, therefore, that the students were charged with causing "malicious damage to property" (sic). The case was dropped on a technicality.

The production of the Gordimer films was not without its problems. Not only were the security police aware of matters affecting production, but, on one or two occasions, they were allowed to view rushes. There was little the producer could do to prevent this state interest, save to attempt to identify the informers on the set.

THE SOCIALIZATION OF DANGER: THE SIEGE MENTALITY

> "The primary aim of the enemy is to unnerve through maximum publicity. In this regard we will have to obtain the co-operation of the South African media in not giving excessive and unjustified publicity to the terrorists and thus playing into their hands."
>
> GENERAL MAGNUS MALAN, *Minister of Defense, August 14, 1981*

The increasing collusion between the South African Defense Force (SADF) and the various media—reflecting an important shift in the balance of power from the police to the military—formed an intrinsic part of Prime Minister P. W. Botha's "total strategy" to meet the "total onslaught" against South Africa.[9] This siege mentality is characterized by cinematic treatments of the bush war where reality becomes a choice between binary opposites—good versus bad, war versus peace, black versus white, communism versus nationalism, Christianity versus Marxism.[10] Films which do not fit this framework may have their meaning inverted through censorship directives. One example is *Terrorist* (1976). On appeal the Directorate ordered cuts and additions where, according to the Appeal Board, "The

emphasis is thus changed from a successful to an unsuccessful terrorist attack." Films involving SADF co-operation, such as *Wild Geese* (1977) and *Game For Vultures* (1979) have to obtain official clearance at the script stage. Even so, such films are apparently subject to stricter censorship constraints at their submission stages than films about wars elsewhere.

The violence permitted in many war films must be seen against the background of the Appeal Board's decision on *Spoor* (1975), and the refusal of the government to act against an Italian production, *Africa Addio,* which was re-released soon after the 1976 Soweto disturbances. The Appeal Board, over-turning a 4-16 age restriction on *Spoor,* argued that children should gradually be made aware of the realities of life, which in this film included graphic scenes of the wounded and the dead, casualties of the Anglo-Boer War. *Africa Addio,* condemned by many African governments as portraying Africans in a bad light, continued to be screened despite protests from the black community and white liberals. Significantly, the film was re-stricted to white audiences only, and four of the six advertising posters were banned, presumably to prevent blacks from reading them. While this form of differential censorship has only rarely been applied under the 1974 Act, it was a matter of course during the 1963 Act under which *Africa Addio* was initially submitted.

Under the 1974 Act only two other films have been banned for blacks but passed for whites, *The Klansman* and *The Autobiography of Miss Jane Pitman.* The latter film, although available on the home movie circuit, has been refused cinema release by both of the major cinema chains, Ster-Kinekor and CIC-Warner. Generally, films which are deemed to harm race relations are banned outright, as was *Apache Massacre.* Under the 1963 Act, by contrast, differential censorship was often applied between the four major race groups: whites, coloureds, Asians and blacks. About one in three films passed for whites was banned for blacks, the most ridiculous example being the ban on Zulu viewers seeing the film *Zulu* (1966). This decision is not sur-prising in the light of a previous statement made by the Minister of the Interior on the matter of differential censorship:

[We] know what sort of film it would be to show to a race that has not yet reached the level of civilization that we have reached ... things which they cannot understand should not be shown to them and ... there are some films which can be exhibited much more safely to a white child of fourteen years than to an adult Bantu.[11]

The major difference in the implementation of the 1963 and 1974 Acts lies in the implicit recognition of an increasing black middle class, urban-based workforce which needs to be co-opted into a lifestyle which secures their alliance with white business while simultaneously severing the allegiance of this emerging class from the more populous working class. This strategy is at work at all levels of the economy. In 1980, for example, the Department of Community Development granted permission for certain drive-ins to go multi-racial. Applications for "open" cinemas had been made as far back as 1976. The desire by exhibitors to open their doors to all races was not an altruistic move, but rather an attempt to maximize their market potential. The growth of white audiences was slowing down and expected to diminish rapidly with the introduction of broadcast television on January 1, 1976. Significantly, those cinemas which applied for open status were located mainly in the central areas which are becoming more black-oriented as white consumers and cinemagoers are increasingly attracted to the decentralized suburban shopping and cinema complexes. Permission for multi-racial cinemas has not been forthcoming, except in the single instance of *Way of Life* (1980), a film on black soccer players participating in the multiracial soccer league. There are, however, a small number of cinemas which have historically been multiracial, where, for example, whites sit downstairs, and blacks upstairs.

A second pressure on local distributors to go multiracial stems from overseas distributors and producers. Many black actors and other blacks involved in filmmaking are making it a condition of release in South Africa that their local agents do everything possible to reach multiracial audiences. By 1986 most cinemas had obtained multiracial status.

CENSORSHIP AND THE CINEMA OF
POPULAR CULTURE

"Of blacks I have no knowledge at all."

Judge Lammie Snyman, The Star, *April 8, 1980*

Unlike many other Third World countries which have been characterized by the emergence of a cinema of popular culture such as Cinema Novo in Brazil, only one critical film, *How Long* (1974), has been made and financed by a black South African. There can be no doubt that such a critical cinema, should one emerge, would be repressed almost immediately, given the experience of the white-owned but black-run newspapers such as *World, Weekend World,* the *Post* (Transvaal) and *Sunday Post.* This would probably pertain despite the fact that the Appeal Board does make allowances for the voicing of black aspirations, for protests against the hardships seen by blacks to be inflicted upon them by the "white" system, and for pleas to change this system. The Board has stressed that blacks should be permitted greater freedom of speech than whites because of the absence of black parliamentary representation. So too, the use of strong, even exaggerated invective is sanctioned. The Board bases its attitude on two ideological premises: (1) that political bias and exaggeration is to be expected *and is counter-productive,* and (2) that it is essential that whites be conversant with black attitudes and grievances.[12] This more lenient and pragmatic attitude, however, only emerged with the assumption by Van Rooyen of the Appeal Board chair in 1980. In contrast to previous administrations, Van Rooyen's reading of the Act has often been at variance with the findings of the Publications Committees and with the decisions made by Snyman. However, though the censors have become more tolerant towards depictions of interracial love affairs and criticism of racial policy, they remain immovable on negative depictions of whites in film. Of Gordimer's *A Chip of Glass Ruby* (1983) which explores the responses of an Indian family about to be relocated to make way for a white Group Area, the Appeal Board stated:

> This film would contribute to racial disharmony and
> would either engender hate or strengthen hate against
> the white section of the population, which is represented
> by the forces of law and order in this film. It transgresses
> the bounds of political criticism and moves into the
> realm of hate.

In a document released in 1982, the Appeal Board conceded that criticism of government policy should be allowed and that "acrimonious language is a typical feature of the South African political scene." Contradicting itself in its next sentence, the Appeal Board states: "What is undesirable must go further than that." Seeing a literal causation between the media and their direct effects on behavior, the Board argued that "protest literature," such as the films *The Grass Is Singing* and *This We Can Do For Justice and Peace,* is permissible providing it does not harm race relations or cause confrontation. Of particular significance is the Board's statement, "The more popular the material, the more likely it is to be undesirable."[18] Thus, the reading of Nadine Gordimer's *A Chip of Glass Ruby* by a literate elite is considered less of a threat to the security of the state than if it is seen in film form by millions of people on television or in the cinema.

A certain, though diminishing, degree of political criticism can be tolerated in the "white" media aimed at white audiences, but similar criticism directed at black viewers is considered a threat to the prevailing order since such information will find a more responsive and volatile audience among the black majority. Although more than 200 films have been made in black vernaculars by white producers, they all fall within the confines of the dominant ideology and are largely controlled by white capital. Some of them were directly financed by the Department of Information, which set out to capture "black" cinema in the interests of the state. The Department, however, failed to pursue its vision, as it was closed down once its many controversial activities had been exposed by the liberal English-language press.

The films are censored by a Directorate composed almost entirely of white adjudicators:

As regards the Bantu people, the Commission feels that their own distinctive orthogenous development is different from that of the Coloureds and Indians and for that reason no specific role in the proposed system of control can be asigned to them.[14]

Furthermore, the Minister went on to say that he had received no expression of interest from any Africans for inclusion on the censorship committees.

SEX, NUDITY AND GEOGRAPHICAL DIFFERENTIATION

> "At present Ster-Kinekor only shows its soft-porn movies in Bophuthatswana, although the company has the franchise for other parts of Southern Africa."
>
> The Star, *August 15, 1983*

Simultaneous with the shifting class structure and the attempt to co-opt the urban black middle classes, there has been a liberalization of censorship with respect to sex, nudity and expletives. Films banned in the 1970s such as *Seven Beauties, Carnal Knowledge* and *The Rocky Horror Picture Show* have been permitted in the 1980s. This attitude occurred with the retirement of Judge Snyman in April 1980. The new administration was determined to regain a credibility for the Directorate and to project a public image of flexibility and reason. Besides, the South African social formation was less threatened by sexual permissiveness than it had been prior to 1980. The narrow Calvinist morality once needed to legitimatize the rigid class divisions upon which apartheid is based, was less critical during the following decade when the political economy was adjusting from primary to secondary industry with its concomitant demands for skilled labor.

In the new period of reform the government felt it was

more important to forge links with the Indian, coloured and black petty bourgeoisies than it was to maintain the traditional support of the extremist Afrikaner right wing. Overlaid on this structural economic change was the tricameral parliament which placed less emphasis on race as the determinant of the broader class divisions. This blurring of the previously inflexible class-race distinction which had occurred progressively with the growth and consolidation of the homeland bourgeoisie and petty bourgeoisie manifested itself in the urban areas of "white" South Africa in a relaxation of some racial restrictions such as the opening up of theaters to multiracial audiences and the opening of the central business district to all races.

The greater black-white interaction was allowed to reflect itself in the media as a means of socializing the wider society into accepting political change. This is clearly demonstrated by the increasing exposure of white South African audiences to hard-core pornography in Swaziland and Lesotho, and soft-core in the "independent" homelands like Transkei and Bophu-thatswana. Since the dominant ideology of apartheid holds that these "national states" are indeed independent, their screening of material banned in South Africa fulfills a double function. On the one hand it provides a vicarious outlet to white South Africans who are denied access to such fare back "home," and on the other, it proves to both South Africans and the world that these states are "free." The fact that the companies which distribute the films and the hotel-casino chains which exhibit them are owned primarily by South African capital, which derives super-profits from these areas, is ignored. Thus the cinema market is profitably exploited without upsetting the Calvinist thinking which informs much of apartheid ideology. The homeland "states" are not only dumping grounds, but also the conduit whereby fractions of white capital—hotel, casino and cinema—are able to expand their markets in so-called black areas.

Cinema exhibition of films banned in "white" South Africa is part of the arsenal used by the hotel industry in South Africa to secure its investments against international incursion. As Julian Baskin points out, the homelands offer considerable advantages over Lesotho and Swaziland. First, tourism capital has the backing of the South African state and South African

financiers for its homeland operations. Second, there is a high degree of cooperation on the part of the South African state in the internationalization of vice and its marketing as a legitimate tourist attraction. Third, homeland investment carries none of the uncertainties of black countries caught between South African domination and a desire for economic independence. Fourth, the homeland governments are subject to much tighter political control by South Africa. Fifth, the circulation of profit is internal to South Africa and the wealth produced is easily appropriated for consumption and investment outside the homelands. Finally, the homeland accessibility to major urban centers has made viable a lucrative short-term market.[15]

The spatial organization of the South African censorship net is thus characterized by pockets of sexual permissiveness in the form of multiracial film festivals in the centers of Johannesburg, Cape Town and Durban and, on a permanent basis, in the form of cinemas owned by South African capital in seemingly independent countries. These pockets nestle within a larger territory of a more conservative nature which appears to be in a constant process of liberalization and reform. The collusion between tourist, cinema and entertainment capital in the homelands through the establishment of hotel-casino chains, some of which are tied to multinational companies, has obvious implications for Van Rooyen's determination of the "probable viewer." It is significant that fanatical lobby groups like Aksie Morele Standaarde have taken little interest in the films shown at homeland venues even though advertized in the major metropolitan newspapers serving "white" South Africa.

The "enlightened" image put out by the Directorate—and reinforced by the press—is itself part of a much more sophisticated strategy on the part of the state to legitimize racial capitalism to dissenting white South Africans in the face of continued world criticism. What is less often discussed, if at all, is the narrowing political censorship of material which calls for political action at a popular level, or which unmasks the economic under-pinnings of apartheid. The extent of state interference—and this extends far beyond the aegis of the Directorate of Publications—depends on the extent to which these films/videos penetrate the working class. At the moment they can be legit-

imately shown under an education exemption at film festivals
and academic conferences attended by mainly bourgeois and petty
bourgeois black and white audiences on university campuses which
are closed to the public. Although the Directorate allows "one-
sided" criticism and even a socialist assessment, the more likely
a film/video is to be seen by audiences engaged in the daily
struggle against the system, the more likely that film/video will
be banned.

On 11 May 1984, the Chairman of the Directorate of
Publications told *The Star* that:

> Basic fundamental morals don't really change. What
> does change are circumstances. In 1974 many people
> would not have been prepared to hear a coloured in
> *Kennis van die Aand* say the Afrikaners were breaking
> him to pieces. But now it's quite clear from the wide
> spectrum of politics that all political parties are avail-
> able for dialogue within this country.

Since Van Rooyen himself places censorship in the political
arena, his further comment that censorship is not about culture
or morals "but involves underlying principles such as privacy
and dignity," one can only surmise that the "privacy" and "dig-
nity" that the censorship apparatus is trying to protect is that
of the hegemonic classes. Censorship is a fundamental device
used by the state to induce consent among viewers for a prevail-
ing social order, or for changes occurring in that order. The
nature of the "dignity" and "privacy" that Van Rooyen talks
of will shift with modifications in the political economy. This
process is already at work on a geographical basis where some
parts of the country—those in which the organic ideology of
apartheid is generated—require a greater degree of privacy, dig-
nity and protection than other parts which provide the vicarious
outlets for members of the hegemonic bloc. Either way the
system wins.

CHAPTER TWO

CONTROL BY SUBSIDY

"Subsidies really make the film industry. The country has to feel that it's important to have a film presence in the world. And the decision has to be taken in Pretoria."

DAVID BROWN, *producer of* Jaws, The Star, *Nov. 3, 1980*

The South African feature film industry owes its viability to the state subsidy scheme which was established in 1956. Although the South African government claims to support a capitalist or "free enterprise" economy, many aspects of national economic life are state supported. Subsidies which are rarely applied in capitalist countries are an integral part of South Africa's financial structure.[1]

Economists have drawn attention to the dangers inherent in the application of subsidy schemes. Where the state takes responsibility for balancing profits and losses, a strong possibility exists that it will eventually take control of the industry in question. The type of funding often creates a dilemma for the more critical filmmaker who may appreciate state aid on the one hand, but on the other, may not wish to have the film's content influenced or prescribed by the state. It is not unusual, however, for filmmakers to exploit the contradictions within a state apparatus to make socially critical works.

Aims underlying the application of subsidy systems vary

from country to country though in all cases subsidies are found
where economic impedances prevent income from equalling the
cost of production. In some capitalist economies subsidies assist
the producer to ignore the logic of the marketplace, which nor-
mally exerts a strong influence on the quantity, quality, and
nature of the films made. In others, it is designed to stimulate
a viable industry from which subsidy can eventually be with-
drawn. Often a subsidy is used to protect local industries from
foreign control as was the case in the mid-1950s in South Africa
when 20th Century Fox bought out the Schlesinger Organization's
entertainment interests.

Socialist states may use subsidies because they feel films
are necessary cultural and social institutions like museums, the-
aters, or hospitals.[2] Films perform an explicit ideological function
by embodying the values and attitudes of the ruling government.
The desire to provide the necessary capital to establish and de-
velop an indigenous film industry is very much in evidence in
the southern African states of Angola and Mozambique. Strategies
there are aimed to create a cinema in a post-colonial political
economy. In Zimbabwe, the industry remains in private hands
but attempts are being made at the production level to stimulate
a cinema critical of neocolonialism and thus one that is an active
factor in post-independence development.

The South African subsidy is one designed to limit the
production of non-commercial films. Unlike the financial aid of
many other nations, the South African subsidy is not concerned
with art or technical competence. Various reports have elaborated
on the posibility of earning foreign exchange through cinema.
The same cinema offers an excellent channel for projecting a
favorable national image to the external world. This is spelled
out in two of the five justifications proposed by the Board of
Trade and Industries for the continued financial assistance of
the South African feature film production industry:

1. The film industry is an art form and communication
 medium which, more than anything else, can enter-
 tain relatively great numbers at a relatively low cost
 while at the same time projecting an image of the
 country to the outside world. It is thus a national

asset of countrywide financial importance which protects us from foreign competition.

2. In spite of the existence of television, there will always be a need for cinema to satisfy certain cultural wants.[3]

Although the mechanisms underlying the state subsidy scheme have been frequently reviewed since its inception in 1956, the validity of the system in its present form continues to be questioned. Critics have called for an evaluation of what benefits the scheme has contributed to the film industry. They have questioned the conditions of qualification. Comparisons have been made with Australia's attainment of international recognition while South African cinema continues in relative obscurity.

Younger filmmakers made their presence felt in the early 1970s by asking uncomfortable questions: why is there no incentive for technical and artistic competence? Why does the subsidy scheme ignore the younger, non-commercial filmmakers or those unable to raise finance for more adventurous scripts? Why does overseas-earned income on a locally made production not qualify for subsidy payments? Why is there no financial assistance for documentaries, short films or other non-feature length forms?

Other questions relate to the long-term effects of the subsidy on the growth potential of the film industry, and the lack of interest with regard to international co-productions. And most important is the recurring discussion on the ideological goals that underlie the structure and effects of the subsidy formula as it has developed since 1956.

THE STATE SUBSIDY SCHEME

"We must commit ourselves to investment so that
films that come out of South Africa will be able to
compete on the international scene. Filmmakers
must not be driven to a situation where they are
so concerned about box-office receipts that they
cannot give attention to standards."

ALEX BORAINE, *Opposition MP*, The Star, *May
25, 1982*

The short-lived golden age of South African cinema oc-
curred between 1916 and 1919. The first full length films made
by African Film Productions, *De Voortrekkers/Winning a
Continent* (1916) and *Symbol of Sacrifice* (1918), established
South Africa as a film making country. Despite a spate of highly
capitalized and internationally well reviewed films between 1922
and 1924 (*Swallow, Sam's Kid, The Blue Lagoon,* and *The Reef
of Stars*), South Africa's distance from world markets and com-
petition from the American film industry put the local producers
at a disadvantage. The losses experienced by AFP during 1922
and 1923 could not be sustained and the consequence was that
feature film production averaged less than two films a year
until 1956 when the state subsidy was first put into operation.

Although talk of various kinds of subsidies had been rife
since the early 1940s[4] it was only with the arrival of British
director Bladon Peake, who was engaged by AFP to make *Hans
die Skipper* in 1953, that things began to happen. He approached
the government with a proposal for a feature film subsidy based
on the Eady Levy in Britain whereby one penny was taxed on the
price of every ticket sold for an imported film. The income so
derived was then invested in national film production. The South
African government was reluctant to deal with an individual and
suggested that Peake form an association with which it could
negotiate. The Motion Picture Producers Association (MPPA)
was duly established on July 16, 1956, with Jamie Uys as its
first chairman. Its subsequent representation to the state for a
financial subsidy was successful.

During the period 1956 to 1983, the subsidy formula underwent the following amendments:

1956: Entertainment tax paid by viewers in respect of a local production was paid to the producer. The maximum payable was R20 000. During this year a little over R6000 was paid to producers.

1962: The maximum reimbursement figure of R20 000 was amended to equal the production cost of the film less R22 500, where the first R10 000 earned was not taken into account. This modification was enacted at the suggestion of producer Tommie Meyer, who argued that the new structure would root out inferior films, increase output and thus reduce risk, and improve quality and thus competiveness both locally and overseas.[5] The Board of Trade and Industry further commented that the revised formula would discourage pictures of a limited appeal, stimulating only those which proved to be box office successes.[6]

In 1964, the Board of Trade and Industries proposed extensive modifications to the subsidy scheme. These included the provision of advance payments on suitable scripts, working capital of R1 million with a further R500 000 voted for documentaries, short films and purchase of equipment. These proposals were remarkably similar to those eventually enacted by Australia, but were not put into effect by the government.

1964: Meyer charged that too many films had qualified under the 1962 scheme and so it was modified to include a threshold of R50 000 earned within four years of the release date. Forty-four percent of gross box office earnings above the R50 000 threshold was paid to the producer. The upper limit remained at production cost less R22 500.

Example:

Gross box office receipt	R200 000
Less amount not qualifying for subsidy	50 000
Total qualifying for subsidy	150 000
Subsidy = 44% of total	66 000
Maximum payable = production cost	
(e.g. R150 000 less R22 500)	127 500

1968: The constraint measured by production cost less R22 500
was abolished. In terms of the above example, the total
cost paid out would equal R66 000 but the maximum
subsidy payable is now unlimited.

After twelve years, during which time the subsidy had
proved its worth in terms of stimulating a feature film produc-
tion industry, a Nationalist member of parliament, Mr. J. A. van
Tonder, questioned the desirability of films which incorporated a
bilingual English/Afrikaans dialogue:

> Afrikaans is being presented alongside English, as
> being subservient to English, as being the language of
> ridiculous "backvelders." Such films earn a great deal
> more in state subsidies, while purely unilingual Afri-
> kaans films, with a cultural value, such as the out-
> standing *In die Lente van ons Liefde* (*In the Autumn
> of our Love*) by Louis Weisner will receive little or
> no subsidy, with disastrous results for the manufac-
> turers. Just as it is the duty of the individual, it is the
> duty of the state to protect and promote Afrikaans in
> the South African film industry. Deficiencies in
> the subsidy system must be rectified without delay...
> if this is not done Afrikaans as a motion picture lan-
> guage is doomed.[7]

Van Tonder had strong support from certain conservative
Afrikaner elements in the industry who were motivated by
ideological considerations. Not least among these was Weisner
himself who had responded to negative press criticism of his

film by accusing the critics of being influenced by communism and "integration propaganda."[8] The growth of Afrikaans, the most recent of world languages, was largely due to its promotion by the South African mass media: first print, then radio. Cinema had remained under the control of English-dominated capital, and even Afrikaans filmmakers either used English or made fun of English-Afrikaner rivalries. This was particularly the case with Jamie Uys's films, like *Fifty-Vyftig* (1953) and *Hans en die Rooinek* (1961).

Responding to Weisner and van Tonder's complaints, the government amended the subsidy scheme in 1969.

1969: An attempt was made to stimulate Afrikaans language films by increasing the subsidy on Afrikaans films from 44 percent to 55 percent. To qualify, 95 percent of the dialogue had to be in Afrikaans. The English language subsidy remained at 44 percent. Applied to the above example, the subsidy earnings of an English-language film would remain at R66 000 while its Afrikaans counterpart would earn R82 000. *Table 1 gives actual payouts.*

Significantly, the 1969 amendment coincided with the capture by Afrikaans-dominated capital of the film industry. The Afrikaner insurance giant, SANLAM, bought out the 20th Century Fox interests, which gave them control of production, distribution and exhibition.

The Board of Trade and Industries reported in 1976 that of the 88 films made between 1970 and 1974, only four would have made a profit without the help of the subsidy.

1973: Calculations up to 1973 were based on gross box office receipts. The formula was amended to read net box office earnings.

Despite an effective 10 percent decrease in subsidy, payments rose in absolute terms during the next two years. The unexpected earning power of Jamie Uys's two films, *Beautiful People* (1974) and *Funny People* (1976), however, was the

precursor to further changes since these two films reaped by
far the greatest percentage of the subsidy available. Both films
were subsidized by more than R700 000 each.

1977: The minimum qualification of R50 000 was raised to
R100 000 retrospective to zero rand. The fixed language
differential percentages were dropped and a sliding scale
based on net box office receipts substituted. A maximum
amount of R300 000 per film could be earned. Only
box office income earned within two years of release
would be eligible.

Example:

A. AFRIKAANS LANGUAGE FILM Subsidy Paid
Net box office receipts
Up to R200 000 70 percent
200 001 to 300 000 60 percent
300 001 to 400 000 50 percent
400 001 to 500 000 40 percent
More than 500 000 30 percent

B. ENGLISH LANGUAGE FILMS were paid 10 per-
cent less than Afrikaans-language films.

1979: The subsidy budget allocated for 1978 was R2.5 million.
In 1979 the allocation was reduced by R500 000 to R2
million. Of this, R1.58 million was paid out. R994 122
was paid on 41 Afrikaans-language films, R127 089 on
English-language productions and R328 660 for 22 films
in African languages.

Where parallel language films (separate prints in either
English or Afrikaans) are made, subsidy is paid accord-
ing to the language of release, but not exceeding R300 000
for the combined total. Examples include *Fifth Season/
Vyfde Seisoen* (1978) and *Someone Like You/Iemand
Soos Jy* (1978).

Twelve features with a total production cost of R2 400 000 were made in 1979 for white audiences. This reduced amount reflects a certain disarray within the industry caused by administrative problems within the Treasury. The result was a six-month delay in the payout of more than R330 000 to producers.[9] This delay seriously affected production schedules and company cash flows at a time when television (introduced three years earlier) was siphoning off cinema audiences.

The industry responded by resurrecting the Feature Film Producers Association (FFPA), electing a young go-ahead MBA graduate, André Scholtz, to the chair. Scholtz had a more long-term conception of the industry and sought to replace the previously short-term, ad hoc responses of the industry with the stabilizing effects of a five-year plan. He conducted a study which elicited the following breakdown on income distribution throughout the industry:

Producers' fee	R340 000
Script	120 000
Directors' fees	80 000
Artists' salaries	220 000
Technicians' salaries	180 000
Equipment rental	240 000
Transport rental	40 000
Film stock	160 000
Sound stock	70 000
Laboratory costs	375 000
Insurance	30 000
Publicity (press, TV and radio)	250 000
Music and dubbing	25 000
Catering and Travelling	100 000
Sets and costumes	50 000
Other	120 000
TOTAL	R2 400 000

Scholtz estimated the distribution and exhibition value of the local feature as follows:

Box office revenue pattern	Total earned
Group 4-wall cinema	R45 000
Group Drive-ins	60 000
Independent cinema	55 000
Average box office revenue per film	R160 000

This revenue is shared by the following segments of the industry:

Producer	R45 000	(28 percent)
Distributor	12 000	(7 percent)
Exhibitor Group	79 000	(50 percent)
Independents	24 000	(15 percent)

The point of this study was to locate the role of the independently owned cinemas (mainly small town and rural) in the profitability curve of locally made features. Scholtz concluded that the independent exhibitors rely on local productions for their profits, while the income derived from overseas films brings them to a break-even situation. Thus, concluded Scholtz, "In the long term one can expect that starvation of local products will eventually result in a large number of independent cinemas closing down."[10]

As a consequence of this situation, and given the uncertainty facing the production industry on a long-term basis, the FFPA approached the government with new proposals for a more efficient subsidy scheme. The objectives were two-fold: to create an environment of confidence in the longer term for the producer and to stimulate the export sector by encouraging more investment in individual films. The proposals submitted by the FFPA, informally supported by the South African Film and Television Technicians Association (SAFTTA),[11] divided films into three kinds, each of which would qualify for subsidy under certain conditions:

1. Films made for both local and overseas markets should be eligible for subsidy. The upper limit of R300 000 should be done away with on films distributed outside South Africa. This would en-

courage local producers to work to higher budgets and enable them to compete more easily with other overseas films on their own.

2. Films made for the local market only should continue to receive subsidy.

3. Non-commercial or art films should be subsidized provided that they can obtain a distribution of some kind. Such distribution need not necessarily be a commercial one, for example, the circuit offered by the Federation of Film Societies.

The benefits implicit in the last proposal are significant, and recall the plea made by John Grierson in 1954[12] that a nation's cinema needed experimentation and funds to stimulate a creative energy. The adoption of the third proposal would lead to a more sophisticated development of themes than was occurring at the present. The viability of such films would not be based on financial returns, but rather on the ability of the filmmakers themselves. As has happened elsewhere, this kind of film making would help new entrants to the film industry gain experience which might be applied later to the production of full-length feature films.

Despite early government assurances that these proposals would be sympathetically received, positive reaction was not forthcoming and the industry continued along its uncertain path until late 1981. In the meantime, producers like Scholtz, and the vice chairman of FFPA, impatient of government stalling and despairing of continuous Cabinet reshuffles, which always seemed to affect the Department of Industries leading to a disruption in negotiations, left the film industry and applied their talents elsewhere.

Changes were announced by the Department only on October 1, 1981, although its provisions were retroactive to April 1. Although claiming to have studied the producers' proposals, the formulation was not changed much from its previous structure. Subsidy was now payable at a rate of 70 percent on the first R1 million net box office and thereafter 50 percent on the next R1 million whereafter no further subsidy is available. The maximum is R1.2 million per film, an increase of R900 000

over the previous formula. The R100 000 threshold qualification was retained. For the first time, screenings in member countries of the Customs Union Agreement also qualified for subsidy. Participants to this accord are Lesotho, Swaziland, and Botswana, as well as those "independent" homelands such as Transkei, Venda, Bophuthatswana and Ciskei which were previously outside of the subsidy qualification area.

Up until 1973, producers of films in African languages qualified for subsidy under the existing scheme. A separate scheme came into being in 1973 when subsidy was paid on films where the leading actor and 75 percent of the other actors were black South Africans. Three-quarters of the dialogue was to be in an acknowledged black South African vernacular. A total amount of R45 000 was paid to the producer by the state, which matched ticket sales on a cent for cent basis up to 18 cents a ticket.

Representations from makers of African language films in 1976 resulted in an increase in the upper limit to R70 000 and the payment of subsidy where the film was shown in venues where individual tickets were not issued, like mine and other worker compounds. The "independent" homelands were outside the qualification area. In 1981, the subsidy paid was raised to 21 cents per ticket with a maximum of R80 000 paid on performance in the Customs Union Agreement area, in any South African language.

RESULTS OF ECONOMIC STIMULATION

> "The Government has a system of film industry sponsorship which gives money to a film that has already been made and has proved a commercial success. The film is, at this stage, already making money and does not need the susbidy."
>
> MANIE VAN RENSBURG, *director*, The Star, *September 1, 1983*

The subsidy has eliminated many of the financial risks as-

sociated with production. The most important is that a locally made film stands a good chance not only of recouping its costs, but also of making a profit in the country of production, a condition that pertains to few other film making countries. It should be pointed out, though, that subsidy payments were not commensurate with the number of films made during any particular year, for it sometimes happened that only one or two films accounted for the bulk of the payments during any one financial year.

An immediate result of the subsidy, particularly in the mid-1960s, was the production of films which successfully competed with imported films on local circuits. Following the 1964 amendment, in the period 1965 to 1967, the average net box office returns on South African films was R307 000. Films screened during this time included *Die Kavaliers, Debbie, Dingaka, Die Kandidaat* and *All the Way to Paris.*[13] This was a period of innovation, of social criticism and the exploration of cultural themes.

From 1968 through to 1970 audiences saw *Hoor My Lied, Dirkie, Jy is My Liefling, Geheim van Nantes* and *The Winners.* These films earned an average net receipt of R309 000. The controversial *Katrina* performed exceptionally well, grossing R900 000. Other than Jans Rautenbach's *Jannie Totsiens*, the adventurousness of the earlier period was missing as the innovative film makers discovered that audiences resisted thematic and stylistic progress.

Between 1970 and 1974 net box office receipts fell by 35 percent to an average of R201 000. This period consolidated the earlier discovery of commercial film genres which worked at the lowest level of public taste. This resulted not only in films of questionable artistic merit, but in the isolation of a particular audience.

Van Rensburg put it this way: "We have a system geared to promote soap operas only, which, in turn, will prevent our films from reaching any other audience ... Art goes out of the door; the money comes in."[14]

During 1975 and 1976, television notwithstanding, most South African films continued to earn receipts in excess of R200 000. These included *Boland, Tant Ralie se Losieshuis, Sonneblom Uit Parys, Kwikstertjie, Vang vir My 'n Droom,*

Kniediep, The Diamond Hunters, Ses Soldate, Liefste Veertjie and *Ma Skryf Matriek*. *Ter Wille van Christene* grossed R90 000 and Jamie Uys's *Funny People* exceeded the R2 million mark, the highest box office take of any film ever screened in South Africa up to that time.

The 1977 amendment was designed to assist producers to overcome sluggish conditions which had pertained since the introduction of television. This medium had successfully competed for cinema audiences, causing a drastic reduction in cinema attendance in television reception areas. Television had the further effect of causing a reduction in the number of feature films made, since the distributors were unable to guarantee the favorable distribution which they were able to offer during the pre-television era. Not only were screens, particularly drive-ins, closing down, but the revived American industry was competing for more screen space.

The South African industry, monopolized by the Satbel holding company of Ster and Kinekor, reacted by merging the two companies into Ster-Kinekor. This combine trimmed previously duplicated staffs, concentrated on the acquisition of large budget blockbuster movies and integrated publicity and advertising into more efficient formats. Although the subsidy qualification had been raised, the distributors responded that "good" South African made films with the appeal of, for example, *The Winners* (1972), would continue to draw large audiences. This observation was made in the light of an improvement in box office take during December/January 1977/78 when audience patronization exceeded all previously established records.

The new subsidy, coupled with the increase in cinema attendance, suggested to distributors and production houses alike that even greater earnings were in the offing. This conclusion rested on the mathematics of the subsidy qualification. Where previously a film earning R100 000 was awarded R55 000 in subsidy, now the same film could earn R70 000. Since most of the better South African films had little difficulty in reaching the R100 000 qualification, particularly if distributed by an associate company (e.g. the Satbel group), this last amendment was most favorable where production, distribution and exhibition occurred within one vertically integrated organization. Satbel

was quick to respond to this amendment and voted a R7 million injection of capital over three years into film production. Other companies such as Cavaliers, Brigadiers and Elmo de Witt films were equally positive about the benefits expected to accrue from the new subsidy system.

The expected benefits, however, did not materialize. Audience tastes had changed. Jan Scholtz' R116 000 *Diamant en die Dief* (1978), a sophisticated comedy, barely broke even after its subsidy payout of R149 000. Satbel's own *Witblitz and Peach Brandy* only recouped its cost, while *Decision to Die* failed altogether. Production slowed and even old formula films failed. *Eensame Vlug*, for example, was nothing more than a compendium of all the clichés that had ever worked in an Afrikaans film, but its returns were only somewhat higher than those for *Decision to Die*.

One reason for the failure of the industry to capitalize on its earlier optimism was that it took little notice of the effects of the introduction of broadcast television in 1976. A Board of Trade and Industries report published in 1976 pointed out that the subsidy would no longer be used to support filmmakers who had recovered their costs. The Board furthermore expected that the family entertainment previously supplied by cinema would be taken over by the television service of the South African Broadcasting Corporation (SABC-TV) and that the film industry would make fewer films of higher quality on less subsidy.[15] This did not occur because even the more adventurous film producers like André Scholtz were unable to sustain the financial burden of reconditioning audiences into accepting higher quality South African films.

Production for white audiences stagnated between 1979 and 1983, while films made for black viewers proliferated. Other than *The Gods Must Be Crazy* and Rautenbach's *Blink Stefaans*, few other films performed exceptionally well. Between 1981 and 1983, the Brigadiers Film Company was the only studio producing regularly. It made a series of films imitating the successful television programs, *Nommer Asseblief, Bosveld Hotel* and *Skooldae*. The path taken by Brigadiers and other companies prompted Pieter Fourie, a consultant to the Department of Industries, to comment:

The film industry in South Africa is out of touch with the requirements that the introduction of television has made on the film medium, namely, to adapt in form, but more particularly in content... the local industry goes ahead with the production of family entertainment, a function which has been completely replaced by television. There is no talk of a differentiation between sub-cultures of taste.[16]

In November 1983, Satbel again announced that it would be spending a large sum, about R9 million, on film production for 1984. These projects were to spearhead a thrust into the world market to intercept the video disc and cable television demands. Two films were to be made by Jans Rautenbach, and co-productions were being sought with West Germany and the United States.

THE ECONOMIC FRAMEWORK

"Never before in South African cinema have there been such opportunities as now for taking our production into the international market."

TIMOTHY ORD, *managing director, UIP-Warner,* Sunday Times, *February 19, 1984*

South African filmmakers have no option but to work within the capitalist relations of production. The structure of production, the attitudes of people within the industry, and the state feature subsidy all have the effect of enforcing commercial values. Even though production costs are not as high as in Europe and America, budgets range from R80 000 to R1 million, formidable investments. Moreover, the investments are risky. Production costs are unpredictable and usually go over budget. For example, *Golden Rendezvous* (1978) went $2.8 million over budget because of production delays and inept management. Despite pre-production sales of $3.2 million, the film failed to break even

due to poor audience response and cancellation of some distribution contracts.

Another problem facing the South African industry is its inability to sustain projects experiencing cost overruns. Again and again, companies begin production without sufficient liquid capital. Films like *The Lion's Share* (1981), *The Second Mile* (1981) and *Sky Blue* (1982) remain uncompleted. Once funds dry up in South Africa, producers tend to look to the United States for salvation. Following the stagnation of the *Sky Blue* project, producer Moonyeenn Lee claimed that there "is still amazing interest in it, including the possibility of financial backing from America."[17] Such interest rarely becomes operational. As a result there are unpaid technicians and multiple owners of an incomplete film. The laboratory claims the negative, the editor the cutting copy, the sound studio the magnetic track.

One of the few films to be completed despite excessively high costs was executive producer David Lewis's *Follow That Rainbow* (1980), but the film failed to return even a quarter of its $1,400,000 costs. Bill Faure, trying to raise $9 million to finance a South African contribution to Columbia's $18 million *Tai Pan,* charged that the lack of financial homework on *Follow That Rainbow* had frightened local investors he had approached. He described the film as "the kind of costly disaster that sets the industry back years. The backers burnt their fingers with the result that raising money for modest, viable projects is now extremely difficult."[18]

South African films costing more than $300,000 are forced to consider international returns in their marketing calculations. This is partly due to the small domestic market in South Africa which is highly fragmented in terms of language. A director's track record, bankable stars, good scripts, and other criteria do not automatically guarantee financial success. Emil Nofal's *The Winners* (1972) provides a useful example. Despite a low budget, no international name stars and a hackneyed story line, the film exceeded the box office income of *Jaws* in the Far East market. *Winners II* (1977) was soon in the pipeline and it too earned high returns in the East. Ivan Hall's *Karate Olympia* (1976) proved highly successful in the United States as did Jamie Uys's *The Gods Must Be Crazy* (1980). The latter was

an international blockbuster and became one of the highest grossing films of all time in Japan, France, and Canada while in constant distribution in Sweden for years after its release.

EFFECTS OF THE SUBSIDY

"One of the major stumbling blocks . . . is the unhealthy preoccupation with the drive-in market."

BILL FAURE, *director*, The Star, *March 17, 1980*

The introduction of the subsidy in 1956 brought with it a number of disadvantages. A financial subsidy which uses gross or net income as the sole criterion for qualification is oblivious to technical and artistic standards. The subsidy actually restricts the development of a genuine cinema. As noted by *Business SA,* "[The subsidy] has produced an attitude where producers set out to make films for subsidy's sake."[19]

Many of the films made since the inception of the subsidy are of extremely poor quality, a large number were never released, and a high proportion of the smaller film producers survived for only a short while. Lionel Friedberg, for many years chairman of the South African Film and Television Technicians Asociation (SAFTTA), noted in 1977:

Almost overnight, butchers, bakers, and candle-stick-makers were becoming filmmakers. There were many cases where farmers and bottle-store owners suddenly became "film producers." Anybody who could rake up R50 000 went into the production of low budget features, simply to cash in on the lucrative domestic drive-in market, with the added benefits of the subsidy to assure him a return on his investment. Anybody who could read a basic "Photographic How To . . ." book, or who managed to thumb through the pages of an Arriflex Instruction Manual became a "lighting cameraman," and so on.[20]

While critics of the subsidy agree that its initial establish-
ment was necessary to launch the local film industry, as of
the 1980s many believe that only a radical restructuring will
prevent the demise of its feature film component. The rush of
production caused by the 1977 amendment resulted in a lack
of exhibition venues. André Scholtz complained, "We have to
fight to get decent showings." He pointed out that he and
his colleagues "are demoralized with making films for the 'C'
income group market where the demand for quality is not
strong." The lack of integrity in South African films is partly
due to the structure of the distribution circuits, and particularly
the drive-in circuit, so popular during the pre-television era. Film
theorist/critic John van Zyl commented:

> The non-discriminatory patronage of the drive-in
> circuit which boasts a captive audience is a situation
> which does not exist in any other country. The drive-in
> is an integral part of the South African entertainment
> system and generally people who patronize these outlets
> make little effort to find out whether what is on is
> worth seeing. Therefore where South African made
> films are concerned, there is little doubt that they will
> reach the subsidy qualification.[21]

Ross Devenish, director of *Boesman and Lena* (1973),
The Guest (1978) and *Marigolds in August* (1980) stated much
more bluntly: "Nobody gives a damn about merit... as things
stand we subsidize the producer's avarice, not art." Mario
Schiess, who directed *Die Vervlakste Tweeling* (1969), *Onwettige
Huwelik* (1970) and *Bait* (1974) concured:

> Like so many blessings bestowed from the top the
> greedy claws of man have perverted this one too. Sub-
> sidy has become the only, completely depended on
> life-line of the South African feature film production
> industry, without which it would slide towards a quiet,
> by some people little regretted demise.[22]

Implicit in Schiess's statement is the acknowledgement that

the South African industry had not yet gained the momentum of a self-sustaining industry. When an industry is unable to generate the momentum to free itself from the shackles of subsidy, the state might well consider retracting its assistance or experimenting with a different form of stimulation. That the South African government followed neither course prompted Van Zyl to state: "All the subsidy system does is to protect the incompetent."[23]

Not all film producers were critical of the subsidy, however. Advertising executive, Michael McCarthy, on trying unsucessfully to raise money for his first film, stated in 1982: "I regard [the subsidy] as a genuine incentive, and I think if a producer does not think he can earn that money, and cannot substantiate his belief with good figures, he shouldn't be in the business." However, to blame the lack of local investor confidence in his film on the "shady" image of the industry is perhaps an overstatement.[24] Incentives are of little use if upfront financing cannot be found. Another conventional argument for subsidy is that the film industry deserves to be subsidized because of the state's generous support of the Provincial Performing Arts Councils. This argument is countered by John van Zyl who said that subsidies spent on theater

> are meant to encourage local productions and productions of classic plays, ballets, etc., that are not normally seen and are not thought of as being commercial. There is no question of the State subsidising Johannesburg's commercial theaters that concentrate on bedroom farces; these compete on the open market and find their own living.[25]

Although the costs of making a film in South Africa aimed at "white" audiences are low in relation to those in other countries, when compared to the size of the cinema-going population, costs are still relatively high.[26] This factor, coupled with the independent nature of most local producers and the alleged under-distribution of South African titles since 1976, suggests that entrepreneurial skill in negotiating with distributors is a greater asset than the quality of the film. *Winners II* (1977)

was more effectively distributed than many other indigenous productions because it was the first local film to be made in conjunction with a major international film distribution organization, Columbia. By using their other titles as leverage, this company was able to negotiate a better than average distribution in terms of theater locations through Ster-Kinekor. Given that the subsidy is paid out in terms of box office income earned at exhibition outlets, it is the *distributors* who indirectly control the subsidy. Poor release patterns result in low box office returns, which in turn affect the amount of subsidy earned. It doesn't matter how "good" the production figures are. The attitude of the distributors is what makes or breaks a film.[27]

The South African economy relies heavily on foreign exchange derived from exports to overcome its balance of payments deficits. In view of this it seems strange that no incentives are provided to encourage local producers to strive for overseas earned income. British director Peter Collinson, who was employed by Heyns Films to direct *Tigers Don't Cry* (1976), warned that the subsidy as it stood then was counter-productive in terms of international requirements:

> The protection offered by your subsidy system has choked any desire to go international on the part of local producers. This results in inferior films using second rate directors and actors, trying to obtain the cheapest possible product. The end result is stagnation.[28]

This self-perpetuating process is encouraged, regulated and controlled by the monopolistic structure which characterizes much of the local distribution-exhibition industry. For a long time, the local film bank (a Satbel company) refused to back any film which did not pander to the drive-in audience. Distributors were thrown off balance when asked to handle an unconventional movie which did not fit into their pre-programmed release patterns. Differential subsidies in favor of Afrikaans further reduced market potentials and led to situations where foreign film directors resident in South Africa were making films in a language they could not speak. *Olie Kolonie* (1975) is one example.[29] Even more blatant were the films being made in

the vernacular by white producers for black audiences. Of the six companies involved in such production between 1972 and 1979, only one boasted a director, or for that matter a crew, capable of speaking the African language concerned.

Veteran producer Emil Nofal has stated that if local productions are to succeed financially, directors have to produce watered down products which comply with local needs and the norms of the censorship board.[30] Such treatments have little integrity and place no demands on the audience. The spectator in turn demands little from the film and remains uncritical of cinematic standards. Until 1978, this incestuous relationship was encouraged by the type of film screened on the drive-in circuit, particularly in the rural towns where cinematic tastes have been conditioned by decades of low grade South African movies supported by Westerns, American "B" pictures and straight genres which specialize in cliché and convention.[31]

Another problem concerning commercial viability rests on the general agreement that a film must first make a profit in its country of origin. *Business SA* has commented on the triteness of this maxim which is quoted *ad nauseum* in a country which by all rights shouldn't even have a film industry:

> This point of view means that no South African film could afford a budget of more than R400 000 at the very outside. When a film is shot with this limitation, international success is near impossible, unless the industry comes up with a "sleeper"—a no-star, cheap budget movie that captures the cinemagoer's interest and makes a fortune.[32]

The probabilities that a low budget film will behave like a sleeper are not very great. One example is *Summer of '42* (1971), which grossed $20 million within a year of release. This film cost double the South African producer's maximum, that is, R800 000. Jamie Uys's *Funny People* (1976) cost R560 000, earning just over R2 million on the local circuit. It has played extensively in Europe, but is unlikely to exceed its South African earnings. Local movies which have become sleepers elsewhere include *The Winners* (1972) and *Karate Olympia* (1976),

which have earned millions of dollars in the Far East and America respectively; but little of this money came back to South Africa for the films were sold outright.

There is little doubt that films made by South Africans critical of apartheid would obtain international distribution. Previous films such as those of Athol Fugard and Ross Devenish, David Bensusan, and Nadine Gordimer, as well as numerous documentaries have been bought, mainly by television stations. However, there are few local producers willing to sponsor anti-apartheid movies as they would be ostracized by the local industry and unlikely to obtain local distribution. This would seriously affect their viability, as these films would not qualify for the subsidy. The producer of the Gordimer series went insolvent despite international sales, and only one of the three Fugard films made a profit.

During the time that South Africa was the number one news item on the international news media from mid 1985, numerous films on the nation and the effects of apartheid were made or planned. These included the Belgian-produced *Dust* (1984), based on the J. M. Coetzee novel, *In the Heart of the Country*; a film about the black consciousness leader, Steve Biko, who was tortured to death by the security police, made by Richard Attenborough; and various films based on the novels of André Brink and Breyten Breytenbach.

Apartheid is a saleable commodity, but this is rarely recognized by South African producers.[33]

CHAPTER THREE

FILMS FOR BLACKS

"The potential is enormous in Africa's sleeping giant—the awakening Black marketplace"

Black Circuit (Pty) Ltd., 1983

For Africa as a whole, cinema has always been a powerful weapon deployed by the colonial nations to maintain their respective spheres of political and economic influence. History is distorted and a Western view of Africa continues to be transmitted back to the colonized. Apart from the obvious monetary returns for the production companies themselves, the values Western cinema imparts and the ideologies it legitimates are beneficial for Western cultural, financial, and political hegemony.[1]

Filmmakers to the north of South Africa have largely sought emancipation from the Hollywood-derived cultural dependency. These include radical film movements (Cinema Djidid, Tropicalist Cinema, Senegalese, etc.), the ethnographic and reconstructive documentary of Mozambique and the anthropological and war-related cinema of Angola. Distribution cooperatives have been established in a number of African countries to challenge the dominance of American, British and French majors with the prime aim of ensuring exposure for African-made films. Efforts are also being made in Zimbabwe and Botswana to reject colonial reflections in cinema through education, film workshops and the critical examination of genres and conventions.

CINEMA AND MIGRANT LABOR

> "There are many blacks in South Africa who, given
> the chance, can rise to meet the challenge of film-
> making for the big and the small screens. But there
> are no structures to cater for them."
>
> VUSI ELDRIDGE TWALA, *cameraman*, The Star,
> *January 13, 1983*

Until the early 1980s, nearly all commentators and film-
makers allied themselves with the white hegemony, which itself
acts as a conduit for international monopoly capital. Criticism
was restricted mainly to "art" films. This preoccupation did
little to uncover the propagandistic use of cinema which was
employed by the state and capital to support efforts towards
a cheap and docile labor force.

While the propaganda value of cinema was realized by
the mining industry as early as 1920, it was also seen as a
danger to "simple" black minds which might imbibe the less
savory aspects of white culture.[2] Although blacks had been ex-
posed to films since 1896, by the 1920s both the Chamber of
Mines and the Municipal Native Affairs Department saw film
as a means of "sublimating criminal tendencies" while also
"making the occupants of compounds more contented," giving
them "something wholesome to think about."[3]

The initial compound circuit started by the American
Board of Missions was taken over by the Native Recruiting
Organization of the Chamber of Mines. The purpose of this
body was clearly economic: to inform "uninitiates of the circum-
stances and conditions of work on the gold mines."[4] This labor-
recruiting intention was rationalized as providing "entertainment"
and "instruction."

In the late 1930s, the Tea Market Expansion Bureau ran
eight mobile units to advertize the merits of tea drinking. This
habit was set against the debilitating effects of alcohol, first
encouraged by mine owners as an aid in proletarianizing African
peasants during the 1890s.[5] However, productivity suffered, and
the mines, aided by the British administration (1902-1907),

enforced a total prohibition. Later, particularly during the 1930s, tea was promoted as a substitute through mobile film units operating in rural areas. Films had a two-brothers theme: the sober tea-drinking one who prospers, and the profligate who suffers the dire effects of alcohol.[6]

African Film Productions' (AFP) *Pondo Story* (1948), funded by the State Information Service, is a docu-drama about "natives in their natural environment," specifically a young man who "voluntarily" seeks work in a Johannesburg mine to pay *lobolla* (bride-price) for his bride. AFP's *Stage and Cinema* blandly stated that the film informed the world "of the care that is taken of the native who comes from the kraal to work on the mine."[7] The ideological discourse employed by *Stage and Cinema* to describe the film illustrates the alliance which developed after 1922 between the mining industry—whose labor practices were, and still are, based on enforced migrancy—and the state's newly applied segregationist policy. This policy was predicated on a migrant labor system with the unemployed supposedly being taken care of by Reserve economies. Few South African feature films deal critically with these overwhelming themes. Three possible exceptions are *Come Back Africa* (1959), clandestinely made by the American Lionel Rogosin; Alexander Korda's less incisive interpretation of Alan Paton's *Cry the Beloved Country* (1951); and David Bensusan's *My Country My Hat* (1983). The latter film is a study of the different meanings that the pass laws, which control migrancy, have on the various characters—white and black.

The Public Relations Media Division of the Chamber of Mines was established as a direct result of the labor crisis that followed the withdrawal by Malawi of its 100,000-strong labor force in 1974. The Division set about recruiting a more "stabilized work-force" drawn from South Africa and its "satellite national states and homelands." In addition to its recruiting function, the Chamber's Teba Film and TV Unit

> ... runs its own film and TV production house, providing a monthly newsreel with coverage of events on the mines and at the mineworkers' home regions. The newsreels are also shown all over Southern Africa by TEBA

field representatives and so familiarize families at home with the mining environment as well as keeping workers in touch with happenings at home.[8]

The audience, about three-quarters of a million, is serviced by ten mobile units operating in the homelands. In this way the Chamber is able to legitimize the practice of migrant labor to both miners and families. The cost of running the Unit is minuscule against the savings effected by employing migrant labor as single units, thereby obviating the necessity of paying a family wage. The families are expected to supplement their subsistence off the homeland "economies." In the absence of family distractions, the Chamber continues to produce material "to assist the mines in entertaining the mineworker in his free time," especially after the mid-1970s, when leisure time was extended.[9] Topics range from a documentary on the Zulu War Centenary Celebrations, films and slide shows on wildlife and nature conservation. With the introduction of broadcast television in 1976, and more particularly, the two "black" channels in 1982 and 1983, mineworkers have been exposed to selected programs relayed to viewing halls capable of seating 700 people at a time in twenty-four gold mines and fourteen collieries.

HISTORY OF "BLACK" FILM PRODUCTION

"Acting is inborn, like rhythm. Look at how a Black baby not a year old will dance rhythmically."

SIMON MABUNU SABELA, *director, Heyns Films*[10]

Although black actors were an intrinsic part of South African feature films between 1916 and 1918, the first film which dealt with more authentic black experiences was *African Jim* (1949). Made by an expatriate white director, Donald Swanson, the film plots the problems faced by a naïve ruralite in the city, and features unique shots of the legendary Jazz Maniacs before they were forced out of business in the late '50s by a combination of

violence in the township halls and the discriminatory actions of the white musicians' union, which resented black competition. Though the film deals with the social difficulties and urban violence confronting the main character, it largely ignores the gathering momentum of enforced segregation, which was to culminate in the brutal February 1955 removals of blacks from Sophiatown. Exposure of the structural violence wrought by apartheid on the black working class is devastatingly portrayed only in *Come Back Africa* (1958).

AFP's musical variety, *Zonk* (1950), was based on the white-inspired stage performance and the film formula which proved successful in the Afrikaans-language *Kom Saam Vanaand* (1949). *Song of Africa* (AFP, 1951) "advertised tribal dances in all their splendid savagery."[11] Swanson's *Magic Garden* (1961) is a humorous comment on the circulation of money in an impoverished urban black community, Alexandra Township. A stolen bankroll passes fortuitously from person to person within the town, conferring positive effects on each of those who handle it. Eventually, it travels full cycle and ends up back in the lap of its rightful owner. Although Swanson's two films are rooted in black communities, like the others, they were aimed at mainly white local and overseas audiences.

In 1970, Anthony Handley made *Knockout* about a teacher who becomes a boxer to pay for his sick wife's medication. Boxing remains the one sure way to escape the discriminatory effects of class determination and is a recurring theme in a number of films released in 1982 and 1983.

Joe Bullet (1974), a sort of black James Bond, was the first "black" film to be made by an Afrikaner, Tonie van der Merwe. An inept film, and a financial disaster, it was followed by his *Nogomopho* (1974), the first film to use an African language. Simon Sabela was the first black director with *u-Deliwe* (1975), based on a Radio Bantu soap opera. Financed by Heyns Films, this company made a further thirteen "black" movies before being exposed as a Department of Information front company.

How Long (1976—from the track, "How long must we suffer?") adapted from the stage musical by Gibsen Kente, was the first black-directed and financed *critical* feature film

to be made on the effects of apartheid. To date it has been screened only in the Transkei, as it was banned in "white" South Africa.

The late 1970s heralded a spurt of production of films aimed at black audiences only. Other than the fifteen relatively expensive Heyns titles, about 200 very cheap "quickies" have been made by inexperienced white producers who sought to service the grossly under-exploited "black market" ignored by the mainline industry. Few of these films have been made by black directors, and only one of the white filmmakers is able to speak an African language. Of the thirty or so registered companies, only one, SASA Films, is wholly black-owned. Another, Murray-Metsing (MM) Films, is a white-black partnership. A third company, Transworld Motion Pictures, is owned by South African Indians. The total of thirty companies creates a deceptive impression of competition and market penetration, however. A closer analysis will reveal that they account for the activities of only ten main filmmaking partnerships.

SUBSIDY FOR "BLACK" FILMS

> "There is little revenue earned back from ticket sales, and this doesn't begin to cover vehicle expenses. Your only income lies in the subsidy."
>
> JIMMY MURRAY/SIMON METSING, *directors, MM Films, September 1983*

Prior to 1973, producers of films in African vernaculars qualified for subsidy under the general scheme. At the bidding of white producers, however, a separate subsidy was introduced for "black" films using vernacular languages. Whereas prior to 1977, a "white" film could earn unlimited subsidy, a "black" film's payment was restricted to R45 000. This was raised to R70 000 in 1977 and R80 000 in 1981. By comparison, a "white" film's subsidy earnings were pegged at R1.2 million in the same year. Seventy-five percent of the actors were to be

black South Africans, and three-quarters of the dialogue had to be in a vernacular language. This latter requirement, however, has not been enforced since 1981. The main criterion now is whether blacks contribute the majority of the audience, irrespective of language. Bensusan's *My Country My Hat* (1983), for example, refused "white" distribution by CIC-Warner and Ster-Kinekor, was classified as a "black" film, and was screened mainly to black audiences. Subsidy is paid on the basis of *every* ticket sold, rather than on a box office threshold. This scheme gives the producer an immediate income, thus reducing the risk on low budget productions. It also allows producers to keep admission prices low and within the affordable limits of the poorer black audience. Since admission prices are so low, 18 cents to R1, once the total subsidy has been earned, it is no longer profitable to keep prints in circulation.

Finance was also available from two other sources: (1) the Bantu Investment Corporation (BIC), a state body promoting apartheid through economic aid, which aimed to stimulate a "Bantu film industry of their own,"[12] and (2) "secret" money provided by the Department of Information to Heyns Films and Andre Pieterse of Film Trust to indoctrinate black audiences and build black cinemas respectively. Pieterse, however, squandered R825 000 on *Golden Rendezvous* (1977), while Van Zyl Alberts, who had infiltrated Heyns Films on behalf of the state, appropriated a large amount for his personal use. Both were severely censured by an investigating judge,[13] but no charges were laid.

EFFECTS OF THE SUBSIDY SCHEME

> "A terrible admission to make ... [is] ... that however bad a film made at this stage, because of the great demand due to a lack of entertainment for black people, you cannot fail."
>
> JIMMY MURRAY/SIMON METSING, *September 1983*

As with the consolidation of the general scheme in 1962,

novice producers scrambled for subsidy by making cheap films.
Budgets were as low as R10 000 with production taking a few
days. Average costs, however, were between R30 000 and
R50 000. With the stagnation of the "white" feature produc-
tion industry resulting from the switch-on of broadcast television
in January 1976, the sector making films for black audiences
has grown exponentially. Most of these practitioners grew out
of Tonie Van der Merwe's Bayeta company, later branching
out into their individual directions. Only one of these com-
panies, Ronnie Isaacs's AIM Films, started with distribution al-
ready operating through his Inter-City Films.

Apart from the lure of a quick profit, Murray suggests
that the state's more lenient attitude to "black" filmmakers is
a further encouragement:

> I believe that the black film industry will continue
> to outgrow the white industry while the subsidy is
> structured the way it is, that you don't first have to hit
> a target, you don't first have to prove how good [com-
> mercial] your film is ... I think that because we were
> permitted to make a few mistakes and get paid for them,
> and the white industry is not permitted to make any
> mistakes, it falls right back.[14]

Some South African commentators are skeptical of the
claims of white producers that they are making films black audi-
ences can identify as "theirs." By implication they would be
equally critical of the idealist BIC philosophy, which aims to
"give" production facilities to the homelands for their "own"
industry, but under the control of state apparatuses. They are
also uneasy about "black" associations run by whites claiming
to speak for "the industry." Nevertheless, the Murray-Metsing
partnership received encouragement from both the Department
of Industries, Commerce and Tourism, and a producer associa-
tion. This positive official attitude is not surprising as it reflects
the state encouragement of an urban-based black middle class
which is required to provide labor for commerce and
manufacturing.

The profits to be had in the "black market" led to the

establishment in 1983 of two competing producers' organizations. Because of the peripheral nature of companies making films for blacks, the Feature Film Producers Association (FFPA) viewed their activities as amateur backyard operations and refused membership to those who applied. The Association for Black Film Producers is constituted primarily of Van der Merwe's twelve associated companies. The other was started by two active members of the industry proper, Stan Roup and Roy Walker. They merged the more amenable producers into the Black Feature Film Producers Association (BFFPA), which is itself represented in the South African Film and Video Institute, the umbrella body which superseded the MPPA and FFPA in 1981.

Van der Merwe's grouping seems to want to protect the isolation of "black" film producers, whereas the BFFPA takes the view that they form part of the industry-at-large and wish to be recognized as such. Despite the growth of this still marginal sector, Roup and Walker realized that its rationalization within the encompassing media network would yield still greater returns. They established Black Circuit (Pty) Ltd., which aims to expose audiences already reached by the BFFPA members to advertising through the consolidation of a cinema circuit. Black circuit expects to intercept the advertising not taken up by the "black" channels of the South African Television Service due to a 300 percent over-subscription of available advertising slots. With the infusion of more professional expertise has occurred a corresponding increase in investment and technical quality in production.

FINANCE

> "*A Way of Life* was made for R80 000 . . . I've made commercials for double that amount."
>
> ROD HAY, Mirage Films, *September 1983*

Heyns Films initiated its black film production program on a low interest loan of R1 million. Half was bank finance and the other half apparently supplied by the Department of In-

formation. Heyns was thus able to work on comparatively high budgets because the financial risk was cushioned by the Department. The Bantu Investment Corporation source did not develop because of an inordinate amount of red tape and the BIC's intention of linking the provision of finance to the ideological scrutiny of scripts.

Clearly, while both the Department of Information and the BIC were concerned with extending white hegemony, contradictions within the system bedeviled the state's overall strategy. Van der Merwe's Bayeta Films was eventually the only company to use BIC funding (R12 000), perhaps because his crudely racist themes largely coincided with the idealistically homeland-oriented efforts of the BIC.

Most of the more recent entrants into the "black" production sector have relied on small-scale entrepreneurial capital. Scores of other attempts by black filmmakers are signalled in newspapers, but few, if any, are able to proceed even with the encouragement of the Department of Industries, Commerce and Tourism. Were up-front funding available from the Department, the situation might change.

The structure of the subsidy largely limits below the line costs to about R40 000, with distribution taking up a further R10 000. Some producers have spent up to R70 000. A new entrant, Australian Rod Hay of Mirage Films, broke through this threshold by obtaining capital from refreshment companies wanting to promote their products. He produced *A Way of Life* (1981) and *Will to Win* (1982) with capital from Mainstay Cane, *Don't Stop the Music* (1982) with support from Autumn Harvest Wine, and *Stoney the One and Only* (1983) for R250 000 with substantial help from Stoney Ginger Beer.

Because of the nature of the market, production companies not only produce, but they also have to publicize *and* distribute their own films. No central distribution organization exists. Despite the advantages which might accrue from a nationally coordinated network, there is considerable producer resistance to the formation of one, other than the loose arrangement brought about by Black Circuit. The reasons are two-fold: (1) because of the desire by the less racist producers to protect their company names from being associated with the more

crude productions or less progressive filmmakers; and (2) to maintain greater control over market penetration and returns. Contradictions are rife, however, particularly for filmmakers like David Bensusan who do not operate their own distribution. Despite its "political" content, integrated cast, and criticism of apartheid, *My Country My Hat* was distributed by a Van der Merwe company, its Nationalist ideology notwithstanding.[15] The deal is that Bensusan has to pay 25 percent of his subsidy earnings in distribution fees.

Although more than one hundred cinemas and drive-ins are available to other than white audiences, less than thirty exhibit "black" films. Consequently, use has to be made of school, community and church halls, tents and open air venues served by mobile units. The mines compound circuit and Administration Board rentals provide an assured income. All but one production company operate between ten and fifteen mobile units. Each carries a projector, generator, screen and black curtains. More than one hundred independent black operators are also serving audiences throughout the country.

Audience demand is high, with an estimated one million viewers for each of the Heyns titles. Two million viewers saw *u-Deliwe*, while in 1978 Van der Merwe claimed that a quarter of a million people saw each of his films. Once the film has earned the maximum subsidy—measured by 400,000 tickets sold—it is withdrawn, as ticket sales alone are insufficient to cover operating expenses.

Johan van Rooyen, a member of Igoli Films in 1979, and later managing director of Focus Films which he bought from Heyns in 1981, complained that producers were unable to reach sophisticated audiences because "only the poorer class people go into a tent or into a school room or into a church hall to attend films."[16] This observation was borne out in a study conducted by the *Post* in 1977. Respondents described the Eyethu, the only cinema in Soweto, which has over a million inhabitants, as "rough" and without airconditioning. Another study noted that fear of township violence reduced night-time cinema-going in Umlazi, near Durban.[17] Community and church halls were not considered cinemas, and therefore were patronized by children only.[18] Irritations were aired about the discriminatory prac-

tices of cinema managers in Fordsburg, Johannesburg, where Indians and coloureds were always given the better seats. Despite these problems, most of the respondents had seen some of the better made films: *u-Deliwe, é Lolipop* and *Dingaka* were those mentioned. A number criticized the cruder films, saying that they repetitively reminded them of their harsh conditions of existence:

> You can close your eyes for 15 minutes. When you open them, you'll still know what was happening. Are we interested in projecting our lives a bit further? Township . . . we grow up in it . . . it is imposed on us. What we are interested in is looking ahead.[19]

Films which show a more positive future are preferred, as are those like *Wild Geese,* which examine black-white relationships within a reconciliational framework.[20]

Although both the major distributors of "white" films, CIC-Warner and Ster-Kinekor, applied continuously from 1975-1985 to the government for multiracial exemption, permission was denied. Some drive-ins, however, have been granted "open" status. A temporary cinema exemption was granted to *Way of Life,* initially shown at the Johannesburg Coliseum. Hay's *Stoney* had a 94 percent black audience and was screened by Ster-Kinekor and CIC-Warner in limited white venues. The film relies more heavily on an appreciation of the cinema style seen in *Raiders of the Lost Ark* than on racial stereotyping. This calls for a market in terms of age rather than race. Hay points out, however, that non-racial distribution is not always appreciated by the distributors:

> It's one of those things one can't determine because the way the system has worked in South Africa, if it's "black" it must be for blacks and if it's "white" it must be for whites, so that when you are trying to sell a reverse concept it's a lot harder. You've got to get rid of these unfortunate traditional obstacles.[21]

The "white" distributors were more amenable to working

with Hay than Bensusan, because of his seemingly non-political films which were unlikely to "offend" white audiences. Bensusan put it more bluntly: "Their immediate reaction was, 'Well, if this film gets shown at the drive-ins, the people will kill us.'"

CREWING

"It's high time that we also got a slice of the pie, seeing that there're so many programmes being planned for black viewers. There are many capable cameramen in the black community and it is important that they be used by the community."

HADLEY MODISELE, *technician, in* The Star, *January 13, 1983*

While a number of companies do use black technicians, scripts, production, and very often direction remain in white hands. Crews vary from as little as two to the twenty employed by Heyns, with the average being eight. Production periods correlate with the size of the crew: smaller units shoot continuous-take quickie films in a few days, while the more highly capitalized productions can take a couple of months. Usually actors double as interpreters to "ensure that the language they [the actors] are using is not swearing."[22] Sabela's point made in 1978 that "lighting, lenses, and all of that will take us a while to learn" and that "technical crews will still have to be multiracial at first,"[23] reflects the total lack of technical training facilities for black filmmakers. Learning opportunities are only available through experience on the film set—whether the relations of production are of the Bayeta/Igoli kind or the more loosely integrated process which typifies other companies. All operate within the rules of apartheid and black filmmakers usually internalize the social discourse of production learnt under whites.[24] Correspondingly, the desire for a totally black crew will not necessarily lead to the making of critical films. Liberation lies not only in technical expertise, but in a counter-ideological

commitment allied to a theoretical knowledge of cinema and its role in society.

SOURCES FOR THEMES

"If I have a story or script, I tell it to my kids, or I show the film to my kids, and if they enjoy it or laugh, then I know the blacks will enjoy it. But if my kids find it boring, or if I show a film to them and they fall asleep, I know it won't go off."

White maker of "black" films, 1979

Other than the Murray-Metsing partnership, the films directed by Peter Se Phuma with MM (*Dumela Sam,* 1980) and Scott Films (*Mathata,* 1983), and Kente's *How Long* (1984), the white producer-directors inevitably reflect a unidimensional white perspective of black experience. Few seem to be aware of the warping effects of their class ideologies or cultural perspectives. Rod Hay, for example, states that:

Many of the things in *Stoney* are based on direct records that I've experienced in my life and activity in the township. Once I've finished the script, I bounce these ideas off with the guys that do work with me and then they can tell me whether they feel that I'm slightly on a tangent that isn't actually going to be appreciated, etc.[25]

The popular culture reflected in these kinds of films is imaged, not from an organic class experience or cooperation, but through media reconstructions of it. These reconstructions inevitably reinforce the dominant ideology of racial capitalism. Hay, for instance, comments: "I scour virtually every ethnic magazine and newspaper there is to deduce what's popular." The choice of print media, however, automatically skews perceptions, for they are the propaganda vehicles of capital. The more liberal of them perform the socializing task of preparing

the new black middle class to form an alliance with capital against their homeland compatriots.

Directors (including non-South Africans) who imagine that they can "objectively stand back and look at things," irrespective of their class determinations, are simply unaware of the degree to which their viewpoints have been determined by their (unconscious) ideology. This contradiction is borne out in the remarks made by Swedish-born Chris Halgryn of Cine World on how he developed themes for his films:

> I go into the black man's background, his way of living, the way he eats, the way he sleeps, the way he robs a bank, and the way he dies. I know every detail about the black man. I put that into practice and that's what they want . . . By talking to them in the street . . . I asked them how to do this, how to do that . . . I will eventually be able to employ black technicians because they will know the black man better than I will ever know him even if I live to be a hundred years.[26]

But Heyns notes that there is an essential dislocation between actual black experience and white cinematic constructions of it:

> We have had the experience that the moment we involve a white scriptwriter we seem to miss the link somehow or other. *The Boxer,* written and conceived by a European, just didn't go, even though he was involved with most of the other films we made. We all thought it would work, even Simon.[27]

What only emerged after the press had exposed the Information Department irregularities in late 1979 was that most of the Heyns Films scripts were vetted by an "anthropologist," Mrs. Van Zyl Alberts, the wife of the company chairman. She was primarily concerned with the "ethnological" accuracy in terms of the ideology of separate development.[28] Sabela did not choose his scripts. This was done by his white employers, often, he claimed, inappropriately: "Then I have to revise them, and

bring them into touch with reality."[29] Twelve of the sixteen films made by Heyns were from original stories bought from black story-writers for R500 each.

Murray's conception of black audience needs coincides closely with those identified in a *Post* study:

> Black's don't want traditional themes any more. They don't like to see where they came from. They want to know where they are going to. They see so much ghetto life, they live in it; they don't want to really see it ... There's enough hardship in life to keep on harping about it ... Part of the reasons for their preferences is because of the degrading way blacks have been portrayed on film.[30]

Discussions with the white filmmakers suggest a limited knowledge about cinema. Ronnie Isaacs consciously models his films after Hollywood's Roger Corman, particularly in terms of productions practices. He aims to provide escapist cinema on the assumption that audiences "don't want to see things that depress you."[31] Rod Hay, who is the South African correspondent for *Screen International,* admires the commercial acumen of Stephen Spielberg and George Lucas. Almost none have any knowledge of African or South American cinema which would provide more relevant models to the South African situation. Lacking access to such films, Murray recounts his and Isaacs's experience on *Umzingeli* (1979), where they were searching for suitable models, not from Africa, but from the imperialist neo-colonial cinema:

> We took a few black actors and created artificially what we thought was a black situation, which wasn't. It was more like an American Negro situation ... the only black films around in those days were Tonie's or American black films. We'd watch the American films and say Tonie's are no good; we must learn from these. When *Umzingeli* came out, it was appalling. We battled to get a return on subsidy, which is unheard of in black distribution.[32]

Responding to a description of the films made by Senegalese director Ousman Sembene, who criticizes colonialism and neo-colonialism, Heyns stated in June 1979:

> At the moment I haven't met any black person who is that aware. At the moment the black people are concerned with their material well-being. I think they are fighting, not for one man one vote, but for a decent house, a decent income and whilst you are busy with such a basic problem, I don't think that you will get to the stage of satire or introversion. I am sure that it will come. We also tend to be careful in the script not to rock the police, although in our case we do give our crew a free reign.

Heyns's allegiance to the state was ensured through the clandestine capture of his company by the Department of Information. The views of business are often co-incident with those of the state, however. As a spokesman for Igoli Films remarked in June 1979, "As with white films you shouldn't make the government look bad." Besides, as Murray observes: "The trouble is that black awareness causes some people a lot of discomfort. It is easier to ignore it."[33] Despite this complete docility, a number of producers complained of police interference. This occurred mainly when police, watching a scene in action, misinterpreted the director's intention, and accused him of "making propaganda for overseas." One producer explained how he overcame suspicious policemen:

> I don't have these problems because I go to the Bantu Administration Boards and say I want to make a movie. Here is my script. They go through it and give me a permit to enter, say, Soweto. I show them the script because I want to prove that I don't make the wrong things and when I get the permit I usually report to the Administration Board during filming.[34]

It is not surprising then, that no "black" film made by a white company has ever been banned. This willingness to work

within discursive ideological limits is further reinforced by the workings of censorship and a desire not to alienate access to the subsidy. Only the group represented by Murray indicated a desire to breach the common sense restrictions white producers impose upon themselves: "I believe that our white film producers censor themselves politically, and there is no excitement left in the film, nothing controversial."[35]

GENRES

> "One wishes, for a while, South Africans would stop and take pride in themselves; understand the things that are for themselves."
>
> JOHN KANI, *actor*, The Star, *June 24, 1980*

Two striking absences mark the narrative structures of pre-1982 films aimed at black audiences. The first is "politics," the second is the absence of whites, even in the streets. In this way, producers have sought to omit points of conflict, over-emphasizing personal causation and individual solutions rather than collective action. Group responses necessarily imply that the drama itself is embedded in the wider society, and that society would then have at least to be acknowledged. This could prove uncomfortable for audiences and mark potential censor interventions. As Harriet Gavshon noted:

The mere image of whites would have the result of drawing correspondences between the fabricated world and the historical reality of the spectator, and corrode the illusion of the logicality of the narrative. Given that a dominant image of these films (and indeed most films in commercial cinema) operates on the supposition of the freedom of the individual to negotiate the conditions of his/her own experience, the presence of whites would evoke wider questions regarding structural boundaries. In every way there is

an attempt to create a "normal" world in which the
aspirations of the characters are met, as in any "normal"
social formation, and it is important that any images
are avoided that would suggest South Africa as an
abberation.[36]

Whereas Afrikaans films generally examine the cultural
traumas resulting from urbanization, the "back to the home-
lands" films are an explicit reflection of "grand apartheid" which
envisages a total separation of the races. Most of the films in
this category come from the Bayeta and Igoli stables and pre-
sent the traditional impression of blacks as unsophisticated and
raw rural dwellers. Gavshon's point is borne out by Van der
Merwe's insistence that "the separation is voluntary" while
simultaneously acknowledging that his emphasis on a closed
society is "getting away from reality," but defending his posi-
tion because "you could cause friction there."[37] These contra-
dictions are smoothed over through the common sense rationaliza-
tions employed by apartheid apologists to defend the "morality"
of segregation.

The "back to the homelands" films usually begin with the
hero, a well-dressed urbanite carrying a suitcase on his way
"home." Home refers to the homeland to which every black
person is allocated, irrespective of whether they were born
there. Once "back" from the city, the ex-migrant workers progres-
sively discard their Western, urban ways and "re-adapt" to tribal
life, wearing skins and beads. They never return to the city.
Maloyi (Witchdoctor, 1978), for example, relates the tale of
a sophisticated city-born woman who is bewitched by a tribal
sorcerer. She discards her Western lifestyle and is won over by
the mysticism of tribal life. Bayeta's *Vuma* (1978) is a "Dynamic
Musical Inspired by Zulu Traditions." Co-directed by Jerry M.
Dlepu, it claims to depict "the ceremonial procedures of love-
life... in an authentic way." Igoli Films' *Isiviko (The Shield,*
1979) shows a young migrant worker's return to a Zulu village
where life is controlled by improbable witchdoctors and water
spirits. Other examples of this genre include *Nogomopho*
(1974), based on an "updated" Zulu legend; *Iziduphunga*
(1977); and *Wangeza* (1977). These films are usually tech-

nically inept, culturally offensive and often racist. According to social scientist Ted Matsetela:

> These films are subtle custodians of the back to the country move envisaged in homeland policy. Like the government, these pictures continually stress that city life is foreign to the black way of life: "the urban setting is not your home; you belong in the homelands."[38]

This is clearly seen in Sam Williams's *Inkunzi* (1976) which tries to demonstrate the economic viability of the homelands in a much more sophisticated manner than do the Bayeta and Igoli films. Personal and financial success comes to a Transkeian man who returns to his homeland when he develops his own retail business. *Inkunzi* is the only Heyns film in this category, possibly due to the fact that it was sponsored by the Transkei Development Corporation.

The conditional urban category was pioneered by the Heyns titles which made a conscious effort at indoctrination. The Department of Information was concerned that South African blacks identified with the heroes and anti-heroes of American black films, mainly of the "B" variety. This insidious influence was to be countered through the creation of local black super heroes portrayed against an ethnic background. The Department expected an improvement in the quality of films, while simultaneously communicating the government's separate development message.[39]

Despite the state's attempts at indoctrination, most of the films made by Sabela are more adventurous and accurate than those found in the "back to the homelands" category. While also self-contained within black society, Sabela's films reflect, not a cohesive, unspoiled black community, but an urban-rural confusion typical of the over-crowded black urban townships. For example, in *u-Deliwe,* a naïve, orphaned Zulu girl in the countryside is seduced by the bright lights and fleshpots of the big city. *I-Kati Elimnyana (The Black Cat,* 1975) exposes the double life of a township burglar. *Ngwanaka (My Child,*

1976) sets a love story within feuding taxi-owning families and township thugs.

Gangsterism, in fact, is one of the major sub-themes of this genre. The "crime does not pay" message is found in the two films made by Cine World (*Phindesela,* 1979; *Utotsi,* 1978), and most of those put out by German-born Rudi Meyer's Afro Film and TV: *Isoka* (1979), *Uzenzile Akakhalelwa* (1981), *Ukuhlupheka* (1982) and *Inyembezi Zami* (1983). Greed, not need, motivates the gangsters, while anomie is very often a cause in itself. Ignoring the structural causes of poverty, these films suggest that the unemployed are lazy, indolent and not interested in the jobs that are available. The moral of these films is that "hard work ensures success." Other than Sabela, Murray's *Umzingeli* and *Ingilozi Yofoka* (1978), most of the gangster films include ludicrous witchdoctor sequences which insensitively portray them as gruff, gross, and noisy buffoons. The superficiality of the narratives can do little else but plant the characters in the cramped, crowded and unkept conditions of the township. Despite this obvious realism, author Mtutuzeli Matshoba asks:

> Why can't even a simple theme like the universal "crime does not pay" be drawn from reality and exploited in South Africa? The answer to this question is ... that the present is seen in relation to the past. ... Therefore social conditions which generally contribute to crime cannot be overlooked in a crime theme and, in the interests of government policy, are better left unexposed.[40]

Another recurring theme contrasts the merits of traditional and modern lifestyles. Sabela's *Setipana* (*The Blanket Story,* 1979), based on *Blanket Boy's Moon,* written by a homeland politician, follows the fortunes of two sons of an African chief. One foresakes his tribe and becomes a successful doctor in London who later returns to serve his people. The other, unambitious but brave, succeeds his father as chief. *Ngaka* (1976) is about a herbalist who is losing business to a new doctor next door. *Dr. Luke* (1982), directed by Simon Metsing, re-

volves around the rivalry which occurs between two brothers: one is a medical doctor, the other an indigenous healer. *Inkedama* (*The Orphan*, 1975) follows a migration in opposition to the "back to the homelands" genre, as it plots the life of an orphaned Transkeian boy who is taken in by an aunt in a township. He graduates as a doctor and the film charts his life in the midst of family quarrels and problems at the hospital where he works.

A third theme pioneered by Jimmy Murray are films with a social message: "If a film doesn't have a meaning, the script doesn't attract us at all."[41] *Sonto* (1979) is about a schoolgirl with an unspecified stomach disease. Because of the high incidence of schoolgirl pregnancy among blacks, the moment she shows signs of her illness, she is accused of being pregnant. She is thrown out of her home by her father and spurned by her boyfriend. She ends up at an aunt's house dying. Her boyfriend finds out that she was not pregnant after all, and with Sonto's father's help they launch a massive search. Sonto dies soon after she is discovered. Although this film initially did badly at the box office, Murray nevertheless concluded, "We feel that the message would not have been so important if she lived, because people think, 'Ah, I can go it alone, it'll all come out right in the end.'"

A second film, *Mathata* (*Life Is Hard*, 1984), directed by Clive Scott, deals with child orphans in Hillbrow whom no one cares about, not even black community leaders. It reveals their glue-sniffing habits and the alleyways in which they live. The film revolves around a white man who is robbed by one of these urchins. He beats the boy up, then is remorseful and drags him home where, much to his wife's disgust and embarrassment, he washes the boy, feeds him and puts him to bed. The remainder of the film deals with the man's efforts to penetrate the inertia of Administration Boards, other uninterested state agencies, the uncaring relatives that the boy does have in the township and so on. All the time the man is ridiculed by his racist wife. Finally, the man discovers the boy's grandmother, who adopts him. *Mathata* is a major thematic step forward for cinema aimed at blacks in that it implicitly criticizes white racism, state disinterest in black social problems and the inertia of the Administration Boards which are the heart of repressive state

control of urban blacks; the film does not penetrate through to the structural conditions that govern apartheid society. Despite being battered by the system, the boy is able to find home and happiness through the intervention of a "bleeding-heart" liberal. The man beats the system, satisfies his conscience, and is lauded by the press, at which stage his wife, not to be left out, includes herself in his altruistic efforts, and shows the world that charity does work. The black boy is delivered back to his "own" in the black township and white Hillbrow has one black urchin less.

To date, films with a social message remain the province of the Murray-Metsing partnership and Clive Scott Films. The ideological limitations of their films notwithstanding, and given the disdain of the established industry toward this kind of film-making, it is a wonder that such films are produced at all. Technically, they still leave a lot of room for improvement. Thematically, these producers are aware of the narrative shortcomings, but are tied to their liberal altruistic commitment to offer reassurance within the system. Unlike the "back to the homelands" genre, and the gangster and traditional-modern themes of the conditional urban movie, the social message strand *does* acknowedge the society in which its action is embedded, its attendant social problems and racial attitudes.

The escape-fantasy category is almost entirely dominated by Ronnie Isaacs of AIM, who offers a celluloid escape from the harsh surroundings of everyday life. Although slow-moving, static, and often using very long takes, they are not patronizing, racist or humorless. Isaacs acknowledges the fantasy element of his narratives, which are set in middle and upper class white suburbs. The characters, however, are mainly black. Sometimes there is also a *Three Stooges* feel to them. Simple narratives are structured around disco dancing. The recurring plot is a fairy tale similar to the story of *Cinderella*. In *Botsotso* (1979), for example, the hero is a dustman who wants to go to the "ball," but like Cinderella, he does not have the appropriate clothes. Miraculously, he gets the clothes, wins the "princess" and the respect of his peers. The suggestion is that class mobility can be effected by changing one's clothes and learning to dance. By the end of the film his brother is no

longer ashamed of him, and in *Botsotso II,* Luki is no longer a dustman. In *Botsotso III* (1983), Luki starts as a cook, but ends up owning the disco.

The motifs seen in the conditional urban movies, whether an accurate reflection of aspects of black city life or simply a perpetuation of the white filmmaker's stereotypes of blacks, do nevertheless convey an understanding of change in the black worker's conditions of existence which came about particularly after the Soweto disturbances in 1976. Unlike the "back to the homelands" genre, these films do not assume temporary urbanization or migrancy. Although no real work relations are portrayed, the conditional urban movie tacitly accepts the semi-permanent urban status of blacks, though still separate from whites.

STRUCTURED INTEGRATION

> "Rod Hay's films could form the link between the white and black films. The one side is moving to the other."
>
> STAN ROUP, Black Circuit, *September 1983*

Multiracialism has been allowed to develop in South Africa under certain circumstances. This follows state recognition for the need for a stable, urban-based black middle class to provide labor for commerce and manufacturing. In its wake has come an upgrading of black townships to city council status, and the increased interaction between blacks and whites on industrial, business, and sports levels.

Certain filmmakers have recognized the cinematic implications of this adjusting class structure. Whereas most producers previously obtained capital from banks or individual financiers, Rod Hay of Mirage Films has locked his efforts directly into the advertising industry itself. Advertisers are now intent upon reaching the new black middle classes, and encouraging consumer-oriented behavior. Parallel with this marketing drive, has come

a recognition of the middle class status of consumers who, unlike their homeland counterparts, are exhorted to look to Western capitalist models. This "new consumer" is very critical of patronizing films. As Rod Hay puts it:

> The days of making primitive pictures for blacks, I think, are now gone. Sure, you can get away with it in certain areas, but I believe that the increased level of black buying power, the increased level of sophistication that has subsequently come through a middle class system will inevitably cause those films to improve because of increased awareness. The involvement of sponsors can only help to generate their products into areas they could never significantly get into.[42]

Hay comments that "there's always a quick stop-gap between soccer, boxing and music . . . subject matter which I knew was very popular." His first film, *A Way of Life* (1981), looks at the phenomenon of soccer among blacks, while *Will To Win* (1982) concentrates more specifically on the success story which surrounds the Kaiser Chiefs soccer team. *Stoney the One and Only* (1983) is a tongue-in-cheek comedy about a larger than life boxing hero. It has elements of both traditionalism and the disco films: "It has a specifically African mystical background . . . with a witchdoctor who doesn't throw the bones unless he checks out his fortune-telling with a calculator." The "good versus evil" works at the basic level of *Conan and the Barbarian,* with the fantasy of *Star Wars,* the excitement of *Rocky,* and a dog from *Annie.* The film is laden with imagery and situations first seen in *Raiders of the Lost Ark.* Over this imagery is imposed a boxing/gangster/disco narrative which monotonously unfolds in a black township setting. *Stoney* uses township English: "I had a situation where I wanted to have people speaking specifically English, but an English that everybody should understand, complementing it by using the vernacular in a way that was natural where it became more a part of the character than language."

The result is a movie which provides touched-up images of the central character, who majestically batters all opponents,

black or white, onto the canvas. He is clean-living, kind, open-hearted and inviolately loyal to his manager-trainer, who is consistently in debt to loan sharks and forever being roughed up by them. Stoney declines all counter-offers for his services and remains loyal to the man who helped him to success. The urban landscape is populated by muscle men, boxers and a motorcycle gang of both black and white weirdos straight out of *The Wild Ones*. All in all, a very strange and alien environment in which to locate a film aimed at blacks, especially black children whose cinematic and social experiences are largely limited to an isolated township existence.

Like the social message films, *Stoney* shows that hard work, loyalty to one's employer, clean living and a knowledge of what is good will inevitably lead the way to success and riches. It is a fairy tale which glides along on the visual imagery of a touched-up Hollywood with South African backgrounds thrown in for good measure. The film is an example of all the problems that occur when trying to marry the corporate image of a sponsoring company—Stoney Ginger Beer—with the demands of a narrative where the hero has to negotiate a world of evil. The result is "a goody goody" hero who is soppy in the extreme. *Stoney* as the "billboard brought to life" remains static, unidimensional and lacking in the content and dynamism required by narrative.

Certain problems regarding overseas markets remain. Hay has moved into fiction partly because of the difficulty he has experienced in selling his sports films:

> People overseas still don't believe that if you show anything on an integrated basis, that it's actually for real. They look for the barbed wire and they look for the faces hovering behind the barbed wire and that as far as they are concerned, is good fodder for overseas. And it does limit your potential enormously. That's why I've now tried to get out of the documentary area and move into the sort of drama elements that *Stoney* is.[43]

Prior to 1981, subsidy stipulations required films to have

three-quarters of the dialogue in South African vernacular.
That this rule has not been enforced is an indication of
the adjustments that the state is making with regard to the
co-option of the black middle class. It is *not* a concession, but
an adaption with respect to emerging markets. The support given
Black Circuit by the Department of Industries, the fact that
producers voluntarily screen their films to representatives of the
Department to persuade them of the relevance and quality of
their product,[44] and the call to the Department by the Direc-
torate of Publications that "they were astounded—these black
films which had been of a fairly low quality, were suddenly
getting quite interesting,"[45] are all indications of the coincidence
of objectives which exist between the state and business.

Two further examples of films in the structured integration
genre are Isaacs's *Umjulukone Gazi* (*Sweat and Blood*, 1982)
and *Johnny Tough* (1983). The former is a "rags-to-riches"
plot where a peasant farmer is forced to take a job on a Free
State mine. Here he subdues the mine bully and is trained as
a boxer by the white mine boxing trainer. In *Johnny Tough,* a
boxer is trapped into being managed by a white mafia-type
hood, a womanizing, cigar-smoking crook who was introduced
in *Sweat and Blood*. Both of these films exhibit racially bal-
anced oppositions: in *Sweat and Blood,* "good" white trainer
versus "bad" white hood; "good" black boxer versus "bad"
black bully; and "good" white trainer and black boxer versus
"bad" black bully and white hood. In *Johnny Tough* the op-
positions are "good" white doctor versus "bad" white hood;
and "good" wife (of the boxer) versus "bad" white tarts
(who cling to the hood). The plots are restricted to the ring,
the gym, the hood's office and, in *Johnny Tough,* the hospital.
In the latter film, we do not know who Johnny is, where he
came from, or in which country the film locates its action.
Similarly, the other characters are limited to the practice of
boxing and its activities.

Set in a sort of sparse Woodstock environment is *Don't Stop
the Music* (1982) with Steve Kekana, South Africa's most suc-
cessful singer, and various black and white performers, including
the British world disco champions. The action is on an open-
air stage in Soweto. Intercuts present black and white disc

jockeys, white record promoters and scenes from 702, a multi-racial music station broadcast from the Bophuthatswana home-land. All the interviewees are talking about how they are pro-moting black South African musicians. This film, amongst others, was shown at the 1983 Amiens Film Festival Against Racism. The intention was to educate audiences on the ideological structures which South Africans erect to persuade themselves of the "morality" of "reform." It elicited an audience response which simplistically correlated this film with "official" govern-ment propaganda. While there can be no doubt that *Don't Stop the Music* and other films like it are useful, they are not made by the government *per se*. While the film is an illustra-tion of the limited change which has occurred in South Africa, it does not discuss the political impediments to integration, the exploitative history of the recording companies, or the fact that permits were needed by the white dancers, singers and film crew to attend the festival in the black area. Instead the film reflects the process of co-option and embourgeoisement, sug-gesting that the pioneering spirit of the singers, dancers, record companies and, by implication, the film itself, is a factor in social change. In an interview with *The Star,* Hay pointed to the wealth of stories in South Africa that involve all race groups and which can be handled so that entertainment becomes a priority and skin color irrelevant.[46] His films are evidence of this philosophy, but his assumptions are exactly those guiding the South African political economy.

PROPAGANDA

"You have to give the Department of Industries full marks. They in no way, even if it [the film] is dealing with a political subject; they haven't tried to restrict it. They are not looking at it [the black industry] in a propaganda sense. They see it— stay within the rules, get the distribution together— and we'll go for it."

STAN ROUP, Black Circuit, *September 1983*

South Africa's filmmakers feel that their films lie outside politics, that they are merely entertainment. But this is not the case. Their class position, their underlying social and cinematic assumptions, their emphasis on commerciality, their Hollywood-inspired models, their working "within the rules," and their displacement of actual conditions by imaginary relations which delineate an apartheid view of the world, make their films susceptible to the propagandistic intentions of the state. For example, in an interview with the *Rand Daily Mail* in 1974 on *Joe Bullet,* Van der Merwe denied that his intention not to mix black and white actors in his films was the beginning of apartheid cinema.[47]

The emerging class alliance and increasing integration of the capitalist ethic into the black middle class world view certainly does deny the "back to the homelands" genre. However, the structured integration genre is complementary, for it both reflects and legitimatizes a *limited* class-bound social change. Very often that change is confused with technique. As Rod Hay says of his own films: "If anything, Pretoria welcomes it because of the necessity for more films of increasingly high standards ... [which] ... have got some chance of being used as a public relations vehicle overseas."[48] The social and cultural coherence suggested by most "black" films assumes a society in charge of its own destiny. It is taken for granted, however, that that society will find its destiny within racial capitalism. This common sense logic explains why white South Africans can claim that they are making "black" films. The very contradic-

tion of the names of the two associations to represent the "black" industry is indicative of this political imbalance. "Black" is thus not seen in terms of skin color only, but in terms of a market which is difficult to reach through orthodox advertising methods. There is no attempt to stimulate a "black" film industry at all, only products aimed at blacks. The confusion of origins, interactions and connections perpetuates a racial and marketing dichotomy. Ideology is working at its most efficient here, for just when white filmmakers think they are "progressing," they are, in fact, merely reinforcing the existing relations of production. Thys Heyns, for example, sees social/racial conflict operating at the level of the individual, as something *separate from* rather than directly related to white hegemony: "I would welcome a story that would really go deeper into the meat of the conflict that these people [blacks] have to go through in their way of life as opposed to the white man's life."[49]

The textual and ideological oppositions are encoded into the very structure of production: "Black" associations representing "white" producers; "white" producers making "black" films; "black" film subsidies paid out by the "white" government; "white" films being classified as "black" in terms of refusals of "white" distributors to take on a film, and so on.

CHAPTER FOUR

FILM MOVEMENTS

"We don't have the resources that Hollywood has,
in the first place. And secondly, if we are going to
have any kind of rational cinema in this country, we
have to start exploring our own roots and our
own history."

JOHN HOOKAM, *director*, The Citizen, *1982*

Despite looking to Hollywood for their model, South
African directors have rarely emulated Hollywood's production
methods, themes, or standards. South African analysis of
Hollywood seldom goes beyond a cursory glance at style and
content. Oft-cited terms like "Hollywood type," "blockbuster,"
"large budget," "formula," and "major American product" have
obscured deeper issues. While claiming that they "can't compete"
with the Hollywood model, South African directors nevertheless
try to. The lack of a critical cinematic heritage prevents South
African filmmakers from understanding the significance of theo-
retical discussion. A director who is self-conscious about goals,
intentions, and social relations is considered to be commercially
irresponsible and lacking in business integrity. To inject a film
with a personal signature or an overt political content is frowned
upon since this contravenes the dictum which lubricates industry
practice: give the public what it wants.

Of all the South African directors only Jans Rautenbach,
Ross Devenish and David Bensusan project a personal style

which cuts through the ideological myths imposed by their society. Of Rautenbach, John van Zyl, writing in 1970, commented:

> Jans Rautenbach is the only director in South Africa with enough integrity to make HIS film, not the film the public wants. This sets him in a different category from the heart-transplant songsters and banana-beachers.[1]

Film critic Barry Ronge concurred, praising Rautenbach for carrying single-handed a torch of talent and intelligence through the murkiest period of South African cinema:

> With only four films to his credit Jans Rautenbach has become the most vital force in the South African film industry . . . *Wild Season* . . . establishes Rautenbach as an accomplished cinematic stylist . . . *Die Kandidaat* [is] a notable innovation in Afrikaans cinema . . . *Katrina* moves into hitherto sacrosanct territory of South African racial policy.[2]

Wild Season generated an Afrikaner cultural backlash, the like of which had never previously been witnessed in South Africa as far as cinema was concerned. At the heart of the matter was the bilingual nature of the film, the fact that some of the main characters are played by blacks and the a-stereo-typical representation of Afrikaners. The film was snubbed by the central committee of the *Suid-Afrikaanse Akademie vir Wetenskap en Kuns* (The South African Academy for Science and Art) which rejected a recommendation from its film section that it be given an award. Producer Emil Nofal, an English-speaker, retorted: "Just as it was felt that Mr. Breytenbach was not awarded the 1968 Hertzog Prize for Poetry for 'other reasons,' so I believe my film suffered from the same fate."[3]

The storm of controversy generated by *Wild Season* was eclipsed in its unbridled fury by *Die Kandidaat* (1968). This film tears apart the deceit and prejudices of the wealthy urban Afrikaner. Extra-marital affairs are disclosed, the parentage of an orphan is meticulously revealed, political

pasts are laid bare and the *verligte-verkrampte* (enlightened-conservative) political divisions of Afrikanerdom reflected. The *Akademie,* not surprisingly, refused to see it. The Publications Control Board was unable to come to a decision for two weeks. The Prime Minister and the Minister of the Interior saw it. The Secretary for the National Council to Combat Communism claimed that the film glorifies "an anti-hero" and makes "a caricature" of the Afrikaner, confirming the worst suspicions of "our enemies." "The heroic martial strains are missing," lamented the secretary.[4] Eventually the film was released with four cuts. Only after 1.3 million South African cinema-goers had seen the film did the *Akademie* award the film a Gold Medal of Honor.

More controversy was to occur with *Katrina* (1969). Based on a play, *Try For White,* the film deals with inter-racial relations between a coloured woman and a white Anglican priest. Nofal and Rautenbach, in order to circumvent possible Publications Control Board objections, shot two endings. The first was multiracial in character, while the second communicated an ambiguous but unmistakable official viewpoint. Not unexpectedly, the Board demanded that the second ending be used.

Rautenbach is one of the few South African filmmakers who has described the depth of the problems facing the South African artist who wants to exploit the full potential of his medium. In an interview with John van Zyl and Anita Worrall he explained:

> For *Katrina* I had a private viewing for the Prime Minister [B. J. Vorster]. You know he has this bulldog thing about him—*"Ek is die leier"* [I am the leader]—and he stood there in the foyer and said—'I like it very much, but," wagging his finger—"the portrayal of the Afrikaner is wrong!" That basically was his attitude. My argument at the time was that I don't want to preach to the converted, and if you can prove that we don't hit kaffirs and kill kaffirs anymore... as basic as that... then I will accept it.[5]

The allegorical implications of Rautenbach's next film, *Jannie Totsiens* (*Goodbye Johnny,* 1970), made without Nofal's

help, seem to have escaped the intellect of the Publications Control Board and apparently the Prime Minister as well. The setting is a mental institution which represents South Africa. The insane run the asylum while the ineffectual doctor in charge represents the Prime Minister who tries to justify his position. The other characters are a cross section of South African society. The only sane person is an Indian waiter. The following discussion alludes to the reasons why *Jannie Totsiens* did not suffer at the hands of the Publications Control Board and government. This extract also identifies an ideological spirit which, had Rautenbach had the support of other filmmakers at the time, could have sown the seeds for the nurturing of a South African film movement:

VAN ZYL: Why . . . did you make it even more difficult for your audience by setting *Jannie Totsiens* in the allegorical mode?

RAUTENBACH: What I want to say I wish to say well, because this is the little pleasure I am getting out of films. I am not making money out of it in the final analysis. In a sense I am the main audience.

VAN ZYL: But why specifically the mental institution? Because with an allegory you can only show, you can't really analyze; and given your unique role in South African filmmaking you have removed this film from your general audience by setting it in a rather obscure thing so that it takes an intellectual to unravel it; and secondly, by making it an allegory you don't really give answers. You don't say—"Look the problem lies here with the HNP [Repurified National Party] or the Progs [Progressive Party]!

RAUTENBACH: But you still have to set questions.

WORRALL: Don't you actually achieve greater depth in this way by hewing through the conventional patterns?

RAUTENBACH: I have got answers.

VAN ZYL: Let's hear them.

RAUTENBACH: No.

WORRALL: Actually, you wouldn't be interesting if you told

these answers. Nobody can come up with really original answers, and the minute you come up with an answer you're just another politician and there are too many in our society as it is. What you need are questions, unconventional questions, which is what you are posing.

RAUTENBACH: Look, let me make the point that as a person I think I am very involved in the social and political structure of this country; and I find myself among a group of people ... people who have a similar perception of the situation, of the problems ... we would like to create the South Africa of the 1980s, but we have not yet achieved the unity among ourselves except to agree on the criticism we level. I have a long-term conception of my role as a filmmaker. My film-making is a long-term project, something like building up credit at a bank. So that one day I can use it totally. Very frankly, I would like to be in a position where my integrity would not be doubted. Then we will have reached the stage where we can supply answers ... credible and acceptable answers. But now, we are moving one step ahead ... not ten.

WORRALL: Would you see your role, then, as an editor who wants to take his readers in a certain direction but knows that he must not move too far ahead of them?

RAUTENBACH: Look, last Tuesday we had the premiere of this film in Cape Town and ten members of the Cabinet were present. I must say this was heart-warming because they came to me, each and every one ... now a bloke like—didn't really know what it was all about ... you know what I mean ... but at least he said—"this is blerry mooi [nice], jong." (Laughter.) But the guys like Connie Mulder, Schalk van der Merwe, Piet Koornhof ... suddenly there was an excitement amongst them ... they discussed it at length, with

a certain amount of pride that the film industry
has reached this point. The point I want to make
is that already your Cabinet can go with a thing
like this . . . when you want to use your reserve
with them you can.[6]

Nofal had gone his more commercial way prior to the
making of *Jannie Totsiens.* Nofal saw himself as an "enter-
tainer," while Rautenbach was "deeply concerned with the fate
of Afrikanerdom and the plight of the Afrikaner intellectual."[7]
He tried to use his film company, Sewentig (Seventy), as a locus
of cultural production around which some sort of unity of pur-
pose would coalesce. He described this company in true *Sestiger*
(Sixtier)[8] terms as:

A spirit. It's people working together. No one person
makes a film. Sewentig has to give every possible per-
son a chance to become involved in film-making. We
have to look to the future. I had to buy this studio re-
cently, and I had to finance it with God knows what
capital in 24 hours, because if we didn't get this studio
and this property [Lone Hill], the whole idea of build-
ing a film centre where people could come and work
and exchange ideas and build onto something was going
to go down the drain. Big business wanted it. I secured
it, now I am arranging for big business to finance it,
and to have a part, but on the filmmakers' terms, not
theirs. I have arranged finance for people who will not
get finance anywhere else because the ideas they have
got are too radical, or they are not set in a pattern. I
will personally see that any film they make will be
worthy of an investment, but not necessarily in the
present pattern of film-making. If we do not experi-
ment, if we do not find our identity as soon as possible,
we are not going to make it.[9]

Despite this awakening collaborative spirit at Lone Hill
where the studio was located, a film movement did not gel.
Audiences were not ready for the intellectuality of *Jannie Totsiens*

and neither was "big business" prepared to finance cultural production on any terms other than its own. The industry, too, was skeptical of Rautenbach's unconventional way of doing things and the "spirit" which underwrote the company stalled with *Pappalap* (1971). In this film Rautenbach was apparently forced to alter the original ending, which portrayed the rape of an innocent Karoo *dorpsmeisie* (village girl) by the local stud, in the interests of the financier and an image considered more befitting to the Afrikaner *volk*.

One of the criteria of a dynamic film movement is that innovations (such as those offered by Rautenbach), production methods and values should be accepted into the film industry and perhaps become incorporated into existing cultural patterns. But norms, values and prevailing organizational structure which governed the behavior of the South African film industry at the time of Rautenbach's attempts to change them, were too stable and too powerful for any change to occur.

The French New Wave was also composed of a minority of the film industry. In 1962 Truffaut commented: "There are seven directors in France who aim to make a good film, twenty don't really give a damn, thirty-five think only of money but do a more or less honest job, and lastly, there are fifty who are utterly deplorable."[10]

South African films have the additional burden of divisions of language and cultural background, with English-speaking directors often showing the least integrity. Rautenbach has this to say about his English-language colleagues:

> The English filmmaker should be ashamed of what he is doing to the English-speaking public in this country. First of all they are not even trying to compete with the English film from overseas. They are not trying to bring their English-speaking countrymen something that is his own. They have no pride in their products, no pride whatsoever. All of them look upon film-making as a cheap way of making money, and they expect the English-speaking South African to be thankful and take whatever they bring them.
>
> When the Afrikaans filmmaker tries something,

they're the first buggers to say: why pull politics into
a film, or a mental institution? But they themselves try
nothing. In the past they've made money out of Afri-
kaans films, most of them based on some second-rate
English script they bought cheaply elsewhere, acted by
English players. Look at the titles of your English films
today: *Banana Beach, Petticoat Safari, Satan's Harvest,
Strangers at Sunrise* ... It smells of decay, of nothing-
ness.[11]

The "spirit of Sewentig" was an attempt to navigate the
industry out of the restrictions on discourse which governed what
may be said, in what kind of film made under what conditions.
Rautenbach is equally critical of the "*boereplaas*" (boer-farm)
themes found in the mainstream of Afrikaans-language films,
as he is of bilingual films like *Lord Oom Piet* (1962), many
of which were made by the Jamie Uys Studio. This critical
stance brought Rautenbach into conflict with the industry and
resulted in the breakup of his partnership with Nofal. He was
eventually persuaded to relinquish his "political" stance and his
later films lacked social criticism of any kind.

Although about 229 feature films were produced between
1969 and 1979, less than 5 percent could be considered cine-
matically innovative. These films, which number about eleven in
all, were isolated occurrences which did not fufill the basic con-
ditions necesary for the growth of a movement. The directors in-
volved—no more than six—did not constitute a sub-culture be-
cause there was no degree of unity among them. In fact, they
were polarized both in terms of language and politics. Their
films were not temporally clustered and did not follow any
significantly identifiable socio-cultural trauma. Although these
directors received sympathetic appraisals from local film critics
and theorists, no formal interaction bound them together. Re-
ception from distributors was generally muted. Sven Persson's
Land Apart (1974), which predicted the social turmoil of 1976,
was initially banned, censored and released two years later as
The South Africans, and barely made subsidy because of poor
distribution and state intimidation.

Where anomalous films like *The South Africans* have man-

aged to breach the conservativeness of capital and the administration of the state censorship machinery, conformity is often ensured through the distributive process. The film was rejected by the chairman of Satbel before he had even seen it. Although Ster's managing director, Sandro Pierotti, liked it and Dr. Wassenaar, managing director of the SANLAM holding company, was receptive, the rejection hinged on the poor performance of a previous political film, *Die Sestig Jaar van John Vorster* (*The Sixty Years of John Vorster*, 1976), which had lost money. Satbel argued that since *The South Africans* was also of a political nature it had little chance of box office success. Perhaps Satbel, itself part of National capital, felt that the film had contravened the dominant political discourse. Paradoxically, the film obtained MGM support, a company owned by American capital, which was sympathetic purely in terms of market considerations. The state, however, threatened sanctions against the local MGM office via MGM International which exerted pressure on its South African office to cancel its distribution agreement with Persson.

The film was eventually screened at independent cinemas, two in Johannesburg and one in Pretoria. Finally, the producer had to borrow a tactic used by Jamie Uys in the 1950s. The film plus a 16mm projector were hawked around the country and screened at universities where it was enthusiastically received. At Potchefstroom, an extremely conservative campus, 600 students packed the audience and after the show they bombarded the director with questions for over two hours. They also formally apologized for the uninvited presence of two security policemen.

Judging from Rautenbach's later works, *Ongewenste Vreemdeling* (1974), *Eendag op 'n Reendag* (1975), *Die Sestig Jaar van John Vorster* (1977), *Winners II* (1977) and *Blink Stefaans* (1981), a noticeable decline in idealism and a withdrawal from public debate has occurred. He had to change his attitude if he was to continue directing for his profit-bound producers.

Nofal too, tempered his stance. His vociferous defense of *Wild Season* (1967) as "pure art," for which only one set of esthetic standards and norms can be applied, has little validity for his later films. No longer applying artistic criteria in the

defense of his films, Nofal found security in ideology: "It may be a dirty word . . . but I deal in entertainment." Nofal was reacting to a statement by Athol Fugard that "that which is authentic and unique to South Africa has been neglected, by and large, by the local industry which really just turns out rubbish."[12] Referring to the satirical mirror of *King Hendrik* (1965), the social comment of *Katrina* and the "socially uplifting" quality of *The Winners* (1972), Nofal criticized Fugard for achieving fame and fortune "in the easiest form of expression—by dramatizing the underdog, trying to survive in a cruel world, studying man's inhumanity to man. In other words, muckraking in the rubbish heap of life."[13]

"Beauty and truth," wrote Godard, "have two poles: documentary and fiction. You can start with either one. My starting point is documentary to which I try to give the truth of fiction."[14]

Nofal is clearly undervaluing his own work embodied in *Wild Season, Die Kandidaat* and *Katrina*. Nofal's reaction is typical, however, of the attitudes of many established producers who are over-sensitive to or derogatory of healthy discussion. *The Winners* in no way emulates the social criticism of his earlier work. Nofal's ideological weapon—art—has become his commercial anesthetic—a superficial entertainment. Or as Ross Hunter expresses it: "I don't want to hold up a mirror to life as it is. I just want to show the part that is attractive—not freckled faces and broken teeth, but smooth faces and pearly white teeth."[15]

It is against this background that Ross Devenish and Athol Fugard made *Boesman and Lena* (1973), *The Guest* (1977) and *Marigolds in August* (1980). While the industry concedes that these films represent some of its better creations, it will immediately point to their non-commercial basis. The blame for this is placed on the filmmakers, not the controllers of distribution or exhibition. The myth that sophisticated films are "non-commercial" continues then to delineate what is acceptable or not to the *audience,* not the distributors. In other words, Devenish defined what could be, but was unable to persuade other producers to follow suit because of market constraints and a lack of identification with Devenish's vision.

If Fugard and Devenish are concerned about all South Africans and blacks in particular, many filmmakers are not. In

a 1978 interview, actor and director Marie du Toit located an indigenous film expression within the confines of Afrikanerdom, rather than a unified South Africa:

> Our whole standard of films has dropped back to where we were in the 1950s and the beginning of the 1960s. What really breaks my heart is that somewhere, somehow, something was lost, right at the moment when we thought, "Now we are set to build a really indigenous film industry with films like *Katrina,* and *Die Kandidaat* which had something to say and something to contribute to the social scene and with people who were not afraid to stick their necks out."[16]

The historical roots that Hookam speaks of were thus divided in terms of specific sub-cultures: Afrikanerdom versus a reassessment of racial and political attitudes. The cohesion necessary to coagulate filmmakers into a movement in South Africa was lacking and became ossified through petty bickering, ostracism of innovators, political intimidation, business timidity and a complete confusion of values, principles, and directions. Attempts to examine underlying issues afflicting the industry are whitewashed by the industry itself and producers, to a large extent, remain contemptuous of any colleagues who express dissatisfaction with the status quo.

CHAPTER FIVE

THE REVIEWER SYNDROME

> "With the review of the film *Boesman and Lena* . . .
> all sorts of things were discussed . . . and lot of es-
> thetic discussions, and no one ever talked about
> bulldozing . . . no one talked about the way in which
> people were just being moved on and made home-
> less; the film was discussed as if it was happening
> in a vacuum, without any reference to its being
> specifically South African."
>
> ROSS DEVENISH, *producer-director*[1]

During its first year of existence (1915), *Stage and Cinema,*
owned by I. W. Schlesinger, published over twelve reviews of locally
made productions. These early commentaries were mainly descrip-
tive, outlining just the story, actors, producer and other credits.
At first, no attempt was made by the reviewer to persuade
readers to see the film, but after a few issues judgements were
occasionally passed. This newly acquired confidence brought
with it a technical knowledge of the cinema and a feeling for
a sense of place, qualities which some reviewers and producers
of the 1980s lack.

This extract from a review of *A Zulu's Devotion* (1916)
is one of the first to comment on cinematic components:

> Although quite a modest production in point of
> length (it is about 1,000 feet), it compares more than
> favorably with the best American dramas of the same

type. The scenario is good, the direction first class, the action rapid, the situation strong, the South African atmosphere well produced, the exteriors are excellent and the interiors correct, and the photography is of a high order.[2]

Local interest was futher engendered by linking factual events with a fictitious story. Examples include *The Liquor Seller* (1916), *A Kract Affair* (1916), *The Piccanin's Christmas* (1917) and *King Solomon's Mines* (1918). This sense of place was particularly evident in the imagery captured in historical films. The epic standards set in 1916 by Gustav Preller and Harold Shaw's *De Voortrekkers/Winning a Continent* have never again been matched in the subsequent history of the South African film industry.[3] Thelma Gutsche commented that the magnitude of this film was totally out of proportion to the reputation of South Africa's nascent film industry. It was conceived on a grand scale and successfully completed despite the absence of the vast financial and technical resources of the best equipped Hollywood studio of the day.[4] Early commentators compare *De Voortrekkers* to D. W. Griffith's *Birth of a Nation* and it is said to have inspired its American counterpart in *The Covered Wagon*. The advanced cinematic quality of *De Voortrekkers* validated the ideological alliance existing at the time of production (the British from whom the Boers were escaping are shown to be blameless).

The financial and critical success of *De Voortrekkers* both at home and in England led to an even more ambitious film in 1918 entitled *The Symbol of Sacrifice*. The *Stage and Cinema* reviewer was ecstatic:

More magnificent pictures there may be—*Cabira*, for instance, and *Intolerance*—but they are more magnificent only on account of the costly splendor of their interior settings. In *Symbol of Sacrifice* there is only one elaborate "interior"—Windsor Castle—and this is fit to rank with the best the screen can show. Otherwise it is almost entirely an open air film, and its realism and fidelity to detail are carried to a point as

near perfection as possible for mortal man to reach.[5]

The reviewer praises the photography, lauds the props department, compares the acting with the best in the world and declares it to be a greater film than *De Voortrekkers* "because it is even more realistic, and because it contains much more story."[6] The same reviewer acclaimed *The Symbol of Sacrifice* as "one of the world's big productions":

> Over 25,000 people, white and black, took part in *The Symbol of Sacrifice,* and the three big battle scenes—Isan'dhlwana, Rorke's Drift and Ulundi—leave nothing to the imagination. They are probably the most faithful reconstructions of historical battles ever depicted . . . The mass of fighting, struggling, killing humanity seen in these battles is inconceivable.[7]

This, and other reviews appearing in *Stage and Cinema,* were infused with a notable pride in the stature of the local industry. However, a lack of exposure to the developing film theory of the Soviet film directors is evident in a recurring racial stereotyping, not only in the films, but also in reviews. Whereas earlier films had erected an acceptable stereotype of black people in cinema, *The Symbol of Sacrifice* appears to have questioned that construct. A second reviewer of this film criticized this ideological inaccuracy and thereby raised a series of issues which have bedeviled directors and distributors ever since:

> The author and producer have managed cleverly to avoid giving offence to any section of the community. On the contrary, they have indicated the points of union and have shown that the symbol of sacrifice is the Flag of the Empire, which stands for the betterment of the human race. Englishmen and Dutchmen are shown standing together for the suppression of barbarism, and while all the better characteristics of the whites are necessarily emphasized, the bravery and faithfulness of the native is brought into prominence. Probably the real truthfulness of the campaign, on one side at least,

has not been more than suggested, and the men who were then savages have been endowed with sentiments far beyond their stage of development, but, generally, the treatment of the subject was sound and careful. Obviously the best expert advice has been used and no small, technical flaws can detract from the impression that it is a great historical romance.[8]

This illogical and contradictory statement is fueled by the ideological discourse of the Afrikaner-English alliance that developed after Union in 1910. The content of that discourse is identified in phrases like ". . . avoid giving offence," which became the slogan of the Publications Control Board; ". . . the better characteristics of the whites are necessarily emphasized" legitimized white dominance; ". . . and men who were then savages" were reduced to servants, parodying Afrikaners in the few cases that they appear in South African films. Most telling, however, is the reviewer's ignorance about the Zulu wars and who took part in them. The Boers ("Dutchmen") kept out of the British-Zulu confrontations, waiting for both sides to exhaust themselves before asserting their own hegemony. The racism evident in this reviewer's writings, however, was consistent with the emerging attitudes of capital and class struggles within the state which was the basis of segregation and, after 1948, apartheid.

THE NEWS ENVIRONMENT

"While the journalists on the front page were actually talking about the evils of the system, the arts editors and others were somehow intimidated by the system and felt that they could not express political comment in their columns."

Ross Devenish, *director*[9]

Since critics are employed primarily as journalists, they tend to see themselves as journalists first and critics second. As journalists they are in the business of reporting news subject to

what Herbert Gans calls "considerations," factors which shape the availability of information and suitability of news judgements. Gans comments that unlike sociologists, who divide external reality into social processes, and historians, who look at these processes over longer periods, journalists see external reality as a set of disparate and independent events, each of which is new and can therefore be reported as news.[10] The result is that film criticism is generally reported in a news framework where the dramatic is singled out, highlighted and made more important than the mundane social processes within which they repose and which may be considered non-news. News is prepackaged ideology assuming a consensus about values and practices. The social order, and the national leadership maintaining that order, are overriding values. For the Afrikaans-language press, this means the institutionalization of the National Party and apartheid; for the English press, the protection of the capitalist mode of production and the present class structure, but without the hurtful race discrimination which is also seen to work against economic efficiency. The white-owned black press articulates the same class values and norms. As Les Switzer notes, the "black" press also is part of the apparatus whereby the white ruling middle class maintains the status quo.[11]

This status quo, or a modified humanist version of it, remains an overriding value in the news. The way threats to it are reported, therefore, are inextricably bound up with the concepts of nation and society: their persistence, cohesion, and the conflicts and division threatening their continuity are all dealt with in terms of the existing class structure, which is merely formalized by apartheid legislation. The value of "order" appears in the arts pages as part of the vocabulary of entertainment news.

The perception of the audience is significant, for blacks have access to very few places of entertainment. Not surprisingly, the arts pages of periodicals tend to report on entertainment mainly from a white perspective, assuming access, Western esthetic values, and the separation of art from life. Individual critics may be supportive of persons putting pressure on the industry to change, but the inexorable pressures applied by the established industry on the arts editors effectively exclude criticism of the structures which sustain the prevailing order.

RECRUITMENT OF CRITIC-JOURNALISTS

> "The advent of the cinema has synchronized with a
> great social awakening, and has given it expres-
> sion . . . this enlarging of the landscape has made
> the working-man healthily dissatisfied with his
> social confinement."
>
> "D.B.J.," Stage and Cinema, September 4, 1915

In Afrikaans' newspapers, journalists fulfill an obvious polit-
ical function, the origin of these papers being the National Party.
More recently though, these newspapers have won for them-
selves a relative autonomy from the Party and act, very often,
as an internal opposition to the government. The English-
language newspapers, being corporately owned from inception,
regard themselves primarily as profit-making enterprises through
the sale of advertising space. Their liberal outlook interprets
apartheid as an economically inefficient and discriminatory sys-
tem based on an irrational race prejudice. Journalists they recruit,
therefore, tend to be selected on the basis of their congruence
with the commercial interests the paper serves and the con-
sequent ideology it inflects. One section editor has commented:

> The imposition of a line comes right at the very
> outset with the selection of an individual . . . What you
> are encouraged to do is to write provocatively about
> something so that it gets lots of people reading it so
> that the marketing department can say, there is our
> readership. If you put an ad under that it will pay off.[12]

On the smaller papers such as the Herald and the Evening
Post few full-time critics are employed. Instead, reporters write
reviews on a rotating basis. On the larger newspapers, such as
the Johannesburg Star, journalists have become critics through
a haphazard process of gravitation to the arts or entertainment
pages. It is not surprising, therefore, that journalist-critics tend
to apply "newsworthy" criteria in their choice of what news is
available. According to Barry Ronge, then of The Star:

> Press critics tend to stumble into it as a job . . . not
> because the person has a particular interest in film or
> theater and not because he has a particularly detailed
> knowledge. It's just that his particular talents include
> an ability to write concisely and neatly with a good
> general touch . . . X, for example, was on the arts page
> for a while. She displayed a certain skill for interview-
> ing so she is now down in the newsroom. She was con-
> sidered wasted as a critic.[13]

In contrast, Afrikaans newspapers appear to have a higher
representation of academically inclined critics. Many write from
an informed intellectual position and are often more critical of
Afrikaans cinema than their English-language counterparts. The
closer connections between Afrikaans press critics and univer-
sities lies in the reverence held by Afrikanerdom for academics
who were at the forefront of Afrikaner nationalism during the
first part of this century. Many of these academics were to
become editors and politicians, thus cementing the link between
the press, academia and politics. Ironically, many of the jour-
nalists now functioning as critics are highly critical of the stance
taken by their newspapers and are sometimes able to com-
municate this through what and how they report on entertain-
ment and cultural activities. The range of material reported on
is much wider than is reflected in the hard news pages.

Neither Afrikaans-language or English-language critics are
appreciated by the industry. Writing in 1977, Ronge—then an
academic—accused press critics of "mere opinion, unsupported
by adequate information or by any clearly stated criteria for
judgement . . . [that] that opinion should be recognized for
what it is, mere bigotry and posturing." At best, he said, news-
paper reviews, constrained by their mass media nature, merely
"coddle people's responses and possibly articulate them clearly,
but don't take them beyond that."[14] Press critiques of *Tigers
Don't Cry* offer one example of Ronge's accusation, while also
delineating the more causative criticism of the Afrikaans re-
viewer. The *Sunday Times* critic, invoking the imagery of a
current toothpaste commercial, wrote: "It needs more than mouth-
wash in the stripes to kill the taste of this political snatchpenny

opera. Scot Finch's screenplay is a cliché, hinged on terminal disease, ransom and assassination attempts; tiresome too is the veneer of infantile racial dialectics."[15]

George Boshoff observed that:

The truth is naturally that there exist two versions of *Tigers Don't Cry*—the one (obviously the true Jacob) for foreign consumption; the other, weak jerky and innocuous (remember the white South African system must be protected at all costs) for white South African consumption.[16]

Until the early 1970s, Afrikaans films, whether knocked or praised, were not considered in any depth by the Afrikaans press. Robert Greig, then of *The Star,* commented in 1977, "An apology situation developed with the English-language newspapers who tended not to slam Afrikaans films because they didn't want to be accused of *boerehaat* (Boer-hater). This forced them to look to Afrikaans films as an example of a burgeoning industry rather than as disreputable rubbish being put out by conmen. Afrikaans producers were quite flattered, but this had no effect on the quality of their films."[17]

Although this view was acknowledged as a valid assessment by both Afrikaans producers and critics alike, William Pretorius of *Rapport* complained, "I think that the English critics were a bit lenient with Afrikaans films," but even then, the "only criticism which is appreciated is if you say: "It's an enjoyable film, please go and see it." Barry Ronge agrees: "The industry and filmmakers really only want good reviews, and they question whether the public go to the newspaper columns for instruction. The cries of *boerehaat* come from the industry itself when they feel they are not getting 'support.' "[18]

While most newspapers and a large number of popular magazines do review films, film criticism appears to be restricted to two or three critics who have few specialist outlets to informed readers. *Forum, Independent* (later *Trek*) and *SA Opinion* were active in the 1930s, 1940s and early 1950s. While some unconvincing attempts were made by the authors published in these journals to enunciate a contextual framework within which

to assess a South African cinema, it remained for *New Nation,* which appeared during the late 1960s and early 1970s to establish relevant critical frameworks which drew on a more rigorous theoretical base. *Speak,* a journal devoted to popular culture, followed for a short while in the late 1970s. *Critical Arts,* established in 1980, however, fired the initial salvo which was to extend the discussion of South African cinema into the international arena. While *Critical Arts* is concerned with a historical materialist enunciation of critical theory in Africa, *The SAFTTA Journal,* put out by the South African Film and Television Technicians Association, also since 1980, cautiously explored a critical approach. By 1983 this journal was in a position to discuss alternative ideas in a more popular discourse. It set out to stimulate debate among technicians and to examine the more progressive elements of production such as independent film-making and the role of film festivals in social change, and to assess the ideological imperatives of the established industry.

The willingness of filmmakers to engage in critical debate only emerged in the 1980s. Nevertheless, much remains behind closed doors. When subsidy systems and other issues concerning the industry are aired on television magazine programs like *Perspektief,* producers have been known to inform the SABC of their disapproval via their public relations agencies. The bland face of the industry is often maintained behind a veil of silence. Those who are prepared to involve themselves in discussion, whether for or against the *status quo,* do so at their own risk and are invariably regarded with suspicion by the industry, especially producers. Doors are closed and eventually the film-maker concerned has to modify his or her philosophy or face a debilitating commercial ostracism.

Most press critics stand outside the issues and approaches so far discussed. One consequence of this intellectual isolation is an inability to differentiate innovative treatments from ideological change. A case in point is the reaction to *April '80,* uniformly hailed as breaking new political ground.[19] The film belongs to the *boereplaas* genre first seen in *Debbie* (1965). During the first phase of this genre cycle of conflict/love between insiders and outsiders, the insiders lived "on the farm" in cultural purity. They are at peace with a natural and divine

order congruent with Afrikaner rural values. The outsider is
a wealthy urban Afrikaner who has spurned the *volk*. The plot
is infused with love triangles where the insider, usually the
boeredogter (daughter of the earth), although marked for
the *boereseun* (son of the soil), is inexorably drawn to the out-
sider or *uitlander*. The clash of cultures results in the *boeredogter*
being coopted by the *uitlander* with both ostracized by the in-
group. The consequent physical and psychological degradations
she suffers confer upon her the status of "maimed heroine."

The young *boeredogter* assumes a relative autonomy and
acts out her function of maimed heroine as an *index* of cultural
trauma. This treatment is a consequence of her prodigal ten-
dencies, which have traumatized Afrikanerdom as she foresakes
her rural heritage and moves to the city with its lure of freedom
and wealth. She survives, if not in body, then in spirit. Whether
blind, crippled or a leper, she will never return to "the farm."
To see the characters as individual manifestations, then, as the
press is wont to do, is critically limited. A more fruitful approach
is to examine them in terms of the social roles they play within
the wider society. The *boeredogter,* for example, shifts her role
in response to the need for urbanization which is determinant
upon the *Broederbond's* desire to capture the English-dominated
"foreign" capitalist system and transform it to the Afrikaner
national character. At the symbolic level, the *boeredogter* repre-
sents the trauma of the urban trek. She is alienated Afrikaner
capital that only unifies with national capital after enormous
travail.

April '80 updates the genre in a manner which bolsters the
policy of apartheid. Now, the *boeredogter* is born in the city.
She is no longer blonde and she speaks English. Her home life,
however, remains difficult, for the clash of cultures has yet to
be resolved. Her mother is Afrikaans, a civil rights lawyer who
now speaks English. Her father is a professor of English at an
inland university who "votes Prog but says thank God for the
Nats." The parents are divorced. The *boeredogter* lives with
her father.

The *boereseun,* whose father belonged to the militant
Ossewabrandwag (Ox-wagon Sentinel) which violently opposed
the South African alliance with the Allies during World War II,

falls in love with the *boeredogter*—a prerequisite of the new set of genre conventions. She, he and her brother are all students at the university. Her brother, Alex, is an activist who, in setting off some pamphlet bombs inadvertently kills two innocent by-standers (who just happen to be Progressive Federal Party voters). Against his will, the *boereseun* is persuaded by the security police to spy on Alex through Alex's sister. The *boereseun* falls in love with her and refuses to inform. His ties with the *volk*, however, prove too strong—even in the face of his ra-tionalization of his father's acts of terrorism while a member of the *Ossewabrandwag* during the Second World War. Both the *Ossewabrandwag* and student activists, he argues, were fighting for freedom, albeit from opposing ideological bases. Nevertheless, in a development non-continuous with the in-ternal continuity of the plot, the *boereseun,* after a visit home to the West coast with his girlfriend, decides to turn Alex in. Alex lures the *boereseun* into a deserted building in Vrededorp. In the meantime, Alex's father, who has disowned him, his sister, who will no longer protect him, and the police all arrive on the scene. Alex shoots the *boereseun* and is killed by the police in retaliation. Alex's sister, a witness to the event, runs not to her brother but to the *boereseun* and professes her love for him. The last shot is of the couple walking along the beach in long shot at sunset. The *boereseun* walks into the sea and throws his crutches into it. They live happily ever after.

April '80 offers only a trivialized reflection of English student politics of a previous decade. Alex has an unmanageable black beard and long hair. He is an irrational, nasty racist who continually vilifies Afrikaners. His political motivations stem from an unhappy childhood and his view of racism dates to the late 1960s when students considered apartheid to be no more than irrational racism. By 1980 student opinion had moved away from this simplistic view and saw apartheid as an ideology used to solidify the class structures which best served the needs of the economy. The clash was less one between the races than one between capital and labor.

The continuity lapse mentioned earlier is not only a func-tion of the *boereseun's* ties to the *volk,* but also of the genre which calls for a socially reassuring movie, not one that classes

the terrorist acts of the *Ossewabrandwag* and student activism
in the same category. In present-day South Africa the myth of
the *Ossewabrandwag* is part of the prevailing moral order as
far as Afrikaners are concerned, whereas student activism is not.
The director accedes to this moral pressure. Where the
Ossewabrandwag "terrorist" is now seen as politically legitimated,
the student "terrorist" is seen as a criminal who is morally
degenerate. He dies as do the two PFP supporters, killed by their
own kind. The implication is that the PFP opposition also stands
for moral and social disorder. Unlike earlier examples of the
genre, criticism is not leveled at the self-righteous *volk,* and the
boeredogter is not denigrated in any way. Following her liberated
role in the war movie, she has become a heroine: she is marked
for and marries the *boereseun.* Thus, *April '80* far from being
a "bold step" is a retrogression. Where earlier Afrikaans cinema
criticized aspects of an ideology unresponsive to changes in the
material base of South African society, *April '80* reassures the
viewer that the consequences of that ideology (i.e. terrorism)
can be reduced to elements such as personality foibles and the
immaturity of dissidents. The oppositions in the film bear this
out: individual moral disorder versus institutional order and
terrorist as morally degenerate versus security police as morally
upright. The fact that *April '80* deals with "serious issues" does
not set it apart from its predecessors, particularly as the treat-
ment favors the existing class structure in South Africa. The only
non-white character, the coloured printer of the subversive
pamphlets, rejects Alex's liberalism and takes bitter reassurance
in white hegemony:

> What sort of justice do you expect in this country
> when the radicals take over? What sort of democracy?
> Have you forgotten how they kicked the coolies out of
> Africa, how they treated the whites, the genocide against
> other tribes?

The erroneous conclusions of the press reviewers were a
consequence of their superficial approaches, their total lack of
understanding of contemporary student politics and, more funda-
mentally, an ideologically clouded liberal view of the structural

determinants of apartheid itself. These problems are further compounded by the way information is reported in newspapers and the class determinations of the journalist-critics themselves. The film was conceived of as "dramatic," being the first local treatment to deal with urban terrorism, an area subject to extreme state censorship. It was deemed "newsworthy" and singled out for rave reviews.

If we accept that the various characters stand for social roles within the wider society, then analysis of their significance must go beyond the surface text and story-line. *April '80* consummates the urban trek. The deeper significance of *April '80* tells us that the inter-penetration of English by Afrikaner-dominated capital has largely been accomplished. Implied, too, is that the "foreign" capitalist system has been adapted to a *Volkskapitalisme* (peoples' capitalism) reflecting the Afrikaner heritage and lifestyle. Outsiders such as the student activist who challenge the system will die, black South Africans will accept what's deemed good for them, and even PFP supporters will be unable to escape the consequences of terrorism. That the ideological content of *April '80* was reassuring in terms of the then prevailing social order was because Scholtz was able to introduce *apparent* contentious political issues and manipulate them in such a way as to convince liberals of their veracity on the one hand, while not questioning Afrikaner nationalism on the other. The state of Eden has been replaced by a state of materialism, militarism and the Security Police.

CHAPTER SIX

FILM CRITICS

"Consumer guidance is the basis of my job as a film critic."

ROBERT GREIG, *critic, 1977*

Non-esthetic criticism is employed by a number of South African film critics, notably Raeford Daniel, Johan Liebenberg, Ian Gray, Victor Holloway and Robert Greig. Of these Greig is the most controversial. His experience ranges through dramatic art, stage directing, poetry and criticism. His concern is with an industrial product, rather than with art. He cites Ross Devenish as a director who has confused art with entertainment. That Devenish wants films to be more than just trivia is admirable, but, warns Greig, there are pitfalls: "If he continues to make films here, he must adapt to a more popular entertainment. The art that happens usually happens as a byproduct of an industrial process, not an intention. I think that this is film's strength—that it has kept in touch with a mass audience. I am suspicious of coterie filmmaking and coterie film discussion—then you reach the stage that ballet has reached—an in-group situation, it's got too sophisticated a code—and the art dies." Greig, however, defines (and perhaps limits) his criticism by arguing that "ultimately criticism is description."

Underlying questions which permeate his often formalistic criticism are: what do the characters stand for? How does the film fit into the South African milieu? Of *Springbok* (1976),

Greig writes, "The film is courageous compared with the usual local product. The plot—a coloured rugby player trying for the Springbok team—is calculatedly explosive; what is more sacrosanct, more symbolic of the *laager* than the scrum?"[1] Greig's comments on the characters seen in *'n Sondag in September (A Sunday in September*, 1976) locate their local social milieu: "The story and the script are predictable: sentimental, attenuated boy wants girl—boy loses girl stuff, though his (Jan Scholtz) direction is firm and clear. But as usual, one is reminded of how well Scholtz knows his people, how they live and, often, how pig-headedly they behave."[2] More cynically, Greig describes *Billy Boy* (1978) for what it is not: "A South African-made film with murder, rape, attempted patricide, suicide and an atmosphere of blood-letting seems destined to get the undeserved reputation of being realistic. Realistic it isn't, except in minor respects . . ."[3]

Generally, comments Greig, most Afrikaans films have a key-plot: the in-group versus the outsider. He typifies the characteristic plot as follows:

Jan is a rugged-face son of a Western Cape wine farmer. Shots of the farm, with its white gables, agreeable family retainers, Dad looking like carved yellow-wood. Mum isn't around. Her photo is on the wall, where it exerts a baleful influence, chastening the behaviour of the servants and the son.

She died sometime in the past—it is never precisely explained how—and Pa never remarried, the vines and the cattle being good enough for him.

However, Granny is on the scene. She is the real mother figure: she trekked with Retief and single-handedly routed Chaka, Dingaan and anyone else you care to mention, including Milner, Rhodes, Kitchener, Smuts and De Villiers Graaf. She supervises the servants, sternly but fairly: they are the children who "like" to know where they stand.

Back to the son. He is engaged to marry the daughter of a neighboring farmer. She is blue-eyed, blonde, with a slim, feminine body, meaning flat-chested.

When the pressures of the flesh get too much for him, he drives his tractor round frenziedly or bashes one of the servants. Sex is not an issue with her, nor emotion with him.

Then the idyl is shattered. A Jo'burg girl, black-or red-haired, in a sports car, loses her way and arrives at the farm. She lures the son away. The blonde fiancee suffers in silence, but she's never angry, just sorry and alone at night...

The son leaves home. He ends up in Hillbrow, which is Hell in the demonology of the SA film. But eventually, he comes back. Granny dies of shock.

What happens to the redhead? She dies, when her car goes out of control.

The polarities are farm/Hillbrow; blonde/red-head; town-living/country-living, the old ways and the new ways.[4]

This raises the question of whether the group is going to open or close. Greig provides the answer, "It's curious to see how the European mythic structure continues with the red-headed, green-nailed villain(ness) who always comes from the city, while the blonde unspoiled heroine is a son (sic) of the earth."

Consider as well this review of *Dit Was Aand en Dit was Môre* (*It Was Evening and It Was Morning,* 1977):

The hero is a son of the soil. The heroine is a daughter of the soil who went wrong. She has a secret sorrow which causes her to frown but, in the end, finds love and settles down to be the best *boerevrou* [farmer's wife] in the district. The villain is, of course, a city girl with red hair, a silly laugh and sex appeal (heroines may smile limpidly, have red hair and maybe kiss). The figure of tradition, usually the endearing matriarch, guides the fortunes of the people, displaying more mental elasticity than her progeny.[5]

This recurring thematic element so ably captured by director

Franz Marx has its roots in history. The ideal *Volks*-film should push the idea of an agricultural socialism, of an uncontaminated and pure Afrikaner society.[6] The evil image of the city was strengthened after the Afrikaners' defeat by the British in 1902 when they were turned into second-class citizens in the land of their birth. In the cities they became poor whites competing with more highly skilled blacks for jobs. Their sojourn in the cities was calculated merely to help them earn enough money to return to their now fast receding Eden in the countryside. The image of a solid *Boere*-character was endemic to this intention. The cinematic result was, according to critic William Pretorius, "a concise little formula." The resolution of the formula is clear—the group must remain closed.

Some Afrikaans directors, however, notably Elmo de Witt, have made films which conflict with the stereotypical "farm" image of the Afrikaner. Greig has observed that "criticism is posed in the sense of a juxtaposition of old and new, but De Witt seems to have loyalties to both." Greig explains his point by quoting P. G. du Plessis's play (later turned into a film) *'n Seder Val in Waterkloof (A Cedar Falls in Waterkloof,* 1978) where he presents the new Afrikaner speaking English; the old Afrikaner comes from the *plaas* (farm) with chickens in the back of his car and fur on the dashboard—the old Afrikaner is an embarrassment—and yet ultimately it is the new Afrikaner who is criticized for allowing the old Afrikaner to be an embarrassment. "But," Greig points out, "the criticism is in terms of pastoral which implies that nothing beyond that is important and that that conflict is not related to larger conflicts—it's related to codes of behaviour within the Afrikaner nation." This criticism is also borne out in the film version which substituted for the *boerefamilie* (farm-family) a bunch of Krugersdorp *jollers* (good-for-nothing revelers) who impose themselves on their prim and proper sanctimonious kin.

It is the conflict between the old and the new that is the subject of *Ter Wille van Christene (For the Sake of Christine,* 1975). Elmo de Witt has allowed a *Volks*-alienation to creep into his films and "in the context of a conservative *dorp* (country town)," writes Greig, "this material is as explosive as it would be in Northern Ireland." The film is an allegory. "Although most

of the film's drama is among church elders, if for 'church' one reads 'state' and for *dorp* one reads South Africa, then *Ter Wille* . . . gains its full resonance":

> The story and characters are simple, even over-simple, though the issues are not. *Ter Wille van Christene* is Romeo and Juliet in the *dorp* Swartruggens, where Romeo is a dominee and Juliet a Roman Catholic nurse.
>
> The choices being presented by Dominee (pastor) Paul's love for Christene are radical . . . They are between following the letter and following the spirit of Christ's teachings; between adapting to change and ossifying; between serving abstractions whether political or religious and accommodating human beings with unique feelings.
>
> Sybel Coetzee's Christene begins pert, witty and frivolous and deepens like Juliet, into a woman who must face the centuries-old split between Calvinism and Roman Catholicism.[7]

An examination of some of De Witt's earlier films will show that this theme and keyplot were already apparent, and initially given form in *Debbie* (1965). *Debbie* systematically exposes the consequences of the urban-rural value clash, the social dangers of pre-marital sex and the problems confronting the unmarried mother. Debbie's rural parents disown her, while the urban parents of the city-reared boyfriend even explore the possibility of aborting Debbie's unborn baby to prevent their son from having to marry her. The film reveals the unhappiness, the guilt, the deprivation and the self-imposed withdrawal forced on the characters. Perhaps aware of his digression from established Afrikaner norms, De Witt muffled the ending in an open-ended ambiguity.

The genre which was exploited by other filmmakers—Jan Scholtz's *Die Winter van 14 Julie* (*The Winter of 14 July*, 1977), for example, recycles the insider-outsider plot within the context of the city. Peter Feldman, whose mode of plot description is similar to Greig's, dismisses it as follows:

> A man doing national service meets a girl. They
> fall in love, they sleep together, she falls pregnant.
> He is an orphan and not suitable. Problems.[8]

Important to Greig's approach is an investigation of mythical
structure and character stereotypes. He wants to know where the
elements and the people are that make up the landscape. What
are the mythical structures within which they behave? The tradi-
tional unspoilt mythical structure of the rural Afrikaner remains
paramount in *Dit Was Aand en dit was Môre*. He notes there is
"no sex, no violence, no cities. The attitudes belong to that never-
never land before gold was discovered, uitlanders (outsiders)
intruded and agitators invented the race problem."

White South African sexual morality is reflected in *Glenda*
(1976) where the viewers learn, according to Greig, that "No
nude is good nude." This film deals with one of South Africa's
more colorful strippers who thumbs her nose at Calvinist morality
by employing a large, ugly python in her act, and who found
it necessary to live in self-imposed exile to pursue her profes-
sion. The film (i.e., the local version), however, reaffirms tradi-
tional conservative values and social mores. Greig offers his
interpretation:

> If, for example, you think naked bodies are sinful,
> you will leave this film confident in your views. Evil is
> punished: Glenda flirts with the Devil and the Devil
> gets her.[9]

One of the problems which filmmakers constantly run
into is the portrayal of the Afrikaner outside of the predigested
mythical confines and traditional codes of behavior. Ross
Devenish talks of a "refugee culture" where innovation in art
does not occur in the absence of indigenous cultural investiga-
tion. This is what Rautenbach, Devenish, and Bensusan have
done, and states Greig, "That's uncomfortable—then you have
to ask awkward questions. Why are blacks only in the back-
ground?" These questions are avoided because they tend to
break down the myths of Afrikaner culture. These same myths
are projected into the environment. Greig notes, "Whenever

you see a black in a film, he is funny, he is somebody below the Afrikaner, he is the comic character, he has got all the virtues of the Afrikaner, he is solid, trustworthy, faithful, respectful to authority—he is almost the negative image of the Afrikaner."

A black-white love-hate relationship is noted in Greig's review of *Terrorist* (1976): "There is a rigged, brief exchange of prejudices between a young American and a Kenyan refugee who talks endearingly about 'black bastards,' which is perhaps true to type."[10] And again on *Grenbasis 13* (*Borderbase 13*, 1979): "[This] is basically a rah-rah act about the boys on the border—the South African boys that is . . . the black enemy soldiers are offensively jeered at . . ."[11] Finally, on *Game For Vultures* (1979): "How better to insult blacks than to say that they are communist dupes? That may get audiences in southern Africa and earn good reviews from the Klan and the National Front elsewhere. It doesn't improve the film."[12]

Greig believes that until about 1972, the majority of Afrikaans critics were simply middlemen between the *volk en die mense daar buite* (nation and the people outside). "Is this what the *volk* should be advised to see?" was the rhetorical question. But things have changed. "Now (1978) I think that they are standing apart and saying: 'Does this film stand up on its own terms?'" Greig attributes this change to better university courses and the high standard attained in *Die Burger* and *Rapport's* arts pages.

On a structural level Greig accuses South African directors of "poor plotting." Links are suggested but not developed. "Characters are introduced as though they are leading to action and endings are contrived or easily wrapped up to fit into the 90 minutes running time." The majority of South African filmmakers are guilty of the latter indiscretion. Referring to *Decision to Die* (1978), Greig writes:

> . . . sentimental explanations are invented at the last moment to ease the task of the scriptwriter in finding an ending. It also means one of those trendy "open" endings posing as profundity. What they actually mean is that the writer suffers from indecision or boredom.[13]

Robert Greig is also concerned with a film's sense of place. He compares the use of film locations to the environments described by early South African poets, notably Thomas Pringle. "These early poets wrote about nature in terms of English pastoral. Where there was a *soutpan* (salt pan) they wrote of a leafy lake. There is a fascination with what's going on but these poets conceive of it in English terms." This occurs in filmmaking as well, both in English and Afrikaans films. Says Greig, "We live somewhere else geographically and in time." But the wheels do seem to be grinding in the direction of a sense of place. The official image of farms and blue gables is being superseded by Johannesburg's skyscrapers, but observes Greig, "You don't get the nitty-gritty, the dust, the sweat or the drabness of it. It's all so picturesque."

That South African films often lack an indigenous identity is partly due, avers Greig, to the inadequacies of most South African critics who make no demands on South African films. "Some don't have suitable backgrounds, others are conceptually rooted elsewhere, and none, apart from John van Zyl, work within a framework which fits South African films." Critics like Barry Ronge he considers "positively dangerous" as they make prior judgements of films. Consequently, these critics don't look seriously at South African films. When they do review them, they look at them through European or American spectacles. "De Witt and Venter cannot be compared to Altman or Truffaut," charges Greig, because conditions are totally different. Barry Ronge in return will retort that Greig's approach is a "trifle condescending, limiting and easy." Ronge's basis for pre-selection is predicated upon directors who project an "integrity" in their films, as with Rautenbach and Devenish. He charges that the Afrikaans key plot which Greig has identified is, in fact, a universal plot that has surfaced in South Africa with a new dialect attached to it.

South Africa's only *auteurist* film critic, Barry Ronge sees his task as "critical refinement" and concedes that his choice of films and style of presentation is "elitist." Ronge has applied an *auteur* analysis to four of Jans Rautenbach's films: *Wild Season* (1967), *Die Kandidaat* (1968), *Katrina* (1969) and *Jannie Totsiens* (1970). He distinguishes a *sestiger* (of the

1960s) cinematic flair which emerged despite the negative effects of censorial edicts and financial constraints. Just as Hollywood directors lacked the freedom that Truffaut and Godard relished, so Rautenbach, like his American counterparts, was forced to express his personality through the visual treatment of material. Rautenbach's first film script, *Wild Season,* says Ronge, "establishes Rautenbach as an accomplished cinematic stylist." Amplifying the *how* of Rautenbach's direction:

> His material is pretty intractable for the plot is basically a melodramatic soap opera, but is redeemed largely by two elements which are to figure very largely in his subsequent work. The first of these is a tendency to visual stylization, the creation of forms and movements which reinforce with images, the emotional complex he has reached in the plot. One recalls the scene in which the two lovers meet for the first time. The entire sequence is filmed reflected in water, and the way in which the images in the water merge and intertwine, presages the depth and closeness of the love these two will share in a delicately symbolic fashion.[14]

The film departed from the pre-established well planned stereotype of the spiritual and personal characteristics of the Afrikaner identity which had been mythified in decades of poetry, literature and film. *Wild Season* portrayed the Afrikaner as something more than a one-dimensional construct:

> The second element to which I refer is far more complex and intangible, for it is a recognition of the Afrikaner as an individual and not merely an idealized cardboard figure. The portraits are sketched affectionately, with a knowing humor, and they are neither condescending nor cosily sentimental. The dour solid forcefulness so often associated with the Afrikaner is shown to be as much perverse pigheadedness as it is admirable determination. The point is that the Afrikaner is being portrayed, almost for the first time, as an individual human being, rather than as the cloutish victim

of heavy handed satire or the long suffering, noble hero of some *volk*-epic.[15]

Rautenbach's next film, *Die Kandidaat* (*The Candidate*) continued in the mold of *Wild Season* and concentrated on the nature of Afrikanerdom. The storm of controversy generated by *Wild Season* unleashed its unbridled fury on *Die Kandidaat*. Rautenbach had once again exceeded the bounds of cultural acceptability and had challenged Afrikanerdom's mythical purity. *Die Kandidaat* begins with a prayer during which members of an Afrikaner cultural foundation fidget, doodle and glance around while the voice-over, which is superimposed on the prayer, introduces them. The Publications Control Board complained that this scene mixed the sacred and the profane. The prayer was therefore cut and the characters introduced later. The second excision removed a scene of a raging argument in which the question of whether coloureds were or could be Afrikaners was raised. The censors felt that *as they might one day become Afrikaners* the scene could give offense and must be dropped. The third and fourth cuts removed anti-English comment by *verkrampte* (reactionary) members of the foundation's board, snide asides on immigrants, and a derogatory reference to reform school boys. Ronge continues his analysis of the thematic interplay between Rautenbach's films:

> Once more the plot tends towards melodrama, but this is balanced, to a large extent, by the sharp intellectual quality of the direction and the icy precision with which the characters are delineated. Entertaining as this skilled development of the plot may be, the showpieces of the film are the long brilliant monologues, spoken mostly by Kobus Roussouw. It is in these that the hypocrisy, the deceit and the prejudices of the wealthy Afrikaner "upper crust" is evaluated. The criticism levelled is never destructive, despite its harshness. It is lucid and sane, and the saving grace of the film is that these criticisms are not made from any ideological standpoint, but from a human point of view.[16]

Far more penetrating than *Wild Season,* this film tears apart the carefully nurtured *volk*-stereotype and shows powerful and ambitious people beset with human weakness and failings. Consider the government official who is trying to explain separate development to the English-speaking fiancee of the candidate for election to the foundation by simply mouthing party-line cliches: "It is the official policy of the government of this country that the Bantu people will have their own homeland where they will develop their own way of life, their own culture and ... er ... their own way of life." In another scene a professional *volksmoeder* challenges a *sestiger,* "you *sestigers,* you write all these things ... these things about sex ... you can tell me nothing about life. We do a lot of foreign traveling." Or again, where the candidate is asked about his politics: "I belong to the National Party," he replies. "Well then, his politics are right," responds a member of the board. Ronge enlarges on the significance of these human portraits:

> It is precisely this pervading sense of humanity, the compassion and the genuine feeling which he elicits for his characters that makes his work so engrossing. It is not a cerebral examination of a clash of ideologies, but a consideration of the effect of those ideologies on the people who create and are caught up in them. His concern with ideology is, therefore, not a political one. He is concerned with it only when it impinges on the life of his characters.[17]

The conflict between personal emotion and a sense of patriotic duty in both a social and a political sense leads Ronge directly to a discussion of Rautenbach's next film, *Katrina.* Again, Rautenbach breaks down traditional conventions and relentlessly moves into new territory:

> This is easily the most popular film he has made, and it also happens to be the most controversial, for it moves into hitherto sacroscant territory of South African racial policy. This in itself is a startling innovation, and the skill with which he makes his very valid criticism

enlivens the proceedings considerably. Typically, how-
ever, it is not politics which figure most prominently,
and it is his depiction of genuinely South African in-
dividuals—in this case a group of Cape Coloureds and
a beautifully etched portrait of a simple middle-class
Afrikaans family—that lends the film its vitality. Once
again the story is told from a purely human point of
view, and the sincerity and candor with which the
characters are portrayed constitute the main strength
of the film . . . As ever, Rautenbach's tremendous cine-
matic sense is in evidence, nowhere more effectively
than in the climactic moment of revelation when
Katrina, who has been living as a white, and her
Coloured husband, Kimberley, whom she has deserted,
mime their anguish under the lurid psychedelic lighting
of a coffee-bar while the Staccato's wail their way
through their song, "Cry to Me."[18]

Again, the film, its implied social criticism nothwithstanding,
is an affirmation of cultural incompatibility and the common
sense of apartheid. The anguish caused the characters is much
harsher under these political restrictions than a normal love
affair can ever be. The officially sanctioned ending checkmates
any sense that love across the color line can ever result in a
workable relationship.

In charting the latent thematic structures and identifying
a common internal set of themes and motifs in Rautenbach's
films, Ronge has brought to the viewer's attention the sig-
nificance of "interior meaning" and the personality of the di-
rector. The table of values that Rautenbach established in his
first three films provides the clue to an interpretation of his
next more complicated film, *Jannie Totsiens* (*Goodbye Johnny*)
which on the surface represents a radical departure from his
established style. Ronge explains some aspects of the *how*:

The story is archetypal in its simplicity. A stranger
enters the small claustrophobic world inhabited by the
inmates of the [mental] institution. He is catatonic,
and his silence and total withdrawal isolate him even

from his fellow patients. They fear him, and when he starts to respond to treatment and tries to establish closer relationships with them, he meets with little success. Then one of the patients dies, and they seize on the outsider as a scapegoat and wreak a terrible revenge on him.

The meaning of the film extends far below the grotesquerie of the plot, however, for we are offered a brief sad glimpse of love among the loveless, of the terrible loneliness that tortures these minds, already so pitifully racked. There is great depth and poignancy here, particularly in the scenes of the crippled boy who waits in hopeful anticipation of a visit that never comes. There is also a condemnation of the people who do not understand the plight of the mentally ill and judge, cruelly, by their own "sane" standards.[19]

Ronge goes on to comment that *Jannie Totsiens* can be seen on two other levels, as "symbolic of present-day South Africa, or as an allegory of a far wider implication." It is on these levels that Rautenbach's patterns of consistency can be identified. In *Jannie Totsiens* the *how* functions as window dressing to shelter the *what*. The implications of this conclusion will be dealt with later, but had Ronge restricted his criticism of *Jannie Totsiens* within the *auteur* mode of analysis he would have failed to acknowledge the more relevant method of analysis.

Ronge's critique of Ross Devenish's *The Guest* is shaped by Eugene Marais's belief that "the existence of life is founded on pain and sorrow":

And this pain is the subject of *The Guest,* a graceful, austere and controlled film which handles its themes with almost musical skill, for it is passed on and explored in almost fuguelike pattern, from person to person, from voice to voice, until Marais's point seems irrefutable.[20]

In this film Ronge pays tremendous attention to technique

and analyzes what happens as well as how it is shaped, how it
appears and what it means:

> The film ends with a kind of calculated abruptness,
> for a cycle has been completed. The opening shot is
> of a car, bearing two men to a farm. The closing shots
> are of the same car, bearing the same two men back
> along the same road. They are going away, their prob-
> lems unsolved, their sad fate unaltered. These beauti-
> fully judged shots do more than lend a formal grace
> to the film, they affirm that the events at Steen-
> kampskraal have indeed been only an episode, that the
> sense of security was only illusory. The sad irony of
> the final title, telling of Marais's eventual suicide has
> been well prepared for.[21]

Ronge adds that this "formal and controlled element" is
"reinforced by a subtle use of Bach on the soundtrtack." He
writes of a "device" for "showing Marais's return to health":

> [He] win[s] over the little daughter of the farm
> on which he is recuperating, by telling her fairy stories,
> and revealing to her the living mysteries of the slumber-
> ing veld. The idea is trite and over-used but Ross
> Devenish has skirted every pitfall and has managed to
> make this relationship work in visual terms.[22]

The significance of cameraman Rod Stewart's at times sub-
jective, hand-held camera allows the spectator to: ". . . see events
from the child's point of view, and sense in the frenetic ugly
movements just how violent and frightening this strange guest
really is."[23] The importance of photography and lighting is con-
tinually emphasized by Ronge:

> Soon after he [Marais] arrives we see them [the
> family] sitting down to a meal. Marais refuses to join
> them and we cut to a shot of linking hands while they
> say grace. The shot is low angled and intimately lit,
> and it suggests the simple unity of loyalty in these
> people.[24]

The Guest contains the indelible stamp of Ross Devenish and his unique understanding of South Africa and its inhabitants. The film embodies most of the elements of the illusive South African cinematic identity. The technical competence of the director coupled with the signature of his distinguishable personality allow Ronge to draw the following conclusions:

> The film is handsomely mounted with a sparse, accurate and evocative set, and a plainness in the photography which conveys the harshness of life in this barren dun-coloured landscape. Not only does this evoke Marais's emotional state, it gives background to the pain of all the other characters. There is a scene in which Tant Corrie tells Marais of her life in a concentration camp, of the family's return to the gutted farm, and of the bitterness and pain of their striving to life. The irony here is particularly graceful and telling for Tant Corrie's pain has strengthened her, it has unified and made strong her family, but Marais has lacked the strength to fight it and has taken refuge in his narcotic dreams. They confront each other, this hard resilient woman, and this brilliant suffering man, and we realize that she has survived what he could not endure, that his very sensitivity and brilliance has made pain into an obsession, and that it excludes him from a life in relationship with people...This is...the film's crux.[25]

Since *auteur* criticism places the signature of an individual—the director—above concern with the collective processes which bring the film to life, it is hostile to "message movies" or any form of materialist analysis. Ronge's study of *The Guest* concentrates on the literal aspects of the film without venturing into allegory where the characters represent the larger conflict occurring with Afrikanerdom as a whole. He does not see, for example, that Marais's pessimistic view of human existence is epitomized in his suicide.

SOCIOLOGICAL CRITICISM

"... one should be aware that the content (the plot
and its resolution, the characterization, the dia-
logue, the simplistic archetypes) and the style
(camera-movement, colour, textures, editing tech-
niques) and other factors like its length, the degree
of self-censorship and the choice of actors and
actresses are all inextricably bound with the social
system. One simply cannot look at a film *in vacuo*."

JOHN VAN ZYL, *lecturer, critic*[26]

In South Africa, the sociological approach is best exemplified
in the early work of John van Zyl. Graduating from an English
literature background he moved into drama, film and television
studies. His early writings concentrated on film while the in-
troduction of television in 1976 saw a shift to television criticism.
Sociological criticism is defined by Van Zyl as the study of signs
and meaning in the cinema and their relation to various forms
of reality. The images presented by film become a means for
analyzing social behavior, for people try to make sense of their
experiences by constructing "fictions" such as dreams, myths,
fairy tales or dramas.[27]

Van Zyl's criticism spans a spectrum of films. His analysis
of the relationship between the images reflected in *Debbie*
(1965) and the social responses of its audience illustrates his
approach.

Reaction to *Debbie* took the form of age restrictions, threats
of banning and restricted release, mostly at the whim of the
Publications Control Board. The recriminations were not unlike
those heard some years later by Mario Schiess in response to
his film *Onwettige Huwelik* (*Unlawful Wedding*, 1970). Jannie
Kruger, then chairman of the PCB, is reported to have said
to Schiess: "How dare you title a film *Unlawful Wedding* here
in South Africa. Here in South Africa there is no such a thing
as an unlawful wedding." After much controversy, *Debbie* was
eventually given unrestricted release. Van Zyl placed the issues
in context:

Consider the facts about *Debbie*. It is the first Afrikaans film with pretentions to direction (in both senses). It conveys an excellent impression of life at an Afrikaans university with *joul, kammies* and *kys* [carnival, roommates and steady girlfriends], and also a variety of out door experiences enjoyed by students.

Botanical excursions to St. Lucia, sport, sailing, motor racing—after all, these are the hitherto neglected staples of local life. And it is integral to the whole film, not tacked on as in *Tokoloshe*. Even the flat-life of Hillbrow is utilized. But to the horror of the Babus the film touches on a pertinent problem, pre-marital sex and the problems confronting the unmarried mother. And, although the ending is horribly muffed, the film clearly stresses the dangers inherent in this sort of situation.

Therefore it cannot be the intention of the film that has been found wanting, but merely the subject-matter. The sobering figures of the number of illegitimite births and abortions that take place in South Africa are the best reasons for the unrestricted release of this film. I would have thought so, even though the film by no means says the last word on premarital sex, unsympathetic drunken fathers, and doctors who are not permitted to perform abortions.[28]

Judging from the reflections offered in later movies, Afrikaans morality has undergone numerous liberating influences. Premarital sexual relationships are tacitly approved of in films like *Die Winter van 14 Julie* (1977), *Vyfde Seisoen/Fifth Season* (1978), *Elsa se Geheim* (1979) and *Grensbasis 13* (1979). Immature love affairs have blossomed between male teachers (or lecturers) and schoolgirls (or students) in *Môre Môre* (1973) and *Eensame Vlug* (1979). Divorces and family breakdown are portrayed in *Dit Was Aand en Dit Was Môre* (1977), *Iemand Soos Jy/Someone Like You* (1978), *Sonja* (1978), *Weerskant die Nag* (1979), *'n Seder Val in Waterkloof* (1978) and *Eensame Vlug*. Films like *Die Spaanse Vlieg* (*The Spanish Fly*, 1978) and *Mooimeisiefontein* (*Lovely Girl*

Fountains, 1977) offer vicarious sexual gratification while rape and asault are intrinsic to the plots of *Fifth Season, Billy Boy* and *Weerskant die Nag.* The latter highlights the hypocrisy of the attitude that rape is acceptable within the bounds of marriage. The pristine values of the *Volk* are questioned and reduced to caricature in *'n Seder Val in Waterkloof* where a high ranking Afrikaner academic is not unwillingly debauched by a scantily dressed masseuse.

The sexual issues which stalled *Onwettige Huwelik* and *Debbie* are no longer important. The maintenance of Afrikaner cohesion became the common theme in films that followed. Although threatened from both within and externally, and spanning a range of plots—urban-rural, student-anarchist, lower class-upper class, local-international, and defender-terrorist—the kind of order offered by a group, and the costs of accepting it, are not examined.

The only Afrikaans film which questions the group, its relations with and perceptions of other South African groups, and the effects of the group's repressive political system which is out of control is Jans Rautenbach's *Jannie Totsiens* (1970). Van Zyl's review charts a parallel between South Africa and Nazi Germany:

> In his book *From Caligari to Hitler* Siegfried Kracauer sketches the rise of German expressionism in the years after World War I. By examining such films as Murnau's *Last Laugh* and Mayer's *The Cabinet of Dr. Caligari,* Dr. Kracauer argues that there is a close connection between totalitarianism and expressionism in that artists find themselves forced into the intensely subjective world either to escape from, or to defend themselves from the reality of dictatorship.
>
> As Jans Rautenbach has chosen a heavily expressionistic style for *Jannie Totsiens,* and bound up the plot in a heavily allegorical narrative, one wonders whether Dr. Kracauer's thesis holds good for South Africa as well. There can be no doubt that Rautenbach is deeply concerned with the fate of Afrikanerdom and the plight of the intellectual. Yet he is no satirist. No

Swift, he is rather a "passionate burgher," as John Arden describes himself. That is why he earnestly and symbolically depicts the pitfalls that lie before the Afrikaner in an allegory that would have done justice to Bunyan.[29]

Van Zyl's intention here is to identify the tensions and currents of the Afrikaner milieu and to define these trends against similar occurrences elsewhere, notably Germany. The question posed: does this film delve beneath the surface plot set in a mental institution? Rautenbach himself comments: "The institution is larger than life . . . it was meant to be larger than life; it is meant to become a stage." Van Zyl's approach of treating film as a form of discourse, as a reflection of human preoccupations, is well suited to investigate this relationship. The concept of the world as a stage, *teatrum mundi*, of people as actors assuming and discarding different roles, and of the world of social reality being a play contrived by higher forces, is a useful tool to investigate the structure and social relations of a society as reflected through the media. Van Zyl invests this approach with the *dramatistic* model which does not merely use the metaphor or simile or the world being like a stage or standing for a stage, but instead, uses the metonymic device of stating that the world *is* a stage. Social reality then, as a system of social discourse, can be analyzed by seeing it as a *teatrum mundi* with the concomitant references to such terms as "act," "seem," "character," "performance," and "role." Regarding Hitler as the *villain* of Europe, speaking about the last *act* of Stalingrad, and the *performance* of the troops in the *theater* of war, can only come from a perception which sees the events as part of a larger, unified syncretic drama. That drama in *Jannie Totsiens* is South Africa. Van Zyl unravels the allegory:

The asylum with its dark (if not black) nooks and crannies, set in the magnificent landscape of the eastern Free State, is obviously South Africa, or more specifically the chequered history of South Africa, a chronology of the grand and the mean, the heroic and the shameful. The doctor in charge is the current leader, be it Vorster

or the legend of Verwoerd, who is impotent and inef-
fectual at the moment. In fact, the insane run the
asylum, while he tries to justify his existence. His situa-
tion is best shown in the sequence where he desperately
assures the caller on the telephone that the situation
is under control while the crippled artist calls for help.

The artist is Rautenbach, crippled by the Establish-
ment (Publications Board?) and only able to shout
encouragement at the intellectual, instead of annihilating
his political opponents.[30]

Rautenbach is posing a set of allegorical questions in
Jannie Totsiens. He does not provide answers, and has removed
the film from his audience to the point where only an intel-
lectual is able to decipher it. He does not overtly state the issue
by saying, "the problem lies with the HNP or Progs," but rather
alludes to it and is himself part of it. The boundary between
acting and being one's self blur as the two actions merge into
one. Reality and performance become indivisible. Consequently,
the audience becomes part of the performance. They identify
reflections of themselves in the film. These thoughts are projected
in the following passages:

> The establishment consists of the para-military
> Ossewa Brandwag [Ox-wagon Sentinel] figure who sees
> "gevare" [dangers] everywhere: *Kommuniste* [com-
> munists], hippies *en die swart gevaar* [and the black
> danger]. His relationship with the "Durban Indian"
> is very interesting, embodying the love-hate relation-
> ship between the Afrikaner and the Black man. The
> demented judge one takes to be a perversion of justice
> in such legal chicanery as the Immorality Act and
> the retention of capital punishment, while the witch
> must be a combination of the *volksmoeder* [mother of
> the Afrikaner nation] of *Die Kandidaat* and super-
> stitious belief in the destiny of the nation.[31]

The tortured characters of *Jannie Totsiens* form part of an
outcast malicious society, riddled by predestination. They are

controlled by unknown forces and their world is disjointed. The dislocation is communicated through photographic style. Whereas the camera work of Rautenbach's previous films had exhibited a high degree of stylization, *Jannie Totsiens* is full of nervous, swirling, vertiginous camera movements which create a deep sense of menace and dislocation between people and their environment and between each other.

The treatment of James, the "Durban Indian," for example, embodies a love-hate relationship. Rautenbach explains the significance: "My servant is somebody whom I love but the next door neighbor's is the Kaffir we must chase into the sea. My neighbor loves his servant and mine is the one who should be chased into the sea. In this country it's a basic as that."[32] Indeed, James is the only sane person in the asylum. He is a soulmate, always there, a part of their society. Comments Rautenbach, "He would be the one to save Jannie."[33] The other characters symbolize South African society, a comment on the political nightmare Jannie has to endure before he can come to terms with himself:

> Liz, the English nymphomaniac, seems to represent the seductiveness of English culture. After all, she is always carrying, although not playing, a violin. And Linda is the essence of Afrikaner idealism. The *volksdogter* [daughter of the nation] in essence, the Whiter-than-White *creme de la creme*. But, as the Simon and Garfunkel-like background music tells us, she wants her beautiful chestnut horse to ride to the moon.[34]

Jannie has to find a way out of the dilemma facing him. Van Zyl outlines the two equally futile alternatives which Jannie, the Afrikaner intellectual, must choose—to leave or stay with the group:

> Should he *verengels* (become English) or not? Should he pursue the unattainable ideals of the impossibly Nordic and Aryan girl? Ultimately Jannie rejects both, casts off his mother, and one assumes pur-

sues his lonely, yet committed way. What the way com-
prises Rautenbach does not tell us. Yet why should he?
One does not ask a demolition expert what he has
created![35]

The connections between art and life are unclear in Devenish
and Fugard's *Boesman and Lena* (1973). This is partly due to
the contradictions within the play itself and partly due to the
choice of actors. Nevertheless, comments van Zyl, in terms of
the South African milieu, the very existence of *Boesman and
Lena* is a miracle. The problem confronting this film is the
structural confusion between sociological study on the one hand,
and the intrusion of metaphysical issues on the other:

> Fugard tends to run together at least two forms of
> alienation in his play with the result that the one
> obscures the other. One is never sure whether the an-
> guish that afflicts his characters has a metaphysical
> origin (and therefore he is writing plays in the
> Brechtian mode) or whether the anguish is purely social
> (and he is writing in the style of Arnold Wesker).
> Are his characters alienated from themselves, from
> their God (of His *Locuns tenens*) or from the struc-
> tures and relationships within South African society?[36]

For the critic, the difficulty of this kind of film is the
question of its susceptibility to sociological analysis. The answer
depends on whether Boesman—a dispossessed squatter outside
Port Elizabeth—is what he is—drunken, unemployable, a down-
and-out—because of what whites have done to him and his
kind, or whether he would have acted the same way irrespective
of his social setting. Boesman's behavior can be interpreted,
states Van Zyl, at a sociological level "in terms of having had
to learn survival techniques (based on the analogy of the
lizard losing its tail), and then hating himself for having had
to do this." Assuming that this is so, Van Zyl asks, "does this
work theatrically? And since it is the film of the play that is
under discussion, does it work cinematically?"

Devenish himself commented that he kept the film wordy

because he wanted to make a statement which went beyond poverty: "which in fact said that poverty isn't the worst thing that apartheid does to a person; it's demeaning of people and sometimes even convinces them of their own inferiority. And I feel that that is much worse than somebody living in poverty. And so I felt that we actually had to give Boesman and Lena their tongues."[37] The effects in the film of this intention are outlined by Van Zyl:

> The greatest structural flaw lies in the fact that Fugard has chosen to make a comment about South African society in a dramatic form which demands characterization, plot, development—all the paraphernalia of the Aristotelian play. Brecht knew that one had to isolate the social and political concerns of the play and involve the spectators intellectually. This flaw in the play the cinema has seized upon and emphasized. One is forced to consider both Boesman and Lena in psychological terms which raises all sorts of irrelevant concerns and causes the hiatus between the personal and the social ... In cinema, when phrases like, "Talk to me" or "I'll go mad" are spoken in close-up, they have an internalizing effect, instead of a centrifugal effect reaching out to social and political forces. Boesman's actions often seem so idiosyncratic that one finds it difficult to take him seriously at any level.[38]

A similar narrative structure is to be found in *The Guest*. It is perhaps this problem which led the novelist John Coetzee to seek out allegorical issues in *The Guest*. The paradoxical structures found in Fugard's films beg a number of questions: is Eugene Marais the way he is because of what he has concluded from his studies? Is disaster, pain and suffering, both physical and mental, a precondition of human existence, or more specifically of the alienated intellectual Afrikaner's existence in South Africa? On this level *The Guest* can be considered an allegory. In such a context Oom Doors' house represents an isolated South Africa, and his family, the traditionally minded, rural Afrikans family. Dr. Andries Visser stands for the aloof,

distant, smooth, worldly urbanized Afrikaner, while Marais signifies the new generation of Afrikaner intellectuals who are torn between Afrikanerdom, symbolized by the invisible influence of the queen bee on the one hand, and a continually changing materialist urban society on the other. Or again, is Marais the way he is simply because his personal addiction to morphine epitomized his theories of animal behavior in general? If pain is central to existence, then escape from pain is one of the prime motivations of life. If this latter contention is correct, *The Guest* cannot be considered an allegory. Coetzee takes it even further: "It is a tragic fate to be a white man in Africa . . . ON THE OTHER HAND, Marais was a Genius. Both ways, the white man wins."[39]

The theme of the film lies then in the interaction between Marais and his environment. In other words, *The Guest* is an index of survival and the need to transcend the constraints of survival. Marais himself summarized the point of the film: "Show me a civilization, a race, a tribe of men who have not had their euphoric drug, not made habitual recourse to the use of poison to induce a feeling of happiness as a remedy for the pain of consciousness." Following this line of thought, the film is not concerned so much with social issues as it is with Marais himself and the elements which made up this man—poet, naturalist, writer, actor, lawyer. In terms of this approach, the critic can justifiably argue a non-sociological approach—Marais is Marais, and nothing else.

In *Boesman and Lena,* however, the critical distinction is not so clear. Boesman is Boesman but Lena is actress Yvonne Bryceland. In *The Guest* the image succeeds, in *Boesman and Lena* the image is cluttered through inappropriate performance. Van Zyl explains:

> Somehow, she [Yvonne Bryceland] is so obviously a sophisticated actress pretending to be a Coloured woman. Her walk, the way she pulls her mouth, her gestures, are simply not those of a Coloured woman *cinematically*. Once more, the fatal eye of the camera has picked up gestures and signs which are larger than life—theatrical. And Miss Bryceland is simply not con-

tained by the director, her acting reduced to those elements of microphysiognomy that speak loudest when almost imperceptible. Her technique of behaving like a child, when she should have been behaving elementally, also reduces her part in the film. At times she is so petulant and childish that her status is quite lost.[40]

Yet Devenish understands the strength of the image, and the contradictions of South African society: "One of the things which is awful, and seems to have happened to the outside world, is that in many ways the outside world has begun to accept South Africa's apartheid, in that they want to cast people in terms of passbooks and identity cards, they seem to be suggesting that we should inquire into a person's ethnic background before casting him or her. I firmly believe that if one is treating people as human beings, the genealogy of an actor is of no importance."[41] This argument makes sense at a political and sociological level and insists on an allegorical interpretation of Fugard's texts. The political nature of the film is further indicated in Devenish's observation that, "It was shown in the days before television, and was widely seen all around the country, playing for a week in places like the drive-in at Naboomspruit and other areas where, possibly for the first time, any political issue in relation to South Africa, and certainly something slightly dissident from the accepted canon of our society had ever been presented. To actually present Boesman and Lena as real human beings, instead of as comic figures, was something which Naboomspruit had never thought of before."[42]

Yet Devenish's claim that *Boesman and Lena* explores "something that is relevant to oneself as a person" and that *Marigolds in August* "tries to affirm human dignity at a stage in this country's history where it is very seldom done," serves to displace the political onto biographical-psychological causation. Devenish's comments thus serve to support Van Zyl's comments on the irresolvable clash between the metaphysical and the social.

Van Zyl praises the overtly political qualities in *Boesman and Lena* thus:

The best part of the film is the opening sequence
where the camera opens up the play, relating the char-
acters to the environment and imaging the social forces
that come into conflict. The images of *real* Coloureds
and *real* Africans reacting to the mindless, antediluvian
violence of the bulldozer levelling their shacks are
so much more effective than the later bickering between
Boesman and Lena.[43]

Other films which project a local integrity are *Jim Comes
to Jo'burg* (1949), *Magic Garden* (1961), *Raka* and *Dingaka*
(1964). John van Zyl comments on *Dingaka's* deeper socio-
logical significance:

> Ken Gampu in *Dingaka* has this significance and pro-
> jects an image of simplicity and nobility which illu-
> minates the theme of the film. This lies beyond his
> undoubted acting ability, and is linked somehow to the
> eternal simplicity of the tribal law of revenge: he who
> kills must be killed.
>
> Complications set in, after Gampu has traced the
> supposed killer of his little daughter to the city, when
> he discovers that the omnipotent witchdoctor is the mur-
> derer. It follows inexorably that the son of the gods
> must be killed and that Gampu will be destroyed in
> doing this.
>
> This is the stuff of the Nordic Sagas, and all credit
> is due to Jamie Uys and Ken Gampu for pulling it off.
> It hardly matters that an impression of an African Tribe
> was created which can be faulted by ethnologists.[44]

On the other hand films such as *Rhino* (1964), *Tokoloshe*
(1965), *Afrika* (1972) and *The Riverman* (1983) reflect an
American tourist stereotype of a savage life in Africa continually
threatened by wild animals, uncivilized black people and witch-
craft. In his critique of *Rhino*, van Zyl justifiably lumps "veld-
fires, elephants, lions, Zulus and crocodiles" into the same
category. In *Makulu* the black tribe is treated in the same way.
They are an anonymous mass who live somewhere down by the

river. They are led by the ubiquitous witchdoctor. There is never any communication between the whites and the black tribe. All is mediated through this traditionally accepted character who is portrayed as the only person intelligent enough to commune with whites. Even chiefs tremble at their presence. This misinterpretation of the role and function of the "witchdoctor" is especially found in *Tokoloshe,* an evil mythical gnome-like figure. The romanticized social relations and picture postcard impressions recur in this film. Van Zyl identifies the problem:

> In the first half we are given the usual quick whip around of all the tourist attractions—crocs, hippos and mountains—all having nothing to do with the film; such irrelevancies as a Zulu dance given to entertain the little Shangaan boy on his way to Johannesburg.
>
> It is all so unnecessary, playing fast and loose with geography and customs, even though the possible overseas audience would not be aware of it.[45]

Attempts to reflect the guerrilla terrorist war psychosis in southern Africa as in *Kaptein Caprivi* (1972), *Aanslag op Kariba* (1973), *Ses Soldate* (1975), *Mirage Eskader* (1975), *Terrorist* (1976), *Wild Geese* (1978), *Forty Days* (1979), *Grensbasis 13* (1979) and *Game for Vultures* (1979) are indicative of a society which confronts reality by simplistic reduction to binary opposities: good versus bad, war versus peace, black versus white, capitalism versus communism and Christianity versus Marxism. Specifically, this can be reduced to terrorist (black) = bad; soldier (white) = good; and loyal' black (especially those on the side of whites) = good + bad (a sort of reformed black). These films which legitimize a "defensive" aggression on the part of white South Africa are supported by the Rhodesian-financed *Whispering Death* (1978) and *Shamwari* (1982). Called "jeep operas" by some critics, these films have externalized previously hidden violent tendencies.

The general resemblance to American culture is in the fact that males occupy center-stage in South African films; women are either mothers or whores; and whores usually die.

What this points to, as well, is a certain sadistic element in South African culture.

White South Africans feel threatened by the war "on the border." Because it is a guerrilla war, its exact location is unknown:

> This means then, that "the farm" is no longer secluded and safe, no longer a shrine of group values. The farm, like the city, is a potential area of conflict: it, too, is a border.
>
> Yet the war has exacerbated racial thinking: it is perceived as struggle between Black and White, however tactfully it is couched in terms of communism versus capitalism, or bad versus good.
>
> The effect, in Afrikaans films, has been to alter the insider-outsider axis. The outsider now becomes a dark, inscrutable and inhuman enemy: to portray the outsider would entail humanising him and this would imply at least a partial denial of the category of enemy.
>
> ... a large proportion of war films is the portrayal of relations between characters on the inside ...
>
> This is one of the chief differences between the Eden and the war film. The focus of the former was the relationship between insider and outsider; the focus of the latter is on relations between insiders, in the context of a war against the outside.[46]

Little film criticism has evolved in South Africa from a strategic perspective. Where Greig tested the limits of newspaper criticism, Ronge finetuned *auteur* criticism within a local context. Only John van Zyl challenged and prodded, but then only within the combative style of a politically oriented journal aimed at an artistically and politically critical readership. Criticism was for these writers an *intellectual* activity not directly connected with the stimulation of alternative or oppositional film-making or popular movements.

A radical and organizationally based style of film criticism emerged only in the early 1980s. Filmmakers teaching in film and media departments merged theory with practice to develop

a praxis for film as a tool in the struggle for democracy. These practitioner/theorists aimed at feeding a theoretically (both political and media) informed criticism back into their own production methods. Because these filmmakers resisted the alienation of their labor, they were also able to influence the responses of their subject-audiences by making them active rather than passive viewers. This kind of criticism identified itself as part of the class struggle and tended to be hostile to production and criticism which does not operate out of a social base.

MARKETING A PRODUCT

"Word-of-mouth is probably the most powerful in-
fluence on the public's decision whether to see
particular films."

JAMES EMSHOFF, *researcher, 1979*[1]

Films are not uniform products like cans of peas. Neither
are they sold at pre-determined prices in terms of length. Once
the specific attributes—stars, wide-scope, quadrophonic sound—
of particular films become commercially important, the idea of
film as a product like any other disintegrates. The value of a
film cannot be assessed in advance. With expected return on
investment unpredictable, two procedures lie open to producers:
First, the industry has induced the social habit of "going to the
cinema." This habit reduces the need for choice or the practice
of examining the product before purchase. Audience expectation
is conditioned and satisfied through the development of genres
and the star system. Located within this process is the newspaper
critic who "functions more or less as a glorified copywriter."[2]
It is through this journalist that the audience is able to "in-
spect" the product before seeing it on screen. It is not surprising,
then, that the industry often regards critics as unpredictable ex-
tensions of their publicity machine.

The second procedure concerns the relationship of produc-
tion costs to laboratory costs. The manufacture of copies is much
cheaper than the cost of production. Export of copies does not

139

deprive the home market and international markets can be developed at relatively little extra cost. By saturating the international market with successful films, the industry is able to pay for its failures.[3] Creation of such a market, however, depends on capturing cinema screens. Success in setting esthetic taste and the capacity to fill screens has made the American industry the world's top income earner. A corollary to this phenomenon is that press critics respond to commercial films within the framework created by the American industry.

South African publicity for a film has two stages: the production publicity and the distribution publicity. Production publicity is engendered by members of the film unit who act as still photographers and press officers. These technicians are subject to the control of the publicist who is directly responsible to the producer. Publicist Melanie Millin describes her function as one that "creates and generates an awareness of film."[4] The publicist plays a very important role in the South African industry because producers are only rarely able to tie up distribution contracts prior to the production of the film. This lack is to some extent responsible for the overproduction which characterized the South African industry in the 1960s and 1970s. Since the decline of the studio system in America and the Schlesinger studio in South Africa, films have increasingly been made on a one-off basis. Since the profits of one film can no longer be used to cover losses of others, production became financially risky, and profits uncertain. The existence of these risks, however, did little to stabilize production in South Africa, mainly because of the stimulant of the subsidy. In numerous countries distributors are in a position to influence film production by providing loans to production companies and by guaranteeing to market films.[5] Other than Jamie Uys, only the Satbel production arm has the assurance of a viable distribution through its sister distribution company, Ster-Kinekor.

The problem facing the publicity team is the decision of what the image of the film should be. Certain elements of the production are selected out as sales points around which to build a publicity campaign. The most common component is that of the "star." South African producers, supported by some theorists, continually lament the lack of South African "stars."[6]

Pieter Fourie, for example, feels that the development of local stars might give South African cinema an indigenous identity, while producers are only interested in stars as something "to hang your film on," that is, as marketable units. The production manager for Brigadiers, David Lawton, stated that South Africa does not have film stars in the American sense that they mainly work on movies: "They have to work on TV, that's their bread and butter, so you use the TV stars for your movies to attract the people."[7] The concept of the "star" is particularly marketable through the press. News often takes on a personified character and stars become news because of the media's predilection for reducing complex social processes to an attention-getting statement made by a Known, someone in a position of power and in whom the press has vested credibility and status. What stars do is probably more important than how they act. Screeds of publicity copy are continually fed to the press by the industry— studios, producers, agents—in an effort to build up a larger than life image of an actor. If successful, audiences will identify with the "success" of these individuals, their wealth and fabulous lifestyles. The *Tonight* section of *The Star,* for example, offers in-depth articles on various actors and directors. The daily press is supported by bi-monthly magazines such as *Fairlady* and *Femina,* weeklies like *Scope,* and the specialist-pulp gossip-mongering publications put out in Hollywood itself.

Another component exploited by publicists is the prestige and past successes of the director. John Ellis suggested that the "notion of individual genius is rapidly becoming a standard marketing device in cinema."[8] This personification of an industrial process guarantees a high degree of familiarity in the case of Jamie Uys. It also ensures a novelty within limits. Jamie Uys's films are difference-within-similarity. They are nearly always extremely funny, and very often repeat in a more sophisticated manner the humorous devices of his previous films.

A third means of eliciting sales points from a production is the identification of "artists" creating a work of art. An increasing status is being accorded to a person who acts, produces, directs, writes or photographs a feature film. This status emerged particularly after the introduction of television to South Africa in 1976. Television is more industrialized and less dependent on

named labor, though some television directors have attained a status normally reserved for cinema practitioners. This is because these individuals have produced more innovative films for television than most film directors have for cinema. Exceptions are Ross Devenish and Athol Fugard. Fugard, internationally known for his theater, writes and acts in his own films. Devenish's fame is consequent upon working with Fugard, together with his undoubted ability and an image of a lone artist in the murky sea that is South Africa, trying desperately to make relevant statements.

Whatever elements are extracted from the production, this information is communicated via media ranging from chewing gum wrappers to radio, press, television and cinema itself. Critics, newspaper reporters, magazine editors and television producers are invited on the set to view proceedings. They are supplied with lunches, press releases and photographs. Pre-release publicity on *Kootjie Emmer* (1977) ran to no less than 68 typed pages, *The Guest* (1977) to 30, *Tigers Don't Cry* (1976) to 75, and *Golden Rendezvous* (1978) to 100 pages of production notes, synopses, suggested punch-lines and biographies. Interviews with actors, directors, producers and stars are arranged. Follow-up material is constantly sent out as the production progresses and the public is kept in touch with selected events occurring on the set. That a wide spectrum of media and journalist-critics are taking an interest in the film is often created by journalists who simply reproduce the PR-puff under their own bylines.

When the film has been completed, production publicity gives way to the second stage of the publicity process, the distribution publicity. This is normally handled by the distribution company although in some cases the production publicist continues to work on the distribution publicity together with the distributor's promotion department. Ster-Kinekor would normally absorb about 15 percent of the total advertising budget, passing the remainder on to the producer, but, said Bill Sharp, "He would still have a back-up service from the whole publicity department, which will write editorials, get the media coverage—television, radio, newsprint—which is thrown in, he doesn't pay for that."[9] Sometimes a film which has had little

or no production publicity will integrate a pre-release publicity campaign with the distribution promotion. The production publicity is paid for entirely by the producer, generally with no support from the distributor, who may or may not have been contracted at the production stage.

Every conceivable medium is used: radio talk shows, simultaneous book launches, magazines and newspaper stories, comics based on the film, billboards, trailers, stickers, pamphlets, write-in competitions. T-shirts, soundtrack releases through record shops, and radio and television hit parades. Grand premieres are covered by radio, cinema newsreels, newspapers and television. Link-ups with fashion houses create promotions worth millions of dollars, directing styles worldwide (e.g., *The Great Gatsby*): big walks organized (*Winners II*); balloons flown over the Kyalami grand prix race track (*The Eagle Has Landed*); the army moved into Commissioner Street, Johannesburg (*A Bridge Too Far*); free trips offered to the Holy Land (*Moses*); Chairman Mao *Little Red Books* (blank of course) issued for *Kaptein Caprivi*; a donkey cart hauled down Commissioner Street (*Witblitz and Peach Brandy*); and Tobie Cronje sitting on a portable toilet (*Kootjie Emmer*). For the Rhodesian war movie, *Shamwari*, the leading white and black actors, Ian Yule and Ken Gampu, were persuaded to walk chained together the 400 miles from Durban to Johannesburg.

The public relations event becomes part of the national consciousness. Melanie Millin says regarding the R90 000 *King Kong* (1976) publicity campaign, "Anybody who could read, write, see or hear, somewhere, somehow saw a *King Kong* promotion." Publicity departments monitor the public reaction in terms of box office returns and modify their campaigns where necessary. The advertising on Zeffirelli's *Romeo and Juliet,* for example, unsuccessful at first, met with a better response when Romeo and Juliet were depicted on a poster holding hands in bed.

Previews are screened to celebrities and press before general release. The responses are nurtured with cocktail parties and cabarets. Word-of-mouth publicity soon begins to filter outward from these opinion leaders and press Knowns. This process is supported and reinforced by parallel advertising and promotional

campaigns which intensify the film's image in the public mind.

The safest strategy is to have the film's image based on stars. Clint Eastwood, for example, is a sure box office attraction in South Africa. Nonetheless, the presence of stars does not guarantee success. Many big productions have failed despite being crammed with internationally known stars. The inclusion of stars can also push up the cost of the film beyond the point of amortization.

Even if film critics and reviewers are ecstatic, as in the case of *The Guest,* a film may still die. Conversely, even when critics are antagonistic, an inane film like *Crazy People* may still perform well. Unfavorable reviews appear only once and offer little opposition to saturation advertising. There is also the experience of first night sellouts of unknown films with no stars and little pre-publicity. Such an occurrence is best explained in terms of the cinema-going habit and audiences which are not very discriminating in their choice of films. This condition certainly applies to the drive-in circuit. Where four-wallers (cinemas) are concerned, the clustering of two or three or more cinemas under one roof ensures that spillover from a booked-out film will go to one of the other cinemas whether or not these viewers are attracted to the title showing. The institutional nature of cinema-going in South Africa is another factor which may draw people to the cinema irrespective of the type of film on circuit. In such cases, the film may have a poor or non-existent image resulting in a low threshold of expectations in the mind of the public, but the film may receive positive word-of-mouth publicity. This may account for the success of the *Rocky Horror Picture Show* (1976), which after three weeks of poor returns way below hold-over threshold suddenly took off and earned a huge income. The performances of *The Winners* (1972) in the Far East, *Kill or be Killed* in America and *The Gods Must be Crazy* in Canada, Japan and France were equally unexpected, as was *A Man and A Woman* (1966) and *Madame Rosa* (1978) in South Africa.

Word-of-mouth campaigns may also be organized efforts, especially boycott campaigns. A number of small minority pressure groups such as *Die Vrouefederasie* (Afrikaans Womens Federation) and *Aksie Morele Standaarde* (Action Moral Stand-

ards) regularly organize "spontaneous" objections to films, either through the medium of the press or directly to the Minister of the Interior. *Seven Beauties* (1975), *Godspell* (1973) and *The Rocky Horror Picture Show* (1976) were banned subsequent to release; *Tommy* (1975) was shortened by two minutes. Additional cuts were imposed on *Mad Max* (1980), while a whole series of films were banned outright: *Looking for Mr. Goodbar, Percy, Carry on Emanuelle* and *Fellini's Satyricon*. *The Omen* (1976) continued with pre-release cuts despite a massive "letters to the editor" newspaper campaign by *Aksie Morele Standaarde*. With the liberalization of censorship in the 1980s this lobby group lost ground and was unable to prevent the unbanning of *The Rocky Horror Picture Show* and a re-issue of a more intact *Night Porter*, among many others. *Aksie Morele Standaarde*, however, were thought to be instrumental in the Minister of Internal Affairs' directive to the Publications Appeal Board demanding a reconsideration of a film previously passed by the Directorate, *Bob and Carol, Ted and Alice*. The appeal was boycotted by Ster-Kinekor on principle and the company issued one of the strongest indictments ever of the government's "political interference":

It has frightening implications for the film industry in this country, because this clause means that no distributor ever has certainty that the film in which he has invested many thousands of rands is safe from political interference.[10]

Many of the *Aksie Morele Standaarde* complaints are made without them having seen the films in question. It would appear that the bulk of their information about particular films comes from the "image" of those titles created by publicity agents in the media. Since the South African press assumes that cinematic progress is allied to South Africans being allowed to view films with a sexual theme, it is not surprising that the "courageous" decisions of the distributors to import such films and the "enlightened" attitude of the Directorate of Publications to pass them should garner a higher degree of publicity. *Aksie Morele Standaarde* are thus basing their moral

indignation, not on the film itself, but on the image of the film that has been planted in their minds by the media. This obviously has serious implications for marketing. In the case of *Seven Beauties,* for example, the Directorate apparently granted censorship exemption on condition that the distributor, CIC-Warner, persuade the newspaper critics to play down the sexual aspects of the movie in favor of its other less controversial attributes. Even this did not prevent further complaints by *Aksie Morele Standaarde,* leading to the film's subsequent banning. The publicity agent is thus faced with having to promote a film on its subsidiary attractions rather than its major themes and interest. That this has to continue after the Directorate's decision as well is all the more irritating to distributors.

PUBLICITY AND SOUTH AFRICAN CINEMA

On-set publicity was a regular feature of early South African feature production between 1916 and 1923 when photographs and stories were carried in considerable detail in *Stage and Cinema,* as well as shorter mentions in the press. Thereafter, coverage was restricted in *Stage and Cinema* to Schlesinger's films only.

The use of paid publicists is a more recent phenomenon, starting with the filming of *Majuba* in 1968. Since then most of the established directors have become responsive to the need for production publicity. Campaigns are aimed at the mass audience which constitutes 90 percent of the cinema-going population. Subcultures of taste which patronize films like *Seven Beauties, The Guest* and *Marigolds in August* constitute perhaps only 10 percent of the total.

The promotion of local films is fraught with difficulties. The effect of production publicity can be reduced because of a delayed release. In any case, advertising budgets allocated for distribution publicity as a rule are not as high for South African-made films as they are for foreign titles. The major audience for local, and particularly Afrikaans films, resides outside the metropolitan areas. This dispersal makes advertising to specific

markets difficult. Only radio and expensive television coverage can saturate this potential audience. Films aimed at black audiences hardly ever use anything more than posters. These will be put up on the day of the outdoor screening in the rural areas, or a few days ahead of time in townships and villages. Most of these films are reviewed in the black-oriented press, but this medium is not available beyond the major metropolitan perimeters.

According to Wayne Duband, for a time managing director of CIC-Warner in South Africa, local audiences relate more to themes than to stars where South African films are concerned. The promotion of a South African film in terms of actors is, therefore, considered more risky than a similar campaign for a foreign film.

Jamie Uys is a "bankable director," having notched up hundreds of millions of dollars in the sales of his films internationally. No matter how sophisticated or inept his films, they always make money. Unlike most directors, his "track record" remains unblemished after 16 films spanning 23 years of production.

Although South Africa has no bankable stars, themes which have proved successful and are entwined with radio and television personalities, are films spawned by television comedies, *Nommer Asseblief* (1981), *Bosveld Hotel* (1982), *Verkeerde Nommer* (1982), *Wolhaarstories* (1983) and *Geen Trui vir 'n Wenner* 1983. Publicity involving these television stars, however, is necessarily different from that of fully fledged film stars. The television star is only in the news when a series in which he or she has acted is being broadcast. In contrast, stars are always in the news.[11] More importantly, television stars lack the ordinary-extraordinary paradox. They are familiar and reassuring, rather than paradoxical and enigmatic as in cinema. Television producers who have been made into Knowns by the press are being enticed by the film industry to direct feature films. Bill Faure, for example, made *Plekkie in die Son* (1979) and has been trying to raise financing for other major projects. In *Plekkie,* much of the publicity focused on the mystique of the director.

CASE STUDY

Released during 1977, *"Dit Was Aand en dit was Môre"* (*It Was Evening and It Was Morning*) relied purely on distribution publicity to offset competition from the newly established television service and to maximize the usual Afrikaans film release pattern which misses most of the major urban first-run theaters. The campaign was devised by publicist Melanie Millin. It included:

● *Radio Campaign:* Saturation advertising (20 spots) on Springbok Radio on release date only. Read by announcer on duty (9.7.77). A pseudo debate discussed the merits of two competing songs, one of which was to be used as the theme tune. Both were composed by Jan de Wet. Hence the title "Jan de Wet vs. Jan de Wet." Announcers broadcast both, explaining the background.

● *Fashion Publicity:* Window displays in Truworths department store illustrated the "country" or "romantic" look (i.e., the farm look as the action occurs on a sheep farm). The fashions were supplemented with pictures from the film and advertising posters. The two female stars modeled these clothes for two separate features published in the *Sunday Times.*

● *Rugby Promotion:* Springboks vs. the world team at Loftus Versveld saw 40 schoolboys bearing placards of the film's title. They stood outside the stadium gates and mingled with the crowd. Drum majorettes holding banner of the title and wearing *Aand/Môre* T-shirts paraded on the field (8.27.77). Reported in the press.

● *Karoo Meat Tie-in:* 100,000 leaflets featuring the Meat Board's recipes were given free to butchery and food store consumers nationwide. Supported by in-store posters and display material.

● *Colored Lambs:* Photographs of three baby lambs dyed different colors and bikini girls with corresponding colors were published on front pages of *The Citizen* and *Die Vaderland* (9.8.77).

● *TV:* "Perspektief" interviewed Frans Marx (8.17.77). A later program on the SA film industry screened clips of the movie (10.12.77).

● *Patrys Write-in:* Schoolchildren to enter a competition through *Patrys* which is distributed to all white SA schools. Prize was a Karoo farm holiday during sheep-shearing season.

- *Sheep-Shearing Competition:* Held in main shopping mall of the Carlton Centre. Winner received a check signed on the back of a sheep which was then cashed in at Barclays Bank. Reported on TV *News* (9.1.77) and the daily press (9.2.77).

- *Press: Keur* ran a serialized photo-story of the film. Coverage was obtained in fifteen other magazines. *Cambedoo* books on the Karoo were sent to film critics as a public relations gesture.

- *Premiere:* Was held at Middleburg in the Cape near where the film was photographed. Covered by *Rapport* (9.4.77 and 9.11.77).

The film performed fairly well in Afrikaans-speaking locations immediately following release. Negative word-of-mouth, however, resulted in a disappointing box office return thereafter. Newspaper reviews in both the English and Afrikaans-language press were cool and both the producer and distributor acknowledged that *Dit Was Aand en dit was Môre* fared badly because it was uninteresting. The publicity campaign was unable to counter the adverse word-of-mouth reaction, although it did appear to be successful in making people aware of the film. The cost effectiveness of this form of publicity is difficult to monitor. Some publicists argue that promotional aspects (sheep-shearing competitions, prizes, free holidays) are wasteful in terms of measured impact per dollar and that they do not necessarily reach the target market. Further, such approaches are argued to impart little information about the film in question, and sometimes even submerge the title of the film under a deluge of irrelevant material. The *Aand/Môre* campaign ensured a lot of exposure for sheep, but not so much for the film. Or as Colin Haynes observes of promotions generally: "Promotions can clutter up the image you are trying to communicate." But the *Aand/Môre* publicity did succeed in tiding the film over until negative word-of-mouth, a direct consequence of the film itself, caused it to fare poorly.

The Guest (1977) is an enigma among South African movies. It received worldwide acclaim and the unqualified praise of local commentators. Despite the overwhelming support of the local press (it received more publicity than *Jaws*), it grossed less than R55 000 within four years of its release date by its distributor, Ster-Kinekor. Such poor support, particularly when

compared to the returns of *Boesman and Lena* (R190 000), *Die Kandidaat* (R250 000) and *Katrina* (R900 000) suggests that *The Guest* projected a poor image and suffered from the introduction of television the previous year. What was the image of *The Guest* in the public mind and how was it formed?

The Guest draws on both the Italian neorealist and French New Wave styles. It deals with an episode in the life of an Afrikaner intellectual, Eugene Marais. Naturalist, poet, editor, author, advocate and journalist. Marais appears to be more well-known in Europe and America than locally. Marais was a rebel. He was educated in English yet is one of the founders of Afrikaans literature. While still in his teens, first as a journalist and later as an editor, Marais published exposés of President Paul Kruger's repressive Transvaal government. Kruger is a hallowed saint in South African political history and is rarely mentioned in any other than reverent terms by Afrikaners.

Marais regularly addressed the Young South African Society on the "Joys of Opium," a substance which was freely available at the time. The episode documented by the film explores the torments of his withdrawal, and came at a time when South Africa was in the process of enacting the harshest anti-drug laws in the Western world. As Devenish himself put it: "The local Afrikaans audience doesn't want to know about Afrikaner drug addicts."[12]

The poetry of Eugene Marais is taught to both English and Afrikaans schoolchildren throughout South Africa. Marais is revered in the Christian National Education courses alongside other great poets who are considered the cornerstone of the Afrikaans language. The official presentation of Marais is one-sided, shallow and totally ignores the less palatable facets of his life—his drug addiction, his opposition to President Kruger and so on. He is mythologized along with all other great Afrikaners. As myth, Marais is indicative of a whole range of cultural meanings derived from the Afrikaner's struggle for the recognition of Afrikaans as one of South Africa's official languages. Devenish, like Rautenbach before him, cut incisively through these mythical stereotypes. He presented Marais as Marais was, not in terms of the cultural construct. The Marais who had been acceptable was replaced with a personality who

was abhorrent to the Afrikaner identity. Thus the film's link with society, particularly South African society, was imprecise. There was little common ground whereby the audience could relate to the film thematically. Stylistically too, a breakdown in communication occurred since few South Africans had been exposed to the documentary styles of European cinema.

On-set publicity for the film was inefficient. The only guideline proposed was that the film should be aimed at all sectors of the South African population. Even in this the publicity was counter-productive. Production publicity was assigned to a journalist whose outlets included a number of influential British newspapers.

Although the press and informed members of the public were invited on the set during shooting, little basic material such as photographs were provided even when asked for. Negative publicity was engendered when critic Roy Christie of *The Star* elicited from Fugard a statement that South African films were generally "rubbish." Emil Nofal reacted through Christie stating that Fugard was a "muckraker."[13] Although these interviews covered a total of three pages in the widely read *Tonight* section, follow-up publicity to either neutralize Nofal's response or to capitalize on it was not forthcoming. Pre-release publicity was better coordinated and more ubiquitous as this stage was handled by Devenish himself.

By the time the distributor came into the picture, the film had acquired the status of an "art" movie. Consequently, it took on a negative commercial image. This occurred despite the efforts of the distributors to popularize the film. Publicity emphasized the South Africanness of the film. Intellectuals were regarded as a captive audience, for many had studied Marais's poetry as schoolchildren. The problem that faced the distributor was the basis on which to promote *The Guest,* particularly in order to maximize Devenish's post-production publicity. Colin Haynes, then publicist for Ster Kinekor, faced up to the problem thus:

> On *The Guest* lots of stories that could have been used to support the launch of the movie were blown before release ... Overkill of production publicity can

make the marketing of a film that much more dif-
ficult. We were prepared to go to lengths to publicize
this film that Devenish objected to. We wanted to do
stories about the neglect of Marais's grave in Pretoria
and what a scandal it was. The gun with which Marais
committed suicide was available. We wanted to exploit
that heavily to popularize the movie ... We were not
allowed to exploit these areas for fear of embarrassing
Marais's family.[14]

Newspaper reporting tended to reinforce the art status of
the film. This approach received further impetus when the film
was shown for the first time at the highly publicized Cape Town
Film Festival during March 1977. *The Guest* and its director
subsequently won awards at the Locarno Film Festival in
Switzerland and the Berlin Festival, also in 1977.[15] Simultaneously,
production notes and interviews with Fugard and Devenish began
to appear in journals variously aimed at an intellectual reader-
ship: *Scenario, Snarl* and *Speak,* while other material of a schol-
arly nature was published in just about every newspaper in South
Africa. In terms of newspaper column inches, *The Guest* re-
ceived considerably more publicity than most films. It appears
that this material, however, served to create more of an aware-
ness of Eugene Marais than it did about the film itself. Never-
theless, certain recurring themes began to filter through and
make their impression on the public mind. Devenish had stated
that people in the cinema world had questioned his intention
to make a film which showed one of the founders of Afrikaans
literature as a drug addict. He was warned by several "experts"
that the film would undoubtedly be banned. Devenish spent
four years living below the poverty line trying to raise money
for the film in a country where capital is generally not hard to
find. All these comments were made public before and during
the release of the film in South Africa.

Devenish had acquired martyr status in a society hostile
to oppositional martyrs and suspicious of introspection and
thematic experimentation. The film had its foreign premiere on
BBC-TV, a channel in a country perceived to be hostile to South
Africa. The already acquired art status was continually rein-

forced by the constant media references towards *The Guest's* overseas artistic achievements. Individual journals like *Scenaria* published a highbrow *auteur* critique, as opposed to its usual commercial commentary and carried an advertisement for the film with three French films under the heading "Exceptional Films."

The Guest was released in the Ster 300 in Johannesburg, where the screen was too small for the television format picture, giving the impression of a top heavy image. It appears that the subject matter was too somber and the issues too deep and too obscure even for the receptive film-goer. Consequently, a negative word-of-mouth ensued. When the film was moved from Ster 300 to Ster 100, this was further evidence to an entertainment-conditioned public that the film fell into an "art" category. Even after it had been awarded six *Rapport* Oscars and received tremendous coverage in this Afrikaans-language national newspaper, audiences failed to respond. Because the film was somehow seen as art, 95 percent of the cinema-going public disqualified themselves from seeing the film and of the remaining 5 percent at least 2 or 3 percent consisted of foreigners and immigrants who are not usually drawn to a South African production.

In conclusion, the public image of *The Guest* was that of an *art film*, dealing with the seamier side of a mythical hero, Eugene Marais. The public had no point of reference or table of values by which it could conceptualize this film into a particular genre. It could not identify with the image and consequently stayed away despite favorable reviews and a preponderance of intellectual discussion.

Had the publicity campaign been more stringently controlled to prevent the intrusion of disturbances into the formulation of the image and had the publicity been able to popularize the subject matter, the film might have had a better chance of success, for the movie itself was comprehensible on a variety of levels from the superficial to the very complex. Like Rautenbach's *Die Kandidaat* and *Jannie Totsiens,* Devenish's *The Guest* was released at the wrong time. These films were ahead of their audiences which could not relate to their inherent values, and

the social conditions were not conducive to a public foresaking escapist entertainment in favor of "art."

Because of the industry's allegiance to Hollywood marketing patterns at the time, *The Guest* was not aimed at a sub-culture of taste which may have provided the basis of a viable distribution. While the Ster-Kinekor publicity department had put its weight behind the film, the company was not sure of how to distribute the film. This inconsistent strategy affected the efficiency of its own advertising. A disappointed Devenish evaluated the response by commenting that, "The outside world doesn't want to know anything about the Afrikaner, and the Afrikaner doesn't either. So by and large we didn't have an audience for the film."[16]

In comparison, the marketing of a film like *Superman* (1978) falls easily into mass consumption patterns of distribution and advertising. The major imported films have an industrial advantage in that the publicity budgets are usually larger than for local films. Campaigns are planned with past experience in mind and are transplanted from country to country. Sci-fi in the form of *Star Wars* (1978) has generated a modern movie marketing phenomenon. This has rewritten the economics of the Hollywood blockbuster and has heralded the age of what *Newsweek* calls the "megabuck" movie.[17] The producers of such films tend to rely as much on non-theatrical sources of income as they do from the box office return of the film itself. The movie is the generator, the contagious fever which diffuses outwards from the studio, sweeping before it hundreds of millions of dollars worth of franchises, merchandising rights, licenses and other marketable gimmicks.

Star Wars' producer, George Lucas, initiated this new marketing concept. Spin-off industries mushroomed overnight. The sale of comics, paperbacks, toys, T-shirts and so on brought in $400 million, more than twice the box office take. The income derived from these ancillary industries together with the film's earnings were fed into sequels. To a certain extent the producers of *Superman* inverted this process. Warner Bros. pre-sold Superman franchises to over one hundred manufacturers to market nearly 1,000 Superman products. This income, supplemented by pre-release distribution guarantees, paid for the movie before

it had even been completed. Hence Warner Bros. could afford to spend $50 million on the film, making *Superman* one of the most expensive films ever made.

In South Africa, large companies like the national OK retail store chain, Clover Dairies, and Beacon Sweets took out local manufacturing licenses. These products included Superman play suits, pajamas, T-shirts, sheets, duvet covers, pillowcases, transfers, mugs, cups, plates, dolls, toy guns, bubble bath, soap, hair shampoo, toothpaste, bumper stickers and so on. These and other kinds of Superman promotions were designed to infiltrate the national consciousness and saturate the cinema-going public from behind every bush, billboard and shop counter. Local manufacturers found consumer response so great that they were able to export Superman merchandise to countries like the United Kingdom, Australia and the Philippines.[18]

Superman was so expensive it had to be aimed at the mass audience of the classic Hollywood formula established during the 1930s and 1940s—quality family entertainment. Consequently, the advertising and promotions campaigns of the megabuck movie are aimed at *teaching* the public "what to want." If the audience discovers that it doesn't really want what it is exhorted to want, the box office sales will decline, a result of the negative word-of-mouth process. *King Kong* (1976) suffered from this malady. If on the other hand the public likes what it is told it wants, the film will do well: *Jaws, Funny People* and *Superman*. The effectiveness of publicity, however, is also determinant upon distribution. *Superman* did not perform as well in South Africa as it might have done. Films marketed as family fare tend to decline in box office revenue at the end of school holidays. This occurred with *Superman* which was released in early December, 1978.

The South African industry has been slow to apply the merchandising concept to the promotion of its own films. Producers who make films for black audiences have taken the lead. Most either use the commercial music already on the Radio Bantu hit parades, or release the film's music track through record companies to coincide with the launching of the film. In the case of *Stoney the One and Only* (1983) a paperback was published by David Phillip.[19] Where the film has been made

from a novel, this may result in the re-issue of the book. In the case of the Gordimer series, Penguin issued a paperback which contained the six stories on which the films were based.

Stoney is a ginger beer which has developed its advertising campaign around the theme of boxing. The film, *Stoney the One and Only,* "brought the billboard to life."[20] The producer signed a licensing agreement with the local company which merchandised the spin-off products of other films like *E.T. Star Wars* and *The Muppets.* While the film gains its point of departure from the Stoney advertising billboard, it avoids overt propagandizing in the film itself. The main character, for example, only changes his name to Stoney once he gets to "the top." From then on he is seen mainly in the Stoney company's corporate colors.

The book on which the film is based, the way it was sponsored and distributed, is indicative of the lengths to which the state will go in cooperating with business to shape the consumer and ideological perceptions of South African blacks. The book was sponsored by two educational trusts connected to big capital through the mining industry. According to its author, the book was written with a language vocabulary acceptable to the educational authorities in the hope that it would be accepted into school syllabi, or at least libraries at schools and on the mines. The producer/author commented that working through school headmasters

> can quite often lead to the opportunity to display products [which] have an association for the viewer immediately afterwards and before [the screening] through poster details and through principal products displayed throughout the school hall and within the cinema area itself. So one will liaise with the representatives of the product, who will then supply X amount of products to be given away as prizes for lucky ticket draws, competitions for coloring in and for various questions that are asked about the content of the film, which collectively build up a general awareness of what the film is all about; not just its theme but also is product usage.[20]

The main character of Stoney is not only selling the soft drink product, but the idea that "success" is an attainable goal for black youths who work hard, are loyal to their employers and who are upwardly mobile. The cooperation from the state educational authorities, and the educational trusts, in the promotion of the *idea* represented by the character of Stoney, is indicative of the need to socialize the newly emerging black middle classes in both the cities and the homelands into a modern urban industrial economy. The urgent need for skilled labor which led to the co-option of a limited number of blacks into the petty bourgeoisie brought about the social conditions reflected in *Stoney* where that class fraction alone is permitted to imagine that success within the traditional capitalist sense is within its grasp.

CHAPTER EIGHT

DISTRIBUTION

"I took it as a foregone conclusion that the majors wouldn't touch it."

DAVID BENSUSAN, *on* My Country My Hat, *1983*[1]

In South Africa, the Monopolies Act (1955) was enacted to prevent situations where a company has exclusive right or *control* of a market, product or service. The enforcement of this Act is very loose and monopolies that would not be tolerated in America and Europe are allowed to exist in South Africa. A look back at the history of centralization and concentration of the South African film industry will illustrate this point.

African Consolidated Films Ltd., a distribution company, and African Consolidated Theatres Ltd., an exhibition company, both under the control of I. W. Schlesinger who entered the industry in 1913, had established a dominant position until their takeover by 20th Century Fox in 1956.[2] During 1961 the film industry was investigated by the Board of Trade and Industries in terms of the Regulation of Monopolistic Conditions Act of 1955 as amended. The Board discovered that certain monopolistic conditions existed. These were voluntarily remedied by Fox.

THE ASCENDANCE OF NATIONAL CAPITAL

Although Fox had existed comfortably in a seller's market

159

for over ten years, by the end of the 1960s it was to be outflanked by national capital on two fronts. The first related to the question of cinema location. Despite Fox's commanding position in the South African market, its remote controlled operation managed primarily from America had become cumbersome and unwieldy. Consequently, it was unable to respond to changing locational, demographic and consumer preference circumstances. Most of Fox's cinemas were situated in the central business districts of the big cities. These cinemas were extremely large, the Johannesburg Coliseum, for example, seating 2,227 patrons. The overall prosperity of the decade had led to a jump in land values and Fox found itself owning a property portfolio of highly rated and therefore expensive to maintain properties which it was reluctant to develop. The *Financial Mail* estimated the market value of Fox's 149 properties to be worth R100 million in 1969.[3] The 1960s were also a period of increased suburbanization. Fox failed to follow this migration with the location of new, smaller and more intimate cinemas to intercept this more mobile audience.

The second cause of Fox's sellout, and possibly the deciding factor, was the sudden and unexpected growth of Ster under the dynamic leadership of Andre Pieterse, and the stabilization of the company's property investments guided by the more sober SANLAM contribution. Ster assailed Fox from two directions. First, through the establishment of an independent circuit comprising both drive-ins and small four-wallers serviced by their own distribution and organization, and then through the bold acquisition of films from two of the majors.

Ster had begun with the Wonderboom Drive-In in 1957 and posed a threat to the Fox monopoly, not only in terms of screens, but also because of its support of feature production outside the Fox production company, Killarney Films. In 1962, Ster's finances were strengthened by an agreement with SANLAM, a massive Afrikaner insurance company set up in 1918 to free Afrikaners from their economic and political subservience to English-dominated capital.

Prior to the intervention of the Board of Trade and Industries in 1962, the only way that an independent could survive was through the drive-in circuit. Fox's hostile attitude toward independent distributors and drive-in owners as well as the

establishment of its own outdoor circuit eventually proved to be the organization's downfall. Ster Films drove a wedge into the Fox dominance by using drive-ins to spearhead the attack. The South African company's position was greatly enhanced by the buoyant economic climate of the 1960s. The growth in consumerism in turn led to a growth in the advertising industry and Ster forayed into "the most lucrative preserve of the Fox subsidiaries," Alexander Films and SA Films.[4] Ster negotiated a merger between Ster Adfilms, Filmads and Independent Film Services to organize and arrange screen time at more than 400 independent and Ster-controlled theaters.

The value of Ster's contacts with companies like Avco-Embassy, secured in 1962, was crucial. Pieterse commented, "You might say that *Zulu* and *Boccaccio '70* put us on the map."[5] Ster then managed to entice the distribution and exhibition rights of first Paramount (in 1964), and then Columbia (in 1965) away from Fox.[6] Ster had offered these American companies considerably more (about R3 or R4 million) than they had been earning through Fox, which was not prepared to match Pieterse's offer.[7] The result was that Ster now found itself in the undesirable position of being contractually bound to screen more films than it had facilities for, at a higher price than Fox would have had to pay under the previous agreement. Ster was therefore forced to embark on an unprecedented expansion program to facilitate these contracts. By the close of 1966, Ster had 38 outlets in comparison to Fox's 107. Ster was, however, still short of screens. The company was now highly indebted to the parent operation, SANLAM, which had a 90 percent equity. The only option available was the purchase of Fox itself. This it did in April 1969.

With the SANLAM takeover, Fox, the Schlesinger Organization, SANLAM and Ster now found themselves to be partners. The *Financial Mail* reported that the American studios were "far from happy to see the two major competitive operations, Fox and Ster, to all intents and purposes united under one umbrella."[8] The studios had stood to benefit from Fox-Ster rivalry since it was through these antagonists that South African capital would be co-opted into expanding the penetration of the local market. Only Fox was secure, having received a 30-year franchise to

exhibit its films in all 128 cinemas transferred to the SANLAM/ Schlesinger partnership.[9] At a meeting in early May, 1969, the Motion Picture Producers Association of America in New York agreed that "individual studios would go it alone, so far as possible, once their contracts with Fox run out [which for several is quite soon]. This means agreeing to compete among themselves for screen time in a cut-throat free market situation in SA."[10]

The worst fears of the American companies were realized when SANLAM announced the new structure of the four-company combine. The Suid-Afrikaanse Teaterbelange Beperk (Satbel) was floated as the holding company of 20th Century Fox, now called Kinekor, and the Ster Group. This infusion of of Afrikaner-dominated capital into the film industry created a monopoly even more awesome than the previous Fox empire. The Satbel management insisted that "on the operating side, the two companies will remain independent and will compete with one another: this should maintain a competitive situation on the film exhibition and distribution side.[11] The cinema count at this point was Kinekor, 128 cinemas, and Ster, 18, out of a total of more than 400 countrywide. Ster had 23 drive-ins and Kinekor 24 out of 114 throughout the country.

Film Trust was formed as a breakaway from Ster by Andre Pieterse, the architect of the SANLAM takeover of Fox in 1969. During 1970 MGM had remained in existence but limited itself to exhibiting and distributing MGM and other films, operating the three Metro cinemas it had sold to SANSO. These theaters were later demolished and the merger with Film Trust gave the new company first call on MGM films in return for an undertaking by Film Trust to develop twenty metropolitan cinemas by the end of 1974.[12] By the end of that year, Film Trust had spent about R2 million on eighteen cinemas in which they planned to release sophisticated films which would run for longer periods in the smaller theaters. Access to movies, however, was dwindling, for MGM in the United States had begun to curtail its film making activities and was investing heavily in hotels and casinos. One offering, *That's Entertainment,* for example, reflected this shift, being essentially made up of short clips from early musicals. Film Trust was faced with further access problems at the time because in 1972, a basic agreement was reached between MGM

and 20th Century Fox which provided for the consolidation of their foreign distribution organizations. In November 1973, two years after MGM and Film Trust became partners in South Africa, the United States company sold its foreign assets to the Dutch-based Cinema International Corporation (CIC). This corporation had been set up in 1970 by Paramount and Universal which realized that the costs of international distribution by individual companies would seriously offset profits that could be obtained through marketing cooperation.

Initially, CIC distributed the films of its two associates together with those of MGM outside the United States and Canada.[13] Each of the two companies owned 49 percent of the shares, with Paramount ranking first and Universal fourth among the seven largest producers. The selling of the South African-based MGM operation for $1.75 million made CIC a 50 percent shareholder in Film Trust.[14] Although CIC was contracted to Ster until the end of that year (1973), Film Trust nevertheless stood to gain from this sale. Film Trust offered CIC a 50 percent shareholding in eighteen cinemas and 100 percent playing time. This was a more attractive deal for CIC than the nineteen first-run houses of Ster in which it had no equity. Ster was also committed to Columbia, Avco Embassy and other distributors across the world. Nevertheless, CIC retained the option of cross-playing the Ster-Kinekor circuit in addition to its access to the CIC-Metro theaters.[15]

The good working relationship which had been established with the independent cinema owners by Pieterse when he was managing director of Ster also worked to his advantage. Ster, Kinekor and Film Trust together contributed 55 percent of the rental of the major suppliers, with the remaining 45 percent coming from the independents. Ster was able to make first-run films available to the independents. With the takeover of Fox by SANLAM in 1969, the independents again had to face, though to a lesser extent, the sort of competition that they had experienced before 1961. Film Trust calculated that through the supply to these independents and the existing Metro theaters, CIC would earn as much if not more than they did through Ster.

The move by Paramount and Universal through CIC from Ster to Film Trust was an important breakthrough, for these two

majors had together contributed more than half of Ster's revenue. Allegiance to only one distributor gave CIC Film Trust the edge over Satbel—the SANLAM film holding company—for where the latter was obligated to screen films for many different distributors and producers for specific periods, Film Trust was able to be more flexible in its bookings. Films which had a high audience appeal were kept on circuit in the first-run houses for as long as demand remained. In contrast, because of contractual commitments, the Satbel operations were forced to change product irrespective of income.

During the same period of the early 1970s, Satbel was also consolidating its interests. Horizontal rationalization began with the merging of five subsidiary companies involved with screen advertising: Alexander Films, Filmlets, Ster Adfilms, Telenews and Radio Drive-in. Two of these companies had previously been kept separate by 20th Century Fox which acquired them with its takeover of the Empire Theatre interests in 1965. The division was maintained ostensibly to maintain a spirit of competition. The Satbel merger, however, was expected to create a greater efficiency of screen access to the advertiser without having to increase personnel.

September 1972 saw the finalization of the restructuring of the R40 million Satbel Group. Management was decentralized and comprised sixteen divisions and partly owned operations. The two largest, Ster and Kinekor, remained in direct competition with each other in the activities of distribution and exhibition. All divisions were to report directly to Satbel on finance, budgeting, operational policies and objectives. Administrative and service facilities were rationalized and centralized under Satbel. The following comprised Satbel's main divisions and operations:

KINEKOR: 83 cinemas and 23 drive-ins, as well as 12 tea room cinemas. Sponsors live shows and provides catering facilities for its cinemas.

STER FILMS: 20 cinemas and 23 drive-ins, 2 ice-rinks. Produces live shows and provides catering facilities for its cinemas.

CINEMARK: markets screen space for advertising purposes.

IRENE FILM LABORATORIES: South Africa's largest film processing laboratoy.

KILLARNEY FILM STUDIOS: produces documentaries, cinema commercials and a newsreel.

SA FILM STUDIOS: located at Lone Hill and engaged in studio and equipment hire. It later moved to SA Film Centre where Killarney Films was located.

MONARCH FILM PRODUCTIONS: a financial participant in the production of South African feature films.

ACF MERCHANDISE: marketing, servicing and installation of cinema, photographic, office and micro-filming equipment.

GROUP PROPERTIES: controls the hundred-plus properties of the Group.

CINE SIXTEEN: distribution network providing films for professional 16mm and home movie circuits.

COMPUTER SERVICES: an independently managed bureau which provides computer services to the Group and to outside companies.

In addition to these major divisions, Satbel also had interests in:

Chemco, which manufactures cinema screens, theater equipment and furnishings;

Chemix, a company which prints publicity material and processes publicity artwork;

Computicket, a computerized booking service for cinemas, theaters and sports events;

Gallo-Fox, which markets audio-visual equipment; and

African Entertainments, the owner of the Boswell circus.

By 1972, Satbel owned 160 of the 360 cinemas in South Africa. Of this total about 20 percent accounted for 50 percent of the turnover. The remaining income was made up from small, suburban, country town and non-white cinemas. They controlled or owned another 30 percent of the balance which gave them at least 60 percent of the total exhibition revenue.

The business maneuvering between Satbel and Film Trust was occurring against the initial tooling-up stages for the introduction of color television on January 1, 1976. Kinekor, which owned the majority of Satbel's older cinemas, intended meeting the expected intense competition by spending as much as R10 million on refurbishing its cinemas. The installation of

broadcast television in the United States in the 1950s had been met by film production companies spending fortunes on technological innovations and big budget productions.

The South African cinema sector had the benefit of hindsight. Not only were the South African distribution and exhibition divisions restructuring themselves during the immediate pre-television period, but further rationalizations were in the pipeline as far as Satbel itself was concerned. At the time, Satbel was vertically integrated in terms of ownership of subsidiary companies, marketing cinema equipment and furnishings, production, distribution, screen advertising, exhibition and promotion. Horizontal integration was effected through the consolidation of its theater chains, screen advertisers and distribution. Despite overwhelming control of the market, Satbel operated Ster and Kinekor as two separate companies in direct competition with each other. This competitive spirit was maintained by the luxury of two separate and autonomous head offices. Despite the anomalies in the administration of what on paper appeared to be a monopoly, *Business SA* warned in 1972 that the SANLAM-Schlesinger merger set an unhealthy precedent in terms of the Monopolies Act and would provide a *cause majore* for a later merger between Ster and Kinekor themselves.[16] This occurred in 1977 as a response to the commencement of television.

In March 1974, the Schlesinger Organization sold its controlling interest in SANSO—the property company—to Anglo-American. Through an offer of one share in Rand Selections for nine shares in the Schlesinger Organization, Anglo-American found itself a minority partner with SANLAM in the ownership of film trading rights and theater operations (70:30) and an equal partner in the properties. These were the properties parceled out between SANLAM and Schlesinger through SANSO in 1969 and which included the finest blue-chip sites in the country. Such repenetration of traditional English-dominated capital, particularly Anglo-American capital so often objectified as the enemy of Afrikanerdom, into Afrikaner enterprize should be seen against the restructuring of South African capitalism as a whole. The emerging partnership between these traditionally and politically distinct capitals was a reflection

of a growing cooperation between English- and Afrikaans-speaking South Africans as the country's economy matured and had to face up to an intensified economic, political and "terrorist" attack from external quarters.

Apart from projects already committed to Ster for distribution, from January 1, 1975, CIC and MGM released their films through a new subsidiary, CINTRO (SA). This decision marked a shift of the American majors away from the Satbel fold. CINTRO's access to Universal, Paramount and MGM assured it an estimated 40 percent of the anticipated major productions from Hollywood. Operating in 47 countries, CIC was fast moving towards the process of consolidation of American cinema capital by maintaining its own distribution arm, and hence profits, which would otherwise be lost to indigenous firms.

CINTRO was in a strong position because of the very high dependence of South African cinemas on the American majors' catalogue. Like the previous strategy of 20th Century Fox, international capital in the form of CIC was aimed at co-opting local capital to provide the required cinema outlets for foreign films. This move towards independence and financial centralization on the part of some of the majors, and which was to later occur with Warner Bros. and United Artists as well, should be seen against the impending introduction of television which provided the impetus for a significant restructuring of the distribution and exhibition divisions of the industry. CIC represented a cost-saving strategy by creating more powerful distributor entities which rebalanced their bargaining power on a global basis.

With the move by Universal and Paramount to MGM Film Trust in 1975, the latter company had to gear up for expansion of its cinema facilities. Requisite funds were to come from Film Trust itself. The international industry was experiencing a resurgence at this time. Whereas 400 films were imported on average during the previous years, by 1976 the figure had risen to over 800. With all these films demanding screen time, there was no doubt that local producers' earnings would be seriously affected as individual playing times per picture were to be reduced and become more subordinate to overseas product than they had been since 1970.

The pressure on cinemas reinforced the trend away from exclusive contracts with one circuit. After 1976, United Artists, previously hooked to Ster alone, asserted its right to play both the Ster and Kinekor circuits. Cintrust, the holding company of the Metro theaters continued to have access to Paramount, Universal and MGM on an exclusive first-run basis, but the group holding company, CIC, did have the right to contract films elsewhere when Cintrust could not deliver. At about this time, Warner Bros. International entered into a distribution arrangement with CIC. Disney remained with Satbel despite Pieterse's attempts to woo it over to Film Trust.

On January 30, 1976, the competitive line-up between CIC and Film Trust on the one hand, and Satbel on the other, assumed the following proportions (Fig. 1):

Broadcast television came into being on January 1, 1976. Cinema attendance was further affected by bad weather and the militarization of South African white society through an extensive call-up following the invasion of Angola near the end of 1975. The mobilization hit the 16-30 age group, committing citizen force soldiers to three months' border duty a year. Four months into the year, an audit showed an 18 percent drop in four-waller attendance and a 35.5 percent fall for drive-ins. The latter decline was of particular significance to South African-made films since these venues provided their most lucrative market. Prior to 1978, any film not distributed by Satbel either had a high chance of failing or not earning its full potential. Alan Girney, producer of *Tigers Don't Cry* (1976), noted:

> They have no holdover figures for South African pictures because their prime income comes from international shows—the South African product is in second position—the film opens at the Kine or Ster 300, the Kine Flora which is a dead area; it opens at the 20th Century at Germiston. That's the pattern for the Reef. It doesn't go to the northern suburbs. It doesn't go to the southern suburbs. It doesn't go to the eastern or western suburbs. The drive-ins are no longer the answer. So they play outside the key situa-

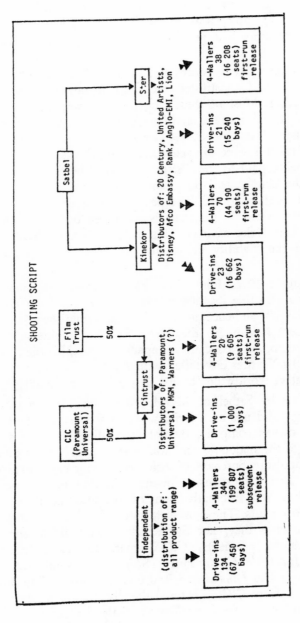

Fig. 1: Ownership and Control of the South African Exhibition Industry
(Source: *Financial Mail*, January 30, 1976, p. 219)

tions where the producer is on a flat rate of distribution, for example, R50 at the Pofadder Town Hall, less distribution charges.[17]

The country areas contributed about 25 percent of box office returns and constituted the most lucrative market for Afrikaans films. Most of these cinemas, however, are privately owned and actual income is difficult to monitor, a result of skewed financial statements. At one stage up to 70 percent of box office takings were allegedly misappropriated and royalties were not being paid to the distributor. Since the South African Theatre Checking Association came into being in 1974, this practice has been restricted. The people who stand to lose most are producers, since their income is calculated on ± 25 percent of the net box office savings. This in turn affects subsidy payments, and the viability of locally produced films is placed in danger.

By August 1976, Film Trust had exhausted its financial reserves trying to tide its theater interests over until the effects of television on audience attendance had diminished. It sold its 50 percent holding in the Metro (Cintrust) cinema chain to Cinintercorp, an associate company of CIC-Warner. This acquisition by Warner dovetailed with the group's policy to buy MGM theaters worldwide for its own exhibition facilities.

The loss by Satbel of MGM, Paramount, Universal and Warner Bros. did not necessarily work to the detriment of the SANLAM owned company. By not controlling or being solely committed to the majors, Satbel was able to avoid losses caused by the compulsory purchase of titles from sources it was contracted to. Free of expensive tie-ups with the majors, Satbel allowed films from alternative sources to appear on its cinema and drive-in circuits. The new distributor absorbed the costs of distribution since they, not Ster-Kinekor, were liable for upfront guarantee payments. CIC-Warner, for example, paid R250 000 for *Wild Geese*, HdH (SA) paid a similar amount for *The Eagle Has Landed* and R60 000 for *Moses*. Film Trust, now separate from CIC, re-entered the distribution market paying R1.1 million for the *King Kong* package.[18] Freed from compulsory contracts, Satbel could force concessions by refusing

to screen films which did not meet their own terms of contract. The merger of Ster and Kinekor in 1977 placed Satbel in an ever stronger position within the company, limiting its own purchase of films to R50 000 up front.[19]

Where supplies are not controlled in periods of recession, profits can be maintained by loosening the vertical monopoly. It was this period of variety which saw the inauguration of international festivals in Johannesburg, Cape Town and later Durban and Grahamstown. These festivals played a major role in identifying a substantial art movie audience thought by exhibitors not to exist. The festivals also spawned a more demanding audience which is largely being satisfied by smaller distributors such as Romay Films. The Johannesburg Film Festival, in particular, has been used by independent distributors as a consumer check for movies thought by Satbel or CIC to be non-commercial.[20] Films like *Sybil,* for example, subsequently ran for over two years.

By 1978 the industry had recovered from the television-induced slump and in December of that year earned greater profits than ever before. This experience was totally at variance with American consumer reaction between 1948 and 1954 when the appearance of television sets in any specific area reduced demand for cinema entertainment, producing the short-run effect of decline in theater receipts and the long-term effect of the reduction in the number of operating theaters.[21] South Africa experienced a temporary decline in box office income, but within eighteen months a renewed confidence led to the building of yet more theaters, even including Cape Town and Bloemfontein where provincial tax reduced income by 33 percent and 25 percent respectively. It was no longer necessary to shift the costs of distribution onto independents as profits were again to be found by contracting directly with the majors. Satbel wrested the R100 million ITC Entertainment package from HdH Films in August 1978 and signed a two-year exclusive exhibition agreement with United Artists in September, including its extensive 16mm library. The South African company reaffirmed its commitment to Fox and Columbia in September. Film Trust was no longer a problem, as it had been

put into liquidation in 1979 with accrued debts of R3 million incurred on its costly flop, *Golden Rendezvous.*

On the other hand, a newly formed large production house, Orion, signed with CIC-Warner in April 1979. Although Cinintercorp was not suitably geared up to handling Afrikaans films, it did attempt to test the market with *Elsa se Geheim* (1979) and *Gemini* (1980) with limited success. The bulk of the South African-made films remained dependent on the Ster-Kinekor circuit, which was more effective in the smaller towns and countryside.

CIC-Warner, which served four-sevenths of the American majors, was reliant on the Satbel cinemas to screen its product since it only had 21 urban cinemas and a couple of drive-ins at its disposal through Cinintercorp. The implications for the local producer of this cooperation between CIC-Warner and Ster-Kinekor are outlined by Andre Scholtz:

> Ster-Kinekor is far more powerful as a merger than when they were operated separately. Prior to the merger, local producers had a greater bargaining power than they have now [i.e., 1980]. A keen competitive spirit existed between Ster and Kinekor which worked to the producers' advantage. This is no longer the case. CIC is not really a competitor. Both CIC and Ster-Kinekor are very strong; each is entrenched, each has its market share; they don't impede on each other's territory, in fact, they help each other by exhibiting on each other's circuits. The local producer has no option but to play the Ster-Kinekor circuit because of its greater spread of cinemas. Local producers are at a further disadvantage for the overseas majors are in a position to demand the best theaters for even their most mediocre product.[22]

The downturn experienced by the exhibition sector between 1976 and 1978 further exacerbated the precarious position of local producers who found themselves increasingly playing second fiddle to imported movies. Since Ster-Kinekor and CIC-Warner are contractually bound to the majors, no South African

film, no matter how well it is performing, will be held over at the expense of contracted overseas films. The greater the number of imported films the less space available for local material.

In 1982, Manie Steyn claimed that, "If a picture has even just a germ of possibility he'll try it on circuit."[23] Eighteen months later, Bill Sharp, manager of publicity for Ster-Kinekor, retorted: "Sometimes against our most wildest reservations, we are taking films for the sake of the industry. We take them at times which will really be best for that local producer because we want to see him survive." Despite these laudable statements, Sharp conceded that Ster-Kinekor had been criticized for not taking Bensusan's *My Country My Hat* (1983). Sharp defended his company's position, arguing that it was:

a decision we made based on business principles as we know them. We're in it for the money, we are not a charitable organization. We felt we would lose money and we didn't take it. We've had bad experiences... *Marigolds in August, The Guest.* Some of those pictures didn't pay back their advertising cost. It's all very well to say promote art and do things about it, but you have cinemas which cost money where you're paying rental for every square foot that a seat occupies, overheads, running costs, rates and taxes—the whole thing. You cannot run it at a loss. You cannot say, it's a fine film, we really feel for it, we're going to stick it out in our theater and play it at a loss and to hell with it.[24]

The contradictions of the Ster-Kinekor position are basically two-fold. On the one hand is an over-commitment to an almost saturated white market and the apparent lack of interest in developing a cinema-going culture among blacks. This throws up anomalous situations whereby a thriller which revolves around a neurotic white working class family and their relationship with an itinerant black gardener is classified by the Department of Commerce, Trade and Industries, as a "black" film as far as subsidy payments are concerned. This decision was not made because of ideological considerations, but because

Ster-Kinekor and UIP-Warner refused to distribute it. *My Country My Hat*, like *Boesman and Lena* and *Marigolds in August* could have earned much more than they did had they been screened to a sub-culture of taste, rather than to the cruder marketing divisions of "white" and "black." The major problem is an artificially limited market structured to reject local films which engage contentious local issues. Thus, *My Country My Hat*, because it is perceived by the distributors to be "political," and therefore offensive to white audiences is, in Steyn's opinion, "a real dog" which must be rejected.

A second contradiction relates to the attitude that, as Timothy Ord, managing director of UIP-Warner put it, "If a film is playable, that is, if it has a good script and a good story, CIC will be delighted to pick it up."[25] But they too turned down *My Country My Hat*. One wonders just how good or bad a local "political" film has to be to qualify as a "good script or a good story." Critic Greg Garden charged that Bensusan's "film and his stance are more devastating proof of the conspiracy against dissent."[26] Producer Dennis Scully adds: "What is seen as a very lousy imported product is getting the full treatment here. So, if they can accord that treatment to imported product, they should accord the same treatment to a local product."[27]

Films rejected by Ster-Kinekor—*Olie Kolonie* (1975), *Wat Maak Oom Kalie Daar* (1975), *Terrorist* (1976), *Dingertjie en Idi* (1977), *Gemini* (1980) and *My Country My Hat*—have had to find other distributors, which means lower incomes, more middle agents and fewer strategically located cinemas. *Gemini*, for example, was picked up by CIC-Warner, *Terrorist* by HdH Films, and *My Country My Hat*, paradoxically, by a Tonie van der Merwe company which belongs to a group producing mainly low budget "back to the homelands" type pictures. Even here the contradictions are rife, for the distributor was of the opinion that *My Country My Hat* is a "white" film. He has, furthermore, "declined to distribute it on the mines because he thinks it's going to cause a lot of resentment and a lot of unrest."[28]

Mimosa Films, a new entrant to the distribution market in 1977, headed by Philo Pieterse (previously managing director of Film Trust), sought to combine local producers and thereby secure better release patterns, particularly at independent cinemas.

The impetus for this company occurred because of the declining influence of Film Trust which had always been a supporter of South African productions. Mimosa Films, however, experienced some resistance from both Ster-Kinekor and CIC-Warner, which regarded this newcomer as a competitor to their own distribution networks. Since the Mimosa stable included the highly "bankable" Jamie Uys, the cinema chains would have preferred to negotiate directly with the producer for they would stand to earn higher profits than if they had to deal with an intermediary. By 1978, Mimosa had also acquired a number of foreign titles which constituted a further incursion into the distribution market as a whole. Two years later, however, Mimosa entrusted its films directly to Ster-Kinekor and announced it would now concentrate on production.

CREEPING DISTRIBUTION

Where a film is perceived by a distributor to be of a high standard but not necessarily a good box office bet, it may be opened at one or two cinemas in the main city centers. The distributor will let word-of-mouth build and will stimulate this process through selective advertising. The viability of the film is measured in terms of a graph of tickets sold. Where the increase is significant, the distributors are able to predict box office performance. Once they are sure of a larger public demand than the first-run theater can efficiently service, the film will be placed in other theaters to meet the rising demand. Jamie Uys's *Beautiful People* (1974) was released on this basis by MGM Film Trust and was the first local film to breach the R1 million barrier, eventually earning more than R1.6 million. The word-of-mouth on this film was exceptionally good and many saw the film more than once.

My Country My Hat was a film well-suited to creeping distribution. It had received extensive critical acclaim from press critics, and word-of-mouth had begun to build from its screenings at the Cape Town and Durban Film Festivals and the

Grahamstown Arts Festival. With minimal publicity, the film was put on at the Piccadilly Cinema in Johannesburg. Audiences grew every night during its five-day run reaching a 75 percent capacity on the last day. Had the cinema been available the following week, Bensusan estimated a 60 percent attendance on word-of-mouth publicity alone.

Referred to among distributors as "get in and get out" distribution, a saturation distribution pattern is applied to films which have a potential for large-scale earnings and which may be *perceived* by the distributor to be of poor quality. The distribution and advertising campaigns are designed on a "splash release" basis where the film is simultaneously released nationally in as many first-run theaters as possible. The rationale behind this approach is to persuade as many people as possible to see the film as soon as possible so that the majority of cinemagoers will have seen the movies before negative word-of-mouth depresses further attendance. Films in this category included multi-million dollar epics like *King Kong* (1977), smaller films like *Exorcist II: The Heretic* (1977) and local inanities like Jamie Uys's follow-ups on *Beautiful People* (1974), *Funny People* (1976) and *Funny People II* (1983). Of course, the splash release is also used to build up the image of a film to create high expectations of good films as well.

The distribution policy on *Funny People* is a classic example of saturation distribution. Basking in the commercial success of *Beautiful People,* a comedy film on wildlife, *Funny People* relied for its image on the reputation of Jamie Uys for making entertaining films, and the use of the word *People* to bind it to *Beautiful People.* Significant also was the fact that South Africans had not yet been exposed to the kind of humor found in *Funny People,* which was based on the American TV series, "Candid Camera."

Funny People had the largest simultaneous release pattern of any film screened (33 prints) in South Africa up to then. The promotion campaign created a sense of expectation and anticipation in the public mind. Press releases stated that for the first time in history both the Ster and Kinekor circuits and independent exhibitors would release the film simultaneously. The public was notified that the world premiere at Ster Pinelands

was to be attended by the State President, Cabinet Ministers and other celebrities.

The media constantly reinforced the image of *Funny People* by making references to *Beautiful People*. The public was told that it would roar with laughter and that "for several months hilarity would reign in South Africa." The release of *Funny People* became a national event.

Within a short while Dirk de Villiers's *Crazy People* (1977) was in the pipeline, capitalizing on the success of *Funny People*. *Crazy People* earned R72 000 in the first week of release in twenty cinemas, but grossed just under R283 000 within the subsidy period. A third derivation of *Funny People* was *Isimanga* (1976), made for black audiences. It was seen by 250,000 people. *Funny People II* was made because of the international success of its predecessor. Saturation distribution made profits for a whole group of poor quality films.

EFFECT OF TELEVISION ON DISTRIBUTION PATTERNS

> "The SABC now has such financial and ideological control of the South African film industry that it is even trying to usurp its traditional role of producing feature films."
>
> GREG GARDEN, *critic*, Rand Daily Mail, *August 13, 1983*

Not all films are released according to the established patterns. Saturation releases often coincide with school holidays. With new channels of advertising opened up by television, the splash release pattern is better able to take advantage of nationwide launch publicity. For this reason too, the drive-ins and independents are being included in the initial launch. Television has also indirectly affected the type of film being shown. Afrikaans audiences have become used to the sophistication of television series and dramas, both original Afrikaans and dubbed. The Afrikaans Drama Department, responsible for programs

like "Bart Nell," "Willem" and "Verspeelde Lente" is having a direct effect on what its audience is prepared to accept in cinemas. Among both language groups, the siphoning away by television of much of the undemanding audience allowed distributors to explore subcultures of taste. Whereas before the introduction of television, films like *Seven Beauties, Madame Rosa, Small Change, Black and White in Color* and *Sybil* would have struggled, now they have become commercial assets.

The impending introduction of television in 1976 led to a fall in South African feature film production, and the onus of ideological and cultural legitimation shifted to SABC-TV. Local film producers soon began to copy television for the screen, producing films such as *Nommer Asseblief* (1982), *Bosveld Hotel. Die Moewie* (1983), *Verkeerde Nommer* (1983), and *Green Trui vir 'n Wenner* (1983). These films were not always self-contained. An understanding of who the characters are, why and what they do, where they live, and the work they perform is assumed from a prior knowledge of the television programs.

The SABC not only screens its own films on television, but also makes features which it intends placing on the cinema circuit. *Anna* (1983), a made-for-television feature, for example, was assigned a prime slot at the 1983 Cape Town International Film Festival, barely three weeks after its national screening on television. Bensusan's film, in contrast, was assigned an inconvenient time four days into the program. The often made charge that the SABC has ideological control of the film industry is perhaps an overstatement, but it does highlight the intricate connections between parastatal bodies and sections of the industry which claim to be "international," "independent" and working for social change.

CHAPTER NINE

ESTHETIC LABOR

"Producers don't appear to be sufficiently interested in talking to us. Maybe they deem it beneath their dignity: maybe they consider us an element in the industry not worth recognising, perhaps the weather conditions were wrong, or possibly they were scared of us."

LIONEL FRIEDBERG, *chairman of SAFTTA, 1976*[1]

Prior to 1974, the South African film industry was characterized by an absence of formal controls on employment practices, a lack of regulated relations between technicians and producers, and a somewhat apathetic attitude toward the establishment of a set of production and esthetic standards by producers. This resulted in a conflict of interests between employer and employees.

Much of the conflict can be traced to the inception of the subsidy system during the 1960s. Many of the films made during this time were of extremely poor quality, a large number never completed, some never released, and many producers survived only for a short while. Established filmmakers resented the indiscriminate employment by producers of cheap inexperienced labor which resulted in poor technical standards and maintenance of low wages. Employers rarely adhered to normal employment practices. Technicians often had to labor under adverse and exploitative conditions. It was not unusual for them to work

179

upwards of 15 hours a day seven days a week for four or five weeks without overtime pay or time off.

The sudden expansion of feature production in an industry not fully prepared for immediate growth had serious repercussions as far as artistic and technical quality was concerned. The situation has been described by Lionel Friedberg:

> In simple terms, many technicians were self-taught. During the dizzy days of the 60s, a technician had to learn by doing it—in all fairness there was simply no other way. We had a few mentors from whom we could learn, and there was absolutely no academic or technical training institution which offered even the most basic course in the rudiments of film production. One learnt by one's mistakes.[2]

Except for the short existence of the South African Society of Cinematographers during the late 1950s, the industry's component actors remained isolated from one another with little labor communication at any level until the 1970s. As Lionel Friedberg reported: "This isolation was reinforced by the lack of contact between English and Afrikaans producers and even within these two confines, little contact occurred between studios, technicians or production houses.[3]

The South African Film and Television Technicians Association (SAFTTA) was formed in 1974 to negotiate with employers who had already organized the Motion Picture Producers Association (MPPA). SAFTTA faced scorn and derision from many quarters. Self-taught technicians often viewed SAFTTA's aim to set standards and to encourage job specialization with trepidation. The question of who was going to set standards and how technicians would be graded was particularly contentious. Technicians were afraid of antagonizing their bosses and even charges of a communist plot were directed at association activists.

Producers initially responded by involving themselves in SAFTTA meetings. The result was that the first chairman of the Executive Council was a producer-technician. Such contradictions took years to resolve as many technicians continued to be em-

ployers on some projects and employees on others. The majority of feature film producers, however, ignored SAFTTA, not even bothering to respond to formal invitations to discuss mutual problems. They objected to the SAFTTA contract and charged that SAFTTA would ruin the industry just as trade unionism had ruined the industry in England. Such an attitude was illogical given the Association's stated objectives, constitution and structure. At that time, 1974, there was no question of SAFTTA applying for trade union status. Even if it had, the Industrial Conciliation Act No. 28 of 1956 would have effectively prevented it from applying many of the disruptive tactics employed by the overseas unions.

The grain of truth in the producers' perspective was that the struggles of South African technicians did have parallels in the conditions which led to the formation in Britain of the Associated Cinematograph Technicians (ACT) in the 1930s. In both cases, registration as a trade union was inevitable given the continuing uncontrolled exploitative demands of producers whose strivings for profit often resulted in appalling working conditions. The irony is that the original orientation of both unions was that of craftspeople seeking to improve standards and contracts but not necessarily to form a union. Lionel Friedberg has noted:

> SAFTTA was born out of a desire to create an ongoing point of contact and to encourage interaction within the industry, to consolidate our interests and to swap ideas. The questions of trade unions and employment contracts had nothing to do with it at that stage. Only once SAFTTA had catalyzed this need for co-ordination did we start thinking of the technicalities that would bind our members together, hence the contract, the laying down of salary scales, medical aid schemes, etc.[4]

Despite SAFTTA's reassurance that the Association would be mutually beneficial to both employer and employee, producers were inevitably angered by the mobilizing of technical labor power. The result would be higher costs to producers and

a less docile labor force. But just as the ACT was unable to decide whether or not it was a union in the 1930s,[5] so SAFTTA denied a union objective. This conservatism arose because of the mainly middle class position of technicians. Film technicians tend to be much more highly educated than workers in other industries and see themselves as professionals whose class ideology is similar to that of their employers. The contradiction between technician and producer in South Africa is further diluted by race, since, until 1980, most film and television technicians were white. Many SAFTTA members viewed trade unionism as unfavorably as their employers.

By 1976, the MPPA was dormant and SAFTTA was the only operative association serving the industry. The SABC's advertising agency, for example, sounded out the Association's opinions, recommendations and views regarding the introduction of commercial television. SAFTTA insisted that commercials should be generated from local industry, thus making decisions which were more properly the concern of producers. Besides, SAFTTA began to find that negotiating changes in employment practices was no easy task as little legislation covered working conditions on film sets. Further hindrances were the differing responses of English- and Afrikaans-speaking technicians. The former tended to be more mindful of their rights. In fact, SAFTTA has rarely had many Afrikaans-speaking members. Producers were therefore protected by entrenched social and industrial attitudes.

FOREIGN TECHNICIANS AND INTERNATIONAL PRODUCTIONS

> "During the past few months, not once, but on
> several occasions, South African technicians have
> had to suffer intolerable insults through widely
> publicized gratuitous comments from some little
> known American and European producers. One
> American producer even had the temerity to state
> that he would never have come to South Africa
> had he known that he would have had to deal
> with a trade union."
>
> *SAFTTA policy statement, November 1980*[6]

With the increasing use by international producers of South
African locations and finance in the 1970s, SAFTTA felt that
it was only fair that local technicians be hired. The industry's
experience on *Gold* (1974) and *Shout at the Devil* (1976)
showed foreign producers generally preferred to pay higher
salaries to imported personnel for jobs which could easily have
been done by South Africans. This problem came to a head
with *Golden Rendezvous* (1978), where in some categories as-
sistant assistants were flown in from Britain. This situation to-
gether with confrontation on other issues between the producer,
Andre Pieterse, and SAFTTA, led to a marked tightening up of
SAFTTA policy with regard to the indiscriminate employment
of foreign technicians. Another issue of importance, which con-
cerned those South Africans who were lucky enough to be
employed on such large budget productions was their treatment
as second class citizens. Technicians who worked on *Gold, Shout
at the Devil, Golden Rendezvous, Wild Geese* (1978), *Zulu
Dawn* (1979) and *Game For Vultures* (1979) were discrimin-
ated against in terms of rates of pay, expense allowances, over-
time rates and accommodations. This was less evident on *Game
For Vultures* due to SAFTTA intervention, but was encountered
in new mutation on *Rally* (1981) where the producer paid ex-
traordinarily high salaries to key Israeli personnel while paying
local technicians at a lower rate. Since the Israelis were con-

tracted to work beyond the ten hour day, the producer could pressure the South Africans to work longer hours, sometimes with overtime pay, sometimes not. When confronted with these contractual discrepancies, the producers invariably accused SAFTTA of being a trade union which did not have the interests of the industry at heart.

A major catalyst to the radicalization of SAFTTA was its experience with Euan Lloyd, the British producer of *Wild Geese*. Lionel Friedberg observed that:

> ... producers used to apply for 50, 80, 150 or whatever number of temporary work permits were required, and in most instances, the Department of the Interior granted the permits. Part of the problem was that the Department was not aware of the number of locally available technicians in South Africa and, secondly, when a producer submitted an application for a "grips" or a "clapper-loader," the Department invariably had no idea as to what sort of people these strange titles meant!
>
> We strongly oppose the idea of using scores (and sometimes hundreds) of foreign technicians who work in this country when the budget for a feature film has been entirely raised in South Africa. (Examples: *Gold, Shout at the Devil.*)
>
> We welcome and applaud the production of international pictures in this country, but where local money is involved, we object to the fact that local technicians are usually denied the opportunity of working on these productions. (Of course, one comes down to the nitty gritty reality of that "relatively unskilled labour pool in South Africa," but this fact can usually be applied to the key technical positions only. In other words, we firmly believe that we have more than enough technicians, in most categories, who can comfortably and justifiably work side-by-side with top imported personnel who would only fill the key technical and creative positions.)[7]

Just as the British technicians had been underdogs vis-à-vis

Americans, the South Africans in the 1970s were subordinate to the British. Previously they had benefitted from a cultural boycott imposed by the Associated Cinematograph and Television Technicians (ACTT), the successor to ACT. This boycott against members working in South Africa was lifted in mid-1977 because of the dwindling employment opportunities in Britain. The chairman of SAFTTA observed that, "With the lifting of the ACTT ban, South Africa would be one of the few places in the world where out-of-work British technicians might find employment.[8]

The only effective retaliation available to South African technicians against this form of imperialism was to obtain the support of the state. This was the strategy followed by SAFTTA following the *Golden Rendezvous* debacle. The Department of the Interior agreed to consult SAFTTA on the availability of local technicians before issuing work permits to imported technicians. Consultations were also held with The Association of Film Production Houses of South Africa (TAFPHSA), which represented producers of commercials. The MPPA was no longer in existence and so access to feature film producers was difficult.

SAFTTA's new arrangement with the Department of the Interior required some time to take effect. Cooperation finally was forged from the experience with Euan Lloyd who paid lip service to the arrangement, while finding every possible loophole to import technicians from Britain. Lionel Friedberg has indicated how producer intransigence elicits antagonism from technicians, often resulting in equally intransigent counter-actions:

> After more than eight weeks of shooting in the Tshipise, Northern Transvaal district of South Africa, Euan Lloyd's $12,000,000.00 production, *The Wild Geese*, returned to Britain on November 20th, for additional three to four weeks studio shooting . . . Despite numerous attempts to contact Mr. Lloyd through his production supervisor, Harold Buck, SAFTTA's envoys never managed to get beyond Mr. Buck's private secretary. The whole nasty issue may be due to the unhelpful attitude of the secretary, but after numerous letters and at least a dozen or more telephone calls,

we regrettably believe that the reason we are not al-
lowed access to Mr. Buck or Mr. Lloyd was because of
an official policy to either ignore or disregard SAFTTA.

All SAFTTA wanted to do, from the early stages
of the film's pre-production was to offer our service
to Mr. Lloyd and Mr. Buck, primarily to enable them
to recruit as many local technicians as possible, without
them having to go to the expense of specially bringing
out unnecessary technicians from overseas. Obviously
on a picture of this magnitude and importance, all the
key technical positions (as well as many other posi-
tions) on the picture would have to be filled by more
experienced technicians than are generally available from
the local labour pool. Our approaches were not only ig-
nored, but blatantly rebuffed by Mr. Buck's secretary.

When reports began to filter in about working
conditions and disputes on location, we again attempted
to contact either Mr. Buck or Mr. Lloyd. Once again ...
nothing happened. We took the matter to the press,
and despite reports in the national dailies, Mr. Lloyd
and his production office did not even have the decency
to reply, or to counteract our complaints. By this time,
the issue was building in importance, particularly when
we eventually learnt that only 15 technicians, on a
nearly 300 member crew, were South Africans. Again,
we took the matter to the press.

Again ... no reply. Then in an indirect counter-
measure to our reports, Mr. Lloyd placed a large ad-
vertisement in *The Sunday Times,* just prior to the com-
pletion of the location shooting. In it he thanked the
various government bodies who assisted in the produc-
tion, as well as the many "local technicians who worked
with experts from Britain." The advertisement was
worded in such a way as to appear that there were
over a hundred local technicians and other personnel
employed on the film. Hundreds? Sure. If one includes
the waiters serving in the hotel's dining room, the
cleaners, drivers, laundrymen and general runners!
This was outright camouflage of the true facts and

SAFTTA had no alternative but to take the entire matter to the Department of the Interior, who are responsible for issuing temporary work permits for foreign crew and producers.[9]

The working relationship between the government and SAFTTA was streamlined and extended to include technicians contracted for both international and local productions, whether feature, documentary or commercial. This policy was not aimed at eliminating but only controlling the indiscriminate use of non-South Africans. By 1979, overseas producers in South Africa had adopted the SAFTTA guidelines on working conditions and salary scales. In contrast, some local commercial producers were threatening to take their productions to other countries, and discriminatory practices continued on some South African feature film sets such as *Follow That Rainbow* (1979).

THE GREAT RIP-OFF

"It's funny that I can't afford a cup of coffee yet I can get R2 million for a movie."

Producer, The Star, *April 19, 1980*

The unease experienced by SAFTTA with regard to *Wild Geese, Shout at the Devil, Slavers* (1975), and *Zulu Dawn* (1979) was justified by an exposé of the film industry which broke in the pages of *The Star* early in 1980. Reporter Mike Sullivan disclosed that South African investors had lost up to R20 million on a handful of international films made in South Africa since 1975.[10] Sullivan wrote:

Private planes, helicopters and dummy invoicing may have been used to smuggle money onto the sets of South Africa's major film productions. Businessmen and producers admit that currency smuggling has become part of international film-making and that for

five years South Africa has been a prime target for smugglers.[11]

The smuggling was done behind a screen of different companies in a variety of countries, mainly Rhodesia (now Zimbabwe) and South Africa. *The Star* investigation probed film sets, studios and the offices of some of the nation's top firms and was hampered by a systematic cover-up, threats, and attempts at bribery. Sullivan wrote, "What we discovered was a world populated by ruthless men who would stop at virtually nothing to achieve their ambitions."[12] The exposé was so devastating there was a tremendously adverse effect on the flow of capital into production. One international producer working in South Africa at the time complained that *The Star* exposé was just rumor-mongering that would result in a "scorched earth" policy designed to sabotage international film productions.[13]

Although constituted to serve technicians, SAFTTA found itself increasingly acting on behalf of the entire (legitimate) production industry, a role it neither wanted nor was capable of handling. The Association was aware of the fact, for example, that many international producers working in South Africa were simply running up debts without any intention of paying them. The consequence was that SAFTTA, being the only constituted body in operation at the time, was called upon by some creditors to do what it could to salvage the situation. Since both the MPPA and its offspring, the FFPA, were dormant at the time, SAFTTA again found itself having to deal with an increasing number of issues which were the domain of the producers' and service associations. SAFTTA, for example, approached the Reserve Bank on the matter of fraudulent accounting practices, and information from its members finally cracked the scandal of *Zulu Dawn,* which was the last of the sets through which currency smuggling allegedly took place.

By 1978, SAFTTA had acquired a moderate image and the service sectors of the industry were approached with a view to sponsor membership. The Association now had over 300 members, but due to the fact that it was run in the spare time of Council members, its administration was erratic and inefficient. Sponsorship facilitated the employment of a part-time

secretary who considerably improved government-SAFTTA liaison. At the same time, the Association was invited to contribute a regular column on its activities to the new monthly, *SA Film and Entertainment Industry*. This gave the Association a high profile within the industry. The sponsor members were very sympathetic to SAFTTA as it had of necessity addressed itself to many issues of mutual concern. Producer support was another matter. Particular members of the FFPA remained hostile, and the only contact occurring between SAFTTA and FFPA was informal.

While the sponsors saw no harm in their association with SAFTTA, they were less prepared to allow the Association access to their work force. A request to Irene Film Laboratories for an address list of their employees was turned down. Had SAFTTA been successful in gaining the massed membership of laboratory personnel, its class and professional profile would have significantly changed. This in turn would have affected its aims and objectives and its ideological identification with its sponsors. Chanan pointed out with regard to the British experience in 1936 that once ACT had opted for a clear trade union policy, the organization of laboratory workers became a prime objective because "without the laboratory workers the Association would have no real working class base."[14]

The laboratory is the only part of the production process where true factory conditions pertain and is, therefore, the actual base of industrial power. Laboratory workers have the power to stall a production by refusing to process a film. Since the Industrial Conciliation Act offers unsuitable and lengthy negotiation procedures for production processes where production periods are short—from one day to a few months—the support of laboratory workers, who are in a position to intercept a film many months after it has been shot, is vital. In South Africa, the existence of only one laboratory makes the industry extremely vulnerable to union pressure, particularly as this sector of the industry is the largest employer of other than white labor.

In August 1980, the Executive Council was instructed to prepare the Association for trade union registration. This followed four years of discussion on the question of unionization with the conservative Trade Union Council of South Africa

(TUCSA), a loose grouping of white and multi-racial trade unions. Initially, the Association decided not to apply for trade union status, given the segregated nature of new unions and the barely 50 percent SAFTTA representation of the total population of film and television technicians in South Africa. But by mid-1980, the Association had become much more aggressive in its recruitment. The Executive issued a strongly worded policy statement which for the first time acknowledged that "the interests of technicians do not necessarily coincide with the interests and motives of producers.[15] Both local and international feature film producers were warned that "the Association has sufficient power within the state legislative machinery to take stringent action against those producers who renege on their agreements with local technicians or who coerce them into signing contracts which would be untenable in other sectors of the economy." The *Government Gazette* of March 23, 1981, announced the scrapping of racial curbs on unions in terms of the Industrial Conciliation Act of 1956 and went on to define unions as any organizations involved in labor relations whether registered or not. SAFTTA was now defined as a union.

Unionization had a two-fold effect on employers. The first was the unilateral retraction of SAFTTA's monthly column by the publishers of *SA Film and Entertainment Industry*. The initial agreement covering a two-year cooperation had run out, with neither party suggesting formal renewal though the column continued to be published. The relationship had been businesslike, but not without some disagreement on content and expression of some articles which had necessitated legal counsel. A letter from the magazine's editor canceled the agreement without consultation but with the observation that the magazine was devoted "to positive comment."

A second effect of unionization was that sponsor members withdrew financial support and became hostile, fearing a repetition of the British experience in South Africa. This transpired despite the circumstances that they had been consistently informed of the differing legislation covering labor relations and that the Association's activities would not be dissimilar to its activities as an unregistered union. The Industrial Conciliation Act procedures were so extensive and cumbersome that the event

of an authorized strike was unlikely, and wildcat strikes and sympathy actions were prohibited.

In 1981 the Executive Council of SAFTTA considered joining the worker-oriented closely managed Federation of South African Trade Unions (FOSATU). Given the peculiar production practices found in film production, the Executive Council eventually opted to remain independent, while using the services of FOSATU lawyers. Despite these shifts toward unionism and increased intervention on international film sets, most of the members of SAFTTA clung to the idea of a craft guild and did not actively solicit laboratory workers as members. This was partly due to the prevailing emphasis on esthetic labor and partly to the business orientation of individual members. The introduction of television in the mid-1970s had created the need for a large number of small production and service facilities. Many of these new companies were established by technicians. In regard to SAFTTA, this led to a conflict of interests not always recognized by the individuals concerned. These contradictions became clearer as more technicians became producers.

Once SAFTTA members began to find each other on opposite sides of negotiating tables, the conflict became obvious. A partial solution was the inclusion of producers as members of the Association but without voting rights that could affect the overall direction of SAFTTA. Producers were granted access on the technicians' terms. More importantly, conservative elements on the Executive Council remained wary of opening up membership irrespective of skills, much preferring the craft guild ambiance which denied access to working class elements. Oddly enough, blacks employed in skilled positions would not be denied access, the criterion being that of technical ability.

The lack of any organization to represent the industry as a whole, particularly at a time when television was settling in, had led a group of employers to explore the idea of establishing a new employers' body to supersede the defunct MPPA and FFPA. The initial negotiations began in October 1978, barely fourteen months before SAFTTA took the decision to unionize. The SA Film and Video Institute took some time consolidating under its arm existing organizations like the CPA which had replaced TAPHSA, the Black Feature Film Producers Associa-

tion, and others. It also established autonomous sub-committees
for the various branches of film and television production, and
invited SAFTTA and the Scriptwriters Association to sit on its
committees. The Institute worked behind the scenes for two
years before making its presence publicly known in November
1981. Thys Heyns, the Institute's first chairman was optimistic
about positive state response where in the past it hardly ever
paid attention to the recommendations of any professional as-
sociations, let alone its own Board of Trade and Industries. Heyns
recalls FFPA deliberations:

> We spent hours meeting ... and really getting no-
> where, because at the end of a meeting, X would go
> and do his own thing and Y would run around and
> see a Cabinet Minister, and the whole thing was a
> bit of a farce. I think that the Department of In-
> dustries has more respect for the Institute now than
> they had for these committees.[16]

The more demanding approach taken by the Executive
Council notwithstanding, SAFTTA was able to enter into agree-
ments on rates of pay, working conditions, time off and other
issues with the Commercial Producer's Association (CPA).
The role of television commercials production began to assume
disproportioned importance within the Association in terms of
role of television commercials production began to assume a
disproportinoate importance within the Association in terms of
work opportunities and income. These agreements were more
easily concluded given the sympathy of the new technician-
producers, many of whom had been extensively involved in the
setting up of SAFTTA.

Since 1980, the Association has been chaired by progressive
intellectuals who have been conscious of the over-arching nature
of the industry within the state; and who are elected by a some-
what liberal electorate within which a minority of radicals—
mainly university film and television lecturers—forged a progres-
sive image through the Association's publications.

By 1984, the commercials production sector was worth R63
million a year. SAFTTA was embarrassed at its primarily com-

mercial-technician membership profile and set about changing its image through *The SAFFTA Journal* which after 1982 aimed to broaden the concept of the film industry to include independent production and activities previously considered of a fringe nature. Previously, conservative elements of the Executive Council had attacked dissidents as happened when the chairman editorialized against Anthony Thomas' anti-apartheid stance, as SAFTTA was trying to work with government to set up controls on the employment of foreign technicians.

A major ideological difference came to a head in 1982 when the Executive Council in the absence of the chairman and editor, and without consulting the editorial board of the *Journal*, refused to allow the publication of an interview with Kevin Harris on his anti-apartheid film, *This We Can Do for Justice and Peace*. Again, the reason given had to do with SAFFTA-government relations. The Executive naively believed that the publication of an interview with a dissident filmmaker, although a SAFTTA member, would antagonize the state during a period of unionization and negotiation. The chairman and editorial board retaliated with an intellectual vehemence which caught the Executive off-guard. The decision was overturned and a demand for editorial autonomy was granted. The *Journal* has since allied itself—both in terms of content and appearance—with the struggle for social change.

The resolution of the editorial conflicts led to the immediate election to office of Kevin Harris. The Executive Council now consisted primarily of filmmakers whose practices were geared towards creating the conditions for change within and beyond the industry. The great contradiction which remained was that the members had to earn their primary income through commercial production and the relationship such production had to the South African state militated against change.

CHAPTER TEN

INDEPENDENT CINEMA

"No theory of production is neutral."

PETER ANDERSON, *videographer-lecturer 1983*

South Africa offers a unique opportunity for making films about interracial relationships, social problems, class conflicts and political despotism. Images, themes, plots and stories scream out from the environment for cinematic treatment, but they are generally missed by the South African producers. Such subjects have been treated by British television, the films of Peter Davis and the productions made under the auspices of the banned African National Congress (ANC). Most, consequently, are made by foreigners for foreign audiences. Only a few have been made with South African capital for South African audiences. These films are aimed at middle class non-South African viewers and have little in common with the notion of "Tercine Cinema" or radical film-making.

Although Tercine Cinema or Third Cinema emerged in other neo-colonial countries in North Africa, South America and Asia during the 1960s and 1970s, this revolutionary cinema has yet to be realized in South Africa. While the economic systems of other Third World countries such as Brazil, Argentina, Chile, Senegal and Algeria have all suffered from colonial and neo-colonial domination, their filmmakers are sufficiently conscious of the structural underpinnings of international monopoly

capitalism to articulate a radical commentary in ways which few South African filmmakers would understand.

Tercine Cinema, so named by Argentinian Fernando Solanas, is the cinema of the guerrilla by camera units: a helping hand in the rebuilding of an oppressed nation and a way of anticipating events in order to expedite them. Revolutionary in content, polemical in form, questioning bourgeois esthetic canons, it re-defines cinema's relationship with the audience.[1] It is this outlook which separates these practitioners from many of their South African counterparts who only began to expose and exploit the gaps in the repressive state machinery to any significant degree in the early 1980s. The more critical South African filmmaker tends to be far more conservative, both in terms of political position and in the use of the medium.

The concept of "independent film-making" is a vexed one which has yet to be given a theoretical content. The term is generally used to describe practitioners working outside a system or industry. Historically, this would range from amateurs through to "entrepreneurial film and video producers who are not affiliated with the networks or highly capitalized producing companies."[2]

Moving from the reality that independent film-making is likely to be low in cost and produced outside the conforming influences of the market place, we may define this type of production in terms of six basic criteria:

1. *Intention.* Whatever else, profit or earning back its costs is not a major criterion.
2. *Alternative Exhibition Venues.* Independent productions are screened (or not screened at all) on alternative circuits such as film festivals, university venues, church halls, trade union venues, and homes of specifically interested audiences.
3. Independent films may or may not have secured *censorship* clearance. Where exemption has been granted it is more than likely that such films will have been passed against the expectations of the producer.
4. Independent film/video production is of a *low budget* nature and is financed either by the film/video makers themselves, or by organizations which have made known their opposition

to the state or the existing order of things. This is the most difficult category to define, for the contradictions of capitalism allow filmmakers to take dialectic advantage of its weaknesses to criticize the status quo. For example, this is presently the case with Brazilian Cinema Novo, which although funded by the state, is nevertheless critical of it. This category would thus embrace co-option of institutional forms of capital where the filmmaker produces a text which runs counter to the accepted norms of those whose money is being spent.

5. Set against the traditionally high costs of film production within the "industry," the independent film is one which by virtue of its relative cheapness and financial autonomy is best able to exploit the *relationship between cost and content*. As Ross Devenish puts it, filmmakers in South Africa should "explore the freedom of their poverty," accepting gladly its limitations and turning them to advantage. In other words, the bigger the budget, the less likely is the film to deal with social realism and contentious class conflicts from the point of view of the oppressed. Worldwide, it is the low budget film made outside, or on the periphery of the established industry, which generally fulfills this function.

6. Independent filmmakers try to work within-the-possible *to prepare the way for the not-yet-possible*. Whether operating from an exile base like Nana Mahomo, Chris Austin or the ANC, or from within the country, these filmmakers deliberately exploit hegemonic fissures in the course of their filmmaking practice within the state.

This circuit of production, distribution and exhibition which operates separately from, but in parallel with the industry—though it may use some of its facilities—has been variously labelled as "independent," "oppositional" or "radical" cinema. These terms are not wholly interchangeable. The term, *independent*, as used here, describes the general social practice of film and video making which operates outside the system in terms of methods of production, content and funding.

More specifically, *oppositional* film-making accounts for the "practice involving an opposition to the strait jacket imposed on film-making by the profit motive and the ideologies that

justify, legitimate or simply fail to engage with capitalist organization of this cultural sector."[3] Oppositional film-making makes visible or draws attention to the structured absences of commercial cinema brought about by the prevailing productive forces and legitimized by bourgeois critical methods.

Radical cinema is used here to describe films which are not only in opposition to the capitalist mode of production, but are aware of their own technique/style/technology/conventions and the way in which these mold the view of the reality portrayed. In other words, radical cinema consistently reminds the audience of its relationship to the film/video crew. Radical cinema thus refers beyond the text and documents not only to the *what*, but the *how* and the *why*. A radical film, furtheermore, is one which devises directions for cultural resistance/action against an oppressive social order in *cooperation with the subject community*.

FUNDING

"In the case of [South Africa an experimental production fund] encourages the discovery of new talent. In . . . other countries, no expenditure has been more effective."

JOHN GRIERSON, *1954*[4]

Although a state subsidy for commercial feature films has been available since 1956, not a single cent was granted between 1964 and 1978 to shorts, documentary or experimental film other than the propaganda films made by the National Film Board. The initial suggestion for an experimental film fund was made by John Grierson of Canada's National Film Board, who was consulted by the South African government on the establishment of a national film board. Grierson's report, submitted in 1954, pointed out that experimentation was germane to national cinematic and democratic progress. The proposed film board was to provide the ideal mechanism through which

the exploration of film could be fostered in what he described as a vigorous political climate. Set up ten years later, the structure of the Board (NFB) in South Africa differed in crucial ways from Grierson's original proposals. These were devised to stimulate a vigorous political forum for the democratic discussion and dissemination of information within the body politic through film. As constituted by the South African government, however, the NFB subverted Grierson's democratic assumptions and, until its dissolution in 1979, functioned primarily as a production and distribution facility for National Party propaganda.

Oppositional and independent filmmakers have had, therefore, to search out other sources of finance. Other than personal investment, funding has been made available by the National Union of South African Students (*Wits Protest*—1970-1974), the South African Council of Churches (*This We Can Do For Justice and Peace, If God Be For Us*), the Inter-Church Media Programme (*Alexandra, Part of the Process* and *A Film on the Funeral of Neil Aggett*), NOVIB (Holland) and the International University Exchange Fund (*You Have Struck a Rock*), European and British television stations (*Athol Fugard: A Lesson From Aloes* and the Gordimer series), and private benefactors such as the Maggie Magaba Trust (*Awake From Mourning*), financed by an expatriate South African now living in London. Limited funding has come from the Danish anti-apartheid movement (*The Other South Africa*), while substantial amounts have been awarded to Ross Devenish by the Ford Foundation and the BBC (*The Guest* and *Marigolds in August*). Universities teaching film and television production have been responsible for a noticeable upswing of oppositional material since 1981. The French government established a Centre for Direct Cinema under the auspices of the Federated Union of Black Arts and the University of the Witwatersrand, Johannesburg, in January 1984, and five black South Africans were selected to undergo a training course in France. One of these, James Mthoba, was invited to manage the Centre. This funding was part of the socialist government's foreign policy in Africa, as it had previously set up similar centers in Mozambique and Angola. Paradoxically, much of the finance for film stock has come from the International Communications Agency, an American imperialist ap-

paratus. The students of the Centre come from all walks of life: laborers, clerical workers, bus drivers and so on. At any one time as many as ten projects are operating in Johannesburg and Soweto.

The Community Video Resource Assoc. (CVRA) of the University of Cape Town is involved with investigative, documentary and trade union videos. Where English language universities have spearheaded the oppositional movement, Afrikaans-speaking campuses have been less concerned with film and video, and even then, with a basically conventional application.[5] Television studios at the "tribal" colleges remain beyond the access of students and staff wanting to make critical material.

Academic conferences are a significant source of inspiration and limited funding. The History Workshop of the University of the Witwatersrand in 1981 assisted the production of a film on Alexandra township which revealed the effects of apartheid, enforced uni-sex hostel life and environmental degradation. *Kat River—The End of Hope* was made for the 1984 workshop. The Second Carnegie Inquiry into Poverty in South Africa held in April 1984 made available R50 000 for film and video production: *I am Clifford Abrahams, This is Grahamtown; The Tot System; Mayfair; Reserve 4; Place of Tears; Loaded Dice* and many others.

The sums granted ranged from as low as $100 to $1,000 in the case of oppositional films, while the more commercial fare of Fugard and Devenish, shown in cinemas and on foreign television stations, might solicit as much as $40,000 from a single source. The Gordimer series, costing about $1 million, was almost entirely funded by German and Dutch television stations.

Distribution of independently made films is a problem. No national co-ordinating agency exists. Distribution is done on an *ad hoc* regional basis which is inefficient and disorganized. Each producing body disseminates its own material to film festivals, academic conferences, universities, churches, trade unions and private homes. No central catalogues exist and the titles available are known mainly to the small group of people connected with the production collective. There are two basic reasons for this state of affairs. The first is that few of these films and videos have obtained censorship clearance. The costs of censorship, which is mandatory, must be borne by the producer. It is doubtful that many of the films made would be granted exemp-

tion. The distribution of non-censored material has led to police surveillance of filmmakers, detentions and confiscation of copies. Second, the mainly working class viewers of such productions would not be able to afford the kind of hire charges necessary to bankroll a central distributing agency.

The lack of a distribution organization puts the community media at a crucial disadvantage. The money, energy and time put into the production of motion pictures is rarely amortized in terms of audience size and composition. These films and videos are mainly seen by the already converted and it is rare indeed that they will be shown to hostile or uncommitted audiences, though many copies have been confiscated by the security police.

PRODUCTION FACILITIES

> "Films from Asia, Africa, and Latin America are films of discomfort. The discomfort begins with the basic material: inferior cameras and laboratories, and therefore crude images in muffled dialogue, unwanted noise on the soundtrack, editing accidents . . ."
>
> GLAUBER ROCHA, *Brazilian director, 1967*[6]

Although cinema was used by Afrikaner Nationalist elements to fight cultural and economic domination by English-speaking South Africans as early as the late 1930s, it was only after 1970 that a critical and independent film movement opposing apartheid began to assert itself. This spurt was stimulated by a number of interrelated factors. The first was the improvement in Super-8 technology, with which most oppositional films were made during the 1970s. The lifting of the embargo on video technology to facilitate the setting up of a broadcast television service in 1976 made small format cameras and recorders available for the first time. The third and most significant factor was the introduction of film and television studies at English-language universities toward the end of the 1970s. Within a

very short time, working with equipment supplied by these institutions, students and staff started producing material critical of apartheid. The makers of many of these films and videos have resisted the lure of the established industry and have forced a space for a progressive cinema not dependent on the industry and profit.

Currently, most of these film or video makers are white. Despite their counter-ideological tendencies, they show a continued allegiance to a culturally ingrained stance on esthetics and form. They often succumb to the mystique of film-making and take too much for granted. Unable to maintain a critical distance from their own ideologies, many have produced confused statements which, paradoxically, lend themselves to appropriation by the dominant ideology. As a result, recurring bewilderment occurs when films like *This We Can Do For Justice and Peace* (1981) and *Awake From Mourning* (1981) are granted censorship clearance. The reasons are generally attributed to the recently "enlightened" attitude of the censors. A more valid explanation, however, is to be found in the relation of the film to its context. Where the context is displaced or obscured, the film is likely to be passed.

Films made to exercise a cinematic urge through the fun of film-making are often a precursor to entering the established industry *per se*. Entertainment is the prime concern of these directors who are hostile to "message movies" or social statements. The classic example is, of course, Jamie Uys. His first film, *Daar Doer in die Bosveld* (1951) was a refreshing departure from previous independent (and commercial) Afrikaans film. The spontaneity with which he captured a uniquely Afrikaner humor catapulted him to fame within a very short period of the film's release. The film cost R6 000 and was shot on reversal stock with a basic Kodak camera. Uys did not remain independent for long, for he was soon to be backed by Schlesinger, and, later, big Afrikaner-dominated capital. Other independent filmmakers operating at that time generally failed because they had neither the technical skills nor the social understanding of the Afrikaans community to make their films attractive.

Authentic cinema, although dealing with other than white

characters, is designed to appeal to a wider than purely black
audience. Such films are not intended for a particular popula-
tion group. Because of their theme, treatment, characters and
style, such films actively solicit cross-cultural and inter-racial
audiences. Examples are *Jim Comes to Joburg* (1949) and *Magic
Garden* (1961), both made by Donald Swanson. The former
deals with the experiences of a black ruralite as he tries to cope
with the strange city life of Johannesburg. It is a highly humorous
film and has a number of scenes with the famous Jazz Maniacs
band which developed an African jazz. Of a more serious nature,
certainly more traumatically accurate, is Zoltan Korda's *Cry the
Beloved Country* (1951), adapted from Alan Paton's novel.
Other examples are Fugard and Devenish's *Boesman and Lena*
(1973) and *Marigolds in August* (1980), David Bensusan's
My Country My Hat (1983) and Ashly Lazerus's *e' Lolipop*
(1975). Lindi Wilson's *Last Supper at Hortsley Street* (1982)
is a moving reconstruction of the last family to leave the
District Six coloured township in Cape Town from which they
had been evicted to make way for a white suburb.

Jamie Uys's *Dingaka* (1964), based on his earlier docu-
mentary, *The Fox Has Four Eyes,* though shot in a Hollywood
panavision style and pandering to an American romanticized con-
ception of Africa in places, would fall into this category. Despite
this film's ignorance of the pass laws which controlled black
migrants and the serious dislocation caused even the more
isolated black rural communities, Mtutuzeli Matchoba described
Dingaka as an:

> ...honest attempt to represent the controversial tradi-
> tional theme. A picture may not be especially intended
> for a particular population group, but because that
> group recognizes itself authentically represented within
> the theme, it will respond positively to it.[7]

The dual theme in *Dingaka* is the opposition between white
justice and black justice—that of a tribal law, "he who kills must
be killed," and that of the "civilized" state. Through the progres-
sion of the plot it becomes clear that despite the formal, in-
flexible trappings of state law, that it is adaptable and can take

account of tribal law. White justice is shown to rule, but black justice is portrayed as more humane.

Most independent films are personal explorations. A couple of these films have been made in 35mm, funded by makers who are wealthy. This wealth, more often than not, has been derived from the extraordinary profits made by working within the system, mostly on advertising films. The desire to make one's "own movie" was an objective common to many of the younger filmmakers who worked during the 1970s. This attitude in itself is something new and is regarded with suspicion by the diehards who see film-making as merely a job like any other job which must fit the demands of the market place. An example of this kind of film is Leslie Dektor's *We Take Our Prisons With Us* (1976), a poetic examination of circus people. These films have a limited distribution since they are not the sort of fare that commercial distributors like, even as supporting programs. Unless they are shown at film festivals, they obtain little exposure.

On 16mm are films like *Angsst* (1979) and *Die Moord* (The Murder, 1980) made by Chris Pretorius. Both were partially financed by Pretorius himself, though he had considerable help from a wealthy benefactor for his later effort. His two films overturn accepted conventions with anarchic determination. *Die Moord*, an experimental counter-narrative, is stylistically more successful, though more frustrating, than *Angsst*. While both work at the level of the sexual, the fear of a young man of women, *Angsst*, apparently more coherent, is laden with potentially symbolic and contextual cues referring to apartheid. It is very much like *Die Moord*, constantly alluding to what is not there, consistently negating itself and thwarting audience expectations conditioned by convention.[8] Indeed, the full meaning of these films only becomes apparent on an *auteur* analysis which relates the text to the personality of the filmmaker.

Fugard's People (1982) and *Athol Fugard: A Lesson From Aloes* (1980) reveal the man through a close examination of his work, his directing methods and origin of the ideas which inform his theater. In the former film, clips from his plays and films are intercut with interviews with Fugard. The latter film, made for the BBC, exposes the fears, traumas and trepidations

of the actors as they rehearse the play. The documentary becomes itself an allegory of repression and state invasion of individual privacy.

On video is *The Story of Sol Plaaitjie* (1981), a rather static examination of an early black writer. In total contrast is *I am Clifford Abrahams, This is Grahamstown* (1984), an investigative *cinema verité* documentary which breaks stylistic conventions, not least of which is the payment—on camera—of the narrator/subject, Clifford Abrahams. The usual separation of subject and production crew is abandoned, and the result is a cinema of deconstruction. Abrahams leads the crew and the viewer to a unique "street" view of Grahamstown, spanning black, white and coloured geographical areas and social spaces. Abrahams narrates his life in the places where he begged, sold newspapers, slept out under bushes and in old wrecked cars. Beaten by his father, grandfather, police, and employers since the age of ten, he has maintained his humor as a defense against a harsh environment. The camera reveals the paternalism and brutality of white Grahamstown and the pressures on blacks through his interactions with the population of the town.

The films of Andrew Tracey on Chopi music are the most well-known South African ethnographic cinema. More recent productions include those made on Super-8 and three-quarter inch video.[9] Some of these have attempted to document cultural responses by blacks to apartheid and come closest to an understanding of both ethnography and cinematic techniques and styles of production.

Ethnographic film is not radical film because it seeks to document rather than provide strategies for resistance. The documentation may itself deal with those strategies, such as the video, *Shixini December* (1984), which shows how the traditional beer drink has become a means of maintaining social cohesion in the face of the destabilizing effects of migrant labor among the remnants of a subsistence economy in the Transkei. Such films may be perceived as "oppositional" in character because they question conventional wisdom and accepted myth.[10]

Films falling into the category of counter-culture and metaphysical explorations place themselves in a context which is closer to U.S. West Coast counter-culture than anything local.

These films lack indigenous symbolism and draw their images and themes from the *Easy Rider*-type cinematic culture. Examples are Cedric Sundström's *Suffer Little Children* (1976) and John Peacock's *A Certain Delegation* (1976), both made in 16mm. *Suffer* is set in a Crown Mines village in 1934, but is a macabre re-enactment of the Biblical martyr, Stephen. Peacock's film deals with the "plastic society" and the violence individuals impose on themselves through technology. A number of others made on Super-8, for example, *Freedom O* (1972) and *The Surfworshippers* (1973), show alienation, death and rebirth. In the former, the characters wrestle with drugs and the "freedom" of the open road, while the latter deals with the compelling, almost religious cult of surfing.

The transformation of short stories into films which explore the South African milieu are seen in Cedric Sundström's *The Hunter* (1974), based on an Olive Schreiner story, and Lynton Stephenson's *Six Feet of the Country* (1977), based on a Nadine Gordimer story. Although made under all the difficult constraints which face the independent filmmaker, the latter film was successful as a pilot on the basis of which a further five Gordimer stories were filmed in 1981/82. Financed by a German consortium and filmed in South Africa and Kenya, they have been screened in several nations but only shown at film festivals in South Africa. One program, *Chip of Glass Ruby,* remains banned, though initially three were assigned this status. Other than the producer and Peter Chappell, who directed *Oral History,* the crews consisted entirely of South African technicians.

The censorship issues which arose with regard to the Gordimer series have already been discussed. The producer had to contend with censorship and security police surveillance. The German executive producer was denied access to South Africa. The production company was registered in Lesotho to obviate the cultural boycott against South Africa and to take advantage of the financial rands incentive existing at the time. This was the only form of subsidy available to the company as the films were not feature length and therefore unlikely to be screened in cinemas even if accepted by the major distributors.

Though a challenging and exciting series, certain recurring themes and character treatments caused considerable unease

among foreign film festival audiences. These concerned the portrayal of the lead women characters by the various male directors. *City Lovers,* for example, was accused of being "racist" and "sexist" by certain members of the audience attending the Amiens Film Festival in France in 1983. While it was clear that these viewers had misinterpreted the subtleties of the relationship between the white German immigrant and the coloured cashier, the accusations of sexism were less easy to counter. An analysis of *Country Lovers* will explain the cause of this problem. The white farmer's son falls in love with a black female farm laborer. They have a child. In order to hide his fall from grace, the farmer's son poisons the baby, and his father sends the woman's family away. The narrative is told from the male point of view, the woman is merely the vehicle for the story. Shot mainly in close-up and mid-close-up, the son's reactions are dominant. Alternatively, the audience is presented with point-of-view shots which originate from the protagonist. The film is shot in flashback, and the first shots establish this male perspective. As one female critic puts it:

> If we are male, we could, presumably, easily identify with the male's dilemma: the threat of emasculation (linked with Nationhood through images of the gun, and references to the vote, his father's Afrikaner history) by "lowering" himself by having an affair with an "unworthy" woman. In South Africa, matters relating to colour take precedence over class, so the woman is "unworthy" because she is black. This adds the further dimension of bringing the *Volk* down—miscegenation would lead to the end of the line which the protagonist's father is keen to preserve.[11]

Essentially, the cinematic emphasis is displaced from the interracial love affair to a plot structure which tries to explain the reasons for the now young man's return to the farm. Because the film appears in flashback it becomes necessary to explain the cause of his reminiscences in the empty farm house rather than to examine the human and social relationships set in motion by their love affair. The farmer's son thus takes on a significance beyond

himself, as a representation of Afrikaners, rather than as an individual caught up in "deviant" sexual behavior. The characters become vehicles to describe a political situation.

Because the farmer's son falls in love with the black woman, she becomes the object of his desire and in so far as the audience is positioned to view from his perspective, she becomes the object of its gaze. This is a male gaze, as all the sexual or vaguely erotic scenes are filmed to stimulate male desire. For example, when the son first sees her climbing down the ladder, the camera (he and the audience) focus on her leg: in the dam scene, she tucks up her skirt and there are close-ups of her legs. Male viewers are thus placed in a voyeuristic position vis-à-vis the action on the screen. That this male emphasis occurs in films made by different directors does not necessarily locate the problem with the writer. It would appear to rest more with the conventions of film-making where the director is unaware of the sexist nature of many of the techniques so often taken for granted. Garden's accusation that the "lack of latitude, and Gordimer's slavish adherence to form and content of the original stories, has made the films stilted and unnatural" may have some validity at the level of performance, but this does not account for the sexist nature of much of the camera framing and editing selection.[12] It was the directors who did not follow through the raw material provided them by the scripts. Had the camera made ironic use of the male gaze to make an anti-sexist statement, the series might have more faithfully reflected Gordimer's original written treatments. This kind of problem has more to do with a lack of knowledge about the *ideological* effects of cinematic techniques on the part of the technicians than with Gordimer's alleged interference.

Social documentaries both challenge the *status quo* and reflect the way in which certain organizations are coping with oppression. Most of these films or videos are made within conventional documentary frameworks, accepting implicitly the raw material presented to the camera without question. Content ranges from highly structured documentaries such as *This We Can Do For Justice and Peace,* which outlines the efforts of the South African Council of Churches (SACC) to combat structurally induced poverty and the appalling consequences of

state enforced resettlement, to Grierson-type documentaries of student demonstrations (*Wits Protest*) and on-camera harangues by resettled homeland dwellers (*Place of Tears*).

Wits Protest, made between 1970 and 1974, was shot on Super-8. Music and commentary were added in the post-production stages. At that time single system direct sound cameras were but a dream. Although *Wits Protest* had not been screened on television, it has been seen at a number of local universities and churches and by overseas groups. The intention of its makers was both historical and functional. During the production period, the film served to communicate what was happening on campus in a manner not available through existing channels. As the events of 1972 unraveled, for example, footage of the police/student confrontations was screened in an unedited state within one or two days of their occurrence. *Wits Protest* started from a straight "objective" style but became more expressionistic as the camera took the point of view of the students. In so doing, *Wits Protest* presents a dramatized documentary. Its participatory style is a conscious and deliberate choice on the part of its makers.

Another film dealing with protest is *You Have Struck a Rock* by Debbie May, which follows the actions of black women during the 1950s in their protests against the mandatory carrying of passes. A rather confusing film to audiences not aware of the momentous history of black repression in South Africa, the film does hint at the double repression suffered by black women through the indifference of black men to their efforts.[13]

The Community Video Resource Assoc. (CVRA) of the University of Cape Town is very active in highlighting particular features of ongoing trade union campaigns. One example is *Passing the Message,* a video made by the South African Food and Canning Workers' Union during the nationwide Fattis and Monis strike. Video was employed to pass messages from the workers in Cape Town to their families in the Ciskei and vice versa. This occurred at a time when many had lost contact with each other and worked to keep channels of communication between the migrants and their families open.

FOSATU: Building Worker Unity documents a non-racial socialist-oriented trade union federation. Though attempting to

contribute to revolutionary action, it fails dangerously, as it is a hodgepodge of incompatible codes and muddled techniques. While context is provided, the narrative relies on verbal codes which are seldom connected to the image. The narration, for example, tells of workers on strike, but presents shots of them working. People within the film are not always identified and many who are working towards a socialist economy are paradoxically portrayed as sinister conspirators hiding behind white skins and dark glasses.[14]

The vast majority of films concentrate on urban communities. This geographical bias is inevitable given the urban location of universities, film and video facilities and technicians. It is, however, paradoxical, in that the cities have become the points of [limited] reform and co-option of the other than white working and middle classes. While there is a struggle in the cities being negotiated through the mechanisms of trade unionism and political groupings like the United Democratic Front and National Forum, it is rural dwellers and marginalized black population who are largely engaged in an unequal struggle for survival itself. Videos like *The Tot System,* which shows how coloured wine farm laborers are held in an alcoholic subservience through wine rations in lieu of some wages, *Kat River—The End of Hope,* which exposes the futile efforts of a coloured peasant farming community to prevent dispossession, and *Shixini December* which documents ways of coping with the stresses caused by migrant labor, are under-represented in their concern for a rural and homeland perspective. The videos commenting on urban issues, though appearing to offer counter-ideologies, often build inconsistencies into the assumptions of their texts. What is omitted from the latter videos is an examination of the *relationship* between the urban events documented and the processes operating within the political economy as a whole. The urban-rural connection is ignored as these videos highlight events at the expense of ongoing social processes. *Future Roots* accomplishes the process most successfully, exposing the structural constraints of bottom-up development strategies. By concentrating on a specific scheme in the Ciskei, the producers argue that they are designed to reduce social and labor costs of mining and industry in the white areas

by creating the conditions for a viable subsistence economy in the homeland. This video, as with *Shixini December,* is clear as to the relationship between the micro and macro elements of the political economy.

Class analysis is also often lacking. An example is *Mayfair,* which deals with the responses of Afrikaners, Indians and coloureds who live in this multiracial suburb, to the government's announcement that it is to be declared an Indian Group area. This video never explains causation or context: how did this suburb become multi-racial in the first place? How did the extreme right-wing racist Afrikaners come to agree to living among people they hate and typify as "foreigners"? Why are significant numbers of this integrated community standing together to resist the government decision? And above all, why are whites going to be moved—the first time this has ever happened to an originally white area?

The producers of *Mayfair* should have examined the context of the shifting class structure which created the conditions for unexpected government action on Mayfair. The analysis would have had to take account of a maturing economy which needs more skilled labor and professionals. This has led to the co-option by the state of the Indian and coloured "population groups" which, together with the alienation of right-wing Afrikaners from the National Party, has resulted in a new political alliance. In a similar vein, *Awake From Mourning,* which documents the role of black women in building community cohesion and providing much-needed social services following the 1976 Soweto disturbances, misrepresents the economic determinants of apartheid.

The question of context is crucial, particularly where the state filmmakers have tried to mystify historical process through engaging the images of oppositional filmmakers, reinterpreting them, and then representing them to both local and international audiences as "communist propaganda." The images of oppositional filmmakers have proved susceptible to co-option by the repressive agencies of the state. Not only have the images of films like Nana Mahomo's *The Dumping Grounds* and *Last Grave at Dimbaza,* amongst others, been turned against the oppressed in state-sponsored films like *To Act a Lie,* but they

have been submitted by the security police as evidence to com-
missions of inquiry designed to intimidate dissident organiza-
tions. This occurred with *This We Can Do For Justice and Peace,*
which was passed by the Directorate of Publications on the as-
sumption that its "biased" and "one-sided" message would prove
to be counter-productive to the South African Council of
Churches (SACC) at a time it was undergoing intensive state
scrutiny. Furthermore, the security police edited together clips
from a number of "anti-South African" films, including *Justice
and Peace* and submitted them on an edited videotape which
collapsed the various films into one another. The resulting
combination presented the appearance of a continuous program.
Some accusatory editorial comment was added and the result was
presented as evidence against the SACC.

RADICAL CINEMA

"If video is to become cultural action for freedom,
its core problem emerges as one of method."

PETER ANDERSON[15]

If the state has outmaneuvered oppositional filmmakers in
terms of the conventions of documentary, it becomes necessary
to explore dialectical forms which should be designed to minimize
the possibility of co-option. Few of the above-mentioned social
films provide historical or geographical contextualization. Even
fewer employ reflexive techniques which identify the ideological
position of the producers in relation to the working class struggle.

One video which is sensitive to dialectical coding, tech-
nology and the trap of conventional approaches is *Kat River—
The End of Hope.* This video offers a detailed historical-
geographical analysis which clearly locates the interviews within
their class contexts, and the relationship of that context to capital,
the state and dispossession. Another is *I am Clifford Abrahams,
This is Grahamstown,* a participatory *cinema verité* documentary
which, at the level of appearance, works as a biographical docu-

mentary. The presence of the crew is stamped into the image and the sound, and the central character, Cliffie, a down and out alcoholic coloured raconteur was also consulted during the editing phase. At a deeper level, the result is an exploration of interacting social, political and economic conditions which locate Cliffie within a particular class fraction. The video shows how he makes out through a number of survival networks which span the black, coloured, Indian and white areas of the town. The reflexive techniques used by the crew make visible their own assumptions and methodology presenting not a camera determined "truth," but Cliffie's interpretation of it.[16]

Analysis of the fourteen films and videos presented at the Carnegie conference on poverty in April 1984 suggests that not only do the majority of these practitioners have little theoretical cinematic or video understanding (though they do have an understanding of social process), but they also have yet to master the basic techniques and conventions of structured documentary. The films exhibited a minimal awareness of how the conventions and techniques employed could be co-opted by vested interests or how they might lead to confused interpretations on the part of even sympathetic audiences. Only *District Six* offered contextual information with largely matching visual material. Most of the others simply attached historically sensitive verbal information to irrelevant and distracting visual material. If filmmakers are going to engage the state in terms of the dominant documentary form, they must at least have a knowledge of that form.

CHAPTER ELEVEN

SOCIAL POLARIZATION

"South Africa is a society where prejudice is ingrained . . . and racism is in the air you breathe. Before you can begin to break free, you have to learn to breathe anew. Even when you have done that, even when you under-stand what you have been breathing, you are still inside that damned society, and you have no choice but to breathe its poisonous air, even when you do it festidiously."

PETER DAVIS, *Cineaste*, V. 14, N. 1, 1985

Writing about the film industry is one thing, writing about the South African film industry is another. Like Alice's experiences in Wonderland, everything in South Africa constantly changes, but nothing is different. Certain central city cinemas, for example, were opened to all races in October 1985. But this status, like other racial exemptions, is by permit applied for by individual cinemas. It is not an inalienable principle. At the national level, the State President constantly regaled the nation about "negotiation," but then sent the troops into the black townships. He talked about democracy and waited for black leaders "to come forward." But they were all in deten-tion, in prison or exiled. Such rhetoric has become known as Bothaspeak.

Speculation on aspects of the future of cinema in South Africa could lapse into idealism, but certain things need to be said if only to identify possible directions and to suggest tentative solutions for the building of a democratic society. Unfortunately,

social scientists don't have the poetic license of filmmakers, so unlike *The French Lieutenant's Woman*, this conclusion has only two possible endings or scenarios, both horrific:

(a) repression on a vastly increased scale on the part of the state, leading to complete totalitarianism and international isolation, or

(b) an intensified civil war with the ANC and state as protagonists, with a growing polarization between pro- and anti-apartheid positions within the country. The internal and external pressures on the state will become so immense that it will eventually collapse. Exactly when is impossible to predict. Whatever adaptations the government makes will be too late, and in any case, there is little doubt that they will continue to be made within an ethnic framework. The period following the fall will probably be no less repressive, as civil war will have to be contained. The extreme Afrikaner right-wing is already mobilizing and has been responsible for acts of sabotage against both white and black dissidents; on the Left, black expectations will not be met with immediate effect, and this may lead to rising discontent and civil disturbances.

To assess the probable role of the South African film industry in either of these two scenarios we need to examine some of the processes that have occurred in the industry since 1984. Sabel has been taken over by vice capital in the form of London based Kersaf, which is owned by Sol Kerzner, a South African casino and motel magnate.[1] Cinema was thus rushed to the white-owned hotel industry in the "homelands," which house various activities banned in white South Africa such as casinos, soft-porn movies, and nude reviews. The surpluses generated by the vice industry have been such that Kerzner was able to take a controlling interest in Satbel and its subsidiaries, Ster-Kinekor, SA Film Studios, Irene Film Laboratories, Video RSA and Ovation Recording Studios towards the end of 1984. This acquisition placed the newly-born Kersaf alongside three of the four power blocs in South African private enterprise.[2] Hotelling and cinema require similar marketing and management strategies and this purchase

consolidated Kerzner's hold over the "leisure" industry.

The ideological implications of the Kersaf takeover are stupendous, connected as Kerzner's operations are with the homeland economies. The homelands are little more than labor reservoirs with little or no industrial capacity. Hotelling in these areas, initially tied to English-dominated South African capital, is increasingly connecting with international capital through Sun International, the holding company of Kersaf, also based in London. The casinos not only fulfill a vicarious function for white South Africans "chasing wealth and the sun," and ascribing soft porn movies "art" status, but they "prove" (to white South Africans, if nobody else) the independence of these "nation-states." These same vices are not permitted in "white" South Africa where censorship, though now less rigorous as far as sexual depictions are concerned, is still very strict in comparison to other Western countries.

Another development relating to the homelands concerned a report about Supracorp International intending to establish a R2 million film animation industry in the tiny homeland of KwaNdebele, employing 350 people. Supracorp, connected to Israeli capital which has been exploiting the homelands in a big way, is also connected to hotelling through the provision of television sets in many homeland hotels. The investment covers studios, equipment and initial training. Scripts and storyboards for animated features will be sent from the United States to KwaNdebele for labor-intensive detail drawing, coloring-in and photography. Processing is to be done by Irene Film Labs. This investment obviously benefits from the massive devaluation of the rand that occurred after the declaration of the state of emergency in June 1985, but also from the ultra-cheap labor to be found in the homelands, not to mention tax incentives and tempting government subsidies for companies locating in these areas. Ami Artzi, chairman of Supracorp, has stated that, "local costing structures will enable us to compete with countries in the Orient, such as Japan and Korea, which at present get most of the international animation production business."[3] Supracorp will no doubt save millions on its production through this intercontinental decentralization of specific stages of production. The labor will be ultra cheap as it is doubly repressed,

by both the homeland and South African governments. Unions
are banned in most homelands, so the workers have to take
what they can get, no matter how poor the pay or unpleasant
the working conditions.

The fall of the rand from $1.30 in 1980 to less than thirty-six
American cents by the middle of 1985 made international film
production very cheap in South Africa. Not only was it ex-
pected that Kersaf would exploit this exchange rate by encourag-
ing big budget film production in South Africa, but that it
would take advantage of this means to move its South African
generated capital out of the country by reaping its dividends
elsewhere in more stable economic environments. In terms of
exhibition, the return to overseas distributors fell to one-third
of what it used to be before the fall of the rand, barely a few
months earlier. The South African market dropped from Ameri-
ca's 11th most profitable, to 17th. International distributors be-
gan to feel that their reduced profits from South Africa were
not worth the trouble of doing further business. During previous
times of crisis, international projects have been cancelled. Fol-
lowing the unrest during 1976, for example, Hertzlia Lab-
oratories, an Israeli concern, cancelled plans to install a processing
facility in Johannesburg.

The industry could survive under a totalitarian regime, pro-
vided a more equitable exchange rate comes about. This could
happen if the government succeeds in blocking reporting about
sabotage and civil disturbances and if it is able to manufacture
an international image of stability and order. This is not likely
as it appears that the government has lost control of the Police,
while the Defense Force seems determined to embarrass the
Department of Foreign Affairs by engaging in what it calls
"hot pursuit" into neighboring territories. Both agencies seem
intent on sabotaging not only the ethnically based reforms enacted
by the National Party since late 1983, but also engaging the
Soviet Union, Cuba and Angola through continuing military
offensives into Angola, while apparently continuing with its
destabilizing strategy in Mozambique, in defiance of the govern-
ment's attempts at peace making. At the time of writing, the
pro-ANC Lesotho government had fallen, while Botswana also

offers a target for its harboring of ANC activists and South African refugees.

The feature film industry has not been slow in lending its facilities for the persuasion of local white audiences about the legitimacy of ethnic solutions, the racially tiered tricameral parliament and "military preparedness." During the mid-1980s, a series of movies were made which, more than ever, deliberately set out to legitimate current political processes and the militarization of South African society. In *Broer Matie* (*Soul Brother*—1984), Jans Rautenbach regurgitated his inter-racial themes of the late 1960s. The film is about the struggle in a Dutch Reformed Church congregation over the acceptance of a "coloured" preacher. The mesage is that "coloureds" should be grateful to whites for including them in the "new dispensation." *Die Groen Faktor* (*The Green Factor*—1985) is a hard hitting satire in which a white National Party candidate turns green through an accident with a bowl of green punch. The "greens" are ostracized by white Afrikaners who classify them "non-white." The malady is contagious, and eventually even the prime minister turns green. His solution: "The question is, what are we going to do with the whites?" Despite the satire, the ethnic solution prevails. Pieter-Dirk Uys's *Skating on Thin Uys* stars a caricature of a South African ambassador in a fictitious homeland who marries the black chief's son to secure newly discovered oil for South Africa. While Afrikaner heroes roll over in their graves at this economic expediency, the plot resolves itself in a political manner that befits apartheid.

Two films which did exceptional business, *Boetie Gaan Border Toe* (*Brother Goes to the Border*—1984) and *Boetie op Maneuvers* (*Brother on Maneuvers*—1985) are more chilling. Made with SA Defense Force help, they exhibit a new generation of technical, textual and propagandistic competence. It is difficult for even anti-conscription viewers not to identify with the "troepies" (troops) for they send up authority and defy instructions. However, the troops and the NCOs discover their comradery in the heat of battle against the invisible "enemy." The baptism of fire turns them into men and galvanizes the forces of civilization against communist abstractions. *Jantjie Kom Huis Toe* (*Jantjie Comes Home*—1985), a made-for-television

movie is about a "coloured" drifter who joins the army and saves a white family on "the Border" from a black "terrorist." He is allowed to be seen on television, even on the Afrikaans channel, as "coloureds" are now part of the "new dispensation."[4]

Films produced for local white audiences will continue to endorse dominant Afrikaner Nationalist perspectives, while racially sanitized cinematic reworkings of television comedies will provide the light relief needed by white audiences in times of crisis. (It is in these parochial army and comedy films that Satbel continues to co-invest under Kersaf ownership.) Afrikaans, and most of English-language cinema under either future scenario will continue to provide both legitimation for National Party political structures and escapism from the inevitable socially destabilizing effects of those structures.

If the "white" industry has reduced its cinematic output to four or five films a year, that sector of the industry making films for black audiences has burgeoned. More than 130 very low budget films were made in 1985 by a handful of producers, few of whom employ talented technicians. Many of these films exhibit an indescribably poor technical quality and often are unable to reproduce even the most cliched conventions in a convincing manner. Each of these films earn R80 000 subsidy from the government on reaching a threshold of 400,000 viewers. As the state heads for large scale bankruptcy, it is unlikely that the subsidy will continue to be paid out quite so easily in the future.

In August 1985, the Department of Trade and Industry enacted a new set of subsidy regulations. The minimum duration is now 70 minutes and scripts and budgets have to be submitted to the Department in advance of production. Super-8 and video transfers to 16mm no longer qualify. A subsidy of 14 cents per ticket sold is now being paid on production costs only (not distribution and advertising as was previously the case). The maximum subsidy payable now is "its actual audited production costs incurred until the date of release, plus 25 percent, up to the maximum of R80 000.[5] In addition to the audit, a declaration by a Commissioner of Oaths is required as is a Certificate of Approval by the Directorate of Publications. These measures are aimed at encouraging producers to spend more on individual

films; reduce the clear subsidy profit paid out on a film; lessen the incidence of falsification of ticket returns and other dishonest practices, and ensure larger audiences. The total amount available for subsidy is pegged annually.

This pattern of making films for blacks may well be but a moment in the sorry history of the South African film industry. Despite a phenomenal output, such films remain marginal to the industry proper and few of their producers have been accepted by SAFTTA, though the SA Film and Video Institute has recognized some. While the Department's new subsidy regulations might reduce the number of incompetent producers entering the industry, it will have little effect on the racist content of the films. Technical quality will improve, allegations of fraud will decrease, and the state will be more satisfied with its administering of the scheme, but this sector is likely to remain marginalized.

SAFTTA continues in its contradictory way, not really sure whether it is a workers union or a craft guild. While *The SAFTTA Journal,* edited by an autonomous editorial board, continues to explore the political debates surrounding the industry (cultural boycotts, critiques of conventional practices, etc.), issues with these themes come in for considerable criticism from some technicians, the SA Film and TV Video Institute and some advertisers. Complaints about its "political" content were rife; however, the SAFTTA Council—after considerable persuasion—agreed to continue publication.[6] The remaining industry magazines, *SA Film and Entertainment Industry* and the host of tabloids that have appeared in recent years continue to blandly reproduce the public relations handouts supplied them by their advertisers. As a union consisting mainly of middle class individuals, SAFFTA's membership represents a minority of South African technicians (180 out of about 1000), though it does represent the majority of freelance personnel. The radically inclined leadership of the late 1970s and early 1980s has given way to a conservative liberal group. Given the largely white make up of the industry, this orientation is likely to continue. Black technicians are mainly employed by SABC-TV and are wary of joining any organization which appears to be in conflict with the state.

One impetus to the exhibition sector pressing for multi-

racial status for its cinemas was the growing momentum of the
divestment and boycott campaigns overseas. In 1985 Woody
Allen banned three of his films from being distributed in South
Africa (though paradoxically in the week he made his announce-
ment SABC-TV screened *Play It Again, Sam*). This was the
first time one of the big American companies had agreed to
the inclusion of a clause agreeing to a boycott.[7] Vanessa Redgrave
followed suit in December 1985, refusing to allow *Whetherby*
to be screened other than at non-racial film festivals in South
Africa. Other filmmakers who apparently support the boycott
vigorously include Jane Fonda, who was turned back from Jan
Smuts Airport after being invited for a lecture tour by the
National Union of South African Students in 1982, and director
Richard Attenborough, who was hounded in the most vicious
way by the SABC when he visited South Africa in 1984 to ob-
tain information for a planned film on Steve Biko. In January
1985 Ster-Kinekor acknowledged that they hoped that their ap-
plication to open all cinemas and drive-ins to mixed audiences
would reduce the threat of the cultural boycott.[8]

While white South Africans continue with their heads in
the cinematic sand, foreign producers are cashing in on South
Africa's international visibility and making the kind of films
that South Africans should be making. Andre Brink's novels are
again under consideration. Sponsored by the French Ministry of
Culture, a French film company will make a film of *A Dry
White Season,* dealing with the death in detention of a black
activist; a Dutch filmmaker, Fons Rademakers, intends producing
An Instant in the Wind; a Belgium-Holland production has
been made of J. M. Coetzee's *In the Heart of the Country,* titled
Dust in Spain; and Richard Attenborough has completed a
film on Steve Biko, the Black Consciouseness leader who
was tortured to death in detention. British television is doing
more for South African cinema than any local organizations,
the BBC having partially financed Fugard's *The Guest* and
Marigolds in August (and a number of Fugard plays), while
Channel 4 is looking at J. M. Coetzee's *The Life and Times of
Michael K.,* directed by South African Cliff Bestall, and a
number of short documentaries. The producers of many of these
films were unable to persuade local investors of the worth of

the projects, including the high earning *Breaker Morant* (1982).

South African themes have also attracted large budget producers. Trevor Medal-Johnson's *Always*, a novel on reincarnation, was filmed by Cannon in London as *Deja Vu*, but was banned in South Africa for its strong language. Meanwhile Cannon intended shooting three large budget films in South Africa by 1987. Pure Gold Film Enterprises announced its intention in July 1985 to finance a film on Joseph Menegele and one on the airlift of Jews from Ethiopia, while Anant Singh, a South African "Indian," plans to follow up his "first SA adult movie," *Deadly Passion*—a very, very soft porn film set nowhere in particular—with a R3 million film in the *Beverly Hills Cop* mold. The film is to be shot in New York and involves a New York policeman who tracks down a South African criminal.

International production partly financed by South African investors was put onto a new footing by Cannon Films which made numerous large budget productions in Zimbabwe, but using mainly South African expertise (e.g., *King Solomon's Mines, Allan Quartermain and Lost City of Gold*). Cannon opened an office in Johannesburg in May 1984 and immediately teamed up with Hill Samuel, a reputable South African merchant bank, and a well known tax and accounting firm. Negotiations with the Commissioner of Inland Revenue resulted in favorable tax breaks on films made for export. The double deduction allows marketing expenses to be deducted against tax as a normal business expense and then allows 75-100 percent of those expenses to be deducted again. This creates a shelter for other earnings by those enterprises by allowing them to reduce taxation on other earnings to the value of the deduction. The bookkeeping intricacies are immense and no-one can say whether Cannon's activities will lead to the development of the local industry, or whether it is "just working the territory." Cannon's business approach is in marked contrast to the international co-productions made towards the end of the 1970s which resulted in an overall loss of more than R20 million to local investors through sharp accounting practices. It could herald the use of South Africa as an international location and finance source. South African entrepreneur Tony Factor has teamed up with Michael Klinger and plans to raise R75 million locally and abroad

for turning four Wilber Smith novels into films. Paradoxically, Kersaf had not moved on international film production as late as 18 months after the takeover.

Many of South Africa's most innovative filmmakers are in exile, and much of their most challenging work is never shown in South Africa. Lionel Ngakane, an actor who has made a film on Nelson Mandela; cameraman Ivor Strassbourg, executive producer for the International Defense and Aid Fund; Barry Feinberg; and directors Ross Devenish and Chris Austin all live in London. Althol Fugard and Hugo Cassirer spend most of their time in the United States. One oppositional filmmaker who worked on video and Super-8 left the country to prevent his subpoena to a treason trial where his material was expected to be used in evidence, while numerous others are prohibited to immigrate or visit (e.g., Peter Chappell and Peter Davis). Nana Mahomo and Wally Serote live in Botswana. Mark Kaplan of the CVRA was deported to Zimbabwe, and the remaining filmmakers who set themselves against apartheid are subject to continued police surveillance and harassment. There are the 60 or so documentaries on South Africa made by nationals and non-South Africans that have never been seen locally.[9] Of the South African features made in 1985 only *Mamza,* which explores the struggles and conflicts of its various characters in overcoming the hardships and injustices in a township milieu stands out.

While repressive state action has devastated the more radical types of film-making, other processes are at work from which an emancipated film practice may emerge to play a crucial role in a liberated South Africa. This kind of production exists as an adjunct to community organization, where the progressive media provide vehicles for black, coloured and Indian community struggles against apartheid in the context of the national struggle.[10] These films and videos are made to facilitate links between and within organizations and communities. As formal production becomes more and more hazardous, "trigger videos"[11] where small units respond to the immediate needs of organizations, facilitate short term interventions to alert people to specific situations. Most media workers functioning under these conditions tend to regard themselves as organizers first, and video/filmmakers second. During the 1970s, *Wits Protest* ap-

proximated this task as far as students were concerned; now small format video makes this process much more immediate, accessible and appropriate on a much wider scale. National distribution is not considered important, even on alternative circuits, because the needs of national audiences differ in terms of the variety of conditions and legislative restrictions operating on the different "race" groups, classes and residential areas. It is much more pertinent to "localize" around particular struggles in specific areas.

Progressive video production democratizes the production process and the subjects are the makers and very often the audience as well. This encourages a "bottom-up" flow of concerns and production methods from individual communities to the wider social networks involved in the national struggle. While this kind of production and distribution has all the attendant problems of transport, liaison, electricity, inadequate projection facilities, poor signal quality, and police surveillance, this grassroots response will hopefully lay the foundations for a democratic media infrastructure which will sustain the popular organizational networks binding the individual communities to the national struggle in the short term. In the longer term, such an infrastructure could provide the basis for a reorganization of the currently authoritarian market related industry and provide cinematic access to all sections of our society.

Film and video, because of their costs, cumbersomeness and time needed for production are less important than other media such as the progressive trade union, community and student presses which are more suitable for the development of progressive democratic structures in the time of unparallelled repression and crisis that faces South Africa today.[12] However, the debates going on at present over the nature, structure and style of production in film and video at the various levels of struggle are crucial to the form that future media networks might take in a liberated South Africa. The debates relate to questions of (a) production strategies; (b) form of content; (c) structure of distribution and exhibition networks; and (d) the problem of alienated labor.

Progressive filmmakers have always had to contend with police surveillance and interference. In South Africa, however,

it was rare that filmmakers were raided, their material confiscated or that they were detained. This changed in 1980. Police raids of video-producing groups became the norm. In line with the crude and deterministic equation by the state of the United Democratic Front with the ANC, the South African Communist Party and Moscow, it appears that the Police see a communist conspiracy behind any progressive media. According to one ex-detainee, it would appear that the Police have assumed that video workers are getting direct instructions from hostile organizations outside South Africa. The state seems unable to comprehend that local inhabitants are organically responding to inherent injustices and are not puppets of external "agitators."

The raids on Afroscope, Afrapix, IMP and the confiscation of video cassettes from foreign television crews, detention and lengthy interrogation of media workers between early 1984 and early 1985 was probably part of an information gathering phase by the police to work up a case against UDF activists facing various treason trials across the country. By insisting on conspiracies where none exist, by looking for individual agitators where there are none, the Police have lost their investigative initiative. Despite the detention of over 7,000 people during the six months following the declaration of the state of emergency in June 1985, the Police were unable to bring successful court actions against activists, or to crack the "conspiracy." They have responded with unprecedented violence, torture and apparent wanton killing of even non-participant black bystanders.

As the 1980s came to an end, progressive film and video activity was literally under siege. However, anti-apartheid documentary films for outside consumption (e.g., *Witness to Apartheid*), continued to be made by independent filmmakers. In the face of government banning of cameras in "unrest" areas, these films will continue to provide the background to the dramatic news events reported on television and in newspapers. They remain a vital link between those in the front line of the struggle in South Africa itself, and those outside of the country who support liberation in South Africa.

The years 1986 and 1987 will likely prove to be a turning point in the history of South African cinema. These two years saw the unexpected production of a number of feature films

which for the first time critically examined the South African milieu, apartheid, war, racial brutality, and colonial history. The new cinematic wave followed the change in Satbel's ownership, the arrival of young and dynamic filmmakers unafraid of politics, and the new willingness of the cinema chains to screen contentious South African material, for both commercial and political reasons. Although both CIC-Warner and Ster-Kinekor had previously shied away from "political" films, they finally recognized their sales value; in addition, the screening of these films might project a more progressive image and undercut the threat of an international cultural boycott. The new film wave took advantage of changing industrial attitudes by offering works on subjects involving historical depictions of black-white conflict and friendship (*Jock of the Bushveld*), the brutal treatment of farmhands by some Afrikaner farmers (*A Place of Weeping*), the effects of war on whites (*'n Wêreld Sonder Grense*—A World Without Borders), terrorism (*City of Blood*) and the trauma of inter-racial conflict (*Saturday Night at the Palace*).

Along with the emergence of the new wave, independent anti-apartheid filmmakers organized to develope structures and strategies for a post-apartheid cinema. A second intention in creating a democratically constituted base was to enable filmmakers as a progressive collective to be drawn more directly into the broader struggle which itself was being waged at grassroots levels. This has been achieved through national organizational structures such as the United Democratic Front and the giant black worker organizations like the Congress of South African Trade Unions. Thirdly, the existence of a proposed film institute with a popular mandate would facilitate channels of communication and negotiation with external anti-apartheid bodies and liberation movements about issues like the cultural boycott, external training and filmmakers, distribution of films and other issues. The emergence of an institute at this time is crucial as the ANC's absolute boycott principle shifted to a strategic application where domestic South African cultural organizations are now being consulted on their ideas and strategies. Mongane Wally Serote, the ANC cultural representative in London, was reported as saying that the ANC, the broad democratic movement in its various formations within

South Africa, and the international solidarity movement need to act together on the issue. The UDF responded by pointing out that the target of isolation is to be the "regime," not the "people of South Africa."[13]

The idea of an institute followed on the heels of a belated, but much needed, emphasis on the role of culture within the popular movements. With the exception of the Azanian Peoples Organization, a black consciousness movement, culture was an ignored category of struggle. The 1982 Culture and Resistance Conference held in Gaborone, Botswana, and endorsed by the ANC represented the first major attempt to locate media and cultural activities squarely within the struggle rather than on its periphery. The seeds of this conference took four or five years to germinate before internal and exiled cultural workers came together for the first time ever. A sign of the growing awareness of the role of culture and struggle is the establishment of an ANC film unit in Lusaka, Zambia. As filmmaker Lionel Ngakane puts it, "The ANC is now taking cinema very seriously ... for audiences outside of South Africa."[14]

The sudden spurt of intelligent South African-made feature films and documentaries held their own in an avalanche of exploitation films about Africa made by Cannon. These films took advantage of tax incentives offered by the South African government and were characterized by cheap production values and racial stereotypes. Such was the original nature of the state's tax stimulus that films scheduled to be made in South Africa by American companies would have cost the government one billion dollars in 1987 alone. In view of this situation, the government had to limit the extent of tax write-offs, reducing them from 700 percent in some cases to 100 percent. At the same time the State President's Economic Advisory Council was investigating the "new" industry with a view to longer term planning. The activity by Cannon and other foreign companies forced the South African industry onto a new financial footing; and for the first time, banks and other financial institutions were brought directly into production.

The National Party remains in power with a stronger white mandate than ever. The neo-fascist Afrikaner right wing with its paramilitary organizations has grown enormously at the same

time that the socialist-oriented black National Forum and the non-racial United Democratic Front, the groups which represent the majority of South Africans, have suffered severe setbacks. The problems of the National Forum and the UDF are a result of mass arrests and detentions and of tactics which have set black right wing factions against progressive black factions in sometimes violent confrontations. Among whites, the political middle ground has moved so far to the right that the National Party is now projecting itself as being *moderate*.

The indications are that divestment will continue. UIP-Warner sold its Metro cinema circuit to Cannon, another American company, in mid-1987, and Warner Home Video facilitated a South African management buyout earlier in the year. The Cannon takeover is opportunistic and probably has little or nothing to do with politics. Yet politics has everything to do with South Africa. Just how the South African industry will define its responsibilities in the worsening political context remains to be seen.

Notes

CHAPTER ONE
CENSORSHIP

[1]Statement made at the Johannesburg Film Society's presentation of the Neil Smith award for the best film screened in Johannesburg during 1979. Excerpts from speech reported in *SA Film and Entertainment Industry,* April 1980.

[2]J. Stodel, *The Audience is Waiting* (Cape Town: Howard Timmins, 1962).

[3]P. Geldenhuys, *Pornografie, Sensuur en die Reg* (Pretoria: Lex Patria, 1977).

[4]I. Wilkins and H. Strydom, *The Super-Afrikaners: Inside the Afrikaner Broederbond* (Johannesburg: Johnathan Hall, 1978).

[5]L. Silver, *A Guide to Political Censorship in South Africa* (University of Witwatersrand: Centre for Applied Legal Studies, 1984).

[6]*Ibid.,* pp. 169-170.

[7]B. Sharp, "Censorship: The Ster-Kinekor View," *The SAFTTA Journal,.* V. 3, N. 1 & 2, 1983, p. 35.

[8]Articles on film censorship and the dangers faced by filmmakers in the course of their practice can be found in *Index on Censorship,* V. 8, N. 4, 1979; V. 9, N. 2, 1980; and V. 10, N. 4, 1981.

[9]G. Moss, "Total Strategy," *Work in Progress,* N. 11, 1980 (Supplement).

[10]Additional Information in K. G. Tomaselli, " 'Adapt or Die': Militarization and the South African Media," *FUSE,* February 1984, pp. 215-218.

[11]*Hansard,* Column 1341, 1963.

[12]Silver, *op. cit.,* p. 195.

[13]Guidelines with regard to Section 47 (2) Act 42 of 1974. Addendum to Appeal Board Case 43/82.

[14]Republic of South Africa, *Report of the Commission of Inquiry into the Publications and Entertainments Amendments Bill* (Cape Town: Government Printer, 1974).

[15]J. Baskin, "Casinos and Development in Southern Africa—a case study of Mzama-Transkei." A paper presented at the Association for Sociology in Southern Africa, University of Witwatersrand, July 1984.

CHAPTER TWO
CONTROL BY SUBSIDY

[1]A. Wassener, *Assault on Private Enterprise: The Freeway to Communism* (Cape Town: Tafelberg, 1977).

[2]J. Fuksiewicz, *Film and Television in Poland* (Warsaw: Interpress, 1976), p. 96.

[3]Republiek van Suid-Afrika. Raad van Handel en Nywerheid: *Ondersoek na die Rolprentvervaardiginsbedryf in Suid-Afrika*. Staatsdrukker, Verslag Nr 1753, 21.12.76.

[4]L. Schauder, "A Film Programme for South Africa," *Trek*, V. 7, N. 22, p. 14; and "Part II" V. 7, N. 23, p. 12. Both published in 1943.

[5]T.W.S., "Afrikaans en die Rolprentbedryf" in B. Kok (ed.), *Afrikaans: Ons Perel van Groot Waarde*. FAK, 1974, pp. 224-239.

[6]Republic of South Africa. *Investigation into Motion Picture Production*. Report No. 1034 of Board of Trade and Industries (Cape Town: Government Printer, 1963), paragraph 59.

[7]Republic of South Africa, *House of Assembly Debates* (Cape Town: Government Printer, June 3, 1938), Column 6367.

[8]Letter, *Die Vaderland*, November 27, 1967.

[9]*Sunday Times*, October 15 and 19, 1978.

[10]*SA Film and Entertainment Industry*, May 1980, p. 5.

[11]This was the first time that the FFPA and SAFTTA had agreed on anything. Discussions were of an informal nature between the chairman and vice-chairman of the FFPA and some members of the SAFTTA Executive Council. The content of this meeting was communicated to the FFPA Executive, who were generally a much more conservative group highly suspicious of SAFTTA, its motives and its actions. These observations also applied to the MPPA, from which the FFPA was born.

[12]Union of South Africa. The Grierson Report. Unpublished 2nd draft, circa 1954.

[13]*Videorama*, V. 2, N. 9, September 1974, p. 3.

[14]Quoted in *The Star*, September 1, 1983.

[15]Board of Trade and Industries, *op. cit.*, Verslag Nr 1753, 1976, paragraph 50.

[16]*Rapport*, June 21, 1981.

[17]Quoted in *The Argus*, October 6, 1982.

[18]*The Star*, March 17, 1980. In many cases overseas companies defrauded local financiers, reducing investor confidence ever further. Also see *The Star*, April 15 & 16, 1980.

[19]*Business SA*, V. 7, N. 4, 1972, p. 60.

[20]L. Friedberg, "SAFTTA, The Industry ... And Foreign Technicians: A Report," *The SAFTTA Newsletter*, V. 3, N. 3, 1977, p. 3.

[21]Interview, 1976.

[22]Unpublished report. Schiess is a stage director.

[23]Tomaselli, *op. cit.*, p. 4.

[24]*The Star*, April 29, 1982.

[25]J.A.F. van Zyl, Report to the Secretary of Industries on the South African Film Industry. September 1980, p. 5.

[26]The latter third of the 1970s saw a shift by distributors of imported films to the greater exploitation of black, coloured and Asian audiences. According to publicist Colin Haynes, many films only became profitable after release to other than white audiences. The parochial nature of most locally made Afrikaans-language films, however, precludes distribution to these audiences.

[27]At no stage in the system of subsidy incentives were distributors or exhibitors encouraged to promote South African films. They can hardly be expected to sustain under-patronized cinemas at the expense of more attractive overseas fare. If the subsidy, however, was of a vertically integrated nature, exerting a

systematic influence on the production-distribution-exhibition chain, the operation of the scheme might be far more efficient while also reducing an accumulation of power in one sector of the industry. This approach does have its disadvantages, however. For example, where subsidies are paid out in compensation for poor attendance, the state should have some guarantee that losses are not incurred through slackness and inefficient management. Further, where the market of origin offers an attractive return no matter what the quality of the film, producers will be less inclined to explore export markets.

[28]Interview, 1976.

[29]This provision allows films made in other Western languages to qualify for subsidy. *Olie Kolonie* was directed by Neil Hetherington. It failed financially. *Amore de Assasino* (1977), directed by Bill Prout Jones (a Hetherington Production) aimed at exploiting the large South African resident Portuguese-speaking population (about 450,000). *Doeie Duikers Deel Nie* (1974), initially a German film, was intercut with Afrikaans clips. Companies making films for black audiences often do not even make use of interpreters. Scripts are written in English or Afrikaans and then translated into the African vernacular by the actors on set.

[30]Letter, *Videorama*, V. 1, N. 3, 1973, p. 6.

[31]The drive-in circuit was largely developed by independent distribution and exhibition companies in opposition to the 20th Century Fox cinema stranglehold. These outlets competed directly with four wall cinemas for audiences.

[32]*Businesses SA, op. cit.,* p. 62.

[33]Indian South African Anant Singh's *Place of Weeping* (1986), about the killing of a black farmhand by a brutal Afrikaner employer, is an exception. This film, directed by Darrell Roodt, was also the first to be released simultaneously in black and multiracial cinemas nationwide.

CHAPTER THREE

FILMS FOR BLACKS

[1]See, for example, Spyros Skouras' comments on the "missionary spirit" of American cinema in the "ideological struggle" against communism and Johnstone's comment that cinema is not *obvious* propaganda in T. Guback, *The International Film Industrty* (Bloomington: Indiana University Press, 1969), pp. 125 & 127.

[2]F. Baer, "The Film and Native Education: powerful vehicle for interpretation of present-day problems," *The Forum*, May 1945, p. 28.

[3]T. Gutsche, *The History and Social Significance of Motion Pictures in South Africa, 1895-1940* (Cape Town: Howard Timmins, 1972), p. 371; and Minutes of the 419th Meeting of the Johannesburg City Council, July, 1922.

[4]*Ibid.,* p. 380.

[5]C. van Onselen, "Randlords and Rotgut, 1886-1903" in *Studies in the Social and Economic History of the Witwatersrand*, 1886-1914 (Johannesburg: Ravan, 1982), pp. 44-102.

[6]Gutsche, *op. cit.,* p. 381.

[7]*Stage and Cinema,* September 3, 1948, p. 39.

[8]TEBA (Employment Bureau of Africa Ltd.), 1983, p. 30.

[9]Untitled document, Chamber of Mines, 1977.

234 THE CINEMA OF APARTHEID

[10]D. S. Deane, *Black South Africans* (Cape Town: Oxford University Press, 1978), p. 161.

[11]*Stage and Cinema,* May 2, 1952, p. 15.

[12]Board of Trade and Industries: *Investigation into the Film Production Industry in South Africa.* Report No. 1753, 1976, Government Printer, Pretoria, p. 27.

[13]Republic of South Africa, *Supplementary Report of the Commission of Inquiry into Alleged Irregularities in the Former Department of Information.* RP 631/1979. Also see the main report RP 113/1978.

[14]Interview, September, 1983.

[15]"*My Country, My Hat*—Keyan Tomaselli Interviews David Bensusan," *The SAFTTA Journal,* V. 3, N. 1 & 2, 1983, pp. 6-13.

[16]Interview, June, 1979.

[17]Lombard, D. H.: Die Ontwikkeling van 'n Rolprentbedryf vir die Bantoe. MBL Thesis, UNISA, 1976, p. 28.

[18]*Ibid.,* p. 24. Lombard points out that in the homelands the breakdown is 30 percent adults and 70 percent children.

[19]*Post* Research Department: A Study into the Attitudes of Black Men and Women Towards Existing Movie Centres, 1977, Photostat.

[20]Interview with E. Sentle, Kudu Cinema, Hammanskraal, 1978. This was substantiated by Wayne du Band of CIC-Warner, though Murray observed that the film was now unpopular as it shows that blacks cannot even defeat a handful of whites and that it assumes that all blacks are inherently corrupt (Interview, March 22, 1984).

[21]Interview, March 21, 1984.

[22]Interview, June, 1979.

[23]Deane, *op. cit.,* p. 162.

[24]Limited university opportunities are available to black students who are admitted to either the Rhodes or Witwatersrand University film and television courses. Up to 1984, entrance to white universities was controlled by the Minister of Education. Thereafter, the universities were free to make their own decisions on whether to accept blacks, though much more stringent entrance qualifications were applied to all students after 1984. Blacks are also employed by companies in the mainline industrty, and at SABC-TV.

[25]Interview, September, 1983.

[26]Interview, June, 1979.

[27]Interview, June, 1979.

[28]Republic of South Africa, *op. cit.,* RP 63/1979 and 113/1978.

[29]Deane, *op. cit.,* p. 162.

[30]Interview, June, 1979; September, 1983; March, 1984.

[31]Interview, September, 1983.

[32]Interview, September, 1983.

[33]Interview, March 22, 1984.

[34]Interview, June 1979. In an interview with Murray on March 22, 1984, he pointed out that permits to enter black townships were more readily available and that only the police, prisons and hospitals wanted to see the scripts if they were involved. He said that the police had drawn red lines through his scripts on occasion.

[35]Interview, September, 1983. This statement is aimed specifically at producers making films for black audiences only. It does not apply, for example, to David Bensusan or the Ross Devenish and Athol Fugard team, whose respective films are aimed at all South Africans, black and white.

[36]H. Gavshon, "Levels of Intervention in Films made for African Audiences in South Africa," *Critical Arts*, V. 2, N. 4, p. 17.

[37]Interview, June, 1979.

[38]Interview, June, 1979.

[39]M. Rees and C. Day, *Muldergate: The story of the Info Scandal* (Johannesburg: Macmillan, 1980), p. 190. One of the few Heyns films which tried to develop a "super hero" was *Mighty Man* (1978), who was a combination of Tarzan, Superman, and Bat Man. It was directed by Percial Rubens.

[40]Unpublished essay, 1979.

[41]Interview, September, 1983.

[42]Interview, September, 1983.

[43]Interview, September, 1983.

[44]Murray pointed out that this was done to make known to the Department of Industries the differences in quality and content between the two producer associations.

[45]Interview with Stan Roup, September, 1983.

[46]*The Star*, March 23, 1983.

[47]*Rand Daily Mail*, April 10, 1974.

[48]Interview, September, 1983.

[49]Interview, June, 1979.

CHAPTER FOUR

FILM MOVEMENTS

[1]J.A.F. van Zyl, "*Jannie Totsiens*," *New Nation*, V. 4, N. 3, 1970, p. 19.

[2]B. Ronge, "Jans Rautenbach in Retrospective," *New Nation*, V. 4, N. 2, 1970, p. 16. Ronge is incorrect in implying that Rautenbach directed *Wild Season*. He was the scriptwriter and worked on set as the production manager. Emil Nofal directed. Also see B. Ronge, "Cowboys, Superstars, and Soppy Lovers," *New Nation*, V. 5, N. 6, 1972, pp. 15-16. Here he describes *Pappa Lap* as a glowing gem.

[3]*Sunday Times*, June 9, 1968.

[4]*Rand Daily Mail*, May 29, 1968.

[5]J.A.F. van Zyl and A. Worral, "Jans Rautenbach Interviewed," *New Nation*, V. 4, N. 3, 1970, p. 17.

[6]*Ibid.*, pp. 18-19.

[7]Van Zyl, *op. cit.*, p. 17.

[8]The *Sestigers* were a literary movement of non-conformist Afrikaans writers who emerged in the 1960s. They had a resounding impact on the content and form of Afrikaans literature, something which Rautenbach tried to translate into cinema.

[9]*News/Check*, May 15, 1970, p. 18.

[10]P. Graham, *The New Wave* (London: Secker and Warburg, 1968), p. 85.

[11]*News/Check*, *op. cit.*, p. 17.

[12]*The Star*, September 7, 1976.

[13]*The Star*, September 16, 1976.

[14]T. Milne, *Godard* (London: Secker and Warburg, 1967), p. 181.

[15]W. Fadiman, *Hollywood Now* (London: Thames and Hudson, 1973), p. 140.

[16]"*Scenaria* Interviews Marie du Toit," *Scenaria*, N. 8, 1978, p. 45.

CHAPTER FIVE

THE REVIEWER SYNDROME

[1]Quoted in S. R. Gray, *Athol Fugard* (Johannesburg: McGraw-Hill, 1982), p. 135.

[2]*Stage and Cinema,* V. 4, N. 40, May 6, 1916, p. 4. Earlier references to cinema can be found in newspapers as far as back as 1895. *Stage and Cinema,* however, was the first informed journal to comment at length on South African-made films. For further information on the early history of film criticism, see T. Gutsche, *The History and Social Significance of Motion Pictures in South Africa—1895-1940* (Cape Town: Howard Timmins, 1972), pp. 383-84.

[3]Harold Shaw was an American who had previously worked for Edison and London Films.

[4]Gutsche, *op. cit.,* p. 313. This film has been preserved by the National Film Archives. For a more detailed account of the film see H. van Zyl, *"De Voortrekkers—*Some Stereotypes and Narrative Conventions," *Critical Arts,* V. 1, N. 1, 1980.

[5]*Stage and Cinema,* April 6, 1918, p. 11.

[6]*Ibid.,* p. 12.

[7]*Loc. cit.*

[8]*Stage and Cinema,* March 30, 1918, p. 4.

[9]Quoted in Gray, *op. cit.,* p. 135.

[10]H. Gans, *Deciding What's News* (New York: Vintage Books, 1980), p. 167.

[11]L. Switzer, "A Critique of the Mass Media at the ASSA Congress," *Critical Arts,* V. 1, N. 3, 1980, pp. 70-75.

[12]Interviews were conducted by the author during 1977, 1978, and April 1981. Names of interviewees are sometimes withheld at their request. We are, in any case, more concerned with the role they perform and the positions they occupy than with individual personalities. As Gans, notes, "News organizations are . . . sufficiently bureaucratized (so) that very different personalities will act in much the same way in the same position," *op. cit.,* p. xiii.

[13]Interview, April, 1981.

[14]B. Ronge, "Criticism," *Scenaria,* Dec.-Jan. 1977/78, p. 33.

[15]*Sunday Times,* February 20, 1977.

[16]*Die Burger,* February 12, 1977.

[17]Interview, April, 1981.

[18]Interview, April, 1981.

[19]The discussion that follows is drawn from a survey of the reviews of the film in *The Star, Beeld, Sunday Times, Hoofstad,* and *Cape Argus.*

CHAPTER SIX

FILM CRITICS

[1]*The Star (Tonight),* August 16, 1976.
[2]*The Star,* December 7, 1976.
[3]*The Star,* November 2, 1978.

[4]*The Star,* August 4, 1979.
[5]*The Star,* September 8, 1977.
[6]H. Rompel, *Die Bioskoop in Diens van Die Volk, Deel I* and *Deel II* (Cape Town: Nasionale Pers, 1942).
[7]*The Star,* October 7, 1975.
[8]*The Star,* October 6, 1977.
[9]*The Star,* March 30, 1976.
[10]*The Star,* December 6, 1978.
[11]*The Star,* June 4, 1979.
[12]*The Star,* June 4, 1979.
[13]*The Star,* September 7, 1978.
[14]B. Ronge, "Jans Rautenbach in Retrospect," *New Nation,* V. 14, N. 2, 1970, pp. 16-17. Rautenbach wrote the script and was production manager on set. Emil Nofal directed.
[15]*Ibid.,* p. 16.
[16]*Loc. cit.*
[17]*Loc. cit.*
[18]*Loc. cit.*
[19]Ronge, *op. cit.,* p. 17.
[20]B. Ronge, "The Guest," *Scenaria,* Aug./Sept. 1977 (supplement), p. 1.
[21]The discussion that follows draws from a survey of the reviews of the film in *The Star, Beeld, Sunday Times, Hoofstad* and *Cape Argus.*
[22]B. Ronge, *op. cit.,* p. 1.
[23]*Loc. cit.*
[24]*Loc. cit.*
[25]B. Ronge, *op. cit.,* p. 2.
[26]J.A.F. van Zyl, "The Sociology of Film and Drama," in *Language of the Arts,* Arts Colloquim, University of Witwatersrand, 1975.
[27]J.A.F. van Zyl, "Towards a Socio-Semiology of Performance," in J.A.F. van Zyl and K. G. Tomaselli (eds.), *Media and Change* (Johannesburg: McGraw-Hill, 1977), p. 41.
[28]Unless otherwise indicated, Van Zyl's critiques were published in the defunct, intellectually-oriented *Sunday Chronicle,* which published for a short while in the 1960s.
[29]J.A.F. van Zyl, "Jannie Totsienst," *New Nation,* October 1970, pp. 18-19.
[30]*Loc. cit.*
[31]*Loc. cit.*
[32]J.A.F. van Zyl and A. Worral, "Jans Rautenbach Interviewed," *New Nation,* V. 4, N. 2, 1970, p. 17.
[33]*Ibid.,* p. 18.
[34]Van Zyl, "Jans Rautenbach Interviewed," p. 18.
[35]*Loc. cit.*
[36]J.A.F. van Zyl, "Boesman and Lena," *New Nation,* March 1974.
[37]S. Gray (ed.), *Athol Fugard* (Johannesburg: McGraw-Hill, 1982), p. 132.
[38]Van Zyl, "Boesman and Lena," p. 13.
[39]J. Coetzee, "The White Man's Burden," *Speak,* V. 1, N. 1, 1977, pp. 4-7.
[40]Van Zyl, "Boesman and Lena," p. 13.
[41]S. R. Gray, *op. cit.,* p. 139.
[42]*Ibid.,* p. 134.
[43]Van Zyl, "Boesman and Lena," p. 13.
[44]*Sunday Chronicle,* circa 1964 (undated).
[45]*Sunday Chronicle,* circa 1965 (undated).
[46]*The Star,* August 4, 1979.

CHAPTER SEVEN

MARKETING A PRODUCT

[1]*The Star,* September 10, 1979.

[2]M. Chanan, *Labour Power in the British Film Industry* (London: British Film Institute, 1976), p. 8.

[3]*Ibid.,* p. 9.

[4]*Interview,* 1978.

[5]J. Ellis, *Visible Fictions* (London: Routledge and Kegan Paul, 1984), p. 187.

[6]P. Fourie, "'n Strukureel Functionele Model vir die Formuleering van die Suid-Afrikaan Rolprentbeleid," University of South Africa, 1982.

[7]Interview, September 26, 1983.

[8]Ellis, *op. cit.,* p. 191.

[9]Interview, September 27, 1983.

[10]*The Star,* October 13, 1982.

[11]Ellis, *op. cit.,* pp. 91-108.

[12]S. R. Gray (editor), *Athol Fugard* (Johannesburg: McGraw Hill, 1982), p. 136.

[13]*The Star,* September 7 & 16, 1976.

[14]Interview, July, 1977.

[15]K. Wlascin, "Swiss fantasies—festival '77: Locarno," *Films and Filming,* November 1977, p. 33. This reviewer writes: "One of the major achievements this year was the rescuing from relative oblivion the new Athol Fugard/Ross Devenish film, *The Guest.* Already shown on BBC-TV, where its world premiere seems to have passed almost unnoticed, *The Guest* was one of the biggest successes at Locarno . . ." *The Guest* was awarded a major prize despite a vociferous anti-South African campaign waged by some communist countries at the festival.

[16]Gray, *op. cit.,* p. 136.

[17]*Newsweek,* October 23, 1978, p. 70.

[18]For more information see K. G. Tomaselli, *"Superman*: Will He Survive His Celluloid Image?" *Scenaria,* N. II, January 1979, pp. 55-56.

[19]R. Hay, *Stoney, the One and Only.* (Cape Town: David Philip, 1984). A new edition of Percy Fitzpatrick's novel, *Jock of the Bushveld,* was published to coincide with the film's launch in December 1986. The cover was a still from the film.

[20]Interview, March 24, 1984.

CHAPTER EIGHT

DISTRIBUTION

[1]Quoted in *SAFTTA Journal,* V. 3, N. 1 & 2, p. 6.

[2]For an analysis of why Fox bought into South Africa, see K. G. Tomaselli, "Ideology and Cultural Production in South African Cinema." Ph.D. Thesis, University of Witwatersrand, Johannesburg, 1983, pp. 163-175.

[3]*Financial Mail,* May 2, 1969, p. 93.

[4]*Financial Mail*, September 16, 1969, p. 41.

[5]*News/Check*, August 22, 1969, p. 41.

[6]*Ibid.*, p. 22, *News/Check* accepted Pieterse's bland explanation on how he solicited Columbia and Paramount without question: "Piss and Vinegar. Enthusiasm. No one likes a monopoly." *Financial Mail*, May 2, 1969, p. 356 put Ster's coup down to "dint of talent, hard labour and timely Sanlam assistance."

[7]*SA Film Weekly*, September 15, 1966, p. 2.

[8]*Financial Mail*, May 16, 1969, p. 564.

[9]*Management*, July, 1974, p. 31.

[10]*Financial Mail*, May 16, 1969, p. 564.

[11]Dr. Wim de Villiers, Satbel managing director, quoted in *Financial Mail*, June 5, 1970, p. 893.

[12]*Financial Mail*, January 10, 1975, pp. 91-92

[13]A. Mattelart, *Multinational Corporations and the Control of Culture: The Ideological Apparatuses of Imperialism* (Sussex: Harvester Press, 1983), p. 201.

[14]*SA Film Weekly*, November 8, 1973, p. 2.

[15]*Financial Mail*, December 28, 1973, p. 1260.

[16]*Business SA*, V. 7, N. 4, 1972, p. 64.

[17]Interview, 1978.

[18]Other films in this package inclued *Orca* and *Lipstick*.

[19]Robert Grieg, *The Star* ("Tonight"), June 9, 1979.

[20]This does not imply that Satbel or CIC-Warner did not have "art films in their catalogues. They did, but they rarely released them. Bill Sharp, in an interview in September, 1983 pointed out that very often films which had played at the festivals fared badly on the commercial circuit. This occurred because of the more stringent censorship for non-festival release, and because "those films which have a limited audience anyway, had exhausted the audience."

[21]F. Stuart, "The Effects of Television on the Motion Picture Industry, 1948-1960," in G. Kindem (editor), *The American Movie Industry: The Business of Motion Pictures* (Carbondale: Southern Illinois University Press, 1980), p. 282.

[22]Interview, May, 1980.

[23]Quoted in *Finance Week*, February 11-17, 1982, p. 177.

[24]*The SAFTTA Journal*, *op. cit.*, pp. 6-7.

[25]Quoted in *Finance Week*, *op. cit.*

[26]*Rand Daily Mail*, August 13, 1983.

[27]Interview, September 23, 1983.

[28]*The SAFTTA Journal*, *op. cit.*, p. 18.

CHAPTER NINE

ESTHETIC LABOR

[1]K. G. Tomaselli, "The South African Film and Television Technicians Association: Its Aims and Objectives," *Audiovision*, V. 1, N. 8, 1976, p. 10.

[2]L. Friedberg, "SAFTTA, the Industry . . . and Foreign Technicians: A Report," *SAFTTA News*, V. 3, N. 3, 1977, p. 5.

[3]The SA Society of Cinematographers was established in 1954. The society limped along until 1982 when it was revitalized by a more committed member-ship. It remains basically a craft guild.

[4]Friedberg, *op. cit.*, p. 10.

[5]M. Chanan, *Labour Power in the British Film Industry* (London: British Film Institute, 1976), p. 30.

[6]K. G. Tomaselli and P. Cockburn, "SAFTTA: the Road Ahead—A Statement of Policy," *The SAFTTA Journal*, V. 1, N. 1 & 2, 1980, pp. i-iv.

[7]SAFTTA News, V. 3, N. 5, 1978, pp. 6-8.

[8]*Loc. cit.*

[9]Friedberg, *op. cit.*, p. 4

[10]*The Star*, April 15, 1980.

[11]*The Star*, April 16, 1980.

[12]*The Star*, April 15, 1980.

[13]Letter by British-born Ed Harper reproduced in *SAFTTA News*, V. 5, N. 4, March, 1980.

[14]Chanan, *op. cit.*, p. 32.

[15]Tomaselli and Cockburn, *op. cit.*, p. ii.

[16]Interview with Heyns, March 20, 1981.

CHAPTER TEN

INDEPENDENT CINEMA

[1]H. Salmane, S. Hartog, and D. Wilson (eds.), *Algerian Cinema* (London: British Film Institute, 1976), pp. 1-4. For an outline of the term, Third Cinema, see F. Solanas and O. Gettino, "Towards a Third Cinema" in B. Nichols (ed.), *Movies and Methods* (Berkeley: University of California Press, 1976). For a general overview of cinema in social change, see L. M. Henry, "The Role of Film Makers in Revolutionary Social Change," *Praxis*, V. 1, N. 2, 1976, pp. 157-175.

[2]P. R. Zimmerman, "Public Television, Independent Documentary Producer and Public Policy," *Journal of the University Film and Video Association*, V. 34, N. 3, 1982, p. 9.

[3]P. Willemen, "Presentation," in D. MacPherson and P. Willemen (eds.), *Traditions of Independence: British Cinema in the Thirties* (London: British Film Institute, 1980), p. 2.

[4]J. Grierson, The Grierson Report, Union of South Africa, unpublished.

[5]For information on approach and course content see *The SAFTTA Journal*, V. 1, N. 2, 1980 and K. G. Tomaselli, "Media Education and the Crisis of Hegemony in South Africa," *Media Information Australia*, Feb./March, 1985, pp. 9-20.

[6]Quoted in R. Johnson and R. Stam (eds.), *Brazilian Cinema* (New Jersey: Associated University Presses, 1984), p. 77.

[7]Unpublished essay, 1979.

[8]For a more detailed criticism see J. Bruwer, "*Die Moord*," and J. van Zyl "Angst," *Critical Arts*, V. 1, N. 1, pp. 54-56.

[9]See K. G. Tomaselli, A. Williams, L. Steenveld and R. E. Tomaselli, *Myth, Race and Power: South Africans Imaged on Film and TV* (Bellville: Anthropos, 1986).

[10]See P. McAllister and G. P. Hayman, "*Shixini December*: Responses to Poverty in the Transketi," Carnegie conference paper, 1985.

[11]Unpublished essay by Lynette Steenveld, Rhodes University Department of Journalism and Media Studies, 1984.

[12]G. Garden, *Rand Daily Mail*, March 23, 1983.

[13]For a review, see J. Margolis, *Cineaste*, V. 12, N. 4, 1983, p. 55.

[14]For a detailed analysis of this film, *This We Can Do for Justice and Peace* and *Awake From Mourning* in the context of radical film, see K. G. Tomaselli, "Strategies for an Independent Radical Cinema in South Africa," *Marang*, V. 4, 1983, pp. 51-85; and K. G. Tomaselli, "Oppositional Film Making in South Africa," *FUSE*, V. 6, N. 4, pp. 190-94.

[15]P. Anderson, "The Tiakeni Report: The Maker and the Problem of Method in Documentary Video Production," *Critical Arts*, V. 4, N. 1, 1985.

[16]L. Steenveld, "Who Sees? A Way of Seeing *I am Clifford Abrahams and This is Grahamstown*," Department of Journalism and Media Studies, Rhodes University, Grahamstown, 1986, 26 pp. Note the introduction by Hayman.

CHAPTER ELEVEN

SOCIAL POLARIZATION

[1]For further details see K. G. Tomaselli and R. Haines, "Homelands, Vice Capital and the South African Film Industry," Paper delivered at the 1968 Association for Sociology in Southern Africa conference, Durban.

[2]*Sunday Times*, September 16, 1984.

[3]*Daily News*, April 29, 1985.

[4]One exception is *I'm Wereld Sonder Grense* (*A World Without Borders*— 1987) from which the SA Defense Force withdrew its assistance after reading the script which deals critically with the war and its effects on white South Africans. Ironically, the film was produced by Wally van der Merwe, better known for his low budget "black" movies.

[5]Department of Trade and Industry, June 24, 1986.

[6]See V. 4 of *The SAFTTA Journal*, 1984. See the Letters Page of V. 5, 1985, for an indication of the nature of the criticism from the Institute.

[7]*American Film*, V. 11, N. 2, 1985, p. 32. Also M. Cooper, "Hollywood Acts?" *op. cit.*, p. 35.

[8]*Sunday Times*, January 19, 1986.

[9]For additional information see Media Network's *Guide to Apartheid and the Southern African Region* (NYC: Media Network, 1985), 12 pp.; P. Duval, M. Mangin, and J. P. Garcia (editors), *Apartheid et Cinema*. Journees Cinematographiques d'Amiens, 1983, pp. 31-32; and K. G. Tomaselli (ed.), *Le cinema Sud-Africain est-il tombe sur la tete?* CinemAction 39, Courbevoie, 1986.

[16]K. G. Tomaselli, "Progressive Film and Video in South Africa," *Media Development*, V. 32, N. 3, 1985, pp. 15-18.

[11]P. Anderson, "Documentary and the Problem of Method," *Criticals Arts*, V. 4, N. 1, 1986.

[12]*Media Development*, V. 32, N. 3, 1985. A special issue on alternative media in South Africa.

[13]*Weekly Mail*, June 5-June 11, 1987. For other discussion on cultural boycott see C. Haines, "For the Cultural Boycott of South Africa," *The Independent*,

V. 9, N. 1, 1986, pp. 16-20; group reply, "A Reply from South Africa," *The Independent,* V. 9, N. 10, 1986, pp. 21-22.

[14]G. Crowdus, "South African Filmmaking in Exile: An Interview with Lionel Ngakane," *Cineaste,* V. 15, N. 3, 1986, pp. 16-17.

Bibliography

Books and Monographs

BARKAS, N.: *Thirty Thousand Miles for the Cinema*. London: Blackie and Son, 1937. The second part of this book offers a chatty account on the making of *Rhodes of Africa*. See pp. 114-97. It ignores the controversy which surrounded the scripting and screening of the film in South Africa at a time when tremendous ideological and political conflicts were occurring between English and Afrikaner South Africans. Illustrated with many photographs.

BENSUSAN, A. D.: *Silver Images*. Cape Town: Howard Timmins, 1966, pp. 53-59. See the chapter entitled "Cinematography," which gives an account of early filmmaking in South Africa. The remainder of the book deals primarily with the history of stills photography in Southern Africa.

BIGELOW, W.: *Strangers in their Own Country: a Curriculum Guide on South Africa*. New Jersey: Africa World Press, 1985. A manual for American high school teachers, the Guide offers questions on and suggests ways of studying *Last Grave at Dimbaza*, *Afrikaner Experience* and *Generations of Resistance*.

CHAPPEL, P. and AUSTIN, C.: "Theatre, Cinema et Apartheid: le travail de Peter Chappel et de Chris Austin," in Duval, P. (ed.): *Apartheid et Cinema*, Amiens: Journees cinematographiques d'Amiens, 1983, pp. 45-46. A discussion of the anti-apartheid films made by Chappel and Austin.

DEANE, D. S.: *Black South Africans*. Oxford: Oxford University Press, 1978. Contains a brief uncritical profile of Simon Sabela, South Africa's first black film director who worked for Heyns Films between 1974 and 1980.

DE KOCK, B.: "Film Artists" in *Standard Encyclopedia of Southern Africa*, Vol. 4, Cape Town: Nassau, 1971, pp. 495-507.

ERASMUS, P. F. and PELSER, J. J.: *Die Rolprent as Massakommunikasie-medium*. Institute for Communication Research, Report No. Komm. 4, 1974, 62pp. An eclectic, superficial functionalist analysis of film and its effects with special reference to South Africa. Attention is devoted to the possible influence of TV on the local industry. A comprehensive bibliography includes most of the more conservative Afrikaans writings.

243

FEINBERG, B.: "Son Histoire Recente," in Duval, P. (ed.): *Apartheid et Cinema.* Amiens: Journees cinematographiques d'Amiens, 1983, pp. 27-30. Reprinted from an article in *Sechaba*, the journal of the African National Congress. A discussion of films in the struggle for liberation. An addendum contains synopses of 48 anti-apartheid films made both in South Africa and outside of it.

FRIEDBERG, L.: "South Africa" in *International Film Guide.* London: Tantivy Press, 1964-1983. Published annually. A yearly update on the production industry in South Africa.

FUGARD, A.: *Marigolds in August.* Johannesburg: AD Donker, 1982. Script and photographs of the film.

FUGARD, A.: *The Guest.* Johannesburg: AD Donker, 1977. Script and photographs of the film.

GARCIA, J. P.: "L'Experience de Michel Kopiloff" in Duval, P. (ed.): *Apartheid et Cinema,* Amiens: Journees cinematographiques d'Amiens, 1983, pp. 43-44. An interview with an anti-apartheid film maker.

GELDENHUYS, P. B.: *Pornographie, Sensuur en Reg.* Pretoria: Lex Patria, 1977. An account of censorship under the 1963 Act.

GODSELL, G., HALL, R. S. and TOMASELLI, K. G.: *A Report on the Industrial Relations Film "Indaba Ye Grievance."* Pretoria: NIPR/ HSRC, 1985.

GRAY, S. R.: "Fugard on Film: Interview with Ross Devenish" in Gray, S. R. (ed.): *Athol Fugard.* Johannesburg: McGraw-Hill, 1982, pp. 130-139. A lively and informative interview with Ross Devenish who directed the three films scripted by Fugard.

GUTSCHE, T.: *The History and Social Significance of Motion Pictures in South Africa 1895-1940.* Cape Town: Howard Timmins, 1972, 404pp. A highly detailed chronological history of the industry, but weak on "social significance." Not concerned with textual analysis, it concentrates on the social effects of cinema on early South African audiences and the growth of the industry. Illustrated with scores of photographs.

GUTSCHE, T.: "Film Production" in *Standard Encyclopedia of South Africa,* Vol. 4, Cape Town: Nassau Ltd., 1971, pp. 498-502.

GUTSCHE, T.: "Film, Sub-Standard" and "Film Archives" in *Standard Encyclopedia of South Africa,* Vol. 4, Cape Town: Nassau Ltd., 1971, pp. 491-495. A very brief, updated history of the industry and discussion of the work of the National Film Archives based in Pretoria.

HAY, R.: *Stoney the One and Only.* Cape Town: David Philip, 1983. Adapted from the film. Illustrated with photographs from the film.

HERBER, A.: *Conversations.* Johannesburg: Bateleur Press, 1979, pp. 34-37. A coffee-table book containing an interview with Ross Devenish.

KOHL, E. E.: *Stel die Rolprent in Diens van die Volk.* Johannesburg: Volksbiskope, 1946. 24 pp. A plea to Afrikaner business for capital to generate an Afrikaans film industry.

LE ROUX, A. I. and FOURIE, L.: *Filmverlede: Geskiedenis van die Suid-Afrikaanse Speelfilm.* University of South Africa, 1982. 246pp. Illustrated with photographs. Incomplete bibliography. The book has two aims: 1) to offer a chronological developmental history of feature films; and 2) to offer a point of departure for urgent film history writing and film evaluation in the future. It provides neither. Its emphasis is on synopses and credits with less than 3 pages of analysis. It is more concerned with endless lists of individuals than a systematic analysis.

MEYER, T. W. S.: "Afrikaans en die Rolprentbedryf" in Kok, B. (ed.): *Afrikaans: ons perel van groot waarde.* Johannesburg: FAK, 1974, pp. 224-239. A bland, uncritical, self-congratulatory evaluation of the contributions of one film company, notably Jamie Uys Films, later named Kavaliers, on the development of the Afrikaans Film industry and its contribution to the Afrikaans language. Meyer was for many years the managing director of this company.

MODISANE, B.: *Blame Me On History.* London: Thames and Hudson, 1963. Journalist Modisane talks about Lionel Rogosin who produced *Come Back Africa* and the making of the film in South Africa. Modisane was a production assistant on the clandestinely made film and found the actors and locations. He explains that the government was wary of Rogosin because an earlier film made by American Ed Murrow called *African Conflict* (1957) was critical and after his trip all American films were suspect.

NGAKANE, L.: "The Role of Films in the Liberation Struggle" in Awed, I. M., Adam, H. M. and Ngakane, L. (eds.): *First Mogadishu Pan-African Film Symposium. Pan African Cinema . . . which way ahead?* Mogadishu: Mogpafis Management Committee, 1983, pp. 22-26. A personal reminiscence of aspects of South African films and history. Written from the point of view of a participant in the liberation struggle. The chapter was the Symposium report on South Africa.

PINNOCK, D.: *The Brotherhoods: Street Gangs and State Control in Cape Town.* Cape Town: David Philip, 1984. See Chapter 3: "Control in the Old City." This chapter looks at the way in which cinema — mainly American—during the 1940s and 1950s, informed and formed the self-image of the Globe Gang—the powerful coloured gang of District Six, a slum area of Cape Town. A thrice weekly injection of cinema from the District's five cinemas led to a strange amalgam of ghetto culture and American styles of dress, terminology, modes of operation and even personal or gang names.

PUTH, G.: *Die Inhoud en Gebalte van 'n Steekproef Suid-Afrikaanse Rolprente voor the die Instelling van Televisie.* Institute for Communication Research, Report No. Komm. 10, 1976, 71 pp. A factor analysis of the content of English language films made prior to the introduction of television in 1976.

REES, M. and DAY, C.: *Muldergate.* Johannesburg: Macmillan, 1980. Contains references to the way that a power-clique within the state tried to capture the film industry for their political purposes. See also the Erasmus Commission listed under Government Publications.

ROMPEL, H.: *Die Bioskoop in Diens van die Volk. Deel I* and *Deel II.* Cape Town: Nasionale Pers, 1942. *Deel I* 117pp; *Deel II* 88pp. Published under the auspices of the *Reddingsdaadbond.* Rompel's objective was to conscientise amateur Afrikaans filmmakers into carrying out his blueprint for a culturally pure Afrikaans cinema rooted in pastoralism and free from jingoistic and American influences. Although part of the very strong Broederbond movement of the time, these monographs had little impact on the future of commercial Afrikaans cinema. Rompel's ideas were in opposition to the organic growth of Afrikanerdom in the cities. Despite his connections with the Broederbond, few contemporary filmmakers have heard of him.

SILVER, L.: *A Guide to Political Censorship in South Africa.* Centre for Applied Legal Studies, University of Witwatersrand, 1984. Provides limited interpretation juxtaposed with numerous Appeal Board judgments on film, books, newspapers, etc.

SLABBERT, M.: "Violence on Cinema and Television and in the Streets" in Davis, D. and Slabbert, M. (eds.): *Crime and Power in South Africa.* Cape Town: David Philip, 1985.

STEENVELD, L.: *VIDEO: Who Sees? A Way of seeing, "I am Clifford Abrahams and This is Grahamstown."* Grahamstown: Dept. of Journalism & Media Studies, Rhodes University, 26 pp.

STODEL, J.: *The Audience is Waiting.* Cape Town: Howard Timmins, 1962. A personal reminiscence of the Schlesinger era of theatre and cinema entertainment. Very light-hearted, very bland and often misleading. Nevertheless, offers ideological insights into the operations of Schlesinger's business practices during the first part of this century.

TOMASELLI, K. G.: *Le Cinéma sud-africain est-il tombé sur la tête?* CinémAction et Afrique littéraire: Paris, 1986. 130pp. Photographs. Fourteen chapters on aspects of South African cinema, specifically, history of South African cinema, the role of the Jamie Uys Film Company and Afrikaner culture, cinema made for blacks, Afrikaans cinema, propaganda documentaries, censorship, oppositional film/ video, Cinema direct, anti-apartheid cinema made outside of South Africa, and an interview with Lionel Ngakane. Four appendices offer pen sketches of 30 filmmakers, film synopses, and a list of fiction films made between 1910 and 1984. Authors published include Jean Copans on South African history, Frank Meintjies on what it is like to be a black person in South Africa, and David Bensusan, Peter Davis, William Pretorius, Lynette Steenveld, John van Zyl and Robyn Aronstam.

TOMASELLI, K. G., WILLIAMS, A., STEENVELD, L. and TOMASELLI, R.: *Myth, Race, and Power: South Africans Imaged on Film and TV.*

Bellville: Anthropos, 1986. Examines local and overseas productions with an eye on the very thin line between propaganda and documentary. Also develops a set of principles of ethnographic film production. Filmography and photographs.

TOMASELLI, K. G. and TOMASELLI, R. E.: "Before and After Television: The South African Cinema Audience" in Austin, B. (ed.): *Current Fesearch in Film*, Vol. 3. New Jersey: Ablex. 1987.

TOMASELLI, K. G., and VAN ZYL, M.: "The Structuring of Popular Memory in South African Cinema and Television Texts" in Haines, R. and Buijs, G. (eds.): *Capitalist Penetration in 20th Century South Africa: The Struggle for Social and Economic Space.* Durban: University of Durban-Westville, 1985. An in-depth analysis of recurring cultural myths and dominant genres of Afrikaans cinema, and its relation to literature, radio and television. The chapter traces the historical origins of images of space, the city, the farm, population migrations and spatial dynamics of South African society.

TOMASELLI, K. G.: *Documentary, Ethnographic Film and the Problem of Realism.* Student Reader, Department of Journalism and Media Studies, Rhodes University, Grahamstown, 1984. 49pp. A discussion of realist film theories with respect to South African documentaries and ethnographic films. Contains reviews of three state propaganda films.

TOMASELLI, K. G.: "The South African and Australian Film Industries: A Comparison," in Gardner, S., Tomaselli, K. G., Gray, S. R. and Vaughan, M.: *Breaker Morant.* Critical Arts Monograph No. 1, University of Witwatersrand, Johannesburg, 1984, pp. 31-50.

TOMASELLI, K. G.: "Un Cinema Pour Distraire" in Duval, P. (ed.): *Apartheid et Cinema.* Amiens: Journees cinematographiques d'Amiens, 1983, pp. 15-26. A brief history of South African cinema and a discussion of the ideological themes of contemporary Afrikaans cinema and films aimed at black audiences. It also contains synopses of 14 South African feature films.

TOMASELLI, K. G.: "Ideology, the State and South African Film" in Durbach, A.: *Art and Liberation.* Cape Town: NUSAS, 1979, pp. 34-43.

VAN ZYL, J. A. F.: "The Sociology of Film and Drama," *Languages of the Arts.* Proceedings of the Arts Colloquium, Johannesburg: University of Witwatersrand Press, 1975, pp. 47-64.

WASSENNAAR, A. D.: *Assault on Private Enterprise: The Freeway to Communism.* Cape Town: Tafelberg, 1984. An extremely influential book by the chairman of the Broederbond-spawned SANLAM which attacks Afrikaner socialism as it developed under the Vorster regime. It exposes state encroachment into the industry and outlines state ineptness when dealing with the film industry with regard to copyright and censorship.

Journals

ANDERSON, P.: "The Tiakeni Report: The Maker and the Problem of Method in Documentary Video Production," *Critical Arts*, V. 4, N. 1, 1985, pp. 1-79.

BENSUSAN, D.: "The Production of Non-Racial Films in an Apartheid State," *The SAFTTA Journal*, V. 6, 1986, pp. 1-6. Reprinted from the original French in Tomaselli, *Le Cinéma sud-africain est-il tombé sur la tête*, listed under Books, above. Bensusan discusses the critical response to his film, *My Country My Hat* and the practice of dissident feature film-making in South Africa.

BLYTHE, M.: "A Review: The Gods Must Be Crazy," *UCLA African Studies Newsletter*, Spring 1986, pp. 17-21.

BOTHA, M.: "Derde Wêreld Rolprent Kuns en Suid-Afrika," *The SAFTTA Journal*, V. 6, 1986, pp. 19-23. An overview of third world cinema in relation to South Africa.

BRUWER, J.: *"Die Moord,"* *Critical Arts*, V.I, N.1, 1980, pp. 54-56. A review of the film.

CALLAGHAN, C.: "Anwar Ismail Interviewed." *Speak*, V. 1, N. 5, 1978, pp. 23-26. A cinema owner complains about discrimination by certain film distributors.

Cineaste: "Clandestine Filming in South Africa," V. 7, N. 3, 1976, pp. 18-19, 50. An interview with Nana Mohomo.

COAN, S.: "Stephen Coan Interviews Michael Raeburn," *The SAFTTA Journal*, V. 2, N. 2, 1982, pp. 2-3. Raeburn directed *The Grass is Singing*, a film made in Zambia and initially banned in South Africa.

COAN, S.: "Kevin Harris Talks on *This We Can Do For Justice and Peace*," *The SAFTTA Journal*, V. 2, N. 2, 1982, pp. 17-19.

COAN, S.: "In Front of the Camera," *The SAFTTA Journal*, V. 2, N. 1, 1981, pp. 4-10. Interview with three South African actors on the difference between stage and cinema acting.

COETZEE, J. M.: "The White Man's Burden: Review of *The Guest*," *Speak*, V. 1, N. 1, 1977, pp. 4-7. Reprinted in Gray, S. R.: *Athol Fugard*. Johannesburg: McGraw-Hill, 1982, pp. 96-100.

COLLINGE, J.: "Under Fire," *American Film*, V. 11, N. 2, 1985, 30-34. As South Africa's crisis deepens, its independent filmmakers document the pain of apartheid. But they are victims of—and are often used by—the very system they seek to destroy. Contains some statements by Hollywood directors, writers and producers on the cultural boycott.

COOPER, M.: "Hollywood Acts?" *American Film*, V. 11, N. 2, 1985, pp. 35-38, 75. A discussion of Hollywood attitudes towards apartheid and the cultural boycott.

CROWDUS, G.: "South African Filmmaking in Exile: An Interview with Lionel Ngakane," *Cineaste*, V. 15, N. 2, 1986, pp. 16-17.

DAVIDS, A.: "Waving or Drowning," *Critical Arts,* V. 1, N. 2, 1980, pp. 47-49. A critique of the earlier version of this book.

DAVIS, P.: *"The Gods Must be Crazy,"* *Cineaste,* V. 14, N. 1, 1985, pp. 51-53. An incredibly incisive analysis of the Uys film. Davis cuts through the is-it-entertainment-or-politics debate and shows how the film functions allegorically as exorcism for the Afrikaner mind.

DAVIS, P.: "A Short Story," *The SAFTTA Journal,* V. 5, 1985, pp. 19-20. A true story of a black South African's attempts to get financing from European and American film investors.

DEVENISH, R.: "Ross Devenish Replies . . . ," *Speak,* V. 1, N. 1., 1977, pp. 7-9. Reply to Coetzee, op. cit.

Film Library Quarterly: "Nana Mohomo Interviewed," V. 9, N. 1, 1976, pp. 11-14.

Forum: "Film Propaganda on The Platterland," July 12, 1941, p. 23-24.

FOURIE, P.: "Die Suid-Afrikaanse Rolprentbedryf: 'n Model vir die Toekoms," *Teaterforum,* V. 4, N. 1, 1984, pp. 19-43. An ahistorical structuralist-functionalist analysis of a hypothetical subsidy system designed to put the South African film industry on a surer economic footing.

FOURIE, P.: "Die Rolprent: van Triviale Vermaak tot Kuns," *Tydskrif vir Geesteswetenskappe,* V. 23, N. 3, 1983, pp. 194-207. A generalized discussion of negative South African attitudes towards film as opposed to other "high arts."

FOURIE, P.: "'n Struktureel-Funksionele Model vir die Formulering van 'n SA Rolprentbeleid Deel I," *Communicatio,* V. 8, N. 1, 1982; "Deel II" in V. 8, N. 2, 1982. Very similar to Fourie, 1984. An idealistic model for film subsidy is developed in the absence of economic, political, social or historical contextualisation.

FOURIE, P.: "Interkulturele Probleme in Beeldkommunikasie," *Communicare,* V. 3, N. 1, 1982, pp. 60-73. A functionalist analysis of film as "inter-cultural communication," particularly between the races.

FOURIE, P. and DU PLOOY, G. M.: "Film and Television Training at the Dept. of Communication at UNISA," *The SAFTTA Journal,* V. 1, N. 2, 1980, pp. 20-23. Discussion of courses at the University of South Africa correspondence university.

GARDNER, S.: "Can you Imagine Anything More Australian? Bruce Beresford's *Breaker Morant,*" *Critical Arts,* V. 1, N. 4, 1981, pp. 16-26. An in-depth assessment of ideological reflections offered in this film which deals with an incident during the Anglo-Boer War. The film was made in Australia. See also *Critical Arts,* V. 2, N. 3, which contains 4 responses to Gardner's article published in Gardner, S., Tomaselli, K. G., Gray, S. R. and Vaughan, M.: *Breaker Morant.* Critical Arts Monograph N. 1, 1981, pp. 1-30.

GAVSHON, H.: "Levels of Intervention in Films made for Black South African Audiences," *Critical Arts,* V. 2, N. 4, 1983, pp. 13-21.

GAVSHON, H.: "Reply to R. W. Harvey," *Critical Arts,* V. 1., N. 2, 1980,

pp. 49-50. A counter-argument to Harvey's critique of the first edition of this book.

GREIG, R. J.: "An Approach to Afrikaans Film," *Critical Arts*, V. 1, N. 1, 1980, pp. 14-23.

GROVE, J.: "First National Student Film and Video Festival. Two Views. View One: Theory and Practice," *Critical Arts*, V. 2, N. 2, 1981, pp. 77-80.

GUASSARDO, R.: "Schisms—Some Cultural Forms and Monopolies in South Africa," *Africa Perspective*, N. 12, 1979, pp. 57-70.

GUTSCHE, T.: "Fifty Years of Cinema in South Africa," *Forum*, May 11, 1946, pp. 31-32.

GUTSCHE, T.: "Critic Sums Up: Candid views should influence production," *Forum*, February 1, 1941.

HAINES, R.: "Closing the Debate: Critical Methodology and *Breaker Morant*," *Critical Arts*, V. 3, N. 3, 1985, pp. 39-47. A historian closes the debate engendered by Gardner *et. al.*, in *Breaker Morant*.

HALL, S. J.: *"Last Grave at Dimbaza,"* *Film Library Quarterly*, V. 9, N. 1, 1976, pp. 15-18. Discussion of the film.

HARVEY, R.: "On Reading *The South African Film Industry*," *Critical Arts*, V. 1, N. 1, 1980, pp. 57-61. A critique of the first version of this volume.

HAYMAN, G.: "Class, Race or Culture: Who is the Enemy?" *Critical Arts*, V. 2, N. 3, 1982, pp. 33-38. A critical overview of the Culture and Resistance Symposium held in Gaborone, July 1982.

HEY, K. R.: *"Come Back Africa*: Another Look," *Film and History*, V. 10, N. 3, 1980, pp. 61-65.

JONES, J.: "Previewing Our Film Future," *Trek*, V. 9, N. 3, August 11, 1944, p. 12.

KAUFFMAN, S.: "Sophisticates and Primitives," *The New Republic*, September 10, 1984, pp. 24-25. A review of *The Gods Must Be Crazy*.

KRETZMER, H.: "Going to the Movies," *The Forum*, March 1954, pp. 51-53.

LAWRENCE, A.: "The Anti-Apartheid Struggle," *Jump Cut*, N. 21, 1979, pp. 10-11.

LEDERMAN, P.: "Cry Me an Acid Drop," *Snarl*, N. 2, 1974, pp. 1-2. A complaint about technical standards.

LEWIN, J.: "Nation Building via Cinema: Films for South Africans by South Africans needed," *Forum*, May 27, 1974.

MARGOLIS, J.: "You Have Struck a Rock," *Cineaste*, V. 12, N. 4, 1982, p. 55. Review of the film.

MERCER, M.: "Namibia: Filling the Gap," *Jump Cut*, N. 21, 1979, pp. 1-2.

MILLAR, S.: "On Reading *On Reading The South African Film Industry*," *Critical Arts*, V. 1, N. 2, 1980, pp. 51-52. A counter-critique of R. W. Harvey, *op. cit.*

MURRAY, W.: "The Film Industry and the TV Challenge," *The Forum,* July 1953, pp. 28-30.

OOSTHUIZEN, J. S.: "Die Verhouding Afrikaner-Englesman in die Films *Lord Oom Piet* en *Ses Soldate.*" *Communicatio,* V. 5, N. 1, 1979, pp. 23-26. An examination of Afrikaner-English relationships in two films.

OSYNSKI, J.: "Interview: *The Guest,*" *Snarl,* N. 6, 1977, pp. 10-11.

PRETORIUS, W.: "Afrikaans Cinema," *The SAFTTA Journal,* V. 5, pp. 23-28. A critical overview of Afrikaans films made in 1984.

RAUTENBACH, J.: "Probleme van die Afrikaanse Rolprentvervaardiger," *Tydskrif vir Geesteswetenskappe,* 3 & 4, 1969, pp. 259-279. A discussion of the unprofessional attitudes of South African filmmakers and their effect on production practices.

RONGE, B.: "A Survey of the Commercial Film Scene," *Speak,* V. 1, N. 4, 1978, pp. 43-44.

RONGE, B.: "Jans Rautenbach in Retrospect," *New Nation,* V. 4, N. 3, September 1970, pp. 16-18. An *auteur* analysis of Rautenbach's films.

ROELOFSE, K.: "Sondagfliek—dabat: 'n Bartianse mite? *Communicatio,* V. 3, N. 2, 1977, pp. 40-43. A discussion of the banning of Sunday cinema.

SAFFORD, K.: "Peter Davis' Film View of South Africa: An American Review," *Critical Arts,* V. 2, N. 2, 1981, pp. 94-97.

SCHAUDER, L.: "A Film Programme for South Africa: Part II," *Trek,* V. 7, N. 23, 1943, p. 12.

SCHAUDER, L.: "A Film Programme for South Africa," *Trek,* V. 7, N. 22, 1943, p. 14.

SCHIESS, M.: "Censorship and the Films," *New Nation,* September 1970, pp. 11 & 20.

SHARP, B.: "Ideology Versus Reality," *Scenaria,* No. 11, 1979, p. 11. A discussion of film censorship.

SHARP, B.: "Censorship: the Ster-Kinekor View," *The SAFTTA Journal,* V. 3, N. 1 & 2, 1983, pp. 35-36.

STEENVELD, L.: "Propaganda Films," *The SAFTTA Journal,* V. 6, 1986, pp. 8-17. Reprinted from the original French in Tomaselli, *op. cit.*

STEWART, G.: "You Can't Zoom with Your Eyes . . . , " *Lamp,* 1984, pp. 79-84. A brief biography of film maker Dave de Beyer who is television producer at the Natal Technikon.

STREBEL, E.: "*The Voortrekkers*: A Cinematographic Reflection of Rising Afrikaner Nationalism," *Film and History,* V. 9, N. 2, 1979, pp. 25-33.

STREBEL, E. "Primitive Propaganda: the Boer War Films," *Sight and Sound,* V. 46, N. 1, 1977. Reprinted in *Communicatio,* V. 3, N. 1, 1977, pp. 21-24.

TOMASELLI, K. G.: "AZAPO on the Cultural Boycott," The SAFTTA Journal, V. 5, 1985, pp. 8-9. Interview with national publicity secretary of the Azanian Peoples Organization.

TOMASELLI, K. G.: "Capital and Culture in South African Cinema: Jingoism, Nationalism and the Historical Epic," *Wide Angle*, V. 8, N. 2, 1986, pp. 33-44.

TOMASELLI, K. G.: "Communicating with the Administrators: The Bedevilled State of Film and Television Courses in South African Universities," *Perspectives in Education*, V. 9, N. 1, 1986, pp. 48-56.

TOMASELLI, K. G.: "Film and Video as Cultural Resistance in South Africa." In *Programme Journalier*. Montbeliard: Third International Video & Television Festival. 1986, pp. 78-81.

TOMASELLI, K. G.: "Grierson in South Africa: Culture, State and Nationalist Ideology in the South African Film Industry," *Cinema Canada*, N. 122, 1985, pp. 24-27.

TOMASELLI, K. G.: "Popular Memory and the Voortrekker Films," *Critical Arts*, V. 3, N. 3, 1985, pp. 15-24. A discussion of how plot and audience responses changed with regard to films on the Great Trek made in 1916 and 1936 respectively.

TOMASELLI, K. G.: "The Economics of Racism," *Critical Arts*, V. 2, N. 4, 1983, pp. 1-5. An analysis of Third Cinema.

TOMASELLI, K. G.: "First National Student Film and Video Festival: Two Views," *Critical Arts*, V. 2, N. 2, 1981, pp. 80-83.

TOMASELLI, K. G.: "Film Festivals—Which Audience: Punk Rockers, European Immigrants or the 'Mass' Audience?" *The SAFTTA Journal*, V. 2, N. 1, 1981, pp. 11-14.

TOMASELLI, K. G.: "Siege Mentality: A View of Film Censorship," *Index on Censorship*, V. 10, N. 4, 1981, pp. 35-37. Historical overview.

TOMASELLI, K. G.: "Cape Town, South African Film Festival and Conference," *Quarterly Review of Film Studies*, V. 5, N. 3, 1980, pp. 427-28.

TOMASELLI, K. G.: "Film Schools: Their Relevance to the Industry," *The SAFTTA Journal*, V. 1, N. 2, 1980, p. 1-3.

TOMASELLI, K. G.: "The Teaching of Film and Television Production: A Statement of Philosophy and Objectives," *The SAFTTA Journal*, V. 1, N. 2, 1980, pp. 6-14.

VAN DER MERWE, F., and THEUNISSEN, C. H.: "Film Produksi by die Teknikon van Pretoria," *The SAFTTA Journal*, V. 1, N. 2, 1980, pp. 1-5.

VAN ZYL, H.: "Die Rolprentjaar 1975 in Suid-Afrika," *Standpunte*, V. 29, N. 3, 1976, pp. 51-61. A discussion of the performance of feature films at the box office during 1975.

VAN ZYL, H.: "*De Voortrekkers* (1916): Some Stereotypes and Narrative Conventions," *Critical Arts*, V. 1, N. 1, 1980, pp. 25-31.

VAN ZYL, J. A. F.: "Review of Three Ethnographic Films: *The Chopi Timbila Dance, Oral Narrative by Venancio Mbande* and *Audrey Bronson*," *Critical Arts*, V .1, N. 4, 1981, pp. 49-50.

VAN ZYL, J. A. F.: " 'No God, No Morality, No History': South African Ethnographic Film," *Critical Arts*, V. 1, N. 1, 1980, pp. 32-37.

VAN ZYL, J. A. F.: "*Angsst*: Same Time, Same Place," *Critical Arts*, V. 1, N. 1, 1980, p. 56. A review.

VAN ZYL, J. A. F. and WORRALL, A.: "Jan Rautenbach Interviewed," *New Nation*, V. 4, N. 2, 1970, pp. 17-19.

The Union Review: "Let's Go to the Cinema . . . and see a Government Film (in Afrikaans)." V. 7, N. 85, 1944, pp. 38-41. An attack on the report of The Cilliers Film Committee, which advocated the Afrikanerization of cinema.

WILSON, L.: "Why My Film was Banned," *Index on Censorship*, V. 10, N. 4, 1981, pp. 37-40. A discussion of the censor board's decision on *Crossroads*, a film on the squatter camp outside Cape Town.

WLASCIN, K.: "Swiss Fantasies Festival '77: Locarno," *Films and Filming*, November 1977, p. 33. A short reflection on the reception of *The Guest* at the Locarno Film Festival.

Work in Progress: "The Director: Nana Mohomo," N. 24, 1982, pp. 27-28. This paper questions the motivation of Mohomo, linking him to the CIA. The information appears to have come from Winter, G.: *Inside Boss*, published by Penguin. This book has since been withdrawn from circulation through libel actions and inaccuracy. It was written by an ex-Boss (Bureau for State Security) agent.

YOUNGE, G.: "In Advance of Film," *Speak*, V. 1, N. 1, 1977, pp. 71-73. A discussion of South African film, subsidy and production constraints.

VOLKMAN, T. A.: "The Hunter-Gatherer Myth in Southern Africa: Preserving Nature or Culture?" *Cultural Survival Quarterly*, V. 10, N. 2, 1986, pp. 25-32. Includes a discussion of *The Gods Must Be Crazy*.

"W. B." (*nome de plume*): "Ons Film Waarheen? *Trek*, V. 8, N. 13, 1943, p. 15. This article reflects the growing strength of Afrikaner Nationalism with regard to cinema.

Articles (Trade, Professional and Commercial)

Business SA: "A Time for Realism in the Film Industry," V. 7, N. 2, 1972, pp. 60-68.

DEVENISH, R.: "*The Guest*—A Personal Reminiscence," *Scenaria*," N. 2, (Supplement), August/September 1977, pp. 2-3.

DICKSON, P.: "Schlesinger—Horse Trader or Horse Thief," *Management*, May 1977, pp. 23-27, 33-40.

DU TOIT, M.: Interview in *Scenaria*, N. 8, 1978, pp. 44-45.

Film and Television Technician: "What Happened on *Zulu Dawn*?," November 1979, p. 8. An exposé by the ACTT of the working conditions and low wages paid to Zulu extras employed on the set.

Financial Mail: "Gray Hofmeyer: The Complex Film Industry," July 8, 1983, p. 67. Interview with TV director turned film director.

Financial Mail: "SA Film Industry: A Picture of Ill-Health," July 9, 1982, pp. 147-148.

Financial Mail: "The Film Industry: Has it Arrived?" Sept. 10, 1965, pp. 736-39.
Financial Mail: "Seeking a South African Hollywood," December 14, 1962, pp. 1066-69.
Finance Week: "Movie Making's Catch-22—Where is SA's film industry heading?" Feb. 11-17, 1982, pp. 117-180.
GUTSCHE, T.: "Vital Need for Dominion Film Boost. Mr. Schlesinger's Scheme to Encourage Local Production," *The Forum*, Aug. 24, 1940, p. 6.
Management: "Facing Up to the Small Screen," July 1974, pp. 26-31.
News/check: "Filmmaker Jans Rautenbach," V. 8, N. 23, 1970, pp. 14-18.
News/check: "Ster Films Rampant," Aug. 22, 1969, pp. 40-42.
News/check: "Emil Nofal in Quest of Identity," June 17, 1969, pp. 32-37.
News/check: "*Die Kandidaat* Comes Unstuck," Oct. 25, 1968, p .7.
News/check: "A Hollywood for South Africa?" April 12, 1963, pp. 20-25.
NEMO, CAPTAIN: "The Truth about the Theatres Trust," Plain Dealer Pamphlets, N. 1 (undated). Exposé by self-appointed ombudsman of the business practices of the Schlesinger Orzanization.
TOMASELLI, K. G.: "Collinson's Complaints: The Big Three Reply," *Audiovision*, V. 1, N. 9, 1976, pp. 4-5. A response by equipment hire companies to Collinson's remarks about the inferior state of local technology.
TOMASELLI, K. G.: "The South African Film and Television Technicians Association: Its Aims and Objects," *Audiovision*, V. 1, N. 8, 1976, pp. 10-11.
TOMASELLI, K. G.: "Keyan Tomaselli Talks to Peter Collinson," *Audiovision*, V. 1, N. 6, 1976, pp. 8-9.

Articles (Popular Magazines)

ALBRECHT, J.: "What is the Future of Motion Picture Production in South Africa?" *Outspan*, July 20, 1945, pp. 13 & 41.
Comment and Opinion: "Film Business in South Africa." July 1949.
DE V HEESE, J: "Triomftog van die Voortrekkerrolprent," *Huisgenoot*, April 26, 1940, p. 47.
DILLON, R.: "Vantu Cinema," *SA Industry and Trade*, March 1970.
FAURE, S.: "Ons Eerste Klankrolprent in Afrikaans—*Moedertjie*," *Huisgenoot*, V. 16, N. 496, 1931, pp. 14 & 18. About the first Afrikaans sound film.
Forum: "*Strange Princess*, first full length color film produced in South Africa," February 28, 1942.
GERMISHUYS, P.: "Flickering Past," *SA Panarama*, May 1963, pp. 2-7. An illustrated history of early South African films.
GUTSCHE, T.: "How the Cinema Came to South Africa," *Outspan*, March 3, 1946.

Operator (pseud.) : "Running a Mobile Cinema," *Nonquai,* January 1943. *SA Panorama: "Zulu,"* September 1963.

SHAW, H.: "Filming *The Voortrekkers," Stage and Cinema,* December 30, 1916, p. 2.

SILBER, G.: "Dream Factory," *Frontline,* V. 6, No. 3, 1986, pp. 30-31. A biting expose of that section of the industry making films for black audiences.

Stage and Cinema: "Father of the Theater in South Africa," March 23, 1949, p. 3. Obituary of I. W. Schlesinger.

Stage and Cinema: "South African Film to Have World Showing," September 3, 1948. An article on *Pondo Story,* 1948, pp. 3-4.

Stage and Cinema: "Criticism or Abuse?" March 5, 1948, p. 3.

Stage and Cinema: "Hollywood Technique in Modern Production Methods in Afrikaans Film," June 1946, pp. 13 & 40.

Stage and Cinema: "An Unbroken Chain of Circuits. Why the African Films Trust Succeeded," July 9, 1921, p. 4.

Stage and Cinema: "The Symbol of Sacrifice," April 27, 1918, p. 13. "Praise from Prominent Men."

Stage and Cinema: "South Africa's Film City," September 1, 1917, pp. 2-3.

Stage and Cinema: "Film Censorship. Draft Ordinance in the Cape Provincial Council. A Cumbersome and Unwieldy Measure," July 7, 1917, p. 6.

Stage and Cinema: "The Voortrekkers: Film," December 23, 1916, pp. 2-3. Comments on the film by Cabinet Ministers and others.

Stage and Cinema: "The Voortrekkers," December 2, 1916, p. 11. Pre-production report.

Stage and Cinema: "The Liquor Seller," June 3, 1916, p. 6. Review.

Stage and Cinema: "A Zulu's Devotion," May 6, 1916, p. 4. Review.

VAN DER MERWE, J. N.: "Waarheen met Toneel en Rolprent?" *Tydskrif vir Letterkunde,* September 1951.

VAN ZYL, J.: "A Reeling Industry: Film in South Africa," *Leadership,* V. 4, N. 4, 1985, pp. 102-106. A brief history of the effects of television with a comparison to Australia.

Theses and Dissertations

ARONSTAM, R.: "An Empirical Study of the Black Feature Film Industry in South Africa in 1985." Long Essay, School of Dramatic Art, University of Witwatersrand, 1985. 52 pp.

BAKER, S. J.: Perspectives on the Problems of the South African Film Industry with Special Reference to the Place of the Filmmaker in this Industry. Ph.D. Thesis, University of Pretoria, 1986. "The present problematical condition of the South African film industry is explained from a functional perspective on the one hand and from a conflict perspective on the other. It is also indicated how the film-

maker's own views on his place in the film industry are affected by each of these perspectives . . . From a conflict perspective it appears that film industries locally as well as abroad are characterized by value, interest and power conflicts. Hence (a) the individualistic behavior of local filmmakers and the continuous rivalry among them, and (b) their conflicting views on filmmaking. As a result of these conflicts local filmmakers make use of various methods of ensuring their survival. This leads *inter alia* to the abandonment of the ideal of establishing an indigenous film industry" (From "Summary" written by author).

BASSON, A. F.: "Film Reviews—A Qualitative and Quantitative Analysis." MA Thesis, University of Orange Free State, 1982. A structuralist-functionalist analysis of press reviews. In Afrikaans.

BRAMWELL-JONES, R. D.: "Film Production Facilities: A Systematic Approach to Their Design." University of Witwatersrand, Degree of Bachelor of Architecture, 1970. 255 pp. Explores the process of filmmaking and the workings of the film studio. It analyzes the functions and relationships between the various departments and proposes an architectural design of a feature film facility. Illustrated with plans, flow charts and photos.

DU TOIT, K. W.: "Some Spiritual Aspects of the Film as an Evangelising Medium." MA Thesis, UNISA, 1972.

FOURIE, P.: "A Structural-Functional Model for the Formulation of a South African Film Policy." Ph.D., UNISA, 1982. See Fourie, under Journals, for publications emanating from this study. In Afrikaans. This thesis formed the background to the Report published in *Rapport* on June 21, 1981.

FOURIE, H. P.: "The Role of Suggestion in Film Persuasion." Ph.D. Thesis, UNISA, 1977.

GAVSHON, H.: "Ideology and Film: An Examination of Films Made for Black Audiences." Long Essay, School of Dramatic Art, University of Witwatersrand, 1980. 73 pp. Develops a theoretical framework within which the author examines a number of feature films made by white producers for black audiences. Detailed content analyses show how these films serve the dominant ideology of apartheid.

GROVE, J. H. M.: "The Teaching and Practice of Film Study at Secondary School Level." MA Thesis, University of Witwatersrand, 1981. A formalistic semiotic analysis.

HEAD, B.: "A Film and TV School Complex for the University of Cape Town in the Gardens." Thesis for Bachelor of Architecture, University of Cape Town, 1980.

KAROL, E.: "A New College for Old Rome: A College of Film for University of Cape Town on the Hiddingh Hall Campus." Thesis for Bachelor of Architecture, University of Cape Town, 1982.

LASORSOHN, S.: "New Premises for African Film Production Ltd. University of Witwatersrand, Degree of Bachelor of Architecture (undated)." 108 pp. An analysis of the existing facilities of African

Film Productions. Sets out to solve the problems of accommodation and organization. Illustrated with plans, diagrams and photos.

LOMBARD, D. H. J.: "The Development of a Film Industry for the Bantu." MBL Thesis, UNISA, 1976. 85pp. A functionalist analysis which looks at the factors which are assumed to affect the development of a "film industry for the Bantu." Its "business" assumptions are couched in apartheid discourse. In Afrikaans.

PUTH, G.: "A Content Analysis of South African Films (1972-1974) with Special Reference to Peters' Theory of Visual Communication." MA Thesis, Randse Afrikaanse Universiteit, 1977. 110pp. A quantitative factor analysis of film content confirms Peters' theory of technical and aesthetic content. In Afrikaans.

SCHOLTZ, A.: "The Formulation and Implementation of an Integrated Planning and Control System for a Film Distribution and Exhibition Company." MBL Thesis, School of Business Leadership, UNISA, 1976.
Develops a management system put into practice at Ster-Kinekor.

TOMASELLI, K. G.: "Ideology and Cultural Production in South African Cinema." Ph.D. Thesis, University of Witwatersrand, 1983, 495 pp.

TOZER, G. C.: "Aspects of the Marketing and Financing of South African Produced Feature Films." Research report, Graduate School of Business Administration, University of Witwatersrand, 1976. Analysis of aspects of film financing and box office returns.

WAKEFIELD, I.: "A Feasibility Study for an Independent Film Production Company in South Africa." MBA Thesis, Graduate School of Business, University of Cape Town, 1983.

Bibliographies/Filmographies

LE ROUX, A. and FOURIE, L.: "*Filmverlede: Geskiedenis van die Suid Afrikaanse Speelfilm,* UNISA Pretoria, 1982. Contains references to all feature films made before 1980. Information provided is unsystematic and tells the reader little more than the title, the names of some key crew, actors and vague descriptions of plot.

OHRN, S. and RILEY, R. (Compilers): *From real to Real: An African Filmography.* African Studies Association, Mass., 1976. Contains synopses of over 126 feature and documentary films made in South Africa.

SCHMIDT, N.: *Sub-Saharan African Films and Filmmakers: A Preliminary Bibliography.* Bloomington: African Studies Program, Indiana University. 112 pp.

Source Guide for Drama, Films, Radio, Plays and Television. Vols. I-V. Human Sciences Research Council, Pretoria, 1970-1974. The *Guide* contains a systematic index of articles, reviews, etc. appearing in South African newspapers and periodicals.

UDEMAN, A. (Compiler): *The South African Film Industry 1940-1971.*
University of the Witwatersrand, 1972. 48 pp. of references.

Specialist Publications Dealing with Film

Critical Arts: A Journal for Media Studies. Published by the Critical Arts
Study Group, c/o Contemporary Cultural Studies Unit, University
of Natal, King George V Avenue, Durban 4001. First issue:
March 1980.
Contacts. An Annual guide to theatre, film and companies, production
houses, service facilities, and other information. Published by Lime-
light, P.O. Box 6769, Johannesburg 2000.
The Limelight. An annual casting directory. See above address.
The SAFTTA Journal. Published by the South African Film and Tele-
vision Technicians Association, P.O. Box 41357, Craighall, 2024.
First issue: July 1980. Published once or twice a year.
The SAFTTA News: First issue: 1974. Published irregularly. See above
address.
SA Film and Entertainment Industry. Published by Clarion Communica-
tions Media. Basically a trade magazine serving the distribution and
exhibition sectors of the industry. First issue: May 1978. Published
monthly. Previously *SA Film Weekly,* which was first published in
1963 under the editorship of Harry Jones. During this time the
magazine was extremely critical of the industry. Under the new title
it has become the PR arm of the distributors.
Scenaria. Published by Triad Publishers. Occasionally publishes interviews
with South African directors. First issue: June/July 1977. Published
bi-monthly.
Other journals referenced in the text such as *Stage and Cinema, Forum,
Trek, SA Opinion, News/check, The Union Review, Audiovision
Speak, Snarl* and *New Nation* have ceased publication.
Of historical interest are the following journals: *Kultuur Filma* (1944-
1946), an Afrikaner-oriented cultural magazine dealing with both
technical and cultural matters, and *Die RARO Journal* (early 1940s)
edited by Hans Rompel of the Reddingsdaadbond, the organization
set up to save Afrikanerdom from alien influences.

Government Publications

FOURIE, P.: "How Can the South African Industry be Rescued from its
Plight," *Rapport,* June 21, 1981. This is an extract from a much
longer report submitted to the Department of Industries. In making
the report public Fourie so incensed the Department that it imme-
diately embargoed all remaining copies and has witheld them from
public scrutiny. While the report is a functionalist analysis of how
the subsidy should work within the confines of *verlig* (enlightened)
apartheid system, it addresses itself to the problem in terms of inte-

cultural communication, self-exploration, art, and humanism. See Fourie under Theses for the conceptual background to the report.

Union of South Africa. The Cilliers Film Committee, 1943. An unpublished report which tried to hijack the film industry for extreme Afrikaner Nationalist purposes. This report is not mentioned in the usual government publication lists, nor were its proposals carried through.

Union of South Africa. *Report of the Inter-Departmental Committee Appointed to Consider the Report of the Committee on State Publicity and the Film Committee and Other Relevant Matters.* Government Printer, 1944, 3pp. Chairman: E. P. Smith.

Union of South Africa: The Grierson Report. 2nd Draft, 1954. Although three drafts of the Report were handed to the South African government, only the 2nd draft remains in existence.

Republic of South Africa. Board of Trade and Industries: *Monopolistic Conditions in the Procurement, Production and Distribution of Motion Pictures in the Republic of South Africa.* Report No. 833(M), 1961. Investigation into the distribution practices of 20th Century Fox.

Republic of South Africa. Board of Trade and Industries: *Investigation into Motion Picture Production.* Report No. 1034, 1963.

Republic of South Africa. Department of Statistics: *Census of Cinema, Cafe-bioscopes and Drive-In Theatres, 1964-1965.* Report No. 04-51-01. Also see Report No. 04-51-02 of the same title dated *1969-1970.*

Republic of South Africa. *Report of the Select Committee on a Question of Privilege.* 1966. A report of the proceedings of a Committee investigating a breach of parliamentary privilege by Harry Jones, editor of *SA Film Weekly.*

Republic of South Africa. Board of Trade and Industries: *Investigation into the Motion Picture Industry.* Report No. 1330, 1970.

Republic of South Africa. *Verslag van die Kommissie van Ondersoek Insake Aangelenthede Betreffende Televisie.* Report No. 37, 1971. Report into matters relating to the introduction of television.

Republic of South Africa. *Supplementary Report of the Commission of Inquiry into Alleged Irregularities in the Former Department of Information.* RP 63/1979. See also the main report RP 113/1978. Chairman: R.P.B. Erasmus.

Republic of South Africa. Board of Trade and Industries: *Ondersoek na die Rolprent Vervaardigingsbedryf in Suid-Afrika.* Report No. 1753, 1976. Report into the film production industry with special reference to the subsidy.

Statutes of the Republic of South Africa—Cultural Institutions. *National Film Board Act,* No. 73 of 1963.

VAN ZYL, J. A. F.: Report to the Secretary of Industries on The South African Film Industry. Unpublished report submitted with Fourie, *op. cit.,* 1980.

South African Feature Films
A Chronology: 1910-1985

Title	Language sub-titles
1910	
The Kimberley Diamond Robbery	Eng
1916	
An Artist's Inspiration	Eng
A Zulu's Devotion	Eng
The Silver Wolf	Eng
The Illicit Liquor Seller	Eng
A Kract Affair	Eng
The Water Cure	Eng
£20 000	Eng
The Gun Runner	Eng
Sonny's Little Bit	Eng
Gloria	Eng
De Voortrekkers. Winning a Continent	Afr Eng
The Splendid Waster	Eng
A Story of the Rand	Eng
A Tragedy of the Veldt	Eng
1917	
And Then?	Eng
The Border Scourge	Eng
The Major's Dilemma	Eng
The Mealie Kids	Eng
The Piccanin's Christmas	Eng
The Rose of Rhodesia	Eng
Zulu Town	Eng
1918	
Symbol of Sacrifice	Eng

Title	Language sub-titles
Bond and Word	Eng
Voice of the Waters	Eng
The Bridge	Eng
King Solomon's Mines	Eng
1919	
The Adventures of a Diamond	Eng
The Stolen Favourite	Eng
Fallen Leaves	Eng
Copper Mask	Eng
With Edged Tools	Eng
Allan Quartermaine	Eng
1920	
Isban Israel	Eng
Prester John	Eng
The Man who was Afraid	Eng
Madcap of the Veld	Eng
1921	
The Buried City	Eng
Under the Lash	Eng
1922	
The Vulture's Prey	Eng
Swallow	Eng
Sam's Kid	Eng
1923	
The Blue Lagoon	Eng

Title	Language sub-titles
1924	
The Reef of Stars	Eng
1931	Dialogue
Sarie Marais	Afr
Moedertjie	Afr
1933	
'n Dogter van die Veld	Afr
1936	
Rhodes of Africa	Eng
1939	
Die Bou van 'n Nasie. They Built a Nation	Afr/Eng
1942	
Newels Oor Mt Aux-Sources	Afr
Lig van 'n Eeu	Afr
Ons Staan 'n Dag Oor	Afr
1944	
Donker Spore	
1946	
Pinkie se Erfnis	Afr
Die Wildsboudjie	Afr
Geboortegrond	Afr
Die Skerpioen	Afr
1947	
Pantoffelregering	Afr
Simon Beyers	Afr
1948	
Kaskenades van Dr Kwak	Afr
1949	
Oom Piet se Plaas	Afr
Sarie Marais	Afr
Kom Saam Vanaand	Afr
Jim Comes to Jo'burg	Eng

Title	Language sub-titles
1950	
Zonk	Eng
Hier's Ons Weer	Afr
1951	
Alles sal regkom	Afr
Daar Doer in die Bosveld	Afr
Cry the Beloved Country	Eng
Where No Vultures Fly	Eng
Song of Africa	Eng
1952	
Altyd in my Drome	Afr
1953	
Hans Die Skipper	Afr
Fifty-Vyftig	Afr
Inspan	Afr
Skabenga	Eng
1954	
West of Zanzibar	Eng
'n Plan is 'n Boerdery	Afr
Die Leeu van Punda Maria	Afr
Daar Doer in die Stad	Afr
African Fury	Eng
1955	
Vadertjie Langbeen	Afr
Geld Soos Bossies	Afr
Matieland	Afr
Wanneer die Masker Val	Afr
1956	
Die Groot Wit Voel	Afr
Paul Kruger	Afr
By an African Camp Fire	Eng
1957	
Dis Lekker om te Lewe	Afr
Donker Afrika	Afr
1958	
The Michaels in Africa	Eng
Die Bosvelder	Afr

Title	Language sub-titles
Goddelose Stad	Afr
Fratse van die Vloot	Afr
Die Sevende Horison	Afr
Nor the Moon by Night	Eng
Ek sal Opstaan	Afr
Come Back Africa	Eng

1959

Desert Inn	Eng
Piet se Tante	Afr
Die Wilde Boere	Afr
Nooi van my Hart	Afr
Satanskoraal	Afr

1960

Rip van Wyk	Afr
Last of the Few	Eng
Die Vlugteling	Afr
Kyk na die Sterre	Afr
Oupa en die Plaasnooientjie	Afr
Hou die Blinkkant Bo	Afr
Bloedrooi Papawer	Afr
Die Jagters	Afr

1961

Skadu van Gister	Afr
Doodkry is Min	Afr
Spore in die Modder	Afr
Die Bubbles Schroeder Storie	Afr
Moord in Kompartement 1001 e	Afr
Basie	Afr
Tremor As die Aarde Skeur	Eng/Afr
Drums of Destiny	Eng
En die Vonke Spat	Afr
Die Hele Dorp Weet	Afr
Hans en die Roinek	Afr/Eng
The Hellions	Eng
Boerboel de Wet	Afr
Magic Garden	Eng
Diamante is troewe	Afr
Hands of Space	Eng

Title	Language sub-titles
Gevaarlike Reis	Afri
Kalahari	Afr/Eng
Diamonds are Dangerous	Eng

1962

Die Tweede Slaapkamer	Afr
Skelm van die Limpopo	Afr
Man in die Donker	Afr
Tom. Dirk en Herrie	Afr
As Ons Twee Getroud is	Afr
Savage Africa	Eng
Gevaarlike Spel. Dangerous Deals	Afr/Eng
Geheim van Onderplaas	Afr
Stropers van die Laeveld	Afr
Murudruni	Eng
Jy's Lieflik Vanaand	Afr
Voor Sononder	Afr
Lord Oom Piet	Afr

1963

Huis op Horings	Afr
Journey to Nowhere	Eng
Gee My Jou Hand	Afr
Kimberley Jim	Afr
Ruiter in die Nag	Afr
Die Reen Kom Weer	Afr
The Lion Speaks	Eng

1964

Piet se Niggie	Afr
Sanders of the River	Eng
Rhino	Eng
The Foster Gang	Eng
Seven Against the Sun	Eng
Dingaka	Eng
Table Bay	Eng
Die Wonderwereld van Kammie Kamfer	Afr

1965

Coast of Skeletons	Eng
Tokoloshe	Eng
Debbie	Afr
Voortrefflike Famalie Smit	Afr

Title	Language sub-titles
Ride the High Wind	Eng
King Hendrik	Eng
1966	
Zulu	Eng
All the Way to Paris	Eng
Operation Yellow Viper	Eng
Sands of the Kalahari	Eng
Die Kavaliers	Afr
The Second Sin	Eng
Jagd auf blaue Diamanten	
The Diamond Walkers	German
The Naked Prey	Eng
Africa Shakes	Eng
Mocambique	Eng
1967	
Die Wilde Seisoen	Afr
Bennie—Boet	Afr
Die Kruger-miljoene	Afr
In die Lente van Ons Leifde	Afr
Die Jakkels van Tula Metsi	Afr
Profesor en die Prikkelpop	Afr
Escape Route Cape Town	Eng
Hoor My Lied	Afr
The Scavangers	Eng
1968	
Oupa for Sale	Afr
The Mercenaries	Eng
The Long Red Shadow	Eng
Die Kandidaat	Afr
Raka	Afr
Jy is my Liefling	Afr
King of Africa	Eng
Twee Broeders Ry Saam	Afr
Dr Kalie	Afr
Majuba	Afr
Find Livingstone	Eng
One of the Pot	Eng

Title	Language sub-titles
1969	
Vrolike Vrydag	Afr
Danie Bosman	Afr
Katrina	Afr
Strangers at Sunrise	Eng
A Twist of Sand	Eng
Stadig oor die Klippe	Afr
Dirkie	Afr
Die Vervlakste Tweeling	Afr
Geheim van Nantes	Afr
Staal Burger	Afr
Joanna	Eng
Petticoat Safari	Eng
1970	
Lied in My Hart	Afr
Haak Vrystaat	Afr
Scotty Smith	Eng
Onwettige Huwelik	Afr
Banana Beach	Eng
Jannie Totsiens	Afr
Knockout	Eng
Forgotten Summer	Eng
Die Drie van der Merwes	Afr
Vicki	Afr
Hulde Versteeg MD	Afr
Shangani Patrol	Eng
Taxi	Eng
Ryan's Daughter	Eng
Stop Exchange	Eng
Satan's Harvest	Eng
Sieraad Uit As	Afr
Sien Jou Môre	Afr
1971	
Mr Kingstreet's War	Eng
A New Life	Eng
Pressure Burst	Eng
Three Bullets for a Long Gun	Eng
Flying Squad	Eng
Freddie's in Love	Eng
Pappalap	Afr
Breekpunt	Afr
Sononder	Afr

Title	Language sub-titles
Lindie	Afr
Gold Squad	Eng
Soul Africa	Eng
Die Lewe Sonder Jou	Afr
Die Erfgenaam	Afr
Die Banneling	Afr
The Men from the Ministry	Eng
Zebra	Afr

1972

Next Stop Makouvlei	Eng
The Manipulator	Eng
K9 Baaspatrolliehond	Afr
Creatures the World Forgot	Eng
The Winners	Eng
Die Wildtemmer	Afr
Vlug van die Seemeeu	Afr
The Last Lion	Eng
Die Marmerpoel	Afr
Makulu (Rogue Lion)	Eng
Boemerang 11.15	Afr
My Broer se Bril	Afr
Liefde vir Lelik	Afr
Afrika!	Afr
Sperregebiet: Diamond Area No. 1	Afr
Salomien	Afr
Lokval in Venesië	Afr
Skat van Issie	Afr
Kaptein Caprivi	Afr
Pikkie	Afr
Leatherlip	Eng
Weekend	Eng
Man van Buite	Afr
Just Call Me Lucky	Eng

1973

The Brave, the Rough and the Raw	Eng
Die Sersant en die Tiger Moth	Afr
The Baby Game	Eng
Siener in die Suburbs	Afr

Title	Language sub-titles
Dog Squad	Eng
Die Bankrower	Afr
Insident of Paradysstrand	Afr
House of the Living Dead/ Skaduwees oor Brugplaas	Afr/Eng
Die Wit Sluier	Afr
The Big Game	Eng
Die Spook van Donkergat	Afr
Afspraak in die Kalahari	Afr
Snip en Rissiepit	Afr
Groetnis vir die Eerste Minister	Afr
Africa	Eng
From Rags to Riches	Eng
Jamie 21	Afr
Aanslag op Kariba	Afr
Die Voortrekkers	Afr
Boesman and Lena	Afr/Eng
Môre Môre	Afr

1974

Joe Bullet	Eng
Bait	Eng
Beautiful People	Eng
Oh Brother	Eng
Pens en Pootjies	Afr
Savage Sport	Eng
Dans van die Vlammink	Afr
Vang vir my 'n Droom	Afr
Call Me Lucky	Eng
Dooie Duikers Deel Nie	Afr
Fraud	Eng
Babbelkous en Bruidegom	Afr
Ongewenste Vreemdeling	Afr
Geluksdal	Afr
Die Kwikstertjie	Afr
Die Afspraak	Afr
Suster Theresa	Afr
The Virgin Goddess	Eng
Skadus van Gister	Afr
Die Saboteurs	Afr
Gold	Eng
Vreemde Wêreld	Afr

Title	Language sub-titles	Title	Language sub-titles
Funeral for an Assasin	Eng	Die Rebel	Afr
Cry Me a Teardrop	Eng	De Wet's Spoor	Afr
Voorvlugtige Spioen	Afr	Olie Kolonie	Afr
Those Naughty Angels	Eng	Diebare Diplomat	Eng
Boland	Afr		
Tant Ralie se Losieshuis	Afr	**1976**	
Met Liefde van Adele	Afr	Killer Force	Eng
Sonneblom uit Parys	Afr	Death of a Snowman	Eng
Land Apart	Eng	Funny People	Afr/Eng
Vrou uit die Nag	Afr	Vergeet my Nie	Afr
Nogomopho	Zulu	The Boxer	Zulu
		Liefste Madelein	Afr
1975		Ngwanaka	Sotho
Voortreflikke Familie Smit	Afr	Hank, Hennery and Friend	Eng
Daar Kom Tant Alie	Afr	Ridder van die Grootpad	Afr
Jakalsdraai se Mense	Afr	Tigers don't Cry	Eng
Trompie	Afr	Karate Olympia	Eng
Die Square	Afr	Erfgoed is Sterfgoed	Afr
Somer	Afr	Glenda	Eng
Seuns van die Wolke	Afr	Sestig Jaar van John	
é Lolipop	Eng	Vorster	Afr
Liefste Veertjie	Afr	Ngaka	Tswana
Lelik is my Offer	Afr	How Long	Eng
Eendag op 'n Reëndag	Afr	The Sportsman	Eng
Shout at the Devil	Eng	Accident of War	Eng
Mirage Eskader	Afr	Mahlomola	Zulu
Wat Maak Oom Kalie		Isimanga	Zulu
Daar	Afr	Terrorist	Eng
Soekie	Afr	I-Kati Elimnyana	Zulu
Sarah	Afr	Die Vlindervanger	Afr
Maxhosa	Eng	'n Beeld vir Jeannie	Afr
U-Deliwe	Zulu	Thaba	Afr
Ma Skryf Matriek	Afr	Inkunzi	Xhosa
Diamond Hunters	Eng	The South Africans	Eng
Sell a Million	Eng	My Liedjie van Verlange	Afr
Ses Soldate	Afr	Springbok	Afr
My Naam is Dingertjie	Afr	'n Sondag in September	Afr
Kniediep	Afr		
Inkedama	Xhosa	**1977**	
Troudag van Tant Ralie	Afr	Winners II	Eng
Ter wille van Christene	Afr	Kom tot Rus	Afr
Daan en Doors oppie		Netnou Hoor die Kinders	Afr
dieggins	Afr	Lag met Wena	Afr
Dingertjie is Dynamite	Afr	Suffer Little Children	Eng

Title	Language sub-titles	Title	Language sub-titles
The Angola File	Eng	Utsotsi	Zulu
Crazy People	Eng/Afr	Abashokobezi	Zulu
The Guest. Die		Isuvumelwano	Zulu
Besoeker	Eng/Afr		
Dit was Aand en dit		**1979**	
was Môre	Afr	Phindesela	Zulu
Irma	Afr	Umzingeli	Zulu
Die Winter 14 Julie	Afr	Botsotso	Zulu
Tears for a Killer. Amor		Isoka	Zulu
de Assasino	Portuguese	Setipana	Zulu
Dingertjie en Idi	Afr	Mightyman I & II	Zulu
Wild Geese	Eng	Weerskant die Nag	Afr
Iziduphunga	Zulu	Pretoria O Pretoria	Afr
Mapule	Sotho	Eensame Vlug	Afr
Wangenza	Zulu	Plekkie in die Son	Afr
Golden Rendezvous	Eng	Forty Days	Eng
Kootjie Emmer	Afr	Charlie word 'n Ster	Afr
Mooimeisiefonten	Afr	Elsa se Geheim	Afr
Escape from Angola	Eng	Greensbasis 13	Afr
Inyakanyaka	Zulu	Wat Jy Saai	Afr
		Herfsland	Afr
1978		Follow that Rainbow	Eng
Sonja	Afr	Umunt Akalahlwa	Zulu
'n Seder Val in Waterkloof	Afr	Ingilosi Yokufa	Zulu
The Pawn	Eng	Game for Vultures	Eng
Diamant en die Dief	Afr		
Someone Like You.		**1980**	
Iemand Soos Jy	Afr/Eng	Skelms	Afr
Spaanse Vlieg	Afr	April '80	Afr/Eng
Decision to Die	Eng	Night of the Puppets	Eng
Fifth Season/		Marigolds in August	Eng
Vyfde Seisoen	Eng/Afr	Sing vir die Harlekyn	Afr
Billy Boy	Eng	Gemini	Afr
Witblitz and		The Gods Must Be Crazy	Eng
Peach Brandy	Eng/Afr	Rienie	Afr
Dr Marius Hugo	Afr	A Savage Encounter	Eng
Nicolene	Afr	Zulu Dawn	Eng
Setipana	Sotho	Baeng	Tswana
The Advocate	Zulu	Umona	Zulu
Nokf	Zulu	Umdlali	Zulu
Abafana	Zulu	Botsotso Pt 2	Zulu
Vuma	Zulu	Biza Izintombi	Zulu
Moloyi	Sotho	Umbdhale	Zulu
Luki	Zulu	Iqhawe	Zulu

Title	Language sub-titles	Title	Language sub-titles
Confetti Breakfast	Eng	Doctor Luke	Eng
Kiepie en Kandas	Afr	Blood Money	Zulu/Eng
Rally	Eng	Impango	Zulu
Kill and Kill Again	Eng	Isiqhwaga	Zulu
Burning Rubber	Eng		
Shamwari	Eng		
The Demon	Eng	**1983**	
Flashpoint Africa	Eng	Wolhaarstories	Afr
Hippo	Eng	Funny People II	Eng
Follow that Rainbow	Eng	The Riverman	Eng
		Geel Trui vir 'n Wenner	Afr
		Inyembezi Zami	Sotho
1981		Motsumi	Sotho
Kiepie en Kandas	Afr	Botsotso III	Zulu
Blink Stefaans	Afr	Mmampodi	Sotho
Kill and Kill Again	Eng	Washo Ubaba	Sotho
Beloftes van Môre	Afr	My Country My Hat	Eng
Nommer Asseblief	Afr	Ngavele Ngasho	Zulu
Birds of Paradise	Eng	Vakasha	Zulu/Eng
Uzenzile Akakhalelwa	Zulu	Umdlalo Umbango	Tswana
Sonto	Sotho	Why Foresake Me?	Eng
Iwisa	Zulu	Moloyi	Sotho
Dumela Sam	Eng/Sotho	Johnny Tough	Eng/Zulu
Isigangi	Sotho	Ndinguwakabani	Tswana
Vimba Isipoko	Sotho	Tommy 2	Zulu
Ukusindiswa	Zulu	Impumelelo	Sotho
Umnyakazo	Zulu	Tora Ya Raditeble	Sotho
Ungavimbi Umculo	Zulu	Running Young	Eng
So-Manga	Zulu	Whose Child am I?	Tswana
A Way of Life	Eng	Amazing Grace	Eng
Tommy	Zulu	Joe Slaughter	Zulu
Inkada	Zulu	Iziphukuphuku	Zulu
1982		**1984**	
Shamwari	Eng	Tawwe Tienies	Afr
Bosveldhotel	Afr	Broer Matie	Afr
Verkeerde Nommer	Afr	Die Groen Faktor	Afr
Ukulwa	Zulu	Survival Zone	Eng
Ukuhlupheka	Sotho	Boetie Gaan Border	
Pina Ya Qetelo	Sotho	Toe	Afr/Eng
Umdlalo Umkhulu	Zulu	Sanna	Eng
Bullet on the Run	Eng	Mathata	Eng/Sotho
Will to Win	Eng	The Spin of Death	Eng
Umjuluko Me Gazi	Zulu/Eng	For Money	
Ubude Abuphangwa	Sotho	and Glory	Eng/Sotho

Title	Language sub-titles	Title	Language sub-titles
Point of Return	Eng/Zulu	Umbodi	Zulu
Mathata	Sotho	Moon Mountain	Eng
Charlie Steel	Eng	Umfana II	Zulu
Upondo No Nkinsela	Sotho	Playing Dirty	Eng
Boiphetetso	Sotho	The Banana Gang	Zulu
Bobe mo Motseng	Zulu	Modise	Tswana
Fanakalo	Sotho	Bank Busters	Zulu
The Musicmaker	Zulu/Eng	Survival Zone	Eng
Usiko Lwabafana	Zulu	The Midnight Caller	Eng
Night of Terror	Eng		
Bird Boy	Eng	**1985**	
Ulaka	Zulu	Indohana	
Bozo and Bimbo	Eng	Yolahleko	Zulu/Xhosa
Honour Thy Father	Eng	ULanga	Zulu/Xhosa
Stoney, the One and Only	Eng	Isinamuva	Zulu/Xhosa
Zero for Zep	Zulu	Bad Company	Eng
Umfana	Zulu	Indlu Yedimoni	Zulu/Xhosa
Iqhawe II	Zulu	Vulane	Zulu/Xhosa
Isalamusi	Zulu	Torak	Zulu/Xhosa
Slow vs Boner	Zulu	Johnny Diamini	Eng
Izigebengu	Zulu	Bhema	Zulu
Mission Spellbound	Eng	Treasure Hunt	Eng
ULindiwe	Sotho	Ukuzingela	Zulu/Xhosa
Yonna Lefatseng	Sotho	Sixpence	Eng
Ace of Spades	Zulu	Mr. TNT	Eng
Bona Manzi	Zulu	Revenge is Mine	Eng
Never Rob a Magician	Zulu	Ukuphindisela	Zulu/Xhosa
Starbound	Eng	Revenge	Eng
Odirang	Sotho	The Taste of Blood	Eng.
The Hitch-Hikers	Zulu	The Murderer	Eng
Inyoka	Sotho	The Dealer	Eng
Crime Doesn't Pay	Eng	Amaphoyisana	Zulu
Run for Freedom	Eng	Foul Play	Eng
Cold Blood	Zulu	Rough Nights in	
I Will Repay	Eng	Paradise	Eng
The Reckoning	Eng	Somhlolo	Swazi
Double Deal	Eng	The Moment of Truth	Eng
Imali	Sotho	Intaba Yegolide	Zulu/Xhosa
Iso Ngeso	Zulu/Eng	Ihlathi Lezimanga	Zulu/Xhosa
Winner Take All	Eng	Allegra	Zulu/Xhosa
One More Shot	Eng	Innocent Revenge	Eng
Mr Moonlight	Eng	Indlela	Zulu/Xhosa
The Cross	Eng	Blue Vultures	Eng
Isithixo Segolide	Zulu	Mapantsula	Zulu/Xhosa

Title	Language sub-titles	Title	Language sub-titles
Lana	Zulu/Xhosa	Joker	Eng
Polao E Makatsang	Sotho	Iholide	Zulu/Xhosa
Umsizi	Zulu/Xhosa	Sonny	Zulu/Xhosa
Rescuers	Zulu/Xhosa	The Last Run	Eng
Lucky	Eng	Diamond Catch	Eng
Iphutha	Zulu/Xhosa	Imusi	Zulu/Xhosa
Uzungu	Zulu/Xhosa	Getting Lucky	Eng
The Man	Eng	Mohlalifi	Sotho
Impindiso	Zulu/Xhosa	Too Late for Haven	Eng
Ukuvuleka	Zulu/Xhosa	Umfana	
Magic Ring	Eng	Wekarate	Zulu/Xhosa
Emgodini	Zulu/Xhosa	The Ace	Eng
Thor	Zulu/Xhosa	Mmila we Bakwetidi	Sotho
Abathakathi	Zulu/Xhosa	Sekebekwa	Sotho
Wind Rider	Zulu/Xhosa	Ransom	Eng
Phindisela	Zulu/Xhosa	Visitors	Eng
Menzi and		Amagoduka	Zulu/Xhosa
Menziwa	Zulu/Xhosa	Isipho Sezwe	Zulu/Xhosa
Hotter Than Snow	Eng	Witch Doctor	Eng
Mountain of Hell	Eng	Stepmother	Eng
Taste of Blood		Spider	Eng
(Part 2)	Eng	Uxolo	Zulu/Xhosa
Mapansula II	Zulu/Xhosa	Contact	Eng
The Long Run	Eng	Nkululeko	Zulu/Xhosa
Tselend Ya Bonokwane	Sotho	Iqaba	Zulu/Xhosa
Survival 1	Eng	Say-mama	Xhosa
Survival 2	Eng	Abathumbi	Zulu/Xhosa
Seganana	Zulu/Xhosa	Black Magic	Eng
Diamonds for Dinner	Eng	Herd of Drums	Eng
Big Land	Eng	Magic is alive,	
The Judgement	Eng	my friends	Eng
Amahlaya	Zulu/Xhosa	Eendag vir altyd	Afr
Somoholo 2	Swazi	You're in the Movies	Eng
The Comedians	Eng	Boetie op	
Fist Fighter	Eng	Manoeuvres	Afr/Eng
Umoni	Xhosa	Deadly Passion	Eng
Guquka	Zulu/Xhosa	Van der Merwe P.I.	Eng
Kidnapped	Eng	Skating on Thin Uys	Eng
The Scoop	Eng	The Lion's Share	Eng
Ulunya of		Mamza	Eng
Lohlanga	Zulu/Xhosa		

Selected Documentary Films

(Made in or about South Africa)

Where possible, a list of critiques have been provided for readers wishing to follow up specific films. The information contained below is not complete, for it was often difficult to determine dates of release, production companies, etc.

GENERAL

A Film on the Funeral of Neil Aggett, Interchurch Media Programme. K. G., Nxumalo, N. and van der Merwe, C. in *South African Labour* Mark Newman, 1982, Super-8, 15 minutes. For review see Tomaselli, Bulletin, V. 8.8 and 9.9, 1983, pp. 120-123.

The Abakwetha, Ray Phoenix, 35mm, estimated 1956.

Africa Mosaic, National Film Board, 16mm.

The Afrikaner Experience, 36 minutes, 1979.

Against the Swirl of Time, Phoenix Productions, Ray Phoenix, 16mm, color.

Die Afrikaanse Taal, NFB. 16mm, Willem Viljoen, 1972.

An Argument About a Marriage, Documentary Educational Resources. John Marshall, 1968. Study Guide available from DER.

Alexandra, Paul Weinberg and Modikwe Dikobe. Super 8, 1980.

And Then Came The English, Independent Film Centre (IFC) and SABC-TV. Lionel Friedberg, and Peter Grossett, 7 episodes, 1983.

Amazulu Wedding Ceremonies, African Film Productions. 16mm.

Apartheid, Inside Outside, Varavisie. Roeland Kerbosh, 45 minutes, 1978.

Apartheid: Sport et Politique, Michel Kopiloff, 52 minutes, 1977.

Au Pays des Reserves, Michel Kopiloff.

Awake From Mourning, Maggie Magaba Trust. Chris Austin, 16mm, 50 minutes, 1981. See Tomaselli, K. G.: "Strategies for an Independent Radical Cinema in South Africa," *Marang*, V. 4, pp. 51-88.

The Battle for South Africa, CBS. 50 minutes, 1978.

Baobab Play, Documentary Educational Resources. John Marshall, 16mm, 1974. Study Guide available from DER.

Bopelo, Brunnon Des Lebens, Protea Films. Werner Grunbauer, 35mm.

Bitter Melons, Documentary Educational Resources. John Marshall,

271

16mm, 1971. DER Study Guide available. Also see *American Anthropologist*, 1972 and *Media Digest*, April 1980.
British Stake in Apartheid, ATV. Anthony Thomas, 50 minutes, 1977.
The Bushmen. See *The Denver Africa Expedition*.
The Bushmen of the Kalahari, National Geographic Society. Robert Young. 1974.
Die Boesman Boogmaker, R. Johnston, 16mm, 1964.
Children Throw Toy Assegais, Documentary Educational Resources. John Marshall, 16mm, 1974. Study Guide available from DER.
The Chopi Timbila Dance, Pennsylvania State University. Andrew Tracey and Gei Zantzinger, 16mm. See J.A.F. van Zyl: "Review of Three Ethnographic Films," Critical Arts, V. 1, N. 4, 1981, p. 49.
The Colour War, BBC-TV. David Wheeler, 84 minutes, 16mm.
Colourful Courtship, Kurt Baum, 1958.
Crossroads, Lindi Wilson, 16mm, 50 minutes, 1979. See Wilson, L.: "Why My Film Was Banned," *Index on Censorship*, V. 10, N. 4, 1981, pp. 37-39.
Crossroads South Africa: The Struggle Continues, Jonathan Wacks, 50 minutes, 1980.
Cultural Identity, IFC & Dept of Information. Lionel Friedberg.
A Curing Ceremony, Documentary Educational Resources. John Marshall, 16mm, 1969.
Dances of Southern Africa, Pennsylvania State University. Gei Zantzinger, 1968.
Dear Grandfather, Your Right Foot is Missing, Yunus Ahmed, 1984.
Debe's Tantrum, Documentary Educational Resources. John Marshall, 1972.
The Defiant White Tribe.
Denver African Expedition, Universities of Denver and Cape Town and the South African Museum, Ernest Cradle and Grant John, estimated 1912. See J.A.F. van Zyl: " 'No God, No Morality, No History': South African Ethnographic Film," *Critical Arts*, V. 1, N. 1, 1980, pp. 32-37.
Diagonal Street, Lynton Stephenson, 16mm, 1971.
The Discarded People, Granada TV. 27 minutes, 1981.
Discover Sannyas, School of Dramatic Art, Wits University. Clare Schwartzburg, video, 47 minutes, 1983.
The Dispossessed, Gavin Younge, 16mm, 40 minutes, 1980.
District Six, Super 8 Film Group. John Berndt, Super 8, 1983.
The Dumping Grounds, Nana Mohomo, 16mm.
Dust to Dust, Granada TV. 1981, 26 minutes, 1981.
The End of Dialogue, Morena Films. 45 minutes, 1970.
Femme de Soweto, Michel Kopiloff, 16mm, 30 minutes, 1980.
Fighting Sticks, SABC-TV. Tommy McLelland, two episodes, 1980.
Follow the Yellow Cake Road, Granada TV. 26 minutes, 1980.
Forward to a People's Republic, IDAF. Lawrence Dworkin, Tony Bensusan, Brian Tilley, 16mm, 20 minutes, 1981.

Fosatu: Building Worker Unity, Human Awareness. Lawrence Dworkin, D. Coleman, 16mm, 1980. For a critique see Tomaselli, K. G.: "Oppositional Film Making in South Africa," FUSE, V. 6, N. 4, 1982, pp. 190-194.

Free Namibia, United Nations. 27 minutes, 1978.

From the Assegaai to the Javelin, Killarney, Estimated 1970.

Funeral of Neil Aggett, Granada TV. 16mm, 20 minutes, 1982.

Future Roots. Rhodes University Department of Journalism and Media Studies. Rob Purdy and Shirley Trautman, video, 60 minutes, 1982.

Gansbaai, 'n Vissers se Gemeenskap, NFB. Henry Nel.

Generations of Resistance, UNESCO. Peter Davis, 1979, 16mm, 60 minutes. For review see Safford, K.: "Peter Davis' Film View of South Africa: An American Review," *Critical Arts,* V. 2, N. 2, 1981, pp. 94-97.

A Group of Women, Documentary Educational Resources. John Marshall, 16mm, undated.

Gebtuns Namibia Wiede, Edward Katjivena, 29 minutes, 16mm, 1983.

The Gold Run, Yorkshire TV. 50 minutes, 1974.

Die Hart van 'n Stad, NFB. Hans Wagner, 1964.

The Heart of Apartheid, BBC-TV. Hugh Burnett, 52 minutes, 16mm.

Hindu Fire Walking in South Africa, Ray Phoenix, 16mm.

The Hunters, Documentary Educational Resources. John Marshall, 1958.

If God Be For Us, SA Council of Churches. Kevin Harris, 16mm, 1983.

Ikaya, SA Institute of Architects. Glen Gallagher, 16mm, 1976.

Il N'Y A Pas de Crise, Sans Optique, 30 minutes, 16mm, 1976.

Indians in South Africa, NFB. 16mm, John Fennel.

Indigenous Healers of Africa, University of Witwatersrand. Len Holdstock, video, 35 minutes, 1980.

Isitwalandwe, IDAF. Berry Feinberg, 51 minutes, 1980.

I Talk About Me: I am South Africa, Chris Austin and Peter Chappell, 1980.

Je M'Appelle Johannes Louthoumbe. 30 minutes, 16mm, 1977.

A Joking Relationship, Documentary Educational Resources. John Marshall, 16mm, 1969.

Die Kaapse Maleiers, NFB. 16mm, Mihaly Brunda.

Kalahari Klaskamer, R. Johnston, 16mm, 1964.

Kat River—The End of Hope, Rhodes University Department of Journalism and Media Studies. Jeff Peires, Keyan Tomaselli and Graham Hayman, video, 35 minutes, 1984.

!Kung Bushmen Hunting Equipment, Documentary Educational Resources. John Marshall, 16mm, 1966.

Kuns van die Rotswende, Killarney. Rod Stewart, 16mm 1970.

Le Laager, Television Suedoise. 60 minutes, 1977.

The Land of the Red Blanket, 5 minutes, 16mm.

Last Grave at Dimbaza, Nana Mahomo, 55 minutes, 16mm, 1973.

Last Supper at Hortsley Street. Lindi Wilson, 90 minutes, 16mm, 1983.

Le Cri Pluriel, J-C Tchuilen, 16mm, 15 minutes, 1980.

274

Let My People Go, Contemporary Films. John Krish, 23 minutes, 1961.

Liable To Prosecution, Granada TV. 27 minutes, 1978.

The Life and Death of Steve Biko, Granada TV. 30 minutes, 1978.

Lion Game, Documentary Educational Resources. John Marshall, 16mm, 1969. Study Guide available from DER.

The Long Search, BBC-TV. Ronald Eyre, 16mm.

La Maree Montante, United Nations. 45 minutes, 1977.

Mapetla, Michel Kopiloff, 16mm, 13 minutes, 1975.

Mayfair, Ad Hoc Video Group and Carnegie. Tony Bensusan, Brian Tilley, Paul Weinberg and Wendy Schwegman, video, 1984.

Mazimbu—ANC Outpost for a Liberated South Africa, 30 minutes, 1982.

My Buurt, My Trots, NFB for the SA Administration of Coloured Affairs, 16mm, 1974.

The Meat Fight, Documentary Eaducational Resources. John Marshall, 16mm, 1974. Study Guide available from DER.

The Melon Tossing Game, Documentary Educational Resources. John Marshall, 16mm, undated.

Mbira, Pennsylvania State University. Andrew Tracey and Gei Zantzinger, six titles, 16mm, 1975.

Men Bathing, Documentary Educational Resources. John Marshall, 16mm, 1972. See *American Anthropologist,* 1972.

Murudruni, Commercial Radio Corporation Studios. Johannesburg, Derek Lamport. 16mm, estimated 1960s.

Nai: The Story of a !Kung Woman, Documentary Educational Resources. John Marshall, 16mm, 1982.

The Nuclear File, Villon Films. Peter Davis, 54 minutes, 16mm, 1979.

On Becoming a Sangoma, Dept. of Psychology, University of Witwatersrand. Len Holdstock and Keyan Tomaselli, Super 8, 45 minutes, 1980.

The Other South Africa, Danish Anti-Apartheid Movement. Keyan Tomaselli, Super 8, 15 minutes, 1973.

Ouvrier de Soweto, Michel Kopiloff, 20 minutes, 16mm, 1976.

Ouvriers de Republique Sud-Africaine, Michel Kopiloff, 16mm, 30 minutes, 1982.

Part of the Process, Human Awareness. Paul Weinberg and Harriet Gavshon, Super 8, 1979.

Passing the Message, Cliff Bestall and Michael Gavshon, 47 minutes, 1981.

A Place Called Soweto, Department of Foreign Affairs and Information, 16mm, 1979. See Steenveld in Tomaselli, K. G.: *Documentary, Ethnographic Film and the Problem of Realism.* Department of Journalism and Media Studies: Rhodes University, 1984, pp. 46-49.

Playing with Scorpions, Documentary Educational Resources. John Marshall, 16mm, 1972.

Pondo Story, South African Information Department and Chamber of Mines. Ray Gettermo, 16mm, 1949.

Portrait of a Marriage, SABC-TV. Gavin Levinson, 1980.

Portrait de Nelson Mandela, Varavision. Franck Diamond, 16mm, 18 minutes, 1980.

Radio Bantu, NFB. 16mm, estimated 1970. See Heider, K.: *Ethnographic Film.* Austin: University of Texas Press, 1972.

Remnants of a Race, Killarney Flims. Estimated 1940.

Reserve 4. Documents and Carnegie. Gavin Younge, 16mm, 1984.

Reverend Jaques ethnographic footage. Lodged in the National Film Archives. 35mm.

The Right Time: A Tale of Four Pregnancies, Family Planning. Kevin Harris, 16mm, 30 minutes, 1984.

Rhythm and Dues, Rhodes University Department of Journalism and Media Studies. Shaun Johnson, video, 60 minutes, 1981.

Rhythms of Resistance, Christ Austin, 16mm, 1979.

A Rite of Passage, Documentary Educational Resources. John Marshall, 1952. Study Guide available from DER. Also see *American Anthropologist,* 1974.

Rock Art Treasures, Killarney Films. Rod Stewart, 16mm, 1970.

The Search for Sandra Laing, ATV. Anthony Thomas, 16mm, 60 minutes 1979.

The Settlers, SABC-TV. Tommy McLelland, 13 episodes, 16mm, 1984.

Shixini December, Rhodes University. Graham Hayman and Pat McAllister, video, 1984. See McAllister, P. and Hayman, G. Carnegie Conference Paper, 1984.

Siliva the Zulu, University of Florence, Attilio Gatti and Lidio Cipriani, estimated 1926. See: J.A.F. van Zyl, " 'No God, No Morality, No History': South African Ethnographic Film," *Critical Arts,* V. 1, N. 1, pp. 32-37.

Six Days in Soweto, ITV. Anthony Thomas, 60 minutes, 16mm, 1979. See Tomaselli, K. G.: *"Six Days in Soweto*: Can Propaganda be Truth?" *Ecquid Novi,* V. 2, N. 1, 1981, pp. 49-56.

Solution to the Dilemma of a Plural Society, Department of Information. 16mm, 1975.

South Africa Belongs to Us, Chris Austin, Peter Chappell and Ruth Weiss, 16mm, 55 minutes, 1979.

South Africa Loves Jesus, BBC-TV. Hugh Burnett, 50 minutes, 16mm, 1971.

The South African Experience, ATV. Anthony Thomas, 16mm, 1979.

South African Native Life, SATOUR. TV Bulpin, 16mm.

South African Mosaic, NFB. Basil Mailer, 16mm.

South African Performing Arts, Department of Information, Raymond Hancock Films. Roger Harris, 23 minutes, 16mm, 1970.

Soweto, Johannesburg City Council. Sven Persson, 1972.

Sowto 1976. Michel Kopiloff, 10 minutes, 16mm, 1977.

Swervers van die Sandveld, Killarney Films, Department of Education, Art and Science, estimated 1940.

Sun People, SATOUR, T.V. Bulpin, 1956.

The Sun Will Rise, IDAF. 16mm, 37 minutes, 1982.

Testament to the Bushmen, Jane Taylor. Paul Bellinger and Lourens van der Post, 16mm, 6 episodes, 1983. For critique see Tomaselli, K. G., Williams, A., Steenveld, L. and Tomaselli, R.: An Investigation into the Ethnographic Myths Encoded into South African Film and Television. Study undertaken for the HSRC, Rhodes University, 1984.

There Lies Your Land, Raymond Hancock Films. Raymond Hancock, 16mm, 1975.

They Came From the East, IFC and SABC-TV. Lionel Friedberg, 6 episodes, 1980. See Van Zyl (1980b) and Tomaselli, K. G., Williams, A., Steenveld, L. and Tomaselli, R.: An Investigation into the Ethnographic Myths Encoded in South African Film and Television. Study undertaken for the HSRC, Rhodes University, 1984.

This We Can Do For Justice and Peace, SA Council of Churches. Kevin Harris, 16mm, 45 minutes, 1980. For a critique see Tomaselli, K. G.: "Oppositional Film Making in South Africa," FUSE, V. 6, N. 4, pp. 190-194.

To Act a Lie, Department of Information, 16mm, 1980. For critique see Tomaselli, K. G., Williams, A., Steenveld, L. and Tomaselli, R.: An Investigation into the Ethnographic Myths Encoded into South African Film and Television. Study undertaken for the HSRC, Rhodes University, 1984.

The Tribal Identity, IFC and SABC-TV. Lionel Friedberg, 8 episodes, 16mm, 1977.

To the Last Drop of Blood, BBC. 16mm, 50 minutes, 1981.

Tsiamelo, a Place of Goodness, Maggie Magaba Trust. Betty Wolpert and Ellen Kuzwayo, 16mm, 1984.

Tug-of-War, Documentary Educational Resources. Timothy Asch and Napoleon Chagnon, 1971. Study Guide Available from DER.

Venda: n' Nuwe Staat, Department of Information. 16mm, 1980.

Vimba—the Miner, SABC-TV. Francis Gerard, 16mm, 1979.

Die Vroue Revolusie, Department of Information. David Shreeve, 1977. See Dickson, W. in Tomaselli, K. G.: *Documentary, Ethnographic Film and the Problem of Realism.* Department of Journalism and Media Studies: Rhodes University, 1984, pp. 40-42.

The Wasp Nest, Documentary Educational Resources. John Marshall, 1973.

The White Laager, UNESCO. Peter Davis, 16mm, 58 minutes, 1977. See Safford, K.: "Peter Davis' Film View of South Africa: An American Review," *Critical Arts,* V. 2, N. 2, 1981, pp. 94-97.

White Roots in Africa, Department of Foreign Affairs and Information. Jans Rautenbach, 16mm, 1979.

The White Tribe of Africa, BBC-TV. David Dimbelby, 1981. See Harrison, D.: The White Tribe of *Africa: South Africa in Perspective.* Johannesburg: Macmillan, 1981. For a critique see Tomaselli, et al.: An Investigation into the Ethnographic Myths

Encoded into South African Film and Television. Study undertaken for the HSRC, Rhodes University, 1984.

UIPTN News Report on Gangsterism in the Cape Flats, Cliff Bestall.

Voices from Purgatory, Varavisie. Roeland Kerbosh, 50 minutes, 1978.

Wits Protest, Aquarius. Keyan Tomaselli and Alan Mabin, Super 8, 35 minutes, 1970-1974.

Witsco, Witsco. Graeme Walker, Lee Hayden, Keyan Tomaselli and Alan Mabin, Super 8, 1973.

Who is Vasco Mutwa, Ministry of Information. 14 minutes, estimated mid-1960s.

A World of Difference, Goldfields, Independent Film Centre. 16mm.

Wits in the Making, University of Witwatersrand. Peter Collins, 90 minutes, 35mm, 1972.

You Have Struck a Rock, United Nations. Debbie May, 28 minutes. For review see Joe Margolis in *Cineaste,* V. 2, N. 4, 19, p. 55.

OTHER CATEGORIES

AUTEUR

Angsst, Chris Pretorius, 16mm, 1979. See van Zyl, J.A.F. in *Critical Arts,* V. 1, N. 1, 1980, p. 56.

Die Moord, Chris Pretorius, 16mm, 1980. See Bruwer, J. in *Critical Arts,* V. 1, N. 1, 1980, pp. 54-56.

Solo Ascent, Duncan McLachlan, 16mm, 1984.

We Take Our Prisons With Us, Leslie Dektor, 35mm, 1976.

BIOGRAPHICAL DOCUMENTARY

Allan Boesak: Choosing for Justice, Hugo Cassirer and Nadine Gordimer, 1984.

Athol Fugard: A Lesson From Aloes, BBC. Ross Devenish, 16mm, 1979.

Fat Cake, Leslie Dektor, 35mm, 1976.

Fugard's People, Helen Nogueira, 16mm, 1982.

I am Clifford Abrahams, This is Grahamstown, Rhodes University Department of Journalism and Media Studies and Carnegie. Clifford Abrahams, Graham Hayman, Keyan Tomaselli and Don Pinnock, video, 48 minutes, 1984.

Once Upon a Circus, Ashley Lazerus, 1976.

The Story of Sol Plaatjie, African Studies Institute of the University of Witwatersrand, video.

SHORT STORIES AND PLAYS INTO FILM

Adrian's Birthday, Lynton Stephenson, 16mm, 1973.

Amok, Souheil Ben Barka, 1982.

The Asylum, Andrew Martins, Department of Drama, Rhodes University, 1983.

Bar and Ger, Ashley Lazerus and Ken French, 16mm, 1978.

A Chip of Glass Ruby, Profile Productions. 16mm, 1982.

City Lovers, Profile Productions. Barney Simon, 16mm, 1982.

Country Lovers, Profile Production. Marnie van Rensburg, 16mm, 1982.

A Dance in the Sun, School of Dramatic Art, University of Witwatersrand. Super 8, 1981.

Good Climate, Friendly Inhabitants. Profile Productions, Lynton Stephenson, 16mm, 1982.

Howl at the Moon, Hugo Cassirer, Junction Avenue, video, 1981.

The Hunter, Cedric Sundstrom, 16mm, 1974.

Oral History, Profile Productions. Peter Chappell, 1982.

Sales Talk, William Kentrdige, 1984.

Shadowplay, London National Film School. Oliver Stepleton, 16mm, 1980.

Six Feet of the Country, Lynton Stephenson, 16mm, 1977.

COUNTER CULTURE

A Certain Delegation, Kinekor. John Peacock, 16mm, 10 minutes, 1976.

Freedom O, Keyan Tomaselli and Alan Mabin, Super 8, 40 minutes, 1973.

Suffer Little Children. Mario C. Veo. Cedric Sundstrtom, 16mm, 1976.

Summer is Forever, Cedric Sundstrom, Super 8, 1969.

The Surfwoshippers, Cadbury Schweppes. Keyan Tomaselli and Alan Mabin, Super 8, 1973.

FEMINISM

Women in Process, School of Dramatic Art, University of Witwatersrand. Harriet Gavshon, video, 1980.

Index